Carolina
Clay

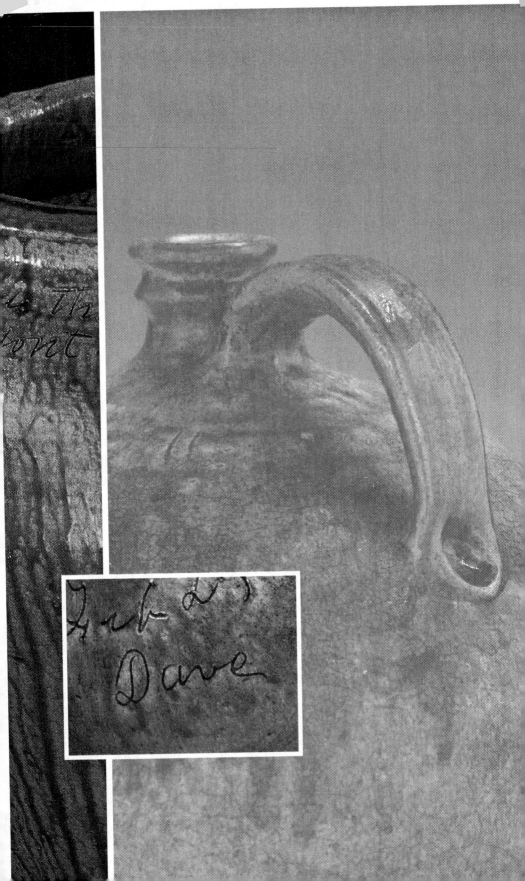

Carolina Clay

The life and
legend of
the slave potter
DAVE

LEONARD TODD

W. W. NORTON & COMPANY

New York London

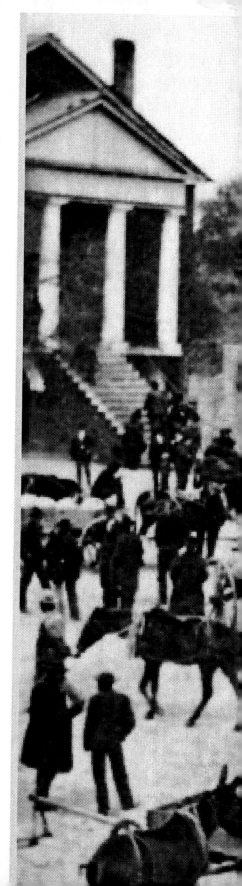

Copyright © 2008 by Leonard Todd

Printed in the United States of America

FIRST EDITION

For information about permission to reproduce
selections from this book, write to Permissions,
W. W. Norton & Company, Inc.,
500 Fifth Avenue, New York, NY 10110

Manufacturing by ?
Book design by Barbara M. Bachman
Production manager: Julia Druskin

LIBRARY OF CONGRESS
CATALOGING-IN-PUBLICATION DATA

TK.
[Lib of CCPD data tk....]

W. W. Norton & Company, Inc.,
500 Fifth Avenue, New York, N.Y. 10110

www.wwnorton.com

W. W. Norton & Company Ltd., Castle House,
75/76 Wells Street, London W1T 3QT

0 0 0 ? 2 3 4 5 6 7 8 9 0

For the people of Edgefield,

black and white,

then and now

I wonder where is all my relation
friendship to all—and, every nation

—DAVE, 16 AUGUST 1857

Contents

Lists of Illustrations

TK

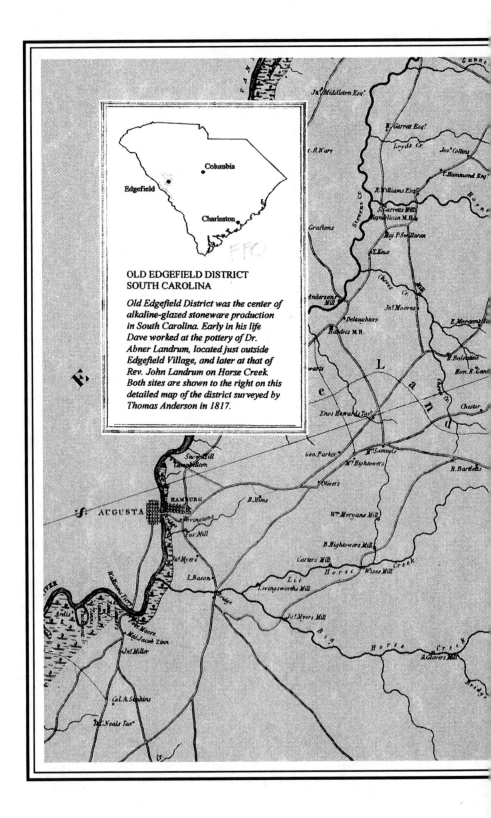

OLD EDGEFIELD DISTRICT
SOUTH CAROLINA

*Old Edgefield District was the center of
alkaline-glazed stoneware production
in South Carolina. Early in his life
Dave worked at the pottery of Dr.
Abner Landrum, located just outside
Edgefield Village, and later at that of
Rev. John Landrum on Horse Creek.
Both sites are shown to the right on this
detailed map of the district surveyed by
Thomas Anderson in 1817.*

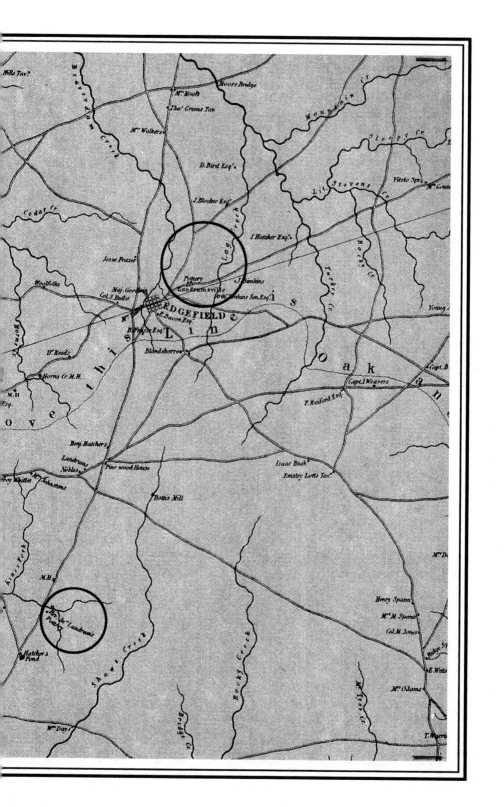

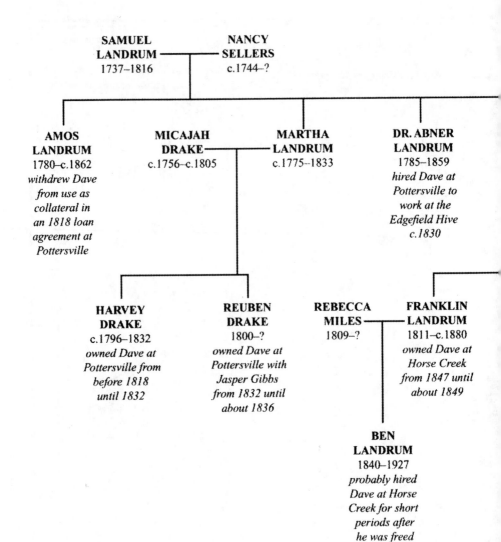

SAMUEL LANDRUM 1737–1816 ———— **NANCY SELLERS** c.1744–?

AMOS LANDRUM 1780–c.1862 *withdrew Dave from use as collateral in an 1818 loan agreement at Pottersville*

MICAJAH DRAKE c.1756–c.1805 ———— **MARTHA LANDRUM** c.1775–1833

DR. ABNER LANDRUM 1785–1859 *hired Dave at Pottersville to work at the Edgefield Hive c.1830*

HARVEY DRAKE c.1796–1832 *owned Dave at Pottersville from before 1818 until 1832*

REUBEN DRAKE 1800–? *owned Dave at Pottersville with Jasper Gibbs from 1832 until about 1836*

REBECCA MILES 1809–? ———— **FRANKLIN LANDRUM** 1811–c.1880 *owned Dave at Horse Creek from 1847 until about 1849*

BEN LANDRUM 1840–1927 *probably hired Dave at Horse Creek for short periods after he was freed*

A FAMILY TREE

of the men who owned the potteries

where Dave worked

AQUILLA MILES
c.1735–1801

HENRIETTA GIROUD
1748–1839

REV. JOHN LANDRUM
1765–1846
owned Dave at Horse Creek from about 1836 until 1846

FRANCES SHACKELFORD
1783–?

LEWIS MILES
c.1778–c.1823

SARAH BLAKELY
1779–1851

MARY LANDRUM
1812–c.1877

LEWIS J. MILES
1808–1868
owned Dave at Stony Bluff from about 1849 until 1865

JOHN MILES
1842–1903
probably hired Dave at Miles Mill for short periods after he was freed

AMERICA MILES
1840–1907

LAFAYETTE B. WEVER
1826–1890
hired Dave in 1866 after he was freed

FRANCES MILES WEVER
1866–1948

ROSALIND SECKINGER
1892–1974

LEONARD M. TODD
1913–

LENA-MILES WEVER
1910–2000

LEONARD TODD
1940–
author of this book

Carolina
Clay

Foreword

I FIRST CAME UPON DAVE'S NAME, QUITE BY CHANCE, IN AN article in the *New York Times*. Written by Rita Reif and published on January 30, 2000, it was entitled "In a Slave's Pottery, a Saga of Courage and Beauty." The lead paragraph said that an enslaved African American potter called Dave—that was his only name for most of his life—had lived in South Carolina in the nineteenth century. This caught my attention, for I had been born and raised in South Carolina before moving to New York City in the early 1970s. Dave's pots, it seemed, were being shown in a major exhibition, which had been curated by Jill Beute Koverman for the McKissick Museum at the University of South Carolina; the show was now coming to Winterthur, the museum on the former DuPont estate near Wilmington, Delaware. The vessels, which were utilitarian in nature, were important not only because of their large size and casual beauty but also because Dave dated them and, even more surprising, wrote verses of original poetry on many of them. Such a thing was unheard of at the time, for slave literacy was severely condemned by most white South Carolinians. During much of Dave's lifetime, in fact, it was illegal for a slave to be taught to read and write. Risking punishment, Dave went on to actually sign his pots and poems in a large, bold hand.

Toward the end of Reif's fascinating article, a familiar name startled me: For a long period Dave had been owned by a pottery entrepreneur named Lewis Miles. I recalled from talks with my grandmother that my great-great-grandfather had been called Lewis Miles. He was my mother's father's mother's father. All I really knew about my ancestor

was that he had lived in Edgefield, South Carolina, a small town I had never visited that lay near the midpoint of the long border between my home state and Georgia. I saw that Dave also had lived in Edgefield. And one of the pottery manufacturers who had owned him earlier was a Landrum, another family name I recognized.

This was *my family* that I was reading about in the *Times*.

That moment of discovery was like finding a door flung wide to the past: Through it, I could glimpse a complex and vibrant world. Because of those few paragraphs in the article, I now knew that my Edgefield forebears manufactured ceramic vessels that are considered important relics of antebellum life; that one of the South's greatest artisans created those containers for them; and that he was an extraordinary man on many levels—a poet as well as a potter. All of this had been lost from my family's consciousness before it could reach me.

The principal loss of information probably occurred when my ancestors left Edgefield in the wake of the Civil War. After disaster-filled wanderings through Georgia, my particular branch of the family eventually returned to South Carolina, where I was born in 1940, in the town of Greenville. It was one of the main communities of the "upper part of the state," meaning the western half at the foot of the mountains. A progressive place, "The Textile Center of the South," Greenville kept its focus on the future. Though we all paid proper respect to Robert E. Lee and Margaret Mitchell, the only direct link to the past that I knew as a boy was a collection of letters and documents that had been passed down in my family from those earlier Edgefield days. My parents and grandmother would bring them out every few years and, with reverence, we would read passages from them. Some names were familiar—a great-grandfather here, a general there—but the life they were part of was a mystery. Soon, I went north to college, to Yale; a few years after graduation, I moved to Manhattan, where I became a writer and a graphic designer. I didn't see the Edgefield letters for many years. A son of the upstate, I kept my focus on the future.

Now, though, I had been given intriguing new information about the past. Filled with excitement, and with the fateful article in my pocket, I drove to Winterthur to learn more about my early family. There, I was welcomed by a huge ceramic vessel that stood alone in the central hall of the museum. "I made this jar . . . ," Dave's own words, was written on the white platform that supported it. I walked up to face the jar. A rich brown glaze covered its surface. The base was level with my hips, and the rim came to my chin. Its shoulders were just opposite mine but wider and fuller. "Hello, Dave," I said.

Many more pots were upstairs in the main part of the exhibit. All sizes and shapes, they ranged from jugs with a narrow neck to enormous, widemouthed containers that were used for the storage of meat and grain. The colors of the glazes were dark brown or ochre or occasionally a fine, pale green. The clients of Lewis Miles wanted these containers for utilitarian purposes, but Dave made them something more. As a designer myself, I could sense the joy that he took in rounding the surfaces, shaping the handles, finding the symmetry that would satisfy what was perhaps unacknowledged at the time, even to himself—his artistry. His signature, freely incised into the damp shoulders of the jars with perhaps nothing more than a sharpened stick, looked wonderfully assured. And all around me were his poems. They ranged from a vivid evocation of "the sun moon and—stars" to a memory, perhaps spiritual, of feeling "the need of Grace." In unpolished yet rhyming language, the poems splendidly described Dave's daily concerns. I had never seen anything like them. Though a number of American blacks had written about life in bondage after they escaped from it, Dave had done so while he was still a slave. He had created a unique document with his inscriptions, a journal on his jars.

As I studied these messages from him, I realized that they were what lay beyond the beautifully written letters and documents that I had inherited from my Edgefield ancestors. Dave's poems were *the other side* of it all. One poem took my breath away:

Dave belongs to Mr Miles /
wher the oven bakes = & the pot biles ///

These words, so direct yet so enigmatic, opened my eyes in a way that nothing had before: My great-great-grandfather *owned* this man. He had paid for him, and he could punish him or reward him or sell him as it suited. Like most white Southerners, I had grown up knowing about slavery in an abstract sense but never thinking about it in such a specific way. If we spoke of it, we did so without using the names of individual slaves, which had long since been forgotten. Now, I couldn't do that anymore. I was confronted here with a real person who had "belonged" to my family. I went over the verse again, and then again, hoping to find some way to interpret it that would make me feel more comfortable with this difficult legacy from my family's past. The words appeared to indicate that Lewis Miles was a benign and caring master, but they could just as well have been written to appease a master who was not. The information on the walls of the exhibition gave me few answers; in spite of much that had been discovered about Dave he remained an enigma—a poet in a world that forbade literacy, an artist in a system that stifled the creative spirit. More questions came to me as I walked among his vessels, alternately attracted by their beauty and disturbed by the situation that had brought them into being.[1]

Back in New York, I read all I could find about South Carolina, about the Civil War, about slavery. I found out that Edgefield County had once been a center of political power. *Ten* governors had come from there, the most recent being Strom Thurmond. I read that through its influence on South Carolina history and through South Carolina's subsequent influence on national history, Edgefield County was considered one of the most historically significant communities in America. I found words I had never seen before, such as "nullification" and "coffle," along with familiar terms that had very different meanings in the world of slavery: "sable," "contraband," "maroon." Each bit of information I gained seemed only to add to the complexity of the story before me.

One of the words I came across was "manumission." It referred to the freeing of a slave, something that had originally been possible in the South under certain circumstances but had become increasingly difficult to accomplish during Dave's lifetime. By the time he was in his mid-thirties, manumission was virtually impossible under the laws of South Carolina. My ancestors wouldn't, then couldn't free him, assuming it had ever occurred to them to do so. Emancipation finally came at the end of the Civil War, and Dave lived his last years as David Drake, a free man. Still, his many modern-day enthusiasts, as I discovered, persist in calling him "Dave the Slave," partly because it's an easy rhyme, partly because little more is known about him. I found that nickname in auction catalogs, on eBay, in pottery newsletters, in conversations with collectors. Even though historians consider him to be "the most outstanding African-American potter of his time," his life seemed reduced to three short words.[2]

I was at a moment in my life just then when new directions were possible. A longtime consulting position as a corporate graphic designer was ending, which gave me a wonderful sense of open time ahead: I had just passed my sixtieth birthday, however, which gave me the opposing sense of time, rather quickly running out. In the subway one day, while waiting for the train at 51st Street, I had a kind of revelation: Yes, my ancestors had owned slaves, Dave among them, but there might be a way to turn that unhappy fact around. Using the papers from my forebears as "passes"—the written slips that once let slaves venture past their normal confines—I might be able to step through that door to the past that had appeared before me. I could go to Edgefield, go back in time to find the sites where Dave had lived and worked. I could study the inscriptions he had written on his brown jars and the letters my ancestors had written on their white pages. If I found the secrets that I suspected were there, the full course of Dave's life might become clear. And I could tell his story.

I made calls to South Carolina to rent a car and a place to live. I packed a bag with books to read on pottery, files to fill with notes, and

hats to shield me from the Southern sun. With my wife wishing me well and assuring me that she would visit me often, I left Manhattan and set off to look for Dave.

AS I DROVE DOWN THE LONG, straight road that led into Edgefield, I could see its handsome brick courthouse straight ahead. Built in 1839, it was thought for many years to be the work of the celebrated Robert Mills, author of the original design for the Washington Monument, but recent scholarship has shown that one of his followers, Charles Beck, was the actual architect. The courthouse is fronted by a wide set of granite steps that lead to a second-story porch. On that elevated terrace, which supports four imposing white colums, one can either step ahead through double doors into the great courtroom beyond or turn and take in a sweeping view of the town. I'd heard about the building all my life as part of the few pieces of Edgefield lore that had been passed on to me. The citizens of the town, it seems, had presented an incredibly fine silver sword to my great-grandfather, Lafayette Brenan Wever, the son-in-law of Lewis Miles, on the front steps of the courthouse. This was in 1849, in recognition of what they termed his "gallantry" in the war with Mexico. I have the sword now, in its original rosewood presentation case, and indeed the word "gallantry" is engraved right there on the scabbard. It's one of those words that Southern boys, myself included, spend their whole lives trying to live up to, while having only the haziest understanding of what it means.[3]

The town square lies at the foot of the courthouse steps, a kind of outdoor assembly hall equally ready in former times to receive the crowds that came for court days and the wagons that brought goods to market. Then, the surface of the square would have been red with the clay that gives this area of South Carolina a distinctive look, but today a neat green sward covers all but the paved street around the perimeter of it. Less bucolic than the village greens of New England, less elegant than the squares of Savannah, it is workmanlike and direct, much like the

people who originally settled the town. The buildings facing the square, mostly one and two stories tall, are generally not impressive. A trio of disastrous fires at the end of the nineteenth century destroyed most of the original wooden structures, and these plain replacements are all of sensible brick. Their finest feature, ironically, is this simplicity: They provide the setting for the courthouse, the town jewel. Slowly driving past their stern facades, I sensed a kind of crusty defiance perhaps one of the less well-known ingredients of gallantry.

It was after four, the square was rapidly emptying, and it appeared that I would soon have it entirely to myself. I parked my car and walked across the grass to the Ten Governors Café. Knowing what the name referred to made me feel like a native already. Finding the café closed, I turned to the biggest and oldest-looking soft-drink machine I had ever seen. It loomed on the sidewalk like a bulky Tin Woodman whose joints had frozen. The large, rectangular buttons that normally serve for the selection of a drink were so yellowed and worn that I could hardly decipher what flavors they represented. I turned to the nearest person, the only person on the square now, and asked him if the machine was working. He was an old and rather thin black man, seated on a wooden bench. A sagging tin roof over the sidewalk shaded him there; rusted metal product signs from earlier generations covered the wall behind him. I wondered for a quick, sharp moment whether Dave had looked like that when he was old. The man was much too polite to answer with any attitude, as we call it in New York City, but somewhere deep in his slow nod was, *Well, 'course it works. That's the last thing in this town we plan to let drop out of order. 'Course it works!*

Pepsi in hand and somewhat chastened, I walked to the corner. There, I discovered a huge "Welcome to Historic Edgefield" painted on the wall of the building. I had to restrain myself from thinking it had been prepared expressly for me. "Stop, Visit & Linger," it said, before launching into a startling quote from William Watts Ball, the author of *The State That Forgot*: "Edgefield has had more dashing, brilliant, romantic figures, statesmen, orators, soldiers, adventurers, daredevils, than any

county of South Carolina, if not any rural county of America." Above that, stretching the entire length of the building, were the names of every single one of Edgefield's ten governors, starting with Andrew Pickens II and going through Pitchfork Ben Tillman and up to Strom Thurmond in our own time.[4]

Staggered by the grandiosity of it all, I made my way again into the square. Past an obelisk dedicated to the memory of the town's Confederate dead and a life-size statue of strom stepping forward with his hand out stretched, I came upon a device called the "History Wall." Freshly built of red brick, it was mounted with panels that presented seven brief essays on the town's past. The first panel was entitled "A History of Violence." From its earliest days it seems, Edgefield had developed a reputation for carnage. At one point, a minister even described it as "pandemonium itself, a very District of Devils!" The panel detailed a stunning list of duels and shootings and murders, pointing out that blood had been shed on every square foot in the town square.

Hoping for a calmer picture of the place where I was going to spend the immediate future, I turned to the panel called "Industrial History." And there I found this mention of an early member of my family: "About 1810, Dr. Abner Landrum developed Edgefield's first major industry, a pottery factory." More important was the next sentence: "The most famous potter in Edgefield's history was an African Ameri-can slave named 'Dave.';thin" Dave was right there on the History Wall, alongside the town's most revered duelists and murderers! It was an honor, of a sort, for him; it was a guidepost certainly for me. Standing in that open space at the center of this odd community so full of the echoes of historical incident, I realized that I had found the rare spot that poet W. S. Merwin calls "an unguarded part of the past." That's what all this was, the self-congratulatory signs and the sagging awnings and the proud courthouse columns above the square, even that enor-mous, rusty drink machine: guideposts pointing back along an unbroken historical stream, ingrown and unquestioned. This place had once been

part of Dave's life. He had driven past here in wagons loaded with pots he had made and poems he had written. Through the passing of time and the discarding of uncomfortable memories, his story had been lost. This is where I could find it again.[5]

I had been told that my newly rented apartment faced directly on the square. I scanned the upper story of the buildings around me. In the far corner of this fine outdoor room, three tall, welcoming windows over Crouch's Hardware looked as though they might be mine.

CHAPTER I *Purchases*

*For pottery has always been one of the
necessary attributes of civilized life.*

—PHILIP RAWSON,
WRITER AND CRITIC, 1971[1]

JUST DOWN THE HILL FROM COURTHOUSE SQUARE IN edgefield is a former mechanics garage that is now a pottery. When I knocked on its yellow door, potter Steve Ferrell pulled it open and stood looking at me. He grinned and said, "Yankee man!" I have to say that flustered me a bit. "Well, I'm originally from Greenville," I said, trying to establish credibility.

"I know, I *know.*" He seemed enormously pleased, as if he were thinking. *The minute you set foot in Edgefield, mister, your whole life got to be common knowledge.* He was relatively young, but he had a white beard, quite full, down to his chest. His head, bald on top, was wreathed with a fringe of white hair. Standing now under the high skylights of his studio, bathed in morning sun, he appeared a little hunched, as if he had just been at his potter's wheel or was eager to get there. He was wearing baggy, knee-length shorts, a loose T-shirt, and sneakers, all of which were spattered with dried clay. Though, as I found out, he had spent much of his early life in California, he had long ago come to South Carolina and fallen under the spell of the early Edgefield potters. He studied their turning, glazing, and firing techniques so thoroughly that he

was ultimately able to produce ware very close to theirs in quality. He became, in effect, their spiritual heir. Visitors to Edgefield always make a point of seeking out the Wild Turkey Museum, the courthouse, and Steve's Old Edgefield Pottery, usually in reverse order.

Every surface in Steve's studio was crowded with pots: pots he had made, pots made by Edgefield potters long dead, pictures of pots, drawings of pots, pieces of pots. Any empty spaces were cluttered with maps and documents from Edgefield's ceramic past. Even more artifacts, including a signed jar by Dave, were in the museum that Steve and his father, Terry Ferrell, had established in a building facing the square. Knowing that it was hard to find Dave jars, I asked Steve how they had come by theirs. He looked pleased and said, "There's this fellow my dad and I know down in Georgia. One day, just fishing for news, he said to somebody down there, 'I hear there's a man around here who's got a Dave jar in his garage.' Turned out there *was* one, so he bought it. Right away, he had three friends who all wanted it. He knew if he sold it to one of them he'd make the other two mad, so he sold it to us!"

"And made all *three* of them mad," I said.

"Yeah!" he said with a grin.

I noticed a silhoutte of a man's profile among all the other documents on the studio wall. Steve saw me looking at it and said, "That's Abner Landrum." He said it with a combination of reverence and amusement that I would encounter again and again when Edgefieldians spoke that name. I stepped up to it and studied the strong, confident profile. He was my great-great-great-granduncle, who, just as the panel on the History Wall proclaimed, had started the whole pottery industry in Edgefield. Dave had described him as "noble Dr. Landrum" in an inscription on one of his jars. Steve came up beside me and said, "You been to Pottersville yet?" He was speaking of the small village that had been the site of Abner Landrum's pottery factory, the first place at which Dave is known to have worked. I thought it had all disappeared long ago. Puzzled, I said, "You mean Pottersville still exists?"

Steve tilted his head to the side. "Yes and no. Two original buildings are still there. One is a house and the other is a kitchen on a separate lot. Abner's factory and the rest of the village is gone, fallen to pieces or maybe burned. But in the right frame of mind you can still see it all. It's right on out Meeting Street, about a mile and a half from here." Though I was a newcomer, an outsider, a Yankee even, I took a chance and said, "I'd like to tag along the next time you're going out there." To my amazement, Steve said, "What're you doing right now?" In minutes, we were in his pale blue pickup truck, flying down the hill, going north from the square. The wind swept into the cab and lifted his fringe of hair straight out behind him. Big, columned houses blurred past us on each side of the road. He looked over and grinned at me. "Don't worry," he said. "My grandfather back in California was Fatty Arbuckle's personal driver!" Ancestors everywhere!

Past a fork outside of town, the road began to rise. Called the Cambridge Road in the old days, it led from Edgefield to Ninety-Six, an important administrative center back then. We passed rolling pastureland on the right and occasional houses set in pinewoods on the left. As we approached the crest of the hill, Steve lifted his hands from the wheel and gestured to both sides. He said, "Welcome to Pottersville!"

Though I saw only an empty green field rolling away before us, I was ready to follow wherever Steve led. We got out of the truck and walked alongside the fence that surrounded the field. With permission from the owner, we swung open a wide gate and stepped inside. In spite of many plowings over the years, the ground still held pottery shards, or sherds as collectors of Southern pottery call them. Steve stooped down to pick up one. It was small with jagged contours. He handed it to me, almost as if he were presenting me the key to Pottersville, *circa* 1815. "When I step into this field," he said somberly, "I hear the noise of the horses and wagons, the sound of the workers wedging the clay, the potter's wheels going round, the turners calling

'more mud!' I can see it all: Abner Landrum supervising the operation; Dave, young and curious, looking into everything that's going on. It comes alive for me."

Together, Steve and I began to crisscross the hillside, doing all we could to establish for ourselves how the village had looked when Dave was there. We examined the spot where Abner Landrum's kiln had stood, even found the lot where he had built his house. "I'll show you where they dug the clay," Steve said, leading me down the slope. We entered a group of trees and quickly came to a creek. Lining its banks were deposits of red clay. Geologic changes that took place many millions of years ago had left great stores of excellent clays in Edgefield District. They included the rich red variety that lay here and a finer grained, almost white clay that was usually visible only where the upper layers of soil had been deeply eroded. Steve scooped up a handful of the moist material in one hand and, to demonstrate its qualities, wiped it smoothly across the palm of his other hand. Thinned now, it glowed vividly on his skin. For a startling moment, it looked like the light of a beacon. In a way, that's what it was: Good Carolina clay, red and white, was what attracted potters to this district in the first place. It sustained my ancestors for three, perhaps four generations.[2]

When Pottersville was thriving, bands of workers had stood shin deep in this muddy stream to dig out the precious material that lay along its banks. Wagon drivers had waited just up the hill to haul it to the production area, which, Steve conjectured, was near the main road. There, they would have stored it in a shed for drying. Close by would have been the pug mill, a simple tub with a pin-studded post standing upright in it; when the tub was filled with clay, a mule, circling slowly, would turn the post to grind the material to a finer consistency. Next to the pug mill would have been an informal building, perhaps even made of logs, that sheltered the wheels where the turners made the pots. It was called the "potting shed" or the "turning house." Dr. Landrum conceived of all these separate units as a full-

scale factory. Unlike potters in North Carolina and Georgia who operated only seasonally, Landrum kept his factory going year-round. Indeed, he called his business, perhaps a little grandly, the "Pottersville Stoneware Manufactory."[3]

Dr. Landrum had two partners in his enterprise. One was Amos, his slightly older brother. Amos was known for his eagerness to undercut all rivals, which may have given the fledgling operation an edge in the marketplace from the very beginning. At the same time, Amos was a serious drinker and a rather sensational ladies' man, qualities that were perhaps less beneficial to the business. After Pottersville, he was involved with a series of potteries and a series of women; he was publically chastised for drunkenness. Amos, from all I gather, was a piece of work.[4]

The other, very different partner was Dr. Landrum's nephew, Harvey Drake. Although the records are not clear, it appears that he was probably born in about 1796. He was descended from a line of Drakes who came to Virginia from England in the early eighteenth century and made their way south along the Great Wagon Road into the Carolinas. When Harvey's father, Micajah Drake, came to Edgefield, he married Martha Landrum, the sister of Abner and Amos, probably in the early 1790s. Micajah died early, in 1805, leaving Harvey little money to give him a start in life. The boy also had an alarmingly weak constitution. Nevertheless, he possessed a powerful mind and a sense of prudence and enterprise, which led Dr. Landrum to find great promise in him. When Harvey attained manhood, his uncle included him in his Pottersville venture. At about the same time, Harvey became a slave owner. And one of his slaves was Dave.[5]

We know that Dave was the "indisputed possession" of Harvey Drake from a mention of the young slave in a mortgage agreement between Harvey and a wealthy Edgefieldian named Eldred Simkins that was drawn up on June 13, 1818. The earliest known documentation of Dave, discovered by Jill Koverman in the groundbreaking research that

led to the McKissick Museum exhibition on him, the agreement serves as a kind of Rosetta stone for decoding his younger years. It tells us that Dave was "about 17 years old" at that time, which establishes his birth date at approximately 1801; it also says that he was "country born," which means that he began life not in Africa but in the United States. All things being equal, a country-born slave was thought by buyers to be preferable to one newly arrived, who would be burdened with the shock of recent captivity, displacement, and grief; a slave in such an emotional state might be prone to rebelliousness or suicide. After the United States outlawed the importation of Africans in 1808, almost all young slaves would be country born, but earlier it was considered a special attribute.[6]

It is not known how Harvey Drake came to own Dave. I could find no indication that he inherited him, for Dave is not mentioned in the estate papers of Harvey's father or in the wills of either of his grandfathers; and the deed books of Edgefield hold no record of Dave being transferred to him by any other party. It may be that Harvey purchased him. In the South at that time, the status of a man generally depended on the number of bondsmen he owned—twenty placed him in the desirable category of "planter"—and Harvey might have been eager to begin the process of accumulating slaves. As early as 1815, when he was probably about nineteen years of age, he could have harnessed a wagon and, with money perhaps borrowed from older relatives, set out to acquire his first slave.

Augusta, Georgia, only a few hours' ride from Edgefield, would probably have been his destination. Because of its prime location where routes to the West crossed the Savannah River, it was known as the "mart of the back country." Brisk trading for cotton took place along the riverfront, but it was at the Market House, which stood at the center of town, that one could purchase vegetables, chickens, tools, and, more often than not, male and female slaves. Sometimes the slave offerings were part of a sheriff's sale to settle debts; sometimes they came from a

coffle that had been marched down from Virginia on the same Wagon Road that the Drakes had traveled coming south. In almost any issue of the Augusta Chronicle from that period, there are announcements of slaves to be sold or hired out at the Market House—"A Negro Boy named Peter," "A Negro man named Jesse," "22 boat hands . . . the best on the river."

Buyers were numerous at the mart, for many workers were needed. Thanks to Eli Whitney's invention of the cotton gin in 1793, which eased the separation of seeds from fiber, short-staple cotton had become a major cash crop in the upcountry. Cotton, though, required an inordinate number of hands to plant it, chop it, pick it, gin it, bale it, and haul it to its destination. Because of this, the number of slaves in Edgefield District increased almost fourfold in the twenty years after Dave's birth in 1801, whereas the number of white people decreased slightly. For better or for worse, Dave arrived just at the beginning of what dealers considered a bull market in black slavery.[7]

For a white buyer in the antebellum South, the purchase of a slave carried little more emotional weight than did the acquisition of a plot of land or a horse. For the slave being purchased, however, the experience was full of personal turmoil as, quite out of his or her control, one life ended and another began. Some understanding of this must have made itself felt in the white community, for in later years certain Augusta residents tried to deny that slave sales ever took place in their city. In the 1930s, when a local white woman made that statement in the newspaper, two former Augusta slaves spoke out to contradict her. Their words were recorded in interviews for the Works Progress Administration (WPA) Slave Narratives, which were being carried out at the time. Eugene Smith said, ". . . I saw 'em selling slaves myself. They put 'em up on something like a table, bid 'em off just like you would do horses or cows. . . . They would sell a mother from her children." Laura Steward said, "Dey would line 'em up . . . and look in de mouf at dey teef; den dey march 'em down togedder to market in crowds, first Tues-

day sale day." They told this to the interviewers, "in spite of what white laides say."[8]

I pictured Dave standing under the eaves of the market, shackled, waiting to be sold. He would have been about fourteen in 1815. He would have been full of uncertainty, even fear. It wouldn't have been fear of being sold into slavery, for he had been a slave from the moment he first opened his eyes; it would rather have been fear of leaving the bondage he knew for bondage that was unknown. If he were lucky, he had spent the years leading up to this day at least partially in touch with his mother. He might never have seen his father, for stable family groups were rare among slaves being bought and sold. He likely had no knowledge at all of his grandparents. Slaves were often brought from Africa as children and, if that were the case with Dave's parents, they would have had only minimal memories of the land and people they left behind to pass on to their son. Rev. James W. C. Pennington, once a slave himself, wrote in his autobiography that one of slavery's great evils was that it threw the slave's family history "into utter confusion."[9]

As Harvey Drake walked along the arcades of the market, the slave dealers might have recognized him as an interested buyer and called out to him. One of them might have pushed Dave forward and cried, *Look here, young master!* In examining the black boy, only about five years younger than he was, Harvey might have found him to be a likely worker with a strong back equal to the many tasks of the pottery. He might have talked to him a bit and deemed him of promising intelligence. When the bidding began, Harvey might have spoken out with confidence and taken the bid high enough to win the day. The average price for a slave then was $250 to $300. Because Dave was young, male, healthy, intelligent, and country born, he might have brought $500, the equivalent of about $7,000 today.

The moment of purchase was an opportunity for a buyer to rename his property to avoid confusion with similarly named slaves

back home or simply to assert dominance. "Slaves never have any name," reported escaped bondsman David Holmes in 1853. "I'm called David, now; I used to be called Tom, sometimes; but I'm not, I'm Jack. It didn't much matter what name I was called by. If Master was looking at one of us, and call us, Tom, or Jack, or anything else, whoever he looked at was forced to answer." Someone along the line, whether it was Harvey Drake or an owner before him, might have looked into the face of his new purchase and said, *'Dave' suits you, boy. That's who you are from now on.*[10]

WHEN DAVE FIRST CAME to Pottersville, he was younger than most of the other workers at the factory. Neither his body nor his personality nor his mind were fully formed, yet all the elements that would one day make him an extraordinary presence in the village—his keen intelligence, his sharp powers of observation, his creativity and sense of humor—were already present, waiting for a spark of inspiration to bring them to life. Given the constraints of the slavery system, these qualities were probably exhibited only sporadically, perhaps in a boy's eager ability to find lost tools or entertain. Dave almost certainly had no opportunity to try his hand at potting during this early period, for at that time itinerant white potters were the primary turners. They had surnames such as Massey, Durham, and Ferguson, and their family roots were in the British Isles; in some cases their forebears had been potters, as well. The other jobs required for the operation, such as digging, hauling, and preparing the clay, were generally reserved for slaves. These were the tasks that Harvey would have assigned to young Dave. There was certainly no shortage of work to do, for the pottery was thriving.[11]

In May 1818, Harvey Drake and Abner Landrum borrowed six hundred dollars from the Bank of the State of South Carolina in Columbia. It's likely that they sought the money to expand their oper-

ation, for an entry in the 1820 Census of Manufactures, which probably refers to the Pottersville Manufactory, notes, "Proprietors about enlarging this establishment." Eldred Simkins, a wealthy landowner whose property abutted Dr. Landrum's, endorsed the loan for them. A month after borrowing the money, Harvey put up collateral in order to protect Simkins from potential loss. Though it's hard to imagine today, Dave was made part of that collateral; if the Pottersville partners defaulted, he would become the property of Simkins. The fact that Harvey would risk losing his young slave appears to indicate that Dave hadn't yet proved his usefulness. Four months later, however, Amos Landrum, the most wily of the partners at Pottersville, stepped forward to present substitute collateral: eighty acres of land and a gristmill on Shaw's Creek, which was a waterway east of Edgefield. Now if a default occurred, the land would go to Simkins, and Dave would remain at Pottersville.[12]

It's not clear why Amos made this change. My theory is that it had to do with the white turners at Pottersville, who had a decided propensity for picking up and leaving for the West, creating serious vacancies in the turning house. Perhaps Amos, fed up with these departures, convinced his partners to fill the most recent empty place not with another itinerant worker but with a slave, who wasn't going anywhere unless they said so. Dave appears to have been considered as a candidate, for someone at about this time began to teach him how to turn pots—how to measure out the amount of clay required for a particular jar, how to center the mound of clay on the wheel, how to open up the mound, then slowly draw up the sides to form a vessel. Similarities between Harvey Drake's pots and later work by Dave suggest that it might have been Harvey himself who was his teacher. This introduction to turning must have been an important moment for Dave. It would have given him hope that he might rise above the bottom rung of the factory's hierarchy; it would have indicated that he had something within him—a talent, perhaps—that was

valuable; and, in a significant way, it would have marked the begin-
ning of his adulthood.[13]

The forms of the vessels that Dave learned to make were profoundly
influenced by the needs of their potential users. A Pottersville storage
jar, for example, had horizontal lug handles just deep enough to accom-
modate a row of strong fingers. The bigger the jar, the more handles it
had. Its mouth was wide in order to receive the foodstuffs that it would
hold. Its rim was pronounced so that a cloth cover could be tied in place
over it. Little by little—it's said to take at least five years to make a pot-
ter—Dave came to understand these requirements and learn how to
accommodate them in the wet clay his fingers. An 1821 Edgefield jug,
furnished with a perfectly executed strap handle and a double-rim neck,
may be evidence of this. Jill Koverman has measured it and found it
nearly identical to an 1853 jug signed by Dave. "These similarities," she
contends, "indicate that Dave, at the age of 21, could have turned this
early jug at Pottersville." If this is indeed Dave's work, it shows that he
was learning his lessons well.[14]

Dave's probable progression at Pottersville led from digging in the
clay beds to performing tasks in the yard to turning pots at his own
wheel in the factory building. Perhaps he helped somehow to engineer
this rise; perhaps it was due only to a kind of survivor's luck. However it
came about, he was a turner now, the highest position to which a pottery
worker could aspire. Records show that at least two other slaves, Daniel
and Harry, also became turners at the factory, probably as more white
workers went west. The use of slaves in the production of stoneware, in
fact, was one of the characteristics that came to define the Pottersville
factory and the other Edgefield District potting enterprises that would
follow it.[15]

Though we can piece together the probable course of Dave's work
life during his early years with Harvey Drake, his existence outside the
potting shed is less discernible. The mortgage agreement of 1818, which
has provided much other information, does shed some light on it, how-

ever. According to the document, a second slave was included along
with Dave when he was offered as collateral to Eldred Simkins. Her
name was Eliza; she was between eighteen and twenty years old at the
time, about two years older than Dave. She was probably not his sister,
because he was described as country born and she was not. It's tempting
to think that she was his wife. If they were a couple, they probably did
not yet have any children, because very young slaves were usually kept
with their mothers, and no children are mentioned in the mortgage
agreement. No indication is given of whether Eliza worked at the pot-
tery or in the fields or in the Drake home.[16]

At that time in the South, slave men and women were allowed and
even encouraged to marry. Slaveholders felt that recognized unions
between their workers increased general plantation stability. James
Henry Hammond, one of Edgefield's most prominent planters, pre-
sented each newlywed slave couple on his plantation with five dollars, a
sizable sum for a slave to receive. He gave the men shirts and pants for a
year and provided the women with needles, thread, and cloth to make
their own clothes. In spite of such approbation, slave marriages were
not recognized as legal. Had they been, couples in bondage might have
been able to make certain claims—to their children, for instance—and
that was unthinkable under the slavery system. Instead of a church-
sanctioned marriage ceremony, the beginning of a union between two
slaves was usually marked by "jumping the broomstick." In this practice,
a broomstick was laid on the ground in front of witnesses and the cou-
ple was invited to step across it together.[17]

One of the most spectacular pots made in Edgefield bears a drawing
of what appears to be a slave wedding. It was made around 1840 at the
Phoenix Factory on Shaw's Creek, one of the potteries that was estab-
lished in the district after the success of Pottersville. It is attributed to a
brilliant white turner named Thomas Chandler. Two and a half feet tall,
it is an elongated watercooler with a small-necked opening at the top
and a hole near the base for a spigot. The incised drawing, filled in with

two colors of water-mixed clay, known as "slip," shows a slave man and woman facing each other. The woman's neat dress and shoes are dark; her kerchief, collar, purse, and pantaloons are white. The man is dressed in a short, dark jacket and well-fitted trousers. He holds what appears to be a formal silk hat in front of him, as if he had just taken it off in honor of his bride. No broomstick is in evidence. Perhaps to anchor the occasion in reality, however, a sow stands in profile below the couple. Occupying its own strip of ground, it contemplates a dark jug not unlike the cooler itself.[18]

Over the years, some slaveholders, chagrined by the knowledge that their slaves were in essence living in sin, attempted to provide a Christian basis for their unions by bringing in a minister, either white or black, to oversee the proceedings. If none was available, they sometimes officiated themselves. There remained, however, the problem of the lack of legal status of the marriages: The words "Till death do you part" were absent, sometimes even replaced by "Till death or distance do you part," making it clear that the owner of the couple could at any time sell one or both of them and thereby dissolve the union. Like the sow on the Chandler cooler, that phrase served to bring onlookers sharply back to the reality of the situation. Former bondsman Matthew Jarrett, reflecting on those days, said, "We slaves knowed that them words wasn't bindin'. Don't mean nothin' lessen you say, 'What God has jined, caint no man pull asunder.' But dey never would say dat. Jus' say, 'Now you married.';thin"[19]

If Dave and Eliza were married, it may be that "distance" came between them, for the document by which Amos Landrum withdrew both of them as collateral also included the information that Harvey Drake had "some intention of parting" with Eliza—in other words, he was considering selling her. How simple that sale would have been for him, yet how difficult for her. Rebecca Jane Grant, who had been a slave in South Carolina, always remembered the pain that her mother endured after she was separated from her husband by a sale. "All de time

she'd be prayin' to de Lord. She'd take us chillun to de woods to pick up firewood, and we'd turn around to see her down on her knees behind a stump, aprayin'. We'd see her wipin' her eyes wid de corner of her apron, first one eye, den de other, as we come along back. . . ."[20]

If Harvey Drake did ultimately sell Eliza out of the area, whatever relationship she and Dave had known would have been considered at an end, and each of them would have been expected to find a new mate. Indeed, we soon find Dave listed in the public record beside a woman named Lydia. The first mention of her, in which she is called Lidy and is said to have two children, is in an 1830 agreement between Harvey and his younger brother, Reuben. Dave and Lydia are described as "servants," whereas others in bondage to the Drakes are designated in the same agreement as "slaves." This shared description, together with their proximity in the document, gives the impression that they are living together as a couple with small children. Estate documents, drawn up two and a half years later, note that Lydia's children are named John and George. George was also the name of one of four male slaves whom the Drake brothers owned during this time: Daniel, Tart, Abram, and George. Because naming patterns among slaves often honored a father or grandfather of a newborn boy, it is possible that this George was the father of at least one of Lydia's sons.[21]

Slavery so complicated the personal lives of those in bondage and at the same time so completely erased the record of what it had done that it is impossible to know what the situation was here. Perhaps Eliza was Dave's wife during his early years at Pottersville; perhaps Lydia, after a prior relationship with George, was Dave's wife during his later time there. Dave might have known pleasure and comfort and perhaps even love with each woman, but "distance" and the threat of it might have brought him much sorrow. He might have lived with all of these feelings inside him and with others we can't imagine.

One additional related detail has survived that shouldn't be overlooked. According to a story that was told many years later by a former

slave who had known Dave, Dave passed out drunk on at least one occa-
sion while he belonged to the Drakes. This might have been the result
of only youthful high spirits; in a darker view, however, it might have
been evidence of the stresses he experienced as a man in bondage with
no control over his life or the lives of his loved ones. Either way, it sug-
gests that he was something of a loose cannon in his community. At the
pottery he might have been a dedicated worker, but on his own time he
apparently sought the altered state that alcohol so easily provided. That
would have made him a problematical mate, a handful for any wife.[22]

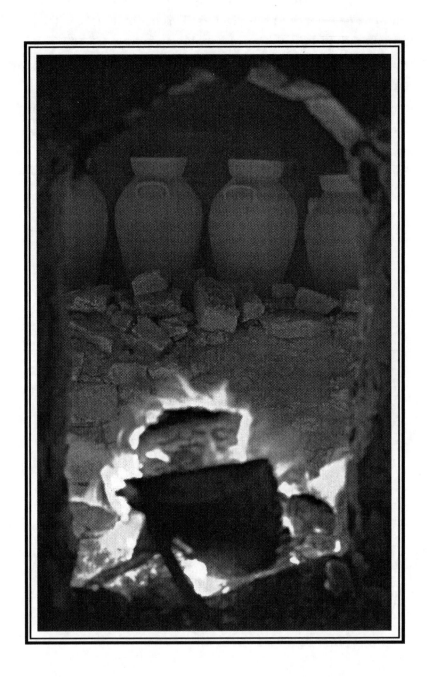

Discoveries

*The first sight of that furnace near thirty
years ago,—can we ever forget it? Have we
ever been able to think of any other kind
of furnace when reading of Shadrack,
Meechack and Abednego?*

—ARTHUR SIMKINS, EDITOR OF
THE EDGEFIELD ADVERTISER,
1859[1]

POTTERSVILLE DURING DAVE'S YOUTH WAS A PLACE OF CE-
ramic innovation and discovery. This was due almost entirely to Abner
Landrum, who seems to have had a sixth sense for the potential of clay.
He may have come by his understanding of the material quite naturally,
even "inherited" it, for there is some indication that earlier Landrums
were also involved in pottery manufacturing. After his great-
grandfather came to Virginia from Aberdeenshire, Scotland, in 1688,
subsequent members of the family moved south along the great migra-
tion trail to North Carolina, where some among them became linked
with important local potters Peter Craven and John Philip Hartso. The
link, as far as we understand it, is tenuous but intriguing: The names
Landrum, Craven, and Hartso appeared together on several documents
associated with the Regulator Movement, in which settlers protested,
sometimes with violent consequences, the taxes and policies of the
colonial authorities. Abner's father, Samuel Landrum, left North Car-

olina in the wake of these troubles and arrived in South Carolina in 1773, on the eve of the Revolution. Family tradition holds that he established a pottery in Laurens and then another when he moved on to Edgefield District shortly thereafter. Abner, possibly one in a line of potters, was born in Edgefield in 1785.[2]

Intellectually gifted, young Abner studied with a celebrated teacher in Abbeville County, Dr. Moses Waddel, who later founded Willington Academy, known proudly as "the Eton of the South." Abner then interned in the Augusta offices of Dr. Benjamin Harris and became a physician. In 1809, however, at the age of twenty-four, Dr. Landrum made a discovery that brought him, perhaps inevitably, back to the profession that his forebears may have practiced before him: In the countryside across the Savannah River, he located a rich deposit of kaolin, the nearly pure white clay valued by producers of fine ceramic ware. He informed the *Augusta Chronicle*, which sent out the news on July 15, 1809: "Dr. Landrum has lately discovered a Chalk in the Edgefield District, S.C., that is represented to be of superior quality—equal at least to that which Edgeworth manufactures near Liverpool—there is a great body of this material in said district, and will soon become highly useful to the country and profitable to the proprietors."[3]

The discovery came at an opportune moment, for Thomas Jefferson had recently embargoed goods from nations involved in the Napoleonic wars. This encouraged nascent American industries to step forward and fill the needs of the country. Dr. Landrum's recent find, the favorable political climate, and his family's possible potting tradition were probably the factors that led him to establish his pottery in Edgefield. He chose the spot that I had visited with Steve Ferrell, which had good access to clay, water, and wood—three necessities for a potter—as well as proximity to important commercial routes. Bringing Amos and Harvey in as partners, Dr. Landrum had his operation up and running in time for "Landrum's Pottery" to appear on a sketch that surveyor Thomas Anderson made for a map of the district in 1816.[4]

The kind of pottery that Dr. Landrum began to produce—and Dave

was taught to make—was known as stoneware. It was very different from earthernware, which had been widely used during the previous century in colonial America. Made from coarse-grained clays, earthernware was fired at relatively low temperatures and consequently did not vitrify, unless glazed, it remained pervious to liquids. Stoneware, on the other hand was made from purer clays, which, as Dr. Landrum had demonstrated, Edgefield District had in abundance. Stoneware was fired at much higher temperatures, causing it to vitrify and become impervious. It, too, was usually glazed, but this was for aesthetic purposes and for making the ware easier to clean. Before tin cans and glass jars were available, containers made of stoneware were enormously useful on the small farms and the large plantations of nineteenth-century America. Everybody at that time needed storage containers for pickles and butter and flour and meats; they needed bowls for soup and pitchers for milk and jugs for whiskey. It was this demand that Dr. Landrum understood and set out to fill on his hillside beyond Edgefield Village.[5]

Perhaps to raise money for his new venture, Dr. Landrum subdivided his property along both sides of the road and sold off lots to other families, creating the village of Pottersville. There were soon about seventeen houses there, compared with about forty-five dwellings in much older Edgefield. Dr. Landrum built a house for himself and his wife, Mahethalan Presley Landrum, who was also from a potting family, at the very center of the village, across the road from his factory. There were stores and artisan shops, and soon there would be a small carriage factory, a schoolhouse, and a church. Dr. Landrum had four potter's wheels at his establishment by 1820, with five men and two children at work there.

A boost for the whole enterprise came in 1826 when Robert Mills spoke highly of it in his comprehensive book *Statistics of South Carolina*: "There is [a village] within a mile and a half of Edgefield court-house, called the Pottery, or Pottersville, but which should be called Landrumville, from its ingenious and scientific founder, Dr. Abner Landrum. This village is altogether supported by the manufacture of stoneware, carried on by this gentleman; and which, by his own discov-

eries is made much stronger, better, and cheaper than any European or American ware of the same kind. This manufacture of stoneware may be increased to almost any extent; in case of war, Etc. its usefulness can hardly be estimated." Partly in jest, partly in real admiration, people began to speak of Pottersville as "*the* juggery of South Carolina."[6]

The original concept for Pottersville may have been more complex than is generally understood. There is evidence that Dr. Landrum considered the sale of stoneware to be the means of financing a much loftier goal: the production of elegant porcelain objects. Making translucent porcelain is far more complicated, however, than making stoneware. Among other things, it typically requires two firings—the first of which is called a "bisque firing"—whereas *stoneware can be produced with only one.* Still, Dr. Landrum seems to have made serious attempts at it. When a team from the McKissick Museum and the South Carolina Institute of Archaeology and Anthropology (SCIAA) examined the Pottersville site in 1987, it found sherds of an unglazed cup that had been bisque fired, a possible indication of experimentation with porcelain.

More evidence comes from Dr. Landrum himself. On April 9, 1830, he issued an invitation to the staff of the *Charleston Courier*: "If the [writer] can command sufficient leisure to manufacture a specimen of the up-country porcelain, he will forward it to the Courier office, as inspection better than words will enable the curious to appreciate the difference in these elegant wares." This makes it clear what his intentions were, but it also indicates that he didn't actually have a presentable piece of porcelain in hand at the time. No one whom I have talked to has ever seen an example of upcountry porcelain except in sherds from a waster pile, the place where failed vessels are discarded.[7]

Though Dr. Landrum's quest for porcelain appears not to have been successful, it may have been the means by which something even more important was discovered. In about 1820, he created a sensational glaze that surpassed any known coating for stoneware. It not only looked good, it was durable and affordable and safe. Until then, the glazing process had presented grave problems for American potters. In colonial

days, they coated earthenware with a lead-based solution before they fired it, but the lead tended to leach out into foods, especially acidic foods, and poison the users. Although stoneware makers in the North subsequently adopted the safe technique of salt glazing, Southern potters found salt to be expensive and not always possible to obtain. Dr. Landrum brilliantly solved the problem by developing a glaze that was composed simply of wood ash, sand, and clay, components that were widely available to all. The wood ash acted as a flux to lower the melting point of the mixture; the clay helped bind the glaze to the pot so it wouldn't run off in firing; and silica in the sand produced a glassy surface when melted. Because wood ash is alkaline, this formulation is known today as an "alkaline glaze."[8]

No one is sure whether Dr. Landrum invented this new technique entirely on his own or whether he found hints of it in outside sources. In his day, the only other place on Earth where pots were glazed in this manner was China, where the practice had existed since the Han Dynasty (206 BC–AD 220.) Because the secret of this technology was carefully guarded, the way in which it apparently passed from the Orient to backwoods Carolina is, in the words of pottery historian Howard Smith, "one of the great American ceramic mysteries." One prominent theory traces the transfer of knowledge to a French Jesuit priest named Père d'Entrecolles, who lived in southeastern China in the early eighteenth century. A man of many interests, he became intrigued with the porcelain produced at the imperial factory at Ching-te-chen. Delicate and exquisite, it was covered with highly refined glazes. He was able to learn the secrets of its manufacture through several of his converts who worked in the factory. He put all the information in a pair of letters, one written in 1712 and another in 1722, and sent them back to Europe, where they were published in Jean-Baptiste Du Halde's *Description . . . de la Chine*. Du Halde's book, translated into English as *The General History of China*, became a standard reference on that distant and mysterious country.[9]

Given Dr. Landrum's interest in ceramics and his desire to produce porcelain from the kaolin he had discovered in the upcountry, it seems

likely that he would have moved Heaven and Earth to obtain a copy of
The General History of China. He would have followed Père d'Entrecolles's
instructions closely, substituting local materials when necessary. If,
indeed, it happened that way, Abner Landrum ended up creating the first
American alkaline glaze while attempting to replicate Chinese porcelain.

Use of Dr. Landrum's glaze spread to other Edgefield potteries, then
throughout the South, as itinerate potters took knowledge of it with
them. It ultimately became the defining characteristic of Southern folk
pottery. Potters in Mossy Creek, Georgia, in what may be an uncon-
scious reference to Père d'Entrecolles's efforts, still refer to it as the
"Shanghai" glaze. Interestingly, the look of the alkaline glaze varied
depending on a number of factors—the ingredients that were added to
the standard "ash and sand" formula, the color of the clay that the ves-
sels were made from, the characteristics of the kiln, the firing condi-
tions on a particular day, and even the location of a pot within the kiln.
Through long trial and error to develop working methods that they
were comfortable with, individual potters often inadvertently achieved
a characteristic look for their ware. Pieces from Dave's youth at Pot-
tersville were typically yellow-green or light gray-green in color; jars
that he turned at other kilns later in his life were dramatically different,
with glaze colors ranging from dark olive green to brownish black.[10]

When the time for a firing at Pottersville approached, a worker
would prepare the glaze by grinding its ingredients between two stone
surfaces in a hand-operated mill; he would then add water and pour the
resulting solution into a large tub. Dave and the other turners would
take the vessels they had made since the last burn, which had been dry-
ing under a shed, and dip them in the tub. If a pot were too large to dip
successfully, they would ladle the glaze onto it. They would coat all the
pots inside and out, while leaving the underside bare so the glaze would
not fuse with the sand floor of the kiln. As the workers dipped their
pots, they would unintentionally prevent the glaze from adhering to the
clay in the spots where their fingers held tight. The resulting bare
places, which can still be seen on some containers at the inner edge of

the rim and at the lowest part of the side, are the actual imprints of their fingers. For me, such vessels are almost painfully evocative. As biographer Richard Holmes writes: "Anything a hand has touched is for some reason peculiarly charged with personality . . . It is as if the act of repeated touching, especially in the process of daily work or creation, imparts a personal 'virtue' to an inanimate object [which is] impervious to the passage of time."[11]

The remains of the kiln that Dave used are just off the road at Pottersville. They form a wide mound near the crest of the hill that dominates the site. The mound is still thick with kiln bricks and stones. Trees have sprung out of it, and a single telephone pole has been planted squarely in its middle. Dr. Landrum chose this particular spot to build his furnace for several reasons. For one, its position near the top of the hill allowed rainwater to drain away from it, so that it would not be flooded; for another, smoke from a chimney on this high location would be easily picked up by prevailing winds and blown southeast, away from the settlement. With entrepreneurial flair, he also may have placed the kiln here because it lay at an important crossing, where an offshoot of the road from upstate joined the Cambridge Road. At that simple T-intersection, Dr. Landrum's chimney, visible even before a traveler reached the settlement, was a ready-made advertisement.

Dr. Landrum's furnace, a type once used throughout the South for firing stoneware, is know today as a "groundhog" kiln. The name derives from the appearance: Partly dug into sloping ground to help contain the heat and buttress the stone walls, it looks like the home of a giant burrowing animal. The Pottersville kiln, like all others of this variety, consisted primarily of one long rectangular space. The narrow front wall was pierced by an entry opening and two or three stoke holes at knee level through which wood could be shoved into a firebox; a stone chimney stood at the far end. The vaulted brick roof of the kiln was quite low in order to concentrate the heat, with just enough clearance for a man to crawl on his hands and knees to arrange the ware for burning. Heat from the fire was drawn across the rows of pots to the chimney. A low

flash wall just past the firebox shielded the ware from direct exposure to the flames. Given sufficient heat and time—2,300 to 2,400 degrees Fahrenheit for twelve to eighteen hours was typical—the fragile clay hardened into stoneware.[12]

It's difficult to tell how big Dr. Landrum's kiln was just by looking at the mound at Pottersville, but it probably would have been somewhat larger than a typical family-operated one, which generally measured about eighteen feet long by eight feet wide. In all likelihood, a low wood-shingled roof, supported by wooden posts, sheltered the vault of the kiln from the weather. The wide chimney would have risen about ten feet above everything else.

A timber agreement signed by Abner Landrum in 1827 suggests that there were firings at Pottersville approximately every two weeks. On the days leading up to a burn, Dr. Landrum would designate two or three of the factory slaves to begin loading the kiln. The smallest among them would crawl inside, receive the pots that the others passed in to him, and position the vessels—the shorter ones along the walls, where the ceiling of the firing chamber was lowest, and taller pieces toward the middle of the space, where clearance was greater. He would make sure that no two pieces touched, for fear of marring the glaze during the firing. Meanwhile, other slaves would ready the all-important fuel, hardwood for slow burning and fat pine for making the furnace as hot as possible. They would split the wood into long, narrow sticks called slabs. In the late afternoon of the day before the burn, Dr. Landrum would have two workers start a small blaze in the firebox and keep it gently burning through the night. It would warm the walls of the kiln and the ware inside.[13]

Just after dawn the next morning, all the pottery slaves, Dave among them, would gather on the slope leading up to the furnace. In my mind's eye, I can see Dr. Landrum raising his walking stick as a signal for the men to brick up the loading door. He might give his workers a short lecture on the importance of keeping the fire low at first. *Patience*, he might say, *is primary at a burn.* This was because the potential for disaster—an entire lot of pottery could crack and be lost in a kiln heated too

quickly—was very real. The slave selected to start the day's work would shove the first thin slabs into the stoke holes. He would drive them in diagonally, so they would fit into the firebox neatly and feed the low fire that was already burning. Stepping close, Dr. Landrum would judge from the comfortable heat and the glow from the holes that the blaze was at the intensity it should be. By constant monitoring, he would keep it at that level throughout the morning.

By early afternoon, observers would begin to gather on the slope around the kiln. They would be from Pottersville and from Edgefield Village, as well. Children, running breathlessly, might begin to link one by one into a curving line for a game of Whip the Snake. Their mothers, clustered in small, neighborly groups, might call to them to stay clear of the furnace. Harvey Drake's younger brother, Reuben, just the age of Dave, might bring out his flute and play a series of martial tunes on it.

Activity at the stoke holes would increase now as Dr. Landrum incrementally raised the temperature of the furnace. Though perhaps wearing a necktie and a vest—he was *Doctor* Landrum, after all—he would roll up his sleeves and perspire as freely as his workers in the heat from the growing blaze. He would make sure that the stacks of wood near the kiln were constantly replenished. Periodically, he would check the fire's progress through a peephole, probably looking through a piece of smoked glass to protect his eyes.

At a certain point early in the evening, after hours of building the strength of the blaze, Dr. Landrum would decisively call for the blastoff, the moment that he and the workers and townspeople had been waiting for. He would order two fresh men to the stoke holes—perhaps Dave was one of them—and tell them to take it up quickly now. Picking up a long slab of fat pine, Dave might position himself on the left; the other worker, Tart, perhaps, might take a stand on the right. Like pistons in a steam engine, they would begin to stoke the fire, one stepping forward to shove in a slab, then dropping quickly back as the other moved into place. The sound of the blaze, which had for so long been a growing crackle inside the firebox, would rise now to a roar. There would be no

time for the two men to rest: Pick up, step forward, shove, step back. Tongues of flame would leap out to meet the wood in the men's hands and catch it even before it reached the opening. Perhaps the townspeople, awed by what was happening, pulled their children a few feet farther down the hill.

Working together, the two men would ultimately succeed in filling the stoke holes to capacity, sharply reducing the flow of oxygen to the fire. This would cause a splendid column of black smoke to billow from the chimney of the kiln. The overload of fuel would quickly be consumed: Fire would engulf the interior of the furnace and a sheet of orange flame would leap from the chimney into the darkening sky. As he quickly wiped his forehead, Dave might see Dr. Landrum raise his walking stick and,: like a magician in an act of wondrous creation, gesture upward at the rising, branching flames. Reuben Drake might whistle a wild little tune of celebration of his flute. And the citizens of Pottersville would cheer at the glory of it all.

The workforce would maintain the magnitude of the blastoff for two more hours, during which the raw clay pots inside would be transformed into stoneware. The fire would be allowed to die down then and the furnace left to cool. Two or three days later, Dave and the others would un-brick the loading door the smallest among them would crawl inside to hand out the ware. They would line it up for sale outside, fresh from the oven. At that spot, where the smell of smoke still lingered, men of African descent, working with European methods and Asian glazes, would have produced one more lot of pottery for an eager South Carolina.

PRODUCING STONEWARE AND PORCELAIN were only two of Dr. Landrum's interests at Pottersville, for he shuttled enthusiastically among commercial, scientific, and intellectual endeavors. He was especially interested in how science could be brought to bear on farming. In 1822, he succeeded in grafting pecan cuttings onto the hardier hickory nut

tree. According to pecan historians, this made him the first to success-
fully create this cultivar. Others in Louisiana later independently suc-
ceeded in making the same graft, which then became the basis of
modern pecan culture. All the while, he practiced medicine (sometimes
treating patients with herbs he had grown) and studied the geological
formations of South Carolina. There seemed to be nothing he wasn't
interested in and almost nothing he couldn't do.[14]

Though Abner Landrum was clearly brilliant, Pottersville, not to
mention Edgefield Village, was beginning to note a certain oddness
about him. First of all, he gave his children peculiar names, each with an
important historical or literary reference. He named one son Manises,
after the Spanish city famous for its lustreware; another he named
Wedgwood, for Josiah Wedgwood, the British ceramics entrepreneur; a
third he called Palissy, for Bernard Palissy, the brilliant sixteenth-
century Huguenot potter whose work bore colored plants and sea crea-
tures in high relief; a fourth he named Linneaus, in honor of Swedish
botanist Carl Linnaeus, who devised the classification system for plants
and animals that is still in use today. One daughter was called Juliette, in
a nod to Shakespeare, and another Eponia, presumably after the Celtic
goddess of horses. All this was admirable homage but surely a nightmare
every time the family had to be introduced to strangers. Only a daugh-
ter, named Sallie, seems to have been spared.[15]

As Dr. Landrum's great-granddaughter, Maude Stork Shull, told me,
"He was so *intent* on what he did. A lot of people thought he was a little
crazy. My mother always said, 'The Landrums were smart, but they were
a little peculiar.';thin" A saying that used to circulate in Edgefield put it
even more bluntly: "Anybody with a drop of Landrum blood in them is
cracked." The family seems to have been aware of its distinctive personal-
ity, though not always sure where it came from. Catherine Holland
Scavens, who was descended from Dr. Landrum's brother, John, told
me, "When I was young, we always thought that our peculiar ways came
from the Smyly family, but an old lady who lived in Edgefield all her life
told me, 'Nooo, it was the *Landrums.*';thin" [16]

" Delightful task, to rear the tender thought,
And teach the young idea how to shoot."

A B C D E F G H I J
K L M N O P Q R S
T U V W X Y Z

a b c d e f g h i j k l m n

o p q r s t u v w x y z &

æ œ fi ff fl ffl ffi

CHAPTER III *Words*

[When the] proud and selfish Anglo-Saxon
seized upon the Negro to be used merely as a
beast, he was soon alarmed to find that he
must undertake the difficult task of forging
chains for a mind like his own.

—JAMES W. C. PENNINGTON,
FORMER SLAVE, 1850[1]

AT THE SAME TIME THAT DAVE WAS LEARNING HOW TO
turn and burn stoneware, he was acquiring another, very different skill:
He was learning how to read. Bondsmen had sought this knowledge
ever since the earliest days of the slave trade. James Gronniosaw, who
had been purchased by a Dutch trader in the 1730s, wrote in his autobi-
ography, "My master used to read prayers in public to the ship's crew
every Sabbath day; and when I first saw him read, I was never so sur-
prised in my life, as when I saw the book talk to my master, for I
thought it did . . . [W]hen nobody saw me, I opened it, and put my ear
down close upon it, in great hope that it would say something to me; but
I became very sorry, and greatly disappointed, when I found it would
not speak." In the 1850s, writer Fredricka Bremer encountered a young
black woman struggling to read the Bible. "Oh, this book," she cried. "I
turn and turn over its leaves, and I wish I understood what is on them. I
try and try; I should be so happy if I could read, but I can not." Freder-
ick Douglass called it "this *mystery* of reading.[2]

It would seem a simple thing for masters to share such basic knowledge with their servants, but like most things having to do with "the peculiar institution," as slavery was sometimes called, it wasn't simple at all. Slaveholders understood that even the smallest education could enable a bondsman to seek information and make decisions on his own, becoming in the process less a slave and more a danger to the status quo.

This attitude began to shift in the early years of the nineteenth century as a religious revival, known as the Second Great Awakening, swept the South. Its fervent spirit reached upstate South Carolina in 1802, and within a decade the number of whites in that area belonging to a church had nearly tripled. The basic Protestant message of the revival was that each sinner should search the Scriptures for himself in order to find salvation. This pricked the conscience of many slave owners, who were painfully aware that their slaves, if kept in ignorance, would not be able to find God in the Bible. This sentiment was especially strong in Abbeville, about fifty miles northwest of Edgefield, where sixty-one slaveholders would sign a statement that proclaimed, "We feel it to be our duty to teach all under our control, servants as well as others, to read the word of God. We are conscientious on this subject . . . Our servants are a part of *mankind*; they have immortal souls. . . ." According to Drake family members who live in the Abbeville area, Harvey Drake shared this conviction. This is not surprising, for he was known during his lifetime to be deeply spiritual, committed to a reformed Christianity based on the writings of Swedish theologian Emanuel Swedenborg. More orthodox but apparently just as dedicated, Harvey's wife, Sarah, was a charter member of the Edgefield Village Baptist Church, where his slave, Polly, was baptized in 1825. It seems probable, therefore, that Harvey, like many other Carolinians who found themselves in the dual roles of Christian and slaveholder, took it upon himself to give instruction to those in his charge. Because Dave was one of these, it may be that this was the beginning of his journey to literacy.[3]

At that time, the teaching of reading usually followed Noah Webster's *Elementary Spelling Book*, known familiarly as the "blue-back speller." It was in almost as many nineteenth-century American homes as the Bible. It emphasized pronunciation by syllables, starting with words of one syllable and building to those of five. A number of former slaves reported that they learned to read from the speller, sometimes on their own, sometimes with the help of others. Even in old age, they could recount how far they had progressed by naming the words they had reached: "I could read to 'baker' and 'shady,';thin" they might say, referring to the beginning of the two-syllable list, and everyone would understand the effort required for that. Any classes that Harvey Drake might have taught using the speller would probably have been informal, perhaps held outdoors after church as a kind of Sabbath school. How meaningful this instruction would have been for Dave: Before his eyes, strings of anonymous marks would have become identifiable letters, then separate words and sentences; pages of type, silent for so long, would have changed slowly into *ideas*.[4]

I examined a blue-back speller in the rare book collection of the Thomas Cooper Library at the University of South Carolina. It was an 1813 edition, one that could have been used at Pottersville. Measuring only about three inches by five inches, it was designed to be slipped into one's pocket for study whenever time allowed. The copy I held had been used so extensively that its thin wooden covers retained only remnants of the sky blue paper that gave it its name. Among the words inside were two that would have especially pleased Dave: "potter," in the list of two-syllable words, and "Edgefield," in a list of the towns of America. If Dave made it all the way through the speller, he would have been able to read at what is approximately twelfth-grade level today. Others among Harvey Drake's slaves probably would also have succeeded in becoming literate, making Dave not as unusual in this particular as is often supposed. No one knows how many slaves across the South could read. The best guess of many historians is that at any given

time they amounted to between 5 and 10 percent of the general slave population.[5]

Whatever classes Dave and his fellows were offered almost certainly steered clear of instruction in how to write. There are several reasons for this: First, being able to read was all that was needed for access to the Scriptures; second, in the early nineteenth century, even within the white population, writing was usually taught separately from reading, if at all, in a later stage of instruction; third, there was no writing book similar to Webster's speller that might facilitate the process. The final and most important reason was that the ability to write gave a slave vastly more power than the ability to read. This was made clear to former South Carolina slave James L. Bradley: "After I had learned to read a little, I wanted very much to learn to write; and I persuaded one of my young masters to teach me. But the second night, my mistress came in, bustled about, scolded her son, and called him out. I overheard her say to him, 'You fool! What are you doing? If you teach him to write, he will write himself a pass and run away.';thin" Even worse, slaves who could write could send messages to others on distant plantations and organize wide-ranging rebellions that might be impossible to contain.[6]

Members of South Carolina's Commons House of Assembly, in fact, considered teaching writing to slaves so dangerous that many years earlier they had made it against the law. This came about in the wake of a major "servile insurrection," which took place on Sunday, September 9, 1739, near the Stono River, just twenty miles southwest of Charleston. On that bloody occasion, a group of almost a hundred slaves began a march toward Spanish-controlled Florida, killing all whites in their path. In some cases, they left the severed heads of the dead on porches along the way. Though the rebellion was quickly and violently suppressed—rebel heads, in turn, were placed on mileposts along the same road—the assembly was fearful enough to pass a severely restrictive set of slave laws the following year. Called "An Act for the Better Ordering and Governing of Negroes," it codified all

aspects of slave behavior, from the clothes they could wear to the passes they were required to carry when off the plantation. Writing had not played a major role in the Stono rebellion, but because of the "great inconveniences" it might occasion, it too was covered. A sizeable fine, "one hundred pounds current money," was set down as the penalty for teaching a slave to write.[7]

Through overconfidence or oversight, this ban was left out of the slave law when it was revised in 1820. Technically, then, it would not have been unlawful for Harvey Drake to give Dave instruction in writing after he was nineteen. It probably never happened, however, for in 1822 an event occurred that affected every South Carolina slave in search of literacy. Denmark Vesey, a free black artisan in Charleston, was accused of conspiring with slaves in the surrounding countryside to march on that city, slay all the white men, and carry off the women. Some of the best-known and most trusted servants in the state were said to be involved, including three who served the governor himself. At the trial of those who were implicated, witnesses claimed that Vesey, who was highly literate, inspired his followers to violence with verses from the Bible, especially Exodus 21:16: "And he that stealeth a man, and selleth him . . . shall surely be put to death." This revelation abruptly halted most attempts to spread biblical literacy among slaves, not only along the coast but also in the upstate. Even Harvey Drake might have questioned the advisability of slave literacy after details of the Vesey plot reached Pottersville.[8]

Consequently, Dave probably had to reach the second, more mysterious level of learning on his own. An example of what may have been his early efforts at writing turned up a few years ago in the yard of the only remaining house from Pottersville, which stands about a half mile down the hill from the ruins of Abner Landrum's kiln. The house dates from about 1815, according to historians who have examined it, and may have been a mechanic's shop for the pottery. A handsome front porch, faintly classical, was added later on, probably when the building was

made into a residence. Shaky legend has it that the blacksmith brother of one of Margaret Mitchell's ancestors lived in it. It now belongs to Steve Ferrell and his father, Terry Ferrell, who plan to restore it. While clearing rocks from the yard behind the house, Terry ran across a large, handmade brick caked in red clay. Potters often produced bricks as a sideline—requiring a lower firing temperature, they could be burned in the cooler areas at the rear of the kiln—so finding one at Pottersville was not surprising. Simply because Terry liked old bricks, he saved it to the side.

Days later, after rains had washed it, Steve walked past the brick and spotted what looked like an inscription. He picked it up and recognized Dave's handwriting. His heart pounding, he traced out "April 18th." Apparently authentic, it is the only known inscription by Dave that is not on a piece of pottery. What makes the brick even more significant is that it may be one of the "practice slates" on which Dave learned to write.[9]

Such improvisation was necessary if slaves wanted to practice their letters, for, in general, they had almost no access to pen and paper. Frederick Douglass recalled that his copybook was "the board fence, brick wall, and pavement; my pen and ink was a lump of chalk." Young Dave apparently found his copybook while working in the brickyard at Pottersville. There, one of his duties would have been to fill a brick mold with clay and scrape the open side smooth with a board. Perhaps finding the resulting surface irresistible, he sharpened a stick and carefully wrote on the damp clay while it was still in the mold. Because a typical mold held four bricks, he could have written the same thing four times, trying to make it perfect. Then he would have turned the mold over and dumped out the newly formed blocks onto a board to dry. According to Steve, the brick probably dates from the 1820s. Dave must have thought no one would notice that he had written on it, certainly not 185 years later.[10]

The distinctive handwriting that Dave developed through such

painstaking practice was part printed and part cursive. I showed samples of his later inscriptions to Robert Backman of the Handwriting Research Analysis Library; he had been recommended to me as one of the best handwriting analysts in the country. I deliberately told him nothing about Dave or his situation. Although the short inscriptions did not provide Backman with enough material for a traditional analysis, he was nevertheless able to give me an insight into Dave's character. "From what I have here," he said, "I can tell you two things: Your subject possessed a great deal of stubbornness and a great deal of persistence. I know this because he stubbornly persisted in carving words into damp clay, a difficult and frustrating endeavor that he returned to over and over again."

The inscription that Dave apparently wrote on the Pottersville brick is an indication of these traits, as well as a demonstration of how deeply he must have longed to read and write. In reaching for these skills, he

perhaps shared the feelings of newly literate Thomas Jones: "I felt at night, as I went to my rest, that I was really beginning to be a man, preparing myself for a condition in life better and higher and happier than could belong to the ignorant slave."[11]

THOUGH DAVE'S ABILITY TO READ and write could have been frowned upon by many in the Edgefield area during this period, it might also have been the reason he was given an unexpected opportunity. It came from Abner Landrum, who was deeply immersed in a new pursuit—that of editing a newspaper. In 1824, he and his neighbor, merchant John Lofton, had purchased an Edgefield newspaper called the South-Carolina Republican and moved it to Pottersville. It soon received positive notice from as far away as Charleston: "So rapid is the erection of new towns among us," the editor of the Charleston Courier wrote on January 9, 1825, "that we never heard of Pottersville until a new paper was received a day or two since, printed at that place near Edgefield court house. It is a neat paper, of good impression and contains several well written articles." Dr. Landrum and another neighbor, Dr. William Brazier, bought out Lofton in 1827 and changed the name of the paper to the Edgefield Hive. The name was, in Landrum's words, "appropriately expressive of a repository of literary sweets of various origin." It may also have symbolized the very hill on which Pottersville stood, topped by the great kiln and alive with science and industry.[12]

In December 1829, Dr. Landrum, who was now known as "the learned bee," began publishing the Hive entirely on his own. He refined it into a journal devoted to "the improvement of the arts and sciences" whose pages also offered news of the country and the world but ignored, as he put it, "the running away of horses, negroes, wives, etc." In a move probably taken to help finance the paper, Dr. Landrum sold the Pottersville Manufactory to Harvey Drake and Harvey's younger brother, Reuben. The sale took place in stages, perhaps reflecting

ambivalence on his part about letting the business go. On July 27, 1827, he parted with the seventeen and a half acres that contained the turning house, the kiln, and other appurtenances of the factory for $1,000; on the same day, he agreed to a yearly fee for the rights to the major source of fuel for the operation, namely the hardwoods and pines that grew on the remainder of his Pottersville property. In November of the following year, he sold that property to his nephews as well for $993.[13]

Even though he was now able to focus entirely on his newspaper, Dr. Landrum would still have been a very busy man. Besides articles to write, correspondence with other editors to answer, and subscription lists to maintain, there were all the nuts-and-bolts jobs to do, the things a bright young helper could accomplish, especially someone who could read and write. Apparently drawn to slave literacy rather than fearful of it, he chose Dave for the job. Though we don't know what arrangement Dr. Landrum made with Harvey Drake, we know that Dave came to work at the *Hive* from a short article in the *Edgefield Advertiser*. Written by editor Arthur Simkins and published on April 1, 1863, many years after the period it recalled, it described this incident:

Good buttermilk is said to be a great promoter of health. It is certainly a very pleasant drink, and in the absence of lemonade and other acid preparations, is calculated to give comfort to the physical man. One day in years gone by, we happened to meet DAVE POTTERY (whom many readers will remember as the grandiloquent old darkey once connected with a paper known as the Edgefield Hive) in the outskirts of his beloved hamlet. Observing an intelligent twinkle in his eye, we accosted him in one of his own set speeches: "Well, uncle DAVE, how does your corporosity seem to sagatiate?"—"First rate, young master, from top to toe—I just had a magnanimous bowl-full of dat delicious old beverage, buttermilk." Who has not often felt his buttermilk as DAVE did. We know a gentleman who never touches coffee if

he can get buttermilk. He says he enjoys double the health under the buttermilk regime. Dr. HALL would give you the reasons for this—we only give the fact, and exhort everybody to the free use of buttermilk.

When this piece was discovered in about 1968, news of Dave's link with the *Hive* rapidly circulated among the early collectors of Southern folk pottery. It led to a quick formulation: If Dave were literate, which was evident from his inscriptions, and if he worked for a newspaper, he must therefore have been . . . a typesetter. People ran with the idea: master of pottery, master of typography, what couldn't he do? After that, virtually every published mention of him included this accomplishment as fact. It was even suggested in the *New York Times* article that first told me about him.

As charmed by this story as everyone else, I was eager to examine the actual pages that Dave had set in type. Copies of the *Hive* are extremely rare, but the Ferrells own a bound set for the year 1830, which they acquired from a man who had found it in a Columbia trashcan. At their invitation, I sat down with the volume and began to gingerly leaf through it. Each weekly issue was a quarto of eight pages. The pages were comfortably small, hardly larger than those of *Time* magazine. Advertisements were printed on a separate insert, so the layout was clear of notices. Each of the eight pages was divided vertically into three equal columns completely filled with text. In a larger publication this might fatigue the eye, but here the effect was pleasing. Scotch rules (the pairing of a thick and a thin line) interrupted the columns to mark major changes in subject matter. An occasional illustrative cut, in the style of Thomas Bewick, indicated the beginning of a special department; the image of a sheaf of wheat surrounded by farming implements introduced the agricultural section, for example. As a graphic designer, I appreciated this simple, classic layout. Clearly, Dr. Landrum cared a great deal about bringing the paper as close to perfection as possible. The role of the typesetter was crucial in this; he had to select the piece

of type that held each letter of each word and carefully place it in a form, while making sure to leave correct spacing between the words and adequate leading between the lines. His work was made even more painstaking by the fact that the letters read backward in order to give the correct impression on the paper.

Comparing in my mind the scrupulously proper text of the *Hive* with the idiosyncratic spelling and layout of Dave's pottery inscriptions, I came to a jarring realization: Though I wanted very much to believe otherwise, I could see that Dave did not set type for this publication. These pages had required the hand and the eye of a professional who had been trained for years in his skill. Dave was an extraordinary potter, but he was not a typesetter.

The person who actually set type for Dr. Landrum was most likely a young man named William F. Durisoe. He was born in 1805 to a French couple who fled from Saint Domingue during the slave rebellion there. His family settled in Savannah, but misfortune followed: His parents both died of yellow fever and his two older brothers were killed in the War of 1812. Young William, left alone, was indentured as an apprentice in a printing office. He ran away before his time was up and made his way to Edgefield, where he found work as a printer. His March 12, 1830, marriage announcement, among the very few carried in the *Hive*, identified him as such. Later, Durisoe purchased the Edgefield Advertiser and was its publisher and sometimes editor for twenty years. Eleanor Mims Hansen, in a book on the editors of the *Advertiser*, claims without hesitation that he was typesetter for the *Hive*.[14]

Though Dave did not set type at the paper, he no doubt did just about everything else—hauled the newsprint, oiled the machinery, cleaned the press, broke down the forms after each page was set. He was probably as busy at the *Hive* as he had been at the pottery. In fact, he may have worked at both places simultaneously, crossing the stretch of hillside between them to go wherever he was most needed. Interestingly, sherds from pots stamped with what appear to be pieces of type have been found at Pottersville. Some of the hundreds of individual let-

ters that went into making up the forms for each page of the *Hive* apparently made their way to the potting shed, where they were used to mark pots just after they were turned. Generally choosing only an isolated letter, potters pressed them into the side of a vessel near its base. For me, these small, type-stamped fragments serve as ready-made symbols of this busy period in Dave's life.[15]

There must have been occasions during this time, though, when Dave was alone in the office of the *Hive* and everything was quiet. This privacy would have given him unfettered access to articles, manuscripts, letters, and reading material of all kinds—a situation almost unheard of for someone in Southern slavery. Even more unusual, he would have had ink with which to practice his letters. For the first time in his life, Dave could have written on paper, not clay. Perhaps one day we will find these sheets, not set by him in type but, even more remarkably, covered by him, edge to edge, with word after word after word.

AT THE *HIVE*, Dave would have been in the presence not only of Dr. Landrum but also of his earlier partner, Dr. Brazier, and of young Durisoe, the printer. These were men of exceptionally high intellectual ability. Emblematic of this was an article that Dr. Landrum wrote for the paper, in which he propounded a new theory to explain the cause of the decomposition of heat and light. Quite lengthy, it was continued in the subsequent issue of the paper, and in the next. In the manner of all brilliant groups, Dr. Landrum's circle enjoyed complex and furious discussions. Dr. Brazier, who at various points in his life had been a missionary to blacks in the West Indies, a doctor among the inmates of the Philadelphia Almshouse, and a minister in Charleston, was an inveterate talker, using "verbal chastisement" for any perceived inattention. Dr. Landrum, for his part, was known to offer such elevated logic that comprehension was sometimes impossible. The baffled editor of another Carolina paper claimed that the argument contained in a letter that Dr. Landrum had written to him "passeth all understanding." It was a mys-

tification, he said, "upon the most magnificent scale that we have ever witnessed. Help us, oh Hercules, to roll this wagon load of metaphysics out of the slough!" Indignant, Dr. Landrum corrected him in the next issue of the *Hive*: the proper divinity to petition in this case, he said, was *Minerva*.[16]

Erudition fairly floated on the air in the office of the *Hive*, and Dave would have overheard everything. He would not have understood a great deal of it, just as I fail to understand Dr. Landrum's theory of the decomposition of heat and light, but I think he would have been irresistibly drawn to it. Mary Chesnut, whose diary is an extraordinary source of information on ninetieth-century life, wrote of a similar exposure that one of her parents' house servants received: "[A]s my father said, Dick, standing in front of his sideboard, had heard all subjects of earth or heaven discussed—and by the best heads in our world." Not surprisingly, Dave seems to have adopted some of the impressive words used around him. One of these was probably "magnanimous," which *Advertiser* editor Arthur Simkins, after calling him "grandiloquent," reported him using to describe his bowl of buttermilk. Strictly speaking, it was a misuse of the word; from a wider point of view, it was a clever and inventive way to employ it.[17]

Simkins also reported that he greeted Dave in one of Dave's "own set speeches," which was, "How does your corporosity seem to sagatiate?" The meaning of this expression has been a mystery ever since the buttermilk article was discovered. When I began to research it, however, I was surprised to find three famous figures who were perfectly at home with its usage. Probably never listed together before, they are Joel Chandler Harris, Shirley Temple, and James Joyce. Harris used it in his retelling of *The Wonderful Tar-Baby Story*, one of the Uncle Remus tales that he collected from blacks in Georgia. In it, Brer Rabbit gallantly addresses the silent Tar-Baby with these words: "How duz yo' sym'tums seem ter segashuate?" In the 1935 film *The Little Colonel*, set in the South after the Civil War, a child played by Shirley Temple is greeted with exaggerated formality by a man out to swindle her father. "Why, good

day, young lady," he says, doffing his hat. "How does your copperosity seem to segashuate? Hmh?" And, most surprising, James Joyce incorporated the greeting in the "Oxen of the Sun" passage in *Ulysses*, where one of his characters asks, "Your corporosity sagaciating O.K.?"[18]

The *Oxford English Dictionary* throws light on it all by explaining that "corporosity" meant "bulkiness of body" and was in colloquial use in the United States in the nineteenth century; sometimes "your corporosity" was employed as a humorous address, in the manner of "your excellency." The *Dictionary of American Regional English* defines "sagatiate" as "to fare, get on" and indicates that it was used chiefly in the South and mid South. Dave's combination of the two words, then, was simply an amusingly highfalutin way to ask, "How are you doing?" He didn't invent the expression—at least I assume he didn't—but his use of it indicates a fondness for incorporating impressive words in his conversation.

Dave must have gone back to his cabin in the evening full of what he had learned at the *Hive* each day. Every new word that he had overheard would have been a puzzle to be taken apart and studied. Perhaps he shared them with the children of the quarter. Mrs. Stella Dorn, a lovely Edgefield woman whose family goes far back into the town's African American history, told me that her father used to sit with his children grouped on either side of him for spelling lessons. He would have them divide lengthy words into syllables and spell them together out loud. Even more than eighty years later, she could recall and spell "com-pres-si-bil-i-ty," one of the words he taught her. I looked it up: "compressibility" means the capacity of being pressed together or squeezed. Because compress is a machine for pressing cotton bales into a compact form for transport, the word was perhaps current years ago in the Edgefield area. It was also on page 110 of Webster's blue-back speller and an excellent choice for a spelling lesson.[19]

As I see it, Dave's greatest exposure to learning came from being around Dr. Landrum and his circle at the *Hive*. During those years, without anyone realizing it, Dave would have moved past being able to read a Bible verse and inscribe a date. Little by little, he would have put

together the beginnings of an education. This would surely have been exhilarating, because few other black men in the South were allowed to reach this stage. He might even have believed the little poem that was printed near the front of the blue-back speller:

> *Good boys who to their books apply,*
> *Will all be great men by and bye:*
> *For true it is, on Nature's plan,*
> *That education makes the man.*

Yet, as he learned that the worlds of history and science and literature existed, it would also have become clear that he, as a slave, would never actually be permitted to enter them and decipher their secrets. He could appropriate their language by picking out intriguing words here and there and employing them with a flourish, which might have given him pleasure, but what pain must have been hidden underneath.

THE EDGEFIELD HIVE.

VOL. I. POTTERSVILLE (S. C.) FRIDAY, NOVEMBER 26, 1830. NO. 48.

Floc indique Gaza.
Congeriæ. VIRG.

PUBLISHED EVERY FRIDAY MORNING BY

ABNER LANDRUM,

At THREE dollars in advance, or FOUR dollars, if not paid till the end of the year.

No subscriptions will be received for less than a year, nor discontinued, but at the option of the Editor, till arrearages are paid.

Advertisements will be published on as usual terms, at sixty cents and a half cents per square, for the first insertion, and for-ty-three and three-fourth cents for each subsequent insertion; and those fourth cents for each subsequent insertion; and those not limited will be continued until forbid, and charged accordingly.

All communications addressed to the Editor must be post-paid.

From the Chronicle and Advertiser.

THE VOICE OF '7...

Mr. Pemberton:—Wise heads, and sincere hearts, have been, for ... in exercise, to extinguish the wild ... has been ingeniously and insidiously ... in South Carolina. Enough has b... newspapers, to convince the patri... eign people, of the deadly impositi... ... demagogues; but the ... is, that very few of the yeomanry ... actively, read the papers. The ... of this baneful faction have been ... and prominent to elevated spheres, ... jects of this delusion! The fir... the real cause of this political comb... Tariff. This is a flimsy subterfu... cannot withstand a moment's refl... ... adequately believed that the ... acts of public tranquility merely fo... Tariff law. That the Tariff acc... ... with the radical spirit of Amer... ... pendence, is beyond rational cer... That we ought to manufacture our... rials, to such an extent, at least, a... the purposes of home consumption, ... formly been the decided opinion o... republicans.

The incompetent, phrenetic ... those would-be-nobles, have slan... bers of the peaceful citizens, and ad... to remove to the tranquil State of Georgia and North Carolina. They are persuaded that positive justice will be inseparably connected with nullification or insurrection.— Like unto Lot, they fly, from the impendent conflagration. These restless revolutionists, in justice to themselves and the community,

ought to specify the horrid calamity, which this hated tariff law has introduced. If, indeed, any injury has resulted from it, the fatal stroke has thrust the people into a morbid state of insensibility, and consequently, in this direful situation, they are insensible of pain. Whether our political comfort is real

... portantin ... idea is perfectly compatible with the intrinsic nature of our republican form of Government.

Now, Sir, is it not obvious to every man of reflection, that the tariff is the feigned and not the genuine cause of the virtual declaration of hostility. Without a breach of char-

...ity, where the real cause of recent proceedings is divulged, the people will discover a source of political corruption, which will deservedly affix an indelible stigma on the authors of the present very lamentable commotion in S. Carolina.

What readers the scheme of the nullifiers ... more mysterious, is its unreasonableness. ... blic Banner says; "the writers ... of such inflammatory articles, ... to the appellation either of ... sages." It is hoped that a will stedfastly attest their ... by a zealous attachment to the ... Numbers of inconsiderate ... position to the remonstrances of ... may become subjects of the ... and thereby procure their ; for it is well known, that ... it is under the most solemn ob-... ... the laws of his country. tionaries will receive no smiles ... from any other section of ... country; for, according to ... ation, the people of slave ... own upon them with astonish-... ... nation. Georgia and N. Car-... the language of the Richmond ... in their tender moments ex-... ; "Pause, pause, for Heaven's ... A native of Carolina, one ... among the disaffected, speaks of ... following manner; "There are ... among us, and even some of our ... who have a longing after the ... Europe, and the mother country, ... who look with a wishful eye, to ... those laws of hereditary succes-... ... ly splendor, particularly adopt-... ... ners and customs of those coun-... adopted in the United States. ... induce our people to believe, in a state of slavery; and that ... nor now, in their present shape, are far inferior to those of Europe, in order to bring about a Revolution, so that they might stand a chance to become chief rulers of the new Government." If this writer's opinions were generally believed, the wild-fire would be prompt-ly extinguished. The turning of public opi-nion against this deleterious faction, would pre-

CHAPTER IV *Fire-Eaters*

*The cause is a great one; greater
than that of the Revolution.*

—SEN. JOHN C. CALHOUN,
1833[1]

IN 1830, DAVE'S WORK AT THE *HIVE* PROVIDED HIM WITH
an intimate view of one of the most tumultuous political controversies in
South Carolina's history. His introduction to it probably came early in
that year, when Dr. Landrum began to devote the columns of his journal
to this violent "collision of opinions and feelings," as he described it. The
federal government had imposed a tariff on goods brought into the
country, which was opposed by virtually all South Carolinians. They con-
tended that their state, which was primarily agricultural and imported
most of the manufactured items it needed, would suffer inordinately
from the higher prices the tariff would bring; worse, as imports lessened,
exports of Carolina cotton would decrease. There was strong disagree-
ment in the state, however, about how to combat the "Tariff of Abomi-
nations." Two clearly distinct factions evolved. One side, known as
Nullifiers, held that each individual state had the right to nullify, or veto,
any measure that the federal government sought to impose on it. The
other side, known as Unionists—Dr. Landrum and the *Hive* were
strongly in this camp—opposed such an extreme approach, holding that
the interests of South Carolina could best be served through moderation
and by working within the existing rules of the Union.[2]

As Dave no doubt quickly learned, a large group of Nullifiers was concentrated in Edgefield. One among them was Congressman Eldred Simkins, the man who had accepted Dave and Eliza as collateral from Harvey Drake in 1818. Simkins had a protégé, a young and brilliant lawyer whose name was George McDuffie. Elected to Congress with Simkins's help, McDuffie became a leading Nullifier and one of the most sensational orators of the period. When he spoke, spectators packed the galleries of the House of Representatives. To see him orate was like watching a tempest, it was said, or a "whirlwind of passion." He and those who supported him came to be called, not surprisingly, "fire-eaters." They were willing to go to any length to get what they wanted for South Carolina, even if it meant withdrawing the state from the Union. This eventuality was Dr. Landrum's greatest fear and the reason he was willing to devote his paper to resisting nullification.[3]

The radical stance of the Nullifiers was due, on its surface, to the cost of the tariff in money and trade. A deeper reason was concern for what the issue boded for the future: If the national government could impose a measure on the South against its will, it might one day move to alter what was discreetly referred to as "institutions that the southern states hold dear." That, of course, was code for "slavery." If slavery were ended, an enormous financial investment would be lost and a released population would be free to wreak a terrible vengeance. The Nullifiers therefore felt that the right of each state to make decisions for itself had to be firmly established at this early moment. Most Edgefieldians, per- haps four-fifth of the population as one observer estimated at the time, supported this and became caught up in McDuffie's whirlwind. (One of my Edgefield ancestors, not a Landrum, named a son George McDuffie; another owned a racehorse called Nullifier.)

Dr. Landrum, though greatly outnumbered, was the most prominent opponent of the movement in the Edgefield area. Week after week, he published his own strong editorials as well as reprints of those from other papers. He quickly became the focus of much resentment. He was labeled "blundering" in a rival newspaper, and no doubt almost daily

called a "submissionist," the favorite epithet of the Nullifiers. He surely steered clear of the crowds that came to Edgefield on public days, for they were strongly pro-nullification and, as historian John A. Chapman remembered, "decidedly in earnest, as Edgefield crowds, in town or county, always are." Any Unionist at such gatherings would find it necessary "to lay low and keep dark." Though Dr. Landrum held resolutely to his course, he included in one issue of the *Hive* a small paragraph that may hint at the stresses that resulted from standing against virtually an entire community. In it, he recommended the balm of poetry to "succeed the angry strifes and wild speculations of political partisans" after "the tornado and the artillery of the heavens have shaken the earth and threatened it with destruction."[4]

The clear voice of Unionism that Dr. Landrum sent out from Pottersville attracted attention outside Edgefield District. In late 1830, he received an invitation from South Carolina Unionist leaders to move his paper to Columbia and become a statewide exponent of the cause. It was an honor that acknowledged his ability as an editor and his personal courage. He knew, however, that if he accepted the challenge of this "hazardous experiment," as he rightly described it, he would be leaving a hotbed of nullification only to find himself in the very "headquarters of this new and fashionable doctrine." His opponents in the state capital would be the governor, a majority of the legislature, and a host of rival editors, all eager to snuff out his upstart paper. His only hope, as he saw it, lay in the righteousness of his cause. He announced his decision to readers of the *Hive* in January 1831: "Suffice it to say," he wrote, "where the voice of [my] country calls, [I am] prepared to go."

People in Edgefield still speak of his departure today. The general perception is that it was rather like being run out of town on a rail. Though that is not at all what happened, the resentment that the majority of local citizens felt toward him was strong enough to resonate through generations of his family. Even all these years later, when I met his great-granddaughter, Maude Stork Shull, she assured me that his leaving Edgefield did not mean he was "against the South." Armed with truth only,

as he put it, and relying upon God and his country, he set out with his wife and children for Columbia. His goal, literally, was to save the Union.[5]

Dr. Landrum obtained offices within sight of the capitol building. On February 5, 1831, he began publishing his newspaper again, now named the *Columbia Free Press and Hive* (and later simply the *Columbia Hive*). To remind the public of what was at stake, he printed copies of the Constitution of the United States as well as that of the State of South Carolina and made them available at his office. Dave, who would have been back at the pottery full-time now, could have kept up with Dr. Landrum through copies of the paper sent to the Drake brothers, who were its Edgefield agents. If Dave perused the papers thoroughly, he would have found a small ad in one of the April issues that suggested how much the editor missed his help: "wanted, A Smart intelligent black boy, about 14 years of age, for a few months—for which, a liberal price will be given, and wages paid monthly. Enquire at this his office."[6]

The editorials that Dr. Landrum wrote in Columbia were even more strongly worded than those he had composed in Pottersville. In one freewheeling piece, he called nullification "this political monster . . . this epidemic scourge . . ." and said, "[W]here these nullification hot-heads may next land us, may confound the d ____ l himself to learn." His hyperbole matched the rising tone of the statewide debate, was soon augmented with violence—a fatal duel in Greenville, a near lynching in Charleston. Dr. Landrum himself was a victim of a physical attack on March 26, 1831, when John S. Preston, irate at what the editor had written about him, entered his office and, before he had time to rise from his chair or remove his glasses, began to viciously strike and kick him. Dr. Landrum was nearing fifty; his assailant was young and athletic. It was, as Dr. Landrum later described it, "a personal abuse more wonton and ignominious, than the most tyrannical master would inflict upon his unprotected slave!" As the attack continued, he understood that his life was in danger and loudly cried, "Murder!" This served to bring Preston to his senses, and he backed away. He flashed a large knife, perhaps as a threat of things to come, then left the office. Dr. Landrum

recounted the incident in detail in the next issue of his paper, taking the opportunity to repeat all that he had originally said about the man.[7]

In spite of the strong and continuing stand of the Columbia Free Press and Hive, Nullifiers emerged from the election of 1832 with large majorities in both houses of the state legislature. A convention ordered by the General Assembly then firmly nullified the hated tariffs. Further, it stated that if Washington tried to "coerce this State," South Carolinians would "forthwith proceed to organize a separate government." It was official now: a loud and defiant threat to leave the union. President Andrew Jackson, though he counted South Carolina as his native state, would have none of it. He issued a militant proclamation in which he held that nullification was counter to the principles on which the country had been founded, and disunion by armed force was treason. He ordered troops to two forts in Charleston Harbor and dispatched ships to protect them.[8]

Boldly, Nullifiers began to assemble a volunteer force of ten thousand men to defend the state. The citizens of Edgefield formed a "red hot nullification rifle company," called the Yellow Jackets, and held it in readiness. South Carolina stood alone in this confrontation with the federal government, however, for no other Southern state rose in support of what was seen as a rash, even delusional, position. An inventive Tennesseean offered to assemble a group of men sufficient "to stand in the Saluda Mountains and piss enough . . . to float the whole nullifying crew of South Carolina into the Atlantic Ocean." No doubt Dr. Landrum would have welcomed such a flood. At the last moment, John C. Calhoun and Henry Clay devised the Compromise Tariff of 1833, which offered a gradual lowering of import rates over the coming years. The Nullification Convention reconvened to grudgingly accept the settlement, and conflict was avoided. Today, many historians see the state's confrontation with the federal government over the tariff as a highly charged rehearsal for the Civil War.[9]

During the course of the nullification controversy, Dave had watched the growing condemnation of Dr. Landrum culminate in John Preston's brutal attack on him. How shocking this story must have been

for Dave: The founder of Pottersville, whom he had heard speak in words that seemed plucked from Heaven, had been cursed by his neighbors, then beaten like an "unprotected slave." I don't know what Dave made of all this. Perhaps he dismissed it as the ravings of white men; perhaps he added it to his education in the workings of the world; or perhaps he made it something more, a kind of morality tale in which a man stands bravely against all punishment that comes his way. Certainly, he must have taken the example of Dr. Landrum's defiance to heart, for within a short time Dave would defy the prevailing conventions of Edgefield in an equally dramatic way.

ON OCTOBER 24, 1832, at the height of the nullification controversy, Harvey Drake died. He was in Pendleton, North Carolina, almost at the Virginia border, when he contracted a fever. A grieved Dr. Landrum wrote an obituary for his nephew in which he spoke of his many strengths, contrasting them with the weakness of his physical constitution, which "gave but too sure presage of premature death." Rhetorically, he asked what consolation remained for the wife who had lost a husband, for the child who had lost a father, and, in a reference that Dave must have noted, the slave who had lost a master. Harvey Drake's death was indeed a significant event in Dave's life, for, as far as we know, Harvey had been Dave's only owner since at least 1818.[10]

Because Harvey died without a will, all his property, including his slaves, had to be sold at auction. This included Dave and Lydia and the two boys, who could each now be purchased by anyone—even George McDuffie, chief of the fire-eaters—and taken anywhere, together or separately. Whether they were a family, as the documents on which they are listed seem to suggest, or whether they simply shared a long and close history, the possibility of separation must have been frightening. On the day of the sale, though, Reuben Drake, who was thirty-three years old now, stepped forward and bought Dave for $400 (about $8,500 today). He purchased him in partnership with another pottery entrepreneur,

Jasper Gibbs, who also became co-owner with him of the Pottersville Manufactory after Harvey's death. Harvey's widow, Sarah, bought Lydia and the boys. This kept them all at Pottersville. As property of separate owners, however, they could count on remaining together only until the next upheaval arrived, whatever and whenever that might be.[11]

At the same time that Dave's life at Pottersville was undergoing change, Southern slavery at large was being shaken by a series of momentous events. The first was the 1829 publication by David Walker, a free black in Boston, of a pamphlet entitled *Appeal to the Colored Citizens of the World.* Its message, which drew on biblical imagery, urged slaves to violently cast off the yoke of oppression and "prepare the way of the Lord." A group of Georgia men, horrified by his writings, put a price on Walker's head. The second event, an 1831 insurrection in Virginia led by a trusted servant named Nat Turner, resulted in the deaths of sixty-one whites. Because Turner, who could read and write, used biblical passages to stir his followers, many slaveholders felt once again confirmed in their belief that it was madness to allow slaves to read the Scriptures. In 1832, a Jamaican slave rebellion led by a black Sunday school teacher provided final proof for them that religion plus literacy equaled rebellion. Nullifiers, still powerful, called for a sweeping new law to end slave literacy in South Carolina once and for all.[12]

In spite of this, the lenient atmosphere that had fostered Dave's literacy at Pottersville continued under Reuben Drake and Jasper Gibbs. This was evident on June 12, 1834, when Dave inscribed not only the date on a pot he had made but also—for the first time that we know of—something more, a word, a stunning one: "Concatination." Though he gave it an "i" at its center rather than the usual "e," it comes from "catena," Latin for "chain," and means "a linking together." The first word that we have from Dave, then, refers at its root to the shackles that held slaves in bondage! He might have known this from Dr. Landrum, who, in his erudite fashion, would probably have taken care to explain the derivation, Latinate or other, of any words that Dave asked him about. Perhaps more likely, the term simply appealed to Dave for its five

syllables. In either case, it was important to him, for less than two years later, he repeated it in a shorter form, "catination," on the shoulder of another jar.

Dave followed up his single-word debut by inscribing *an entire rhyming couplet* in clay on July 12, one month later:

> put every bit all between
> surely this Jar will hold 14

This, the earliest of Dave's surviving poems, was a simple set of instructions that Edgefieldians would have understood perfectly: pack this fourteen gallon jar tightly with hog meat. But the fact that it was written by a slave—*in rhyme*—would have been startling. Those who saw it must have puzzled, as we do today, over how he ever came to do such a thing. Perhaps he was inspired by the blue-back speller, which grouped words that rhymed: favor, flavor, savor; fuel, duel, cruel, gruel. Dave could have become intrigued by the concept of rhyming as he memorized these almost hypnotic columns of words. He might also have been attracted to the poetry that Dr. Landrum ran in the *Hive*. He could have copied those verses when he worked there, perhaps to practice his penmanship, and that might have led to composing his own poems. At the *Hive*, he would have been writing on scraps of paper that could be hidden away or burned; now, though, he was writing words on almost imperishable clay to be sent out to the world.

The possible stress of that first "publication" shows in the way the words are inscribed: Whereas most of his later poems are deeply carved and "wet" looking, indicating that they were written right after he finished throwing the pots, the letters of this first one are quite lightly drawn and thin, suggesting that the couplet was written after the clay had begun to dry, perhaps when Dave was alone in the potting shed at the end of the day. Using a very sharp instrument, he grouped the words far over at the left handle, as if he were not yet ready to let them sprawl freely across the surface of the pot. He was making a huge statement,

nevertheless. He was demonstrating that he, an enslaved man at Pottersville, could not only spell and write but *control* words as well. What courage it must have taken to reveal that in this period of rising opposition to slave literacy. This first, simple couplet was as powerful a statement as any that Dr. Landrum made in the *Hive*. Both men countered a system that was deeply entrenched around them. In Dave's case, he did it not by writing words of protest but by daring to write at all.

Only a few months after Dave composed his earliest surviving poem, the South Carolina General Assembly—as if outraged by what he had done—passed the harshest anti-literacy law in the state's history. It was on December 17, 1834. Over the opposition of the Unionists, many of whom favored slave literacy, the law stipulated that a white person convicted of teaching a slave to write or, now for the first time, even to read would be fined up to one hundred dollars (a little more than two thousand dollars in today's money) and imprisoned for up to six months; a slave convicted of teaching another slave would be given up to fifty lashes; informers would receive half the monies collected.

Passage of the law ushered in a period of repression that is sometimes referred to as the "Great Reaction." To criticize any slave law, even to suggest that slaves be allowed to read their Bibles, made one a suspect in the eyes of the state. A "massive orthodoxy" regarding slavery settled firmly over South Carolina. "But whether carried on by overt violence or covert pressures," writes historian William W. Freehling, "the Great Reaction achieved the most thoroughgoing repression of free thought, free speech, and a free press ever witnessed in an American community."[13]

Slaves who wanted to learn to read and write had always been required to be judicious about revealing it. Now, they had to hide that desire completely. In interviews for the Works Progress Administration, several former South Carolina slaves spoke of what would happen if they were found out. Sylvia Cannon said, "[If] dey catch we black chillun wid a book, dey nearly bout kill us." Elijah Green said, "An' no for God's sake, don' let a slave be catch with pencil an' paper. Dat was a

major crime. You might as well had kill your master or missus." One of
the threatened consequences was particularly frightening. "[Iffen] er
nigger wus ter be foun whut cud write," reported Abram Harris, "den
right straight dey wud chop his fore finger offen dat han whut he write
wid." Some called such punishment "thumb mashing."[14]

Incredibly, Dave continued to write openly during this repressive
period. And it wasn't because he was hidden away where no one knew
about him. Two references suggest that he was a real attraction at Pot-
tersville. One reference written in 1859 by Arthur Simkins and pub-
lished in the *Advertiser* as a bit of nostalgia, described Dave this way: "Do
we not still mind how the boys and girls used to think it a fine Saturday
frolic to walk to old Pottersville and survey its manufacturing pecu-
liaristics? to watch old Dave as the clay assumed beneath his magic
touch the desired shape of jug, or jar, or crock, or pitcher, as the case
might be?" The other, a letter composed in 1832, is a firsthand account
of one of these visits to the Pottersville Manufactory. William Miller, a
student at the Edgefield Academy, wrote to his father, ". . . I understand
that the composition of which the Jugs & Jars are made consists of sev-
eral sorts of clay, one of which is chalk to turn them into stone. I under-
stood there from a Negro that it consists of 12 sorts." The worker in
question sounds as though he might be Dave, passing on Dr. Landrum's
glorification of the pottery-making process. On the way back to school,
William and his schoolmates disagreed about the use of multiple clays.
Swayed by their arguments, William added this to his report to his
father: "but I was afterwards informed otherwise by one of the students
here. The Negro on this may be incorrect." At the last minute, he drew
heavily through these added lines. The black potter, he apparently
decided, knew what he was talking about.[15]

In the minds of most other South Carolinians of that particular
moment, however, any slave with the characteristics that Dave pos-
sessed would be considered highly untrustworthy. Like Denmark Vesey
and Nat Turner, Dave was an intelligent black artisan who could read
and write. Such accomplishments would make it possible for him to

conceive of and bring to fruition a rebellion of the first order, if he chose to do so. Why, then, was he accepted, relied upon, even celebrated by the people of Edgefield District? Why were his owners not made to account for allowing him to exhibit his learning in such a public manner? Great pressure could have been brought to bear on the Drakes and on Dave himself, but nothing has emerged to indicate that anything like that ever happened.

My guess is that Dave's puzzling immunity resulted from, among other things, good timing. He learned to read and write during a period in which teaching those skills to slaves was sometimes frowned upon but not unlawful. By the time the Great Reaction set in, he and his literacy were already known quantities, already discounted. The oddness of the Landrums, another known quantity, could have helped by making his own particular singularity seem less surprising, certainly less threatening. Even so, another man in Dave's position might have tried to remain anonymous during this dangerous period. As William Styron's Nat Turner put it, "A Negro's most cherished possession is the drab, neutral cloak of anonymity he can manage to gather around himself, allowing him to merge faceless and nameless with the common swarm: impudence and misbehavior are, for obvious reasons, unwise, but equally so is the display of an uncommon distinction, for if the former attributes can get you starved, whipped, chained, the latter may subject you to such curiosity and hostile suspicion as to ruinously impair the minute amount of freedom you possess."[16]

Instead of remaining faceless, however, Dave made himself one of the best-known slaves in the district. He welcomed visitors at his wheel; he entertained and informed; he produced handsome jars, wrote amusing poems, used impressive words—and apparently charmed everyone around him. If he did this as a conscious defense, it worked brilliantly. Even editor Simkins was disarmed by the "intelligent twinkle" that he saw in his eye. Improvising as he went along, Dave succeeded in altering the rules in his favor. By hiding nothing, he seems to have been able to do almost anything, all this in the very lair of the fire-eaters.

CHAPTER V *Trips*

"*A rage for emigration [has] possessed
the minds of our people*"

— THE EDGEFIELD ADVERTISER,
11 FEBRUARY 1836

THREE YEARS AFTER THE DEATH OF HIS BROTHER, REUBEN
Drake began to harbor thoughts of moving west with his family. All
around him, men whose fathers and grandfathers had come down from
Virginia and North Carolina, as his had done, were continuing that
migration by taking their families to newly opened areas of Alabama
and Mississippi. Reuben's desire to leave came from three main causes:
Land was wearing out, the number of families was increasing (necessi-
tating more land), and news of the wonderful country to the west was
proving irresistible. By 1836, so many people were leaving Edgefield that
the first issue of the *Advertiser* devoted almost an entire column to the
phenomenon. "A rage for emigration," it reported, "[has] possessed the
minds of our people; and a wild spirit for adventure presides at their
council. All those associations[,] which were wont to connect them to
the places which their fathers settled, have now been forgotten. New
scenes and new friends supply the places of those which have become
tiresome and ceased to interest." In 1835, when his close friend and
future brother-in-law, Martin Canfield, made plans to journey from
Edgefield to Louisiana to visit relatives, Drake and a group of Baptist
friends urged him to search out a place for them in this new territory.

Canfield found an ideal site for a new settlement in the northern part
of the state between the Ouachita River and the Red River. When he
returned to Edgefield with a glowing report, Drake immediately began
preparations for moving his wife, Mary, their three children, and his
friends to Louisiana.[1]

Once again, Dave, Lydia, and the other Drake slaves at Pottersville
were faced with possible separation from one another. The breaking up
of black families and friendships was common as emigrating owners
sold some of their slaves and took others with them deeper into the
South. The breach was usually final, for, unlike their owners, the dis-
placed bondsmen could not correspond by letter with the loved ones
they had left behind, or subscribe to hometown newspapers, or make
return visits to renew their family ties.

The lot of Lydia and the two boys may have been decided when
Harvey Drake's widow, Sarah, announced that she would be joining the
Louisiana party. She had purchased Lydia and the boys at her husband's
estate sale, and it seems likely that she would have wanted to take them
with her into her new life. Dave's future may have been less clear: On
one hand, Reuben Drake, who had probably known Dave almost his
entire life—they were both thirty-five now—might have considered it
unthinkable to leave him behind; on the other hand, he might have felt
that Dave's expertise made him an integral part of the value of the man-
ufactory, and he should remain with it when it was sold.[2]

As it turned out, a flask of rum and a railroad train determined
Dave's fate. The rum got him drunk and the train rolled over him, cut-
ting off one of his legs. The story of this terrible episode in his life
comes down to us from two contemporary sources, both of them for-
mer Edgefield pottery workers, one black and one white, who were
interviewed in 1930 by researchers from the Charleston Museum. One
of the workers, Carey Dickson, actually knew Dave. "Of course I knew
Dave," he said. "I know all about him. He used to belong to old man
Drake and it was at that time that he had his leg cut off. They say he got
drunk and layed on the railroad track." The other worker, George

Ulysses Fletcher, who was German and not born until 1862, never knew Dave, but he heard about him when he came to work in Edgefield. "I remember being told about an old potter there," he said, "a one-legged negro named Dave. He was said to have been mighty good." If the testimony of Dickson and Fletcher about Dave's injury is true, and I see no reason not to believe it, the accident that caused it would have occurred sometime between 1833, when the railroad was completed, and 1836, when the Drakes left for Louisiana. Three jars by Dave from 1834 appear to narrow the time frame even further, perhaps placing the event in 1835.[3]

The railroad train that ran over Dave was set in motion by hard economic times in Charleston. For years the Savannah River had directed upstate trade away from that city and brought it instead to Savannah, Georgia, which lay at the river's end. To capture this trade, Charleston leaders took massive measures: They built the longest rail line in the world. It began in Charleston and struck across the state for 136 miles to the burgeoning town of Hamburg, just across the river from Augusta. When it began service, the new South Carolina Rail Road, with its green and red and yellow steam engine called The Best Friend of Charleston, was a sensation. Maximilian Laborde, the first editor of the Edgefield Advertiser, marveled that, although it had always taken his father one month to make the trip to Charleston and back, he was now able to get to the coast in one day. "In an instant the train was in motion," Laborde wrote to his readers. "Heavens!! What a spectacle! Night was still lingering, and our Locomotive puffed and snorted with a fiery fury, sublime and terrible, scarce equaled by the volcanic explosions of an Aetna. . . . [C]asting my eye before and behind me, [I] felt indeed that the exploits of my ancestors were nothing, and rejoice[d] that my lot was cast in an age so glorious."

The pottery manufacturers of Edgefield were now able to load their products onto the train at Hamburg for distribution to any of the towns along the way to the coast. Several Dave vessels, in fact, have been found on farms along the route of the train; two others are inscribed with the

name of a grocer, Panzerbieter's, located at King and Columbus streets in Charleston, at the far end of the line.[4]

Alcohol was the second factor in the equation that brought disaster to Dave. This is puzzling, for throughout his early life he had been surrounded by temperance advocates: Harvey Drake, as a strongly religious man, was against drinking; William Brazier, Dr. Landrum's newspaper partner, had once been a protégé of Dr. Benjamin Rush of Philadelphia, a temperance leader; and Dr. Landrum wrote a piece on alcohol abuse that could have been addressed to Dave himself: "There is no slavery so degrading, cruel and infamous," he said, "as that imposed by this intoxicating poison!" He cared enough about the problem to publish the following poem in the *Hive*:[5]

> *Oh Whiskey! Thou'rt the greatest curse,*
> *To soul, to body, and to purse,*
> *Pandora's box held nothing worse*
> *Than Whiskey.*

Teetotalers by no means dominated Southern communities, however. The South was famous for its drinkers. As we've seen, Amos Landrum, third member of the triumvirate that first owned the factory at Pottersville, was one of them. Because of his lack of sobriety, he was forced to leave the membership of Horn's Creek Baptist Church, where his brother, John, was minister. In spite of all the temperate men around Dave, it may have been Amos who most intrigued him in the end.[6]

Dave was far from the only Edgefield slave attracted to liquor. A vivid picture of the situation has been preserved in an 1830 letter to the Edgefield Carolinian, a short-lived newspaper that preceded the *Advertiser*, from a man who called himself Sobriety. Printed on the front page of the paper, it said, "I stopped for a few moments on a late Sunday evening, at your Village, and among large numbers of blacks, I think I discovered the evident effects of stupor and drunkenness in the faces of 3 out of 4.—Good God!" He complained that "every slave who is

di[s]posed to get drunk (and perhaps nine tenths of them are so dis-
posed) can do so, *at any time*. Formerly our negroes only got a dram on
holydays, or at gatherings, such as house-raisings, log-rollings, or corn-
huskings, but now they can get drunk *every night*. . . ." He acknowledged
that there had been a most encouraging shift among the whites toward
temperance in the last several years, but "every observing man knows
that the exact reverse has taken place among the *blacks*."[7]

How Dave's accident came about is not known. My guess is that it
happened after he delivered a load of ware from Pottersville to the rail-
road depot in Hamburg, twenty-five miles away. Though probably not
the wagon driver himself, he was trusted and experienced enough at this
point in his life to be the man in charge of such a delivery. As I imagine
events unfolding, Dave would have first helped to unload the pots at the
station, then probably bought supplies to bring back to Pottersville the
next day. One of the purchases on occasions such as this, as a Landrum
descendant has told me, was always a five-gallon keg of rum, which was
possibly for medicinal purposes in the pottery. No doubt Dave would
have had the required written permission from Reuben Drake to buy it.
Back in the wagon, knowing it was wrong and doing it anyway, he might
have siphoned off a portion of the rum into a small stoneware flask and
enjoyed it with his companions as they passed the evening near the
Hamburg tracks.

Feeling gloriously fine, Dave might have picked up the flask, refilled
several times now, and set out for a stroll along the tracks into the coun-
tryside. Before long, he might have sat down on one of the rails, then
spread the length of his body beside the tracks to better survey the stars,
spinning now, above him. Perhaps he flopped a leg comfortably over the
cool metal rail. And then, if Carey Dickson is correct, he fell into a sleep
so sound that even the shriek of the oncoming train, hurling down the
tracks at the first hint of dawn, failed to wake him.

A description that is uncannily close to what must have happened
appeared in the *Georgia Constitutionalist,* an Augusta paper, on January 3,
1834. It was contained in a letter from a visitor to the South identified

only as "a Yankee among the Nullifiers." In describing his voyage into the upstate on the new train, he told of feeling a strange and sudden jolt from something on the tracks[9]:

> Presently "stop" was heard from one of the passengers. "Stop, engineer," was vociferated all around: At last the engine was stopped. Some of the passengers began to get out. I looked out and saw something crawling at a distance of the rear, beside the rails.—On approaching nearer, I saw a groaning Negro. "Was he injured much?" said one. I went to the sufferer, and saw in him a Negro of about 50 years of age, wounded in the head and legs.—"I am all over for this world," said the poor fellow. On looking still further, a chill came upon my nerves, as I saw blood streaming profusely from his right foot, and his left but one mingled mass of blood, dust, and broken bones. Part of it was smashed to atoms!
>
> He was placed in the car and carried to Columbia. "Bind it in spirits of turpentine," cried one. For my own part, seeing the kind of surgical skill to which the poor fellow was to be subjected, as a duty to humanity, though a stranger, I stepped up and begged them to wash away the dirt and clotted blood with warm water, and to stop the hemorrhage with clean linen lint, and a bandage upon the parts above, until a surgeon could be procured. "Do you think he will ever be worth anything again?" cried one. "How much will he sell for now, suppose?" said a second. At length, seeing my advice little heeded, and hearing muttered cries about the "_____ meddlesome Yankee," I deemed it prudent to withdraw.
>
> What became of the wounded black, I could never again learn. And why the engineer never saw him upon the rails, or did not stop the engine in time, remains to me still a matter of mystery.—But a slave, you know, "has no soul." So mote it be.

The wheels that bore down upon Dave were nearly five feet in diameter. If he woke and saw them in the moment before the train

passed over him, they would have looked enormous. They were rimmed with an L-shaped flange, which fit over and around the rail to hold them on the tracks. Thus, when a wheel crossed over Dave's leg, it both crushed and sliced it. Because the engine had two sets of wheels set quite close together, he was probably run over at least twice before the train stopped, and perhaps more. Suffering from shock and loss of blood, he would probably have been treated on the spot with the rudimentary emergency procedures that "a Yankee among the Nullifiers" recommended, then taken to a local doctor, either in Hamburg or across the river in Augusta. There, if his leg were mangled rather than severed entirely, the injured portion would have been amputated. Because anesthesia was not introduced until 1846, the operation would have been extremely painful and, no matter how carefully performed, far from expertly done. Before the Civil War, when surgeons famously gained experience in severing limbs, medical men knew little about amputations and performed them only under the most desperate circumstances. The patients often died, if not from the dual traumas of injury and operation, then from infection that set in afterward.

Somehow, Dave survived the loss of his leg. When he was well enough to be moved, Reuben Drake would have sent the wagon from Pottersville to bring him home. Lydia and the Drake women would probably have helped in his care. Abner Landrum might have sent words of encouragement to the patient: *Tell him it will make him a better potter, poor boy! Remind him about Josiah Wedgwood!* The great ceramics entrepreneur, whom Dr. Landrum so admired, had also lost a leg by amputation, in his case because of disease in his right knee resulting from a childhood attack of smallpox. Some claimed that his early frailty made him focus on his pottery. Dr. Landrum might have encouraged Dave to follow this example and turn misfortune to his advantage.[10]

No matter how well Dave recovered, however, no matter how quickly he learned to get around with a crutch and a wooden peg, going west with the Drakes was now impossible. Unable to walk long distances, he would have taken up precious space in the wagons. A few

months later, about January of 1836, Dave would have had no choice but to watch Lydia and the two boys walk away behind the Drake caravan. Most of Dave's companions from Pottersville probably left with them. They would pass through vast territories and along wide rivers to reach, finally, far-off Louisiana, where they would build a town for their masters. Painful displacement of this kind was repeated so often across the South that historian Ira Berlin calls it the "Second Middle Passage." From the late eighteenth century to the Civil War, more than a million slaves were taken from the seaboard states to the Deep South, a movement that dwarfed the earlier transfer of Africans to the coast of the United States.[11]

Mt. Lebanon, the outpost that the Edgefield settlers established in northern Louisiana, still exists, hardly bigger than it was in their time. I made the trip there, not in the spectacular and varied ways employed by the Drakes—wagons to steamships—but in a much-used Ford sedan, traveling on the back roads past cotton fields. When I arrived, I found that the landscape of this distant place looked almost exactly like that of Edgefield: rolling green hills, thickets, small lakes—results of a similarly moderate climate. Reuben Drake had taken his party to a part of the world in which they could put down new roots, yet not leave the place they loved. They created a square at the center of the new settlement similar to the one in Edgefield, though it was longer and narrower and called the Parallelogram, in the style of the times. Reuben became the first postmaster of the little town and its first storekeeper. The new settlers, acutely aware of their heritage, called themselves the Edgefield Colony and considered their village an outpost of Southern culture. Many of the tombstones in the cemetery bear Edgefield family names and take care to mention the town the loved ones came from.

When Jasper Gibbs, who had briefly co-owned Dave with Reuben Drake, joined the settlers in 1843, he completed this duplication of Edgefield by starting a pottery. I was shown with pride a pot that is thought to be the first piece ever made there. It is about fourteen inches tall and looks a bit tentative, a far cry from the grand vessels of Pot-

tersville. Indeed, the pottery near Mt. Lebanon lasted only a short time, perhaps for want of good clay, perhaps for want of someone like Dave. Nevertheless, the settlers did well. Jasper Gibbs became the largest slaveholder in the area; Reuben Drake established a salt works near Natchitoches, about seventy miles to the south, and quickly became a wealthy man.[12]

I had hoped to discover in Louisiana what happened to Lydia and her children, but I was not able to find them in the 1840 or 1850 slave schedules for Sarah Drake, or in her will and estate papers; I did not find them in the slave records of Jasper Gibbs, who had married Sarah's daughter, Laura; I did not find their names in the Deeds and Conveyances of Bienville Parish and Claiborne Parish, where slave sales in Mt. Lebanon would have been recorded; I did not find them in the baptism rolls of the Mt. Lebanon Baptist Church, where slaves worshipped along with their masters, or on the tombstones of the black section of the Mt. Lebanon Cemetery. As far as I could determine, Lydia, George, and John, all three of them, completely disappeared from the records after they left Edgefield County.

This was, in an odd way, an accurate reflection of what happened: They vanished from Dave's life the moment they went around the turn in the road leading out of Pottersville. Barring some miracle, he would never see any of them again. How the pain of that separation must have lingered with him, like the phantom ache that amputees report feeling in limbs they no longer posses.

CHAPTER VI *Sermons*

> *[Slavery is] an Institution of heaven and
> intended for the mutual benefit of master and
> slave, as proved by the Bible.*
>
> — IVESON L. BROOKES, EDGE-
> FIELD MINISTER, 1850[1]

IN 1836, AT THIRTY-FIVE YEARS OF AGE, DAVE HAD REACHED almost the midpoint of his life. It was a moment of multiple losses: He had lost a leg to the railroad, he had lost friends to Louisiana, and he had lost Lydia and her children to—God knows where. On March 29 of that year, in the same month that the Drake party arrived at the site of what would become Mt. Lebanon, he wrote his second known poem:[2]

> horses, mules and hogs—
> all our cows is in the bogs—
> there they shall ever stay
> till the buzzards take them away ;equals

Dave's words convey a palpable sense of sadness. Newly crippled, mired in his old life, a little self-pitying, he may have been portraying himself in this image of painful stasis. Many of the former slaves who spoke with interviewers from the WPA equated their experience in bondage to that of livestock. Historian Mia Bay has noted that they remembered "being fed like pigs, bred like hogs, sold like horses, driven

like cattle, worked like dogs, and beaten like mules." It may be that Dave, at this point in his life, was making a similar comparison. It was shortly after this, on April 12, that he wrote "catination" on one of his jars, a variation of his first known inscription, "concatination." With its association to the links of a chain, it could be further evidence of his acute sense of being held in place.[3]

Just as no public records have emerged to explain what happened to Lydia after the Drakes left Pottersville, none have survived to tell what next befell Dave. He is not mentioned again in papers at the Edgefield Courthouse until 1847, when he appears in the estate of my great-great-great-grandfather, Rev. John Landrum, who was the eldest brother of Abner Landrum and the uncle of Reuben Drake. Like his relatives, Reverend Landrum ran a pottery, which was located on the southeastern side of the district; it had been in operation since at least 1816, when it was shown on the original survey for Thomas Anderson's map of Edgefield. Reverend Landrum may have purchased Dave for his establishment directly from his nephew when Reuben was preparing to leave for Louisiana, or he may have obtained him somewhat later, when the Pottersville factory went through several changes of ownership. In either case, Dave, far from remaining "in the bogs," would soon experience the one major move of his adult life: Carried out of Pottersville by wagon, he would be taken twelve miles across Edgefield District to the headwaters of Horse Creek, a tributary of the Savannah River. There, his new owner possessed thousands of acres on which he had developed not only the manufactory for which Dave was destined but also a cotton plantation, sawmill, gristmill, and tannery. Whether Dave came there in 1836 or a few years later, this part of the district would be his home for the rest of his life.[4]

Though the trip from Pottersville to the Landrum enterprises at Horse Creek would have taken only about four hours by mule-drawn wagon, the psychological distance for Dave must have been considerable. At Pottersville, he had been part of a thriving community, with Edgefield Village and its clamorous public events less than a half hour's

walk away. Reverend Landrum's plantation, on the other hand, was in a much more isolated situation. Even though Dave would be closer now to the villages of Aiken and Hamburg and the town of Augusta, it was unlikely that their citizens knew about him; he could not expect their young people to come over on a lark to watch him perform his "magic," as youthful Edgefieldians had done. Still, the land and the waterways around the Landrum place made it ideal for the manufacture of stoneware. Other entrepreneurs would soon realize this; within a few years they would establish their own factories in the area, mostly on nearby Shaw's Creek, thus shifting the center of the district's stoneware production away from Pottersville.

Though Dave was no longer able to operate the foot treadle that moved the potter's wheel, sherds from the waster pile at John Landrum's pottery make it evident that he was productive there: Many sherds have incised marks or letters that are similar to those on Dave's known vessels. As Carey Dickson, one of the sources for the story of Dave's railroad accident, recalled, "After Dave was crippled he had Henry Simkins, who was crippled in the arms, to drive the wheel for him." What an image: two men, both damaged, helping each other to remain productive, the only real measure of worth under the slavery system. It must have worked, for Kathryn Landrum Diveley, great-great-granddaughter of John Landrum, informed me that as a young girl she was told that Dave had been "instrumental" in the pottery, that he had "perfected the glaze." Her sister, Louise Landrum Murphey, remembered their father, Hastings Landrum, saying, "Dave was the best potter they had in there.[5]

John Landrum, Dave's new owner, was born in present-day Chatham County, North Carolina, on May 10, 1765, during the Landrum family's slow move south. He was the first child of Samuel and Nancy Sellers Landrum, who brought him to South Carolina in 1773, when he was eight years old. There, as it happened, his early experience with learning was not so different from Dave's. Denied a formal education, probably because of the upheavals of the Revolution, John was

taught only to read. With this one tool, he began to educate himself.
During the day, he collected wood knots, which he set ablaze at night in
order to have light for studying. In this way, he eventually acquired a
general knowledge of most of the sciences and learning of his day. The
Revolution molded his character in other, even more direct ways. Once,
as he led a horse loaded with corn to a gristmill, young John met a Tory
on the road. The Tory, seeing a chance for fun, shoved the sack of corn
off the horse's back, causing it to spill across the ground. He left the boy
crying. After the war, John again met the man, who had come back to
the area. Fully grown now and far stronger than his old tormentor, John
would have fought him and punished him in fine Edgefield style, had his
friends not prevented it.[6]

When he was about twenty-five, John Landrum became a Baptist
preacher of the Gospel, a pursuit he followed untiringly for more than
fifty years. Forever on the alert for sins not forgiven, he made it his goal
to "correct the morals and mend the heart" of his fellow men. It was
said that he saved the souls of countless Edgefieldians through "the
warm appeals of his plain and earnest eloquence." If Abner was the bril-
liant crusader of the Landrum family, and Amos was its wayward sinner,
John was its great and respected minister of the Lord.

It must not have been easy for John's sons to grow up in his lengthy
shadow. One son also named John, moved to the other side of the dis-
trict and became a successful physician; another son, Benjamin
Franklin, known as B. F. in the community and Franklin within the
family, stayed at home to help manage his father's businesses. An
achiever, as he perhaps had to be to hold his own in the company of his
famously achieving father, Franklin was running the family sawmill
when he was twenty-five years old. Because he would emerge in later
years as an important pottery entrepreneur, he was probably also learn-
ing the complexities of pottery manufacture from his father at the
same time.[7]

As pious as he was, Reverend Landrum was for much of his life in an
odd moral position: He was a minister of God who owned other chil-

dren of God. He is thought to have been a Separatist Baptist at the beginning of his career and, as such, believed that slavery was wrong and should be abolished. This stance, taken early on by many religious people in the upstate, proved impractical after about 1810, when cotton, with its need for vast numbers of workers, became the region's main source of income. The Baptists (and virtually all other denominations with the exception of the Quakers) shifted to a position that sought to justify slavery. The white man, they new argued, was simply carrying out God's plan by bringing African heathens to western soil, where they could be saved by the teachings of Christianity. This view prevailed, leaving Reverend Landrum and other religious leaders morally free to own slaves if they wished.[8]

One of the most extensive projects that Reverend Landrum accomplished with slave labor was the construction of an earthen dam at the center of his homestead tract. The long, meandering lake it held in place provided power for his mills and a handsome view for his home, which stood on high ground above it. The house, though not a mansion, was large and quite fine for its time. Family tradition contends that it was built from trees that were cut locally; because the Landrum sawmill was not yet in place, the trunks were rafted down nearby Shaw's Creek, whose waters join the Edisto River before reaching the coast, and shipped to England to be dressed. Construction lasted from 1780 until 1805. If these dates are accurate, the house was probably built by John's father, Samuel Landrum, who was born in 1737 and died in 1816.[9]

The ruins of the Landrum home are still visible at the site. A deep, rectangular depression where the house stood is divided by the path of a chimney that fell to earth. Scattered around the perimeter of the depression, partly hidden by leaves and grown over with lichen, are the fallen granite pillars that held up the porch. They were square cut and apparently somewhat stubby, not lofty columns in the classical tradition. There are other granite remains, probably part of the front steps, whose edges have carefully carved moldings. One piece, perhaps from the lowest tread, is curved in on itself like a big comma. The heavy fragments

seem to have been lifted and thrown down, as if the upheavals of Southern history had taken tangible form here.

Farther up the hillside is another indentation in the ground, this one not as extensive. It is what's left of Reverend Landrum's kiln, a groundhog structure like the one his brother, Abner, had at Pottersville, though it appears to have been smaller. Large, flat stones still lead up to what was once its front opening. The top stone is covered with spilled glaze that was hardened by the heat of the furnace. It is a light brownish gray, one of the colors typical of John Landrum's glazes. Down the hill at the creek are the ends of the dam, which gave way long ago; they still project from the slopes on either side. Great wooden beams and pieces of what look like the mill wheel lie submerged in the stream. These remains suggest how active this hillside must have been when Reverend Landrum had everything up and running: slaves cutting trees from the forest, dressing timbers in the sawmill, grinding corn in the gristmill, turning pots, glazing them, firing them.

Reverend Landrum did not own anywhere near the number of slaves that the great planters did—as late as 1846, he owned only eighteen, half of them women or small children—so he probably hired additional workers from neighbors when necessary or borrowed them from his son, Franklin. Dave was no doubt welcome when he came from Pottersville, one more worker in this heady mix of religion, slavery, and industry.[10]

ACCORDING TO A STORY HANDED DOWN in the family, the Landrums built a house of worship on part of their property. Though they were members of Horn's Creek Baptist Church, where Reverend John was a minister, they also may have held services in this neighborhood sanctuary. If they followed the practice of the time, they allowed their slaves to worship along with them; many congregations in South Carolina, in fact, had more black members than white. Each church kept the races separate, either by building a balcony for the blacks or simply setting

aside a section for them. Slaves also found ways to worship by them-selves, often in "brush arbors," secret shelters made of pine branches that they constructed in the forests. After the Civil War, the story goes, the Landrums gave the church building to their former slaves. Twice burned and rebuilt, it is now the Springfield Missionary Baptist Church."

Wanting to attend a service on the spot where Dave might have worshipped, I visited the Springfield church one gray Sunday morning in late winter. The present brick building is capped by a gable roof and surrounded by a wide, sandy cemetery; with its colored-glass windows and short steeple, it presents a straightforward image of the House of God. The road it stands on is paved now, but only a few years ago it was surfaced in red clay, just as it had been when the Landrums lived nearby. I got out of my car and looked farther down the road toward where their Horse Creek compound had once stood. On Sundays long ago, Dave, leaning on his crutch, might have walked along that road to the spot where I stood now.

As I lingered there, an elderly black man came up to me. He was short and compactly built, his hair cut close to his head. He wore a black suit and a white shirt. "Elijah Blocker is my name," he said, holding out his hand to me. In a serious manner, he invited me to come inside with him, and I accepted gratefully. In contrast to the somber day outside, the sanctuary was warmly lit by glowing, bowl-like glass fixtures that hung from the ceiling. A wide aisle, carpeted in red, cut through the middle of perhaps twenty rows of polished oak pews, many of them already occupied. The aisle led to a raised platform with a pulpit at its center. A dramatic background of draperies, the same red as the carpet, covered the wall behind the pulpit.

Mr. Blocker walked down the aisle toward the front of the sanctuary, then looked back for me to follow. Not wanting to impose too much on the hospitality that had been offered me, I raised my hand to him and slipped into an empty pew about halfway down the aisle. The congrega-tion was already quietly singing. Some among them were standing.

There was no musical accompaniment. I settled in my place and listened. An older woman, dressed in a white suit and a white straw hat, sat alone in a row of choir pews on the left of the platform. As I watched, she bent forward and slowly sang out, "Jesus is my Lord." Around me the worshippers sang back, "Call him by his name." She repeated her call in a different form, again and again, but it was always answered with "Call him by his name." A tall man in a black suit rose from his seat in the front row and, with his straight back to the rest of us, began a rhythmic swaying from side to side in time to the music: right-two, left-two. One by one, others rose and picked up the motion until all of us were standing and moving simultaneously. I had to concentrate on the rhythm, for this was new to me.

Elijah Blocker came forward to lead the singing now. He gave out one line at a time, and the congregation sang it back to him:

> *Late in the evening*
> *The sun is going down.*
> *You know I got to leave here*
> *I'm bound for higher ground.*

As I listened to Mr. Blocker, I could almost see Dave standing in his place. Respected for his ability to read the Bible, Dave might have been the one to get up before the congregation, when the Landrum slaves worshipped by themselves, and lead the group in song. It occurred to me that he might even have written some of his poems for call-and-response singing of the kind I was hearing. Several of his inscriptions are religious in tone, referring to the Bible and the need for "Grace." One, which he wrote on November 9, 1836, probably about the time he first came to Horse Creek, sounds as though it might have been based on the biblical story of Daniel, who was cast into a den of lions:

> a better thing, I never saw
> when I shot off, the lions Jaw

God rescued Daniel by sending his angel to firmly close the mouths of the lions. The King James Version of the Bible uses the word "shut," which in plantation retellings could have changed to Dave's *shot*. A slave spiritual that grew out of this story even changed it to "lock"[12]

Who lock, who lock de lion,
Who lock, de lion's jaw?
God, lock, God lock de lion's jaw.

When we were seated again, the minister of Springfield, Rev. Leander Jones, stepped to the pulpit from his place on the platform. A tall, fine-looking man, he wore a black robe with gold trim. He raised his arms like wings to lead us in an empassioned prayer. When he began his sermon, however, he spoke in a relaxed, almost conversational voice. He let us know from the start that following the word of God was not something you could do just now and then. He emphasized his points with the word "Amen!" It was thrown in quickly, like an exclamation. Individual members of the congregation contributed their own exclamations of agreement, usually also "Amen!" If they weren't moved to do so, Reverend Jones would request an "Amen" nevertheless. "*Listen* to me, Church," he said in an increasingly intense tone, "you can only serve *one* side. You have to be on *God's* side or the *other*. Somebody say, "Amen!';thin"

"Amen!"

As Reverend Jones continued his sermon, I became aware of a soft, lightly pulsing sound that hadn't been there before. Brought forth by a neatly dressed man seated at the keyboard of a small electronic organ, it punctuated the message. "And God won't *let* you," cried Reverend Jones, "he won't let you get away with changing sides. You got to make your *choice*. You got to come down on the side of the *Lord*." He turned to the man at the organ. "Let me hear that note," he said. "*Amen*."

Toward the end of his sermon, Reverend Jones began to sing his words in a rich, stirring voice. The organ music increased in volume. The

church members rose one by one and joined him in singing, moving in that now familiar left-to-right sway. The deacons set two chairs at the end of the center aisle and turned them to face the congregation. An unvoiced call to come forward hung in the air. This was a loaded moment in Southern church services, one with a long tradition in Edgefield. Planter James Rainsford wrote in his diary in 1833 that he had attended a two-week revival in Edgefield in which blacks and whites participated. He said that at the end of nearly every evening "most of the congregation were affected to tears, from very old men to young men and boys. [Many] went to the ministrating brethren, requesting them to pray for their salvation. . . ."[13]

A young man, perhaps fifteen years old, walked past me from the rear of the church. He was wearing a white shirt with long sleeves. His collar lay open and back at his neck. He sat down in one of the chairs facing us, self-conscious, his head tilted to one side. As we continued to sing, the pastor came down from his pulpit. The young man rose and whispered to him at length. Reverend Jones turned to us and raised his hand for silence. "This young man," he said, "has come forward *to ask us for our prayers.* We all know the difficulties our young people face today. He has asked us to help him at this time by telling *Jesus* about him." As we bowed our heads, Reverend Jones placed his hand on the boy's forehead and called out, "God, you know this young man didn't make himself. You made him. *You* know his troubles at this time. We ask you to *help* him, Lord." The congregation prayed silently for their fellow member. At length, the pastor removed his hand. The young man thanked him shyly, then began to walk back down the aisle. He walked leaning forward, and he dipped his shoulders slightly to each side, as if he were testing to see whether his burden had finally slipped away.

Reverend Jones started to sing again, and the congregation picked it up. He called for us to step into the aisle and take one another's hands. I found myself in a small circle of worshippers. We lifted our clasped hands to shoulder height and moved them in that same swaying

rhythm—left-two, right-two. I recognized the hymn we were singing from long ago when I was a young church member.

> *Precious Lord, hear my plea,*
> *Precious Lord, rescue me,*
> *Take my hand, Precious Lord,*
> *Lead me home.*

Elijah Blocker, somber and square shouldered, gazed at me from the other side of my circle. The young man who had asked for prayer broke from the group he was in and, laughing now, joined the circle beside ours. I could see him just beyond Mr. Blocker. I lost the rhythm of the hymn momentarily, for in the space of that second I felt as though I were witnessing the whole of Dave's life, from youth through old age, in the boy and the man before me. I could see the same pain and loss and pride and triumph that Dave had known. They were again manifested in this smooth face and this lined one, in this sanctuary, on this Sunday, on this land where Dave had walked.

		$	C
Hubs & Wagon Timber	B. F. Tillman	1	75
1 lot of old Iron	B. F. Landrum	3	06½
Mill Crank & Gudgeon	B. F. Landrum	2	50
Grind Stone	L. J. Miles	1	62½
117 # Damaged Hides 5 cts pr th	M. C. Geary	5	85

Negroes

		$	C
Man Dave	B. F. Landrum	801	00
Man Phil	L. J. Miles	785	00
Man Lawrence	Ag. Miles	575	00
Boy Jack	L. J. Miles	625	00
Boy Milligan	Joseph Ranlo	400	00
Woman Louisa & children Nico & Tucker	B. B. Tillman	900	00
Phillis and Child George	Collin Rhodes	910	00
Girl Caroline	L. J. Miles	400	00
Girl Louisa	Ag. Miles	305	00
Boy Samuel	B. F. Landrum	180	00
Woman Jinney and Two Youngest children	Collin Rhodes	690	00
Woman Sally	B. F. Landrum	135	00
Man Henry	L. J. Miles	50	00

CHAPTER VII *Families*

> *Dese all my fader's children,*
> *Dese all my fader's children,*
> *Dese all my fader's children,*
> *Outshine de sun.*
>
> —SLAVE SONG[1]

LEWIS MILES, MY GREAT-GREAT-GRANDFATHER, CAME TO Horse Creek at about the same time that Dave did. According to notes in the Charleston Museum Archives, Lewis was "fine looking—dressed and looked like Gen. ['Stonewall'] Jackson—awful intelligent face— broad white forehead." I've found no likenesses of him, but I have a photograph of his son, John Miles, that shows what must be this same impressive brow, along with eyes that seem to let the whole world in. Lewis had recently married Rev. John Landrum's daughter, Mary. The 1840 census shows them living only four houses away from Reverend Landrum and right next to his son, Franklin Landrum, probably on a large tract of land that Lewis owned in the area. Lewis and Mary first had two sons, Milton and Newton, then, in 1840, a daughter named America, whose line in the family tree would eventually lead to me.

Under the guidance of Reverend Landrum and perhaps even using his kiln at first, Lewis began to manufacture pottery. We know this from Rebecca Benjamine Landrum Steele, Reverend Landrum's great-granddaughter, who told researchers in 1930 that "Rev. John's pottery was bet[ween the] house at Fosketts and [the] grist mill. Louis Miles

married his daughter Mary and worked with him." Rebecca Benjamine gave no details of the arrangement between the two men. My guess is that Reverend Landrum, in the Edgefield tradition of sharing pottery slaves as needed, lent Dave to his son-in-law at this time to help him get his fledgling operation under way. It's clear that Dave was working for Lewis as early as January 23, 1840, because Dave inscribed "L. Miles" on one of his jars then. As far as we know, this is the first time he wrote that name; he would repeat it often during the following months in every possible variation—"Mr. Miles," "Mr. L. Miles," "Lm."[2]

Lewis was the grandson of an early settler of Edgefield, Aquilla Miles, one of the justices who presided over the legal proceedings of the district. Quite well-to-do, Aquilla owned twenty-one slaves in 1797, a large number for that time and place. He was married to an extraordinary woman, Henrietta Giroud Miles, who was quite talked of in my family when I was a boy. An elderly relative, Bob Hammond, enthralled us with tales about her: Descended from Huguenots, beautiful and talented, she had been sent from South Carolina to be educated in France; more important, she was a cousin of the Vicomte de Beauharnais, the first husband of Josephine de Beauharnais, who later married Napoleon Bonaparte. Bob Hammond promised to bring us a relic of Henrietta Giroud, a tortoise shell comb with which she pinned up her hair. The comb never materialized; nor was I ever able to find any documentation for our link, however slim, with Napoleon. Still, it's the kind of family legend you're reluctant to give up. Henrietta lived long after her husband had died, long after their children had married, long after *their* children had married. Only one son, Aquilla Jr., who was blind, remained with her on the family plantation, along with an ever-growing number of slaves. She seems to have been extremely strong willed, holding on to the family land as tightly as she held on to life. In 1830, her children finally sued for distribution of the estate. She died in 1839 at the age of about ninety-one.[3]

This is all to say that Lewis Miles came from strong stock and was a good match for a Landrum. He may have lacked the intellectual brilliance of his new inlaws—and their persistent oddness—but he made up

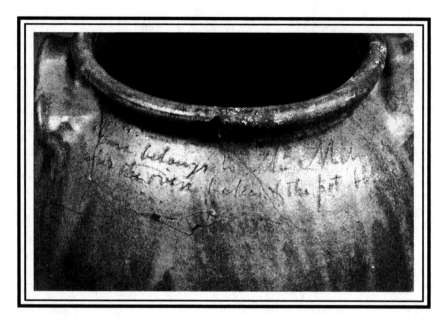

for it in warmth of spirit. He had a reputation for generosity to the poor that was widely known: "If you give a dollar," people said, "he'll give a hundred." His open personality may help explain the unusual freedom of action he allowed Dave. On January 27, 1840, just four days after writing out Lewis Miles's name, Dave added *his own name* on the side of the pot he had made that day. This was an audacious act for a slave. Though white turners and factory owners often signed their work— Abner Landrum incised his name on the earliest known dated piece of Edgefield ware, a medicine container of July 20, 1820—it was unheard of for a black worker to do so. Not one slave in all the years of pottery making in Edgefield had ever done such a thing.[4]

Irene Gingrey, the great-great-granddaughter of Rev. John Landrum, remembered hearing about what may have been this development in Dave's life when she spoke with pottery historian Cinda Baldwin in 1987: "I know they had one old black man that worked there, and they let him make some of his pottery and use his own trade mark on it." How simple and offhanded that sounds! Yet it was an enormous step for Dave. After that first time, he often signed his work,

though by no means always. Many perfectly good vessels bear only a date and "Lm" and perhaps a sideways horseshoe, which he seems to have used as a shorthand way of claiming his work. Some pots that have been attributed to him carry no marks at all. But on those occasions when he chose to write "Dave" in the damp clay, it was almost as though he were imprinting the jar with his soul. Sojourner Truth's question was, *Ain't I a woman?* Dave's affirmation was, *I made this jar.*[5]

On July 31, 1840, in that same early collaboration with Lewis Miles, Dave wrote this poem:

> Dave belongs to Mr Miles /
> wher the oven bakes = & the pot biles ///

These are the words that startled me when I first saw them in the exhibition at Winterthur. The second line of the couplet, at least, now made perfect sense to me. Although it suggested that plenty of hot, sustaining food was available at the Miles place, I could see that it also referred to the final stage of the pottery-making process, when the glazed vessels "boiled" in the "baking" furnace. In those few words, Dave painted a wonderfully complex picture that evoked kitchen and kiln. The first line, though, still baffled me. I found it hard to understand how Dave could state the fact of his bondage in such a straightforward way. Even if he were satisfied with the position he had reached in the world of slavery, wouldn't the very fact of being a slave cause deep resentments that would be hard to hide? And, according to the way I interpreted his situation at this time in his life, didn't he actually belong to Reverend Landrum, not to Mr. Miles? Was he perhaps attempting to curry favor with Lewis by calling him his owner?

I think it's important, when pondering this verse, to consider the nature of the relationship between Dave and Lewis. Although it was essentially based on bondage, it seems to have included a significant component of trust, as well. The primary evidence of this are the inscriptions that poured from Dave when he worked for Lewis: slave

trusted owner enough to reveal himself in this open way; owner trusted slave enough to let him do it freely. This mutuality may have been due in part to their personalities and in part to the intimacy fostered by working together in the potting shed. Lewis, who was seven years younger than Dave and apparently new to pottery, surely understood that this black man, who by then was experienced in every stage of stoneware production, had much to teach him. It seems likely that Dave, like others in the community, found Lewis to be a good man and valued him for it. Although the relationship between the two men included all the injustice and inequality that went with the slavery system, there sometimes existed within that system as Paul D. Escott has commented, "cases of genuinely warm feeling between slaves and their masters. Although southern society decreed a rigidly subordinate place for blacks as a group, some whites chose to be friendly to certain blacks, who responded in kind to considerate treatment. In such cases the individuals involved made an exception of each other without forgetting the enmity that existed between their groups."[6]

This leads me to think that the poem that has troubled me for so long might have been written as an acknowledgment of good feeling between Dave and Lewis, a picture of a friendship between a black man and a white man at that particular time and place. It is presented in the language of slavery, which is what Dave knew, but perhaps his feelings reached past that. I don't know. The meaning of this line may always remain just beyond us somehow, one of the puzzles of Dave's life that we will never truly understand.

Three years after Dave wrote his couplet about Lewis Miles, something happened to alter the creative link between the two men. Its results are unmistakable: Dave mysteriously ceased making inscriptions of any kind on his pottery. A straightforward "L. Miles" and "Dave," written on October 13, 1843, ushered in a period of silence that would last for almost five and a half years. Though a wealth of inscriptions from before and after this time have been found, no Dave vessel bearing a date or a signature or a poem has surfaced to break this prolonged

hush. No one knows what happened. One strong possibility is that Dave was forbidden to write. This interdiction could have grown out of fears engendered by an 1841 insurrection plot in Augusta, in which local slaves were accused of planning to storm the arsenal, set fire to the city, and kill the white residents. Perhaps Reverend Landrum and his son, Franklin, became uneasy with Lewis Miles's tolerant attitude toward slave literacy and felt that in the present period of racial tension they could no longer allow Dave to write. Perhaps Lewis, in an effort to keep peace in the family, went along with them.[7]

There is a photograph in the Charleston Museum Archives that symbolizes for me this troubled time in Dave's life. Narrow and horizontal, it shows three groupings of glazed pottery sherds set against a plain background. The largest sherds, which are in the center grouping, are inscribed in what looks like Dave's handwriting. The only legible portion of the inscription reads ". . . y my chic. . . ." The photograph is in an envelope with a matching photo of additional sherds, on the back of which is written, "From scrap heap of pottery of the Rev. John Landrum." The sherds were probably gathered by researchers from the museum during a trip to Edgefield and may still be in some unpacked box in the museum storerooms. It's possible that they represent the very moment when Dave's silence was imposed on him. In my mind's eye, I can see a pot with forbidden lettering on it—never mind if it simply said "buy my chickens"—being pulled from a group of recently fired vessels and thrown with a resounding crash onto the waster pile.[8]

REV. JOHN LANDRUM DIED on December 9, 1846, at the age of eighty-one. In his will, he specified that everything that belonged to him be auctioned off and the proceeds divided among his heirs. His property, of course, included Dave. After having been sold to Harvey Drake, lent to Dr. Abner Landrum, sold to Reuben Drake and Jasper Gibbs, sold to Rev. John Landrum, and lent to Lewis Miles, Dave was destined yet

again for the block. The whole circle of friends that he had created since he left Pottersville would also be going up for sale: "18 likely Negroes," totaled the *Advertiser*, "among whom are two good Wagonners, an excellent Stone Ware Turner, and a good Cook." Those to whom Dave had been close at Pottersville had been taken from him ten years earlier; now, his world at Horse Creek was also imperiled.

In John Brown's memoir, *Slave Life in Georgia,* the former bondsman wrote about the anxiety occasioned by a sale such as the one that now faced Dave and those around him: "I remember well the grief this caused us to feel, and how the women and men used to whisper to one another when they thought nobody was by, and meet at night, or get together in the field when they had an opportunity, to talk about what was coming. They would speculate, too, on the prospects they had of being separated, to whose lot they and their children were likely to fall, and whether the husbands would go with their wives. The women who had young children cried very much. My mother did, and took to kissing us a good deal oftener. This uneasiness increased as the time wore on, for though we did not know when the great trouble would fall upon us, we all knew it would come, and were looking forward to it with very sorrowful hearts."[9]

The sale of Rev. John Landrum's estate took place on February 22, 1847. The original record of it is at the Edgefield County Archives. It inventories every item sold that day—mules, cattle, hogs, a carriage, a pianoforte, blacksmith tools, raw and tanned hides, stoneware, bacon, even a framed map of Africa, among many others things, each followed by the name of the buyer and the amount paid. Everything is written in a scratchy, entirely prosaic hand until the section that lists slaves. Aware that these were the big money items, the scribe that day took great care with his presentation. He made the word "Negroes," solitary and large at the top of the column, into a marvel of penmanship. "Man Dave," who was the "excellent Stone Ware Turner" described in the announcement, led the list with grandly elegant "D" at the beginning of his name. He was followed by

"Man Phil" and "Man Lawrence," who were probably the "two good Wag-
onners," and a pair of boys, Jack and Milligan. These names were posi-
tioned one above the other along the left side of the column.

The women and children came next, but this section was oddly laid
out. The first named was "Woman Louisa," possibly Reverend Lan-
drum's "good Cook." Indented below her were the names of Nice(y)
and Tucker, identified as her children, then "Phillis and child George,"
then "Girl Caroline," "Girl Louisa," and "Boy Samuel," each name on a
separate line and each moved a little farther to the right to form a diag-
onal across the page. After a line space, the inventory resumed its gener-
ally flush-left layout with the names of the other women and children.
Breaking the established convention of naming the men before the
women, "Man Henry" was listed alone at the end of the tally. Because of
the extremely low value he was given in an estimate made one month
before, this may have been Henry Simkins, the man with crippled arms
who was teamed with Dave in the pottery shop.[10]

As a longtime graphic designer, I knew that page layouts always had
meaning, even if they were unintentional. Studying this one, I could see
that in each of the three cases where the relationship of mother to child
was made explicit, the child's name was listed on the line below the
mother's and indented. I then realized that the odd skewing of names
after Louisa might well be showing that *all* those children were hers, not
only Nicey and Tucker, the two directly after her, but also Phillis, Caro-
line, Louisa (perhaps named for her mother), and Samuel. George, the
child of Phillis, then, would be her grandson. In "Woman Jinney's" case,
her offspring were not listed by name but simply as "Two youngest chil-
dren." This implied, of course, that she had other, older children on the
list, who would probably have been the boys Jack and Milligan.

Hoping to further penetrate the anonymity of the list, I divided the
group into gender categories. I discovered that there was an equal num-
ber of adult males and females: Dave, Phil, Lawrence, and Henry in one
category, and Louisa, Jinney, Sally, and Phillis in the other. It occurred to
me that it might have been important to Reverend Landrum, as a spiri-

tual leader, to have his slaves settled into unions that came as close to Christian marriages as slavery codes would allow. This list, then, might actually be a careful delineation of four distinct families.

If this were true, one of the women on the list would be Dave's wife. He would have met her when, parted from Lydia, he came alone to Horse Creek. Perhaps reminded by others that spouses were bound only until death or distance came between them, he might eventually have looked around him and, to his surprise, found someone who pleased him a good deal. An inscription on a recently discovered jar by Dave gives insight into his romantic state of mind at that time. Dated February 10, 1840, it reads,

> whats better than Kissing —
> while we both are at fishing

A few months later, on August 26, Dave restated his interest. On the side of a beige storage jar covered with tiny spots of iron ore, he wrote:

> another trick is worst than this +
> Dearest miss: spare me a Kiss +

In the second of these quite amorous verses, the plus signs he added as line endings may be a code for future romantic moves. Clearly, both messages were meant for an important woman in his life.

But who was "Dearest miss"? According to the 1840 census, Lewis Miles owned no female slaves at this time, and Franklin Landrum owned only two; one was too old to be a romantic attraction for Dave, and the other was probably too young. Unless Dave looked to some other plantation in the area, "Dearest miss" was one of the four women in Reverend Landrum's estate. She probably wasn't Phillis, who, listed under Louisa, had not yet been given the designation of "woman", though she had a child of her own, she was likely not much older than a child herself. Sally, listed last of the women and given the least value in

the earlier estimates, might have been elderly. Jinney could have been Dave's wife, though her two older boys would probably have come from an earlier union. It was Louisa who tugged most at my imagination. The fact that she was first on the list among the women, just as Dave was first among the men, would seem to pair them; I sensed that the person who compiled this roster, given his precise methods, might have made such a link between them, even if unconsciously. Like Jinney, Louisa had more children than Dave could have fathered in the ten years he had been at Horse Creek, but she could have had an earlier mate who had died or been sold away. Although acknowledging that I had no real evidence to back it up, I added to my notes that Louisa might be Dave's new wife.

On the day of the sale, the beautifully written list that brought together the black men and women at Horse Creek just as neatly split them apart. They were divided among six different buyers. As I interpret the record, Louisa was parted from her husband and her older children, as was Jinney; Dave, Phil, and Lawrence were separated from their wives and children; and the older boys and girls on the list were taken from their parents and siblings. Dave might have expected that Lewis Miles would buy him, but Franklin Landrum, in what may have been a strong competitive move against his brother-in-law, bid a winning $800 for Dave; it was equivalent to more than $17,000 today, the most paid for any single slave in the sale. Franklin also bought the boy Samuel and the woman Sally. Lewis Miles succeeded in acquiring the second most expensive male, Phil, along with the boy Jack, the girl Caroline, and finally Henry, for whom he paid only $50."

I found it hard to accept that the Landrums would allow this splintering of families to occur, yet there were divisions of this kind all across the South when slaves were sold. One of the largest such sales took place in Georgia on the plantation belonging to a financially strapped Pierce Butler. Sidney George Fisher wrote about it in his diary on February 17, 1859: "It is a dreadful affair . . . selling these hereditary Negroes. There are 900 of them belonging to the estate, a little com-

munity who have lived for generations on the plantation, among whom, therefore, all sorts of relations of blood & friendship are established. Butler's half, 450, to be sold at public auction & scattered over the South. Families will not be separated, that is to say, husbands & wives, parents & young children. But brothers & sisters of mature age, parents & children of mature age, all other relations & the ties of home & long association will be violently severed. It will be a hard thing for Butler to witness and it is a monstrous thing to do." A few slaveholders chose to suffer financially when they were faced with this kind of situation. In 1858, William Massie of Virginia, finding himself burdened with debt, chose to part with a beloved homestead rather than sell his slaves: "To know," wrote Massie, "that my little family, white and *black*, [is] to be fixed permanently together would be as near that thing happiness as I ever expect to get. . . . Elizabeth has raised and taught most of them, and having no children, like every other woman under like circumstances, has tender feelings toward them."[12]

The Landrums chose their own path of action. They were able to keep the youngest slave children with their mothers and sell only to buyers who were, except for distant neighbors Joseph Rambo and B. R. Tillman, Landrums or Landrum relatives. *The Negroes will remain in the family,* they could tell each other, *rest assured.* But keeping black slaves within an extended white family was far different from keeping a black family together. For one thing, it was difficult for slaves to visit between plantations, even with the blessing of their masters; for another, Edgefieldians often moved on, taking their slaves with them, as the Drakes had done when they went to Louisiana. In fact, both Phillis, with her child George, and Jinney, with her two youngest children, were probably removed from the Edgefield area as early as 1853, when their buyer, Landrum relative Collin Rhodes, sold his pottery on Shaw's Creek and moved his family and most of his slaves to Mt. Lebanon. Though B. R. Tillman, who bought Louisa and her children, Nicey and Tucker, took them only as far as Chester Plantation, ten miles to the southeast, they too might as well have gone to Louisiana.[13]

There are no known inscriptions from Dave during this trying time, which falls within his period of silence. Years later, though, in 1857, Dave composed a poem that suggested he was still thinking of what happened on the dreadful day of Rev. John Landrum's sale:

> I wonder where is all my relation
> friendship to all — and, every nation

It is the most heartfelt of his poems. This time he didn't speak of jars or horses or bogs. Instead, he sent out a simple, plaintive greeting to loved ones blown to the four winds—not only to those taken away at Reverend Landrum's sale but to those carried off in 1836 from Pottersville. He could have been thinking back even farther, to the mother he might have lost when he was a boy, and longer ago still to his forebears across rivers, across oceans, in every nation.

CHAPTER VIII *Murders*

Servants, be obedient to them that are your
masters according to the flesh, with fear
and trembling, in singleness of your heart,
as unto Christ.

—EPHESIANS 6:5

WITH REV. JOHN GONE, FRANKLIN LANDRUM AND LEWIS
miles were left in control of the Landrum pottery at Horse Creek. The
brothers-in-law were very different from each other, however. For one
thing, Franklin, apparently lacking the ease with which Lewis related to
his workers, was a far more controlling master. Perhaps due in part to
this, difficulties arose between them. Rebecca Benjamine Steele,
Franklin's granddaughter, told researchers that the two men "continued
[the] pottery together but later disagreed and each started a separate
pottery." Franklin took his part of the business across the lake, where he
constructed an entirely new factory—pug mill, potting shed, glaze mill,
kiln. He may have already been planning for this when he bid so force-
fully for Dave on the day of his father's estate sale. Though he had prob-
ably paid more than he wanted to, a turner of such caliber was
invaluable to him now. In spite of falling out with each other, the men
necessarily remained associated because of their complex family ties:
Lewis was married to Franklin's sister, Mary, and Franklin was married
to Lewis's sister, Rebecca.[1]

Franklin and Rebecca lived on the far side of the lake in a house they

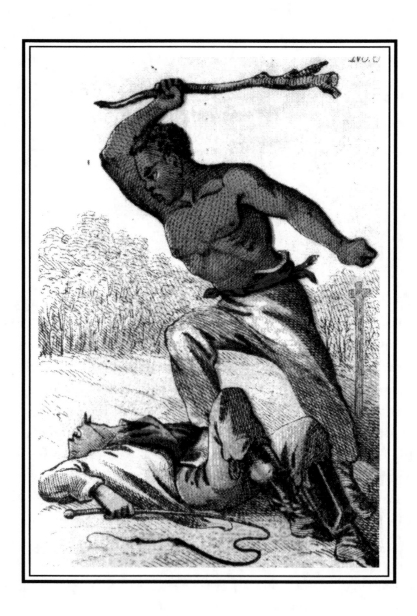

had built in 1844. It was only a brief walk along the sloping hillside from the new pottery. Not as grand as Reverend Landrum's home, it was nevertheless large and comfortable. It was taken down in 1950, but family members have recalled its features for me: two large rooms on the first floor with bedrooms above, a double fireplace, hand-carved mantels, oversize doors, a crape myrtle tree that bloomed lavishly in late summer, orange daylilies in a sunny garden, terraces leading down to the water. "At this home," reported the *Advertiser* in later years, "there were many guests and large house parties continuing for days at a time. There was an old square piano of early make. Plays and even operas were given in the time when they had many servants." In these more than pleasant surroundings, Franklin and Rebecca Landrum raised their children—three sons and six daughters.[2]

Rebecca's in-laws privately called her "the French woman," probably in reference to the Huguenot blood she had inherited from her grandmother, Henrietta Giroud Miles. Far from a compliment, it was meant to indicate that Rebecca was as steely and strong-willed as her *grandmère*. For reasons that are now lost, she adamantly refused to let her son, Ben, who wanted to become a doctor, go to medical school. In contrast, she sent her daughters on to higher education at Salem College in North Carolina. Quite wrapped up in her children, Rebecca fell easily into bouts of anxiety about them. A vial of laudanum, listed among Franklin's purchases in 1854, might have been intended for her. She was a high-strung lady, determined, "French."

A legend in the Landrum family tells that Rebecca brought with her "the formula for the glaze" when she married Franklin. According to the story, her personal slave carried the combination of ingredients in his head. Because Rebecca was born just about the time Abner Landrum was founding Pottersville, the glaze in question could not possibly have been his famous alkaline glaze. However, the story indicates that she was viewed, not fondly, as a woman with secrets and power and background. Rebecca and her grandmother Henrietta are the only women from the early generations of the family still talked of today. Amidst all their col-

orful male relatives, both of them have managed to find a way to the front of the family portrait to leave a strong and lasting impression. A symbol of this French legacy was actually stamped on the walls of the Franklin Landrum house: Until the structure was taken down, its main rooms were covered with gray papering stenciled with gold fleurs-de-lis.[3]

As the new head of the family at Horse Creek, Franklin must have found life to be good. God had blessed him with a cultured wife, musical daughters, a house overlooking a lake, extensive fields for the cultivation of crops, a new kiln of his own, and enough slaves to do what had to be done—one among them "an excellent Stone Ware Turner." But on March 25, 1847, just one month after the sale of his father's estate, his family was dealt a terrible blow. It was of the kind that haunted the sleep of every white Southerner. Rebecca Miles Landrum's brilliant and charming first cousin, Dr. Augustus W. Burt, who lived in the lower Horn's Creek area of the district, was brutally murdered by one of his slaves.

The killing sent tremors through an extended network of kin. Burts and Mileses had been closely allied since the 1790s, when three sons of Matthew and Ann Burt married three daughters of Aquilla and Henrietta Giroud Miles. One of these unions, between Susanna Miles and Harwood Burt, produced Rebecca's cousin, Augustus. Edgefield historian John A. Chapman remembered him as a "tall, commanding figure, with fine face, winning manner and pleasing address. He was popular, and enjoyed the confidence and esteem of a large clientage." Thirty-eight years old when he was killed, he was married and had two young children. The seeds for his death were sown five to six years before, when two Edgefield slaves who were working in a field together got into an argument. Carried away with anger, one of the men raised his hoe and crushed in the forehead of the other worker. Dr. Burt somehow managed to heal him. Not long thereafter, the owner of the two workers died and they were put up for sale. In what must have seemed to some a tempting of fate, Dr. Burt bought the assailant.[4]

Dr. Burt's newly purchased laborer was named Toll. Burt put him to work in the fields with his other slaves, but Toll did not become friendly

with any of them. One morning he "stayed late," according to two of the other workers. This amounted to an infringement of the rules, and the doctor whipped him for it that evening. The next day in the fields, perhaps angry still because of his punishment, Toll balked at a command from his owner. When Dr. Burt attempted to punish him a second time, the slave picked up a heavy, sharp-edged tool, called a "club-axe," and came at him with it. The doctor ran, but Toll caught him and knocked him to the ground. The fallen man called out for help. Before any of the other slaves could reach them, Toll raised the axe and, just as he had earlier done to his fellow worker, brought it down repeatedly.

The *Advertiser* called it a "Horrid Murder . . . a shocking murder." Five blows, it said, "were inflicted on him with that instrument—on the face, head, and neck. He died almost immediately in the fields." Both masters and slaves had understood from the earliest days of Southern slavery that the swing of the whip always had the potential to unleash the counterforce of retaliation. It might come days later as a mysterious fire or a poisoned soup or a stolen hog, or it might come instantly, as it did with Toll's descending axe. Toll was quickly apprehended and brought to the jail in Edgefield Village. On March 29, he was tried and convicted by a Court of Freeholders, property owners of the district, and sentenced to death; on April 9 he was hanged.[5]

Franklin Landrum, in particular, must have been troubled by the fate of his wife's cousin, for he, too, owned a difficult slave. Her name was Ann. She worked with Dave and the others in the pottery shop, probably performing some of the many supporting tasks that were required there. Franklin had owned her for three years. From the beginning, she had exhibited a surly disposition. She was, in fact, not unlike Prue, the universally disliked slave woman in *Uncle Tom's Cabin*. Tall and bony, with a sullen, grumbling voice, Prue was prone to disrespectful glances and self-pitying statements. If Ann's surliness rose past that of Prue's to the level of actual defiance, Franklin was doubtlessly prepared to "break" her, for he was a firm believer in discipline. We know that he whipped his workers when they were slaves

and continued to whip them even after the end of the Civil War, when they were freedmen. On one occasion in 1865, as his neighbor James Tillman noted in his journal, Landrum came to Chester Plantation with a Yankee soldier for the purpose of "thrashing" a free black man named Thomas, who had somehow displeased him. Tillman, though not known for leniency toward slaves or freedmen, apparently saw injustice in the situation and intervened. He did it, he said, not only for Thomas but also "for the sake of Landrum."[6]

That odd aside by Tillman may have taken into account one of the great ironies of the slavery system: Although it provided a slaveholder with money and leisure enough to evolve into a cultured individual, it also sometimes required him to become a punishing demon. No other institution, it was said, subjected a man of care and feelings to such a dilemma. In Charleston, owners who wished not to do violence to their feelings could send recalcitrant slaves to the workhouse for others to punish, but that was not the way in Edgefield. As far back as the early days of Franklin's father's ministry, the local Bethel Baptist Association had instructed its slaveowning members to "use the rod if needs be." Employing a whip, in fact, was considered a reform measure in the treatment of slaves, because it replaced ear cropping, branding, the wearing of iron collars, and other punishments that were common earlier.[7]

Franklin was not the only Edgefield master to be concerned about slave management in the months following Dr. Burt's murder. The topic so consumed the members of the Beech Island Farmers' Club, a group of local planters, that they debated it at two consecutive meetings. Virtually every man whose opinion was recorded in the minutes for the meetings favored the whip as a means of control, but the degree to which they proposed using it varied dramatically. John J. Boyd suggested that case of disobedience, instead of perpetual scolding and threatening, "use the rod but do it in moderation and prudence." Joshua Moody disagreed sharply, contending that the better you treated slaves the worse they behaved: "[T]he best plan would be to give them 25 or 30 lashes a piece every Saturday night anyhow, which probably [would] keep them straight until

Monday morning." He thought that the women should receive the higher number, for they were "worse than the men."[8]

Although no doubt aware of all such advice, Franklin Landrum, as the son of a great minister, probably relied on the Bible for the final word on how to deal with his slaves. There, in Deuteronomy 25:1–3, forty lashes were recommended for the guilty; one less, for a total of thirty-nine, ensured moderation. There was also Hebrews 9:22: "And almost all things are by the law purged with blood; and without shedding of blood is no remission."

The final clash between Franklin Landrum and Ann occurred on the morning of November 23, 1848, when he gave her an order to carry out a task in the pottery. Standing there, probably right in front of the other workers, she refused to do it. The story of what subsequently happened has survived in the report of the coroner for Edgefield District, A. B. Addison. From his vivid account, we know that Franklin began to whip Ann. Because Franklin owned only about four adult males in 1848, Dave was very likely "one of the negroes left in or about the shop," as Addison described it, making him a direct witness to the beating. Dave had worked for a series of men who, as far as I have been able to discover, were evenhanded in their treatment of him. Here, though, he was being given a violent lesson: If he ever diverged from the limited role of artisan—perhaps if he began to drink as he had at Pottersville or write poems as he had for Lewis Miles—he would feel the bite of that leather strap himself.[9]

I once saw a whip that had been used to punish slaves. Incongruously, it lay in tissue paper in an air-conditioned storage room in Charleston. When I picked it up, I found its wooden handle to be perfectly smooth, as if from repeated use. Two leather bands, wrapped around the handle, kept six square-cut leather strips in place. The strips were about sixteen inches in length and meant to sharply burn the skin. Pasted on the handle, just at the edge of the bands, was a deeply yellowed label on which was written, "A relic of Slavery." The thin letters of the inscription suggested that the hand that wrote it had been weak and wavering. What a

contrast to Franklin Landrum's punishing hand as he brought his lash, of this or another design, down across Ann's back.[10]

When he was done, Franklin once more ordered Ann to carry out the task he had assigned her. Again she refused to do it. She raised the degree of her defiance by threatening to run away. In response, he tied her up with a rope. He left her there in the turning house and walked across that lovely hillside, barren now at the end of autumn, toward his new home. I wonder whether he was shaken by what had happened: *The whip had failed.* Neither the Bible nor all the advice that had spread through the district from the Beech Island Farmers' Club meetings had dealt with that eventuality. At the house, Franklin stepped up onto the porch, went inside the front door, and sat down at breakfast. Did he consult Rebecca? Did he open the Scriptures in search of further word? Or had all of this happened before, often enough to assure him that in the end he would prevail?

Three-quarters of an hour later, according to Addison's report, he retraced his steps to the pottery. As he approached the building, one of his slaves ran toward him: *Ann had hanged herself, Ann was dead.* Landrum went into the shop and found his workers loosening the rope from around her neck. As soon as she was let down, he searched for her pulse to see whether she was still alive, but he could find none. He had Ann's body carried to his kitchen house and laid out there. He then went to the home of his neighbor, John L. Atkinson, told him what had happened, and brought him and his son William back with him to examine the body. He also took them to the pottery shop and showed them where Ann had hanged herself. He pointed out a brick that had been loosened in the fireplace when she threw herself forward. Because the coroner was away in Columbia, Franklin and his two neighbors buried Ann's body.

The coroner's inquest was held at the Landrum house more than two weeks later, on December 8. Potter Collin Rhodes was foreman of the jury, which included twelve other men from the neighborhood. Franklin told them that from the position Ann was in when he found

her, he believed she had "wraped the end of the rope that hung by her twice around her neck and squatted or leant upon it so as to choak herself to death." He explained that Ann had "threatened to run away, was of turbulent disposition was the reason he confined her by tying." His neighbor, John Atkinson, described examining her body for injuries and finding "marks of the whip but none that broke the skin." Nor did he find bruises that would indicate that she had been otherwise injured. He did not think her neck was broken "but that she choaked herself to death." Ann's former owner, John Whitlock, from whom Franklin had apparently purchased Ann, testified that she was "of the worst disposition of any negro he ever knew." He had sold her because he thought she "was just of devlish disposition enough to kill herself." She would not work, he said, but would piddle about and sleep. "Whipping done no good." Finally, to reinforce it all for the coroner, John Green, who had lived with John Whitlock part of the time he owned Ann, repeated that she was "of the worst disposition of any person he ever knew."[11]

The coroner and the neighborhood men he had assembled found no fault in what Franklin Landrum had done and did not send the case to trial. I presented the same facts to Edgefield County's current coroner, Thurmond Burnett. It was entirely possible, he told me, for Ann to lean the weight of her body into a rope wrapped around her neck and kill herself: The pressure of the rope would cut off the flow of blood through her carotid arteries, causing unconsciousness; continued loss of blood to her brain would cause it to stop sending signals to her heart, which would stop beating, and she would die. Immediately after her death, her skin would have had a reddish tint; her mouth might have been open, her tongue sticking out. The original report says that an inquest was held "on the body." Because it had been buried about two weeks, however, Burnett thinks that the coroner probably did not have it exhumed. Protected by a wooden coffin at best, it would have deteriorated enough in that time to make any evidence it offered unreliable.[12]

As far as we can know, Ann died by her own hand. The question then is why she chose to kill herself. If she really possessed the turbulent

disposition that the witnesses claimed, she might have chosen to do it out of a desire to injure Franklin Landrum financially, as her death surely did. This was another of the cards that slaves could play at any time. I wonder, though, whether reasoning of this nature, however wayward, was possible in those moments after Franklin left her. She was lying alone in the potting house, bound, angry, hurting badly, with welts rising on her skin. A slave is reported in the WPA narratives to have hanged himself "to 'scape he mis'ry." In the same way, Ann may simply have felt that she could continue her life no longer.

The coroner did not question any of Franklin's slaves about her. I wonder whether Dave, had been asked, could have told them how she came to be the harridan whom everyone complained of. Prue, her fictional double, had become horrible and a drunkard, but only after her owners had taken child after child from her and sold them away. Prue, too, had died after a whipping, glad, really, to find an end to her grief. A character in Stowe's novel says, "The horrid cruelties and outrages that once and a while find their way into the papers,—such cases as Prue's, for example,—what do they come from? In many cases, it is a gradual hardening process on both sides,—the owner growing more and more cruel, as the servant more and more callous. Whipping and abuse are like laudanum; you have to double the dose as the sensibilities decline."[13]

Less than three months later, Franklin Landrum was named in his turn to a coroner's jury and called in to view the body of a white neighbor, Matilda Posey. He and the others on the jury determined that she had been beaten to death by Appling, a slave who had since disappeared. This dreadful act of slave violence must surely have made Franklin feel justified in managing Ann with a strong hand. What evils might she have perpetrated had he not raised his whip against her? The moral lesson became cloudy, however, when it emerged that Matilda's husband, Martin Posey, had hired Appling to kill his wife, apparently so he could marry her sister. He had then murdered Appling and buried his body. The incident was one of the most sordid in the district's history, and at the resulting trial, Martin was sentenced to be executed. All

the details would have been known at the Landrum compound, for the family had an intimate connection to the drama: Eliza Rhodes, the daughter of Amos Landrum, was a close neighbor of Matilda Posey; her husband, Collin Rhodes, was among the men who found Matilda's body. What a disturbing, complicated time this whole period of anger and punishment and treachery must have been for the families, slave and free, at Horse Creek. If Dave had been able to write freely on his jars what images he would have had to draw on.[14]

I visited the hillside where Franklin and his slaves once lived. The lake between his house and his father's, released when the dam gave way in later years, was now a swamp. Uphill from it, a large waster pile, regularly plundered by pot seekers, marked the area where Franklin's pottery had been located and where Ann had hanged herself. I knew that the broken chimneys of the Landrum house were only a short walk from the pottery, but they were so overgrown with vines that I never found them. As I tried to visualize the setting in its earlier incarnation— blooming trees, rows of freshly fired vessels, glimpses of fleurs-de-lis through open windows—it unexpectedly took the form of a work I had once seen by artist Kara Walker. An enormous panorama cut from black paper and affixed to a white wall, her composition presented a candy-box version of a Southern plantation scene. Only on carefully studying the silhouettes of the graceful mansion and dancing slave children and ladies in tilting skirts was it apparent that horrors were being perpetrated in the secret spaces between black and white. Images of shameful abuses—whippings, even murders—emerged from the details of the seemingly innocent composition. In the same, silent way, horror grew out of the spaces between Dr. Burt and Toll, between Franklin Landrum and Ann, between Matilda Posey and Appling and Martin Posey. My memory of Kara Walker's silhouettes fitted so neatly over the scene in front of me that I had the brief, awful impression that she had used this hillside as a template for her vision.

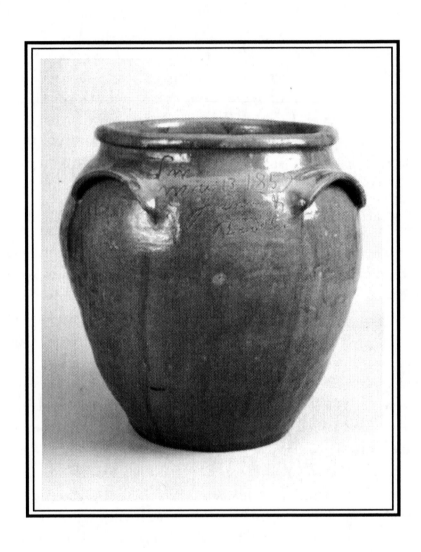

CHAPTER IX *Jars*

> *Lm says this handle*
> *will crack*
>
> —DAVE, 28 JUNE 1854

IN EARLY JUNE OF 1849, A LITTLE OVER SIX MONTHS AFTER
Ann's death, Mary Landrum Miles, Lewis's wife, made a petition to the
State of South Carolina. She asked the court to modify the portion of
Rev. John Landrum's will that specified that her inheritance be put into
a trust administered by her brother, Franklin. She was not questioning
the stipulation itself, which was a common part of wills at the time and
was designed to keep a daughter's inheritance from being used by her
husband to cover his debts. Mary simply wanted her brother replaced:
He had "not acted nor consented to act in the execution of said Trust
and now renounces and declines the same."

The request didn't specify that Lewis and Franklin had fallen out as
partners, or that Franklin treated his slaves callously, or that Rebecca
Landrum was a pain in the neck, but I suspect that its subtext included
all that and more. Mary asked that Aquilla Miles, her husband's brother,
be appointed as her new trustee. The court agreed and instructed
Aquilla to put her money in "negroes or other property for the benefit
of the beneficiaries." The amount in question was approximately
$2,500, which is more than $60,000 in today's money. The names of
any slaves in whom Mary's inheritance was subsequently invested are

not recorded. Thanks again to Dave's own record keeping, however, we know that he could have been one of them. Starting in 1849, his pots suddenly have "Dave" and "Mr. Miles" once more inscribed on their shoulders, making it clear to the world that Dave was no longer the property of Franklin Landrum. However, if Dave were purchased with money held in the trust, he would not have belonged to Lewis Miles either. Dave now technically would have belonged to *Mrs.* Miles.[1]

Other important changes took place at Horse Creek. Lewis acquired the sawmill that had been owned by Rev. John Landrum and named the area where it was located "Miles Mill." He also built a pottery factory of his own, just as Franklin Landrum had done. Rather than locating it at Miles Mill, however, he chose a part of his property where a stream had long ago worn away the side of a hill, leaving a high, meandering bluff strewn with boulders. Lewis put his new pottery at the base of this feature and called it the "Stony Bluff Manufactory." He installed Dave and his other pottery workers there. The Miles family home must also have been nearby, for several letters written by his son, Milton, are headed "Stony Bluff."[2]

Although most of the other locations associated with Dave—Pottersville, Rev. John Landrum's pottery, Franklin Landrum's place—had been found over the years, Stony Bluff, where Dave made his greatest pots, had always remained elusive. This was in spite of serious efforts. Researchers had attempted to trace it in the archives and in the countryside, but it seemed unobtainable, a kind of Holy Grail for those fascinated by Dave's story. I arrived in Edgefield just in time for its discovery, not by one but by two and perhaps by three separate researchers, almost simultaneously. Ferociously independent, each of them kept it a secret, with the result that none of them knew about the others' achievements. They kept it quiet for two reasons: The first, quite admirable, was that they didn't want "pot diggers" descending on the site from all over the state and destroying archaeological evidence; the second, somewhat less noble, was that they wanted to keep for themselves this piece of Dave lore that no one else possessed. (As one

longtime collector informed me, "In this pottery group there's a lot of peculiarities.") They each let me in on the secret because, as they told me, I was the great-great-grandson of Lewis Miles and "deserved to know." They warned me to keep my mouth shut just the same. One said, in what I *think* was a kind of Edgefield jest, "If you tell anybody, I'll take you out in the Square and *hurt* you."

The ways they found Stony Bluff varied. One man, who was used to poking into byways of the district, just kept trekking over the area where he knew it must be until he literally stumbled over it. Another, potter Steve Ferrell, was actually handed a clue to its location. "I got onto it," he told me, "because the owner of some land southeast of here wanted to make a dam, they're always making dams down there, and when he started moving dirt he turned up a pot. An *intact* pot. A *good* one. His wife brought it in for me to see and I had a feeling. I said, 'Just turn around, I'm gonna follow you back out there!' I jumped in my truck and flew out after her, followed her back into the woods, and there it was—a sandstone bluff and the mound where the kiln had been and everything!"[3]

At this writing, the location of Stony Bluff is *still* a secret. With Steve's help, though, I was able to get permission from the current owners to visit it. On a gray February day, Steve and I rode southeast of Edgefield, turned off the paved road, and followed a sandy track deep into the scrub pines. As we rounded a bend, I saw a woman standing alone by a low metal gate. To me, it seemed almost as though she were guarding the gateway to the past. She signaled to us, got into her car, and led us into an open valley that surrounded a lake. We crossed a dam and came to a halt on the far side of the water. Proudly, Steve stretched his arm out the window toward a strip of rocky land that rose perhaps fifty to seventy feet above the level of the valley: "That's what Stony Bluff was named for!"

I got out of the truck and turned in a slow circle, wanting to take in all of it. This was the long-sought-after land of Lewis Miles and Dave, the place where both of them spent their most productive years. I tried

to imagine how it must have looked when they lived there. The Miles house would probably have been on top of the bluff, with one side facing the road to Edgefield and the other looking out over the valley. Each morning Lewis Miles would have walked down to his factory below. All the structures and equipment that I had "seen" at Pottersville would have been here, too, probably between the stream that was now a lake and the base of the cliff. There would have been a dirt road leading out of the valley so that wagons could take the newly made stoneware to Aiken or Hamburg. The slave cabins, where Dave would have lived, were probably along that road. Back then, this quiet valley, a bit solemn today, would have had the look of a busy and dedicated workplace.[4]

The woman who had led us in came to welcome me. Gray haired and direct, she was the matriarch of the family that now owned the land. She told me how pleased she was to have a descendant of the Mileses "coming home." Moments later, her daughter arrived in an SUV, along with four young children and a dog. This sudden press of humanity animated the place. As the children crowded around us, I asked Steve to show us where the kiln was. He smiled and said, "Follow me." He led us into a group of small trees that had grown up near the base of the bluff. The hardwoods among them had lost their leaves for the winter, but it was still difficult to see through them for any distance. Briars slowed me down. Well ahead of me now, Steve stopped and called back, "Look around you!" Turning, I discovered a low, broken wall of stone to my left, then a matching one to my right. About fifteen feet apart and parallel, they followed a gradual incline toward the base of the cliff. I suddenly understood: *I was standing in the Stony Bluff kiln.* It was the center of Dave's whole story. Steve shouted, "When I first saw that, I dropped down on my knees!"

The kiln area was huge. Though the vaulting had fallen in, I could see that this furnace was much larger than the one at Pottersville. In great excitement, I followed the remains of the walls to their downhill end and located the mouth of the kiln. The soil was still black with

charcoal from the wood that had once burned there. To measure the
structure and fix it in my memory, I began pacing the length of its inte-
rior. By the time I reached the place where the chimney had once been,
I had made twenty-five paces. The inside dimensions were, by my
count, approximately fifteen feet wide by seventy-five to eighty feet
long. The heat from the firebox would have been pulled along this
entire length, enveloping Dave's jars and jugs, slowly hardening them
for their duties in the world. The heated air would then have been
sucked up the chimney and lifted out across the valley by the wind.

Steve came up beside me, accompanied by eager children and the
dog. "This is the biggest kiln I know of," he said, full of awe. "This is
Stony Bluff."

COMING TO STONY BLUFF marked a new beginning for Dave. With
Henry, his friend with crippled arms, probably again turning the foot
treadle for him, Dave produced work that achieved real success in the
marketplace. As Edgefield turner George Fletcher later told researchers,
the vessels made at the Lewis Miles factory had the reputation for being
the "best ware in [the] country." They were peddled all over Georgia,
South Carolina, and North Carolina. The 1850 industrial census for
Edgefield District shows that Lewis Miles had seven male and two
female workers and the value of his annual product was $4,000—
almost $100,000 today. This was well in excess of the figures for his
former partner, Franklin Landrum, who had only five male workers and
$1,800 in annual product. Both men, of course, also had income from
other activities.[5]

Though Dave had begun signing and dating his vessels again in mid-
1849, it was not until October 17, 1850, as far as anyone has been able to
discover, that he picked up his pointed stick to make an extended
inscription. This was more than ten years after he had written his last
known couplet. His fingers must have felt unaccustomed to such writ-
ing, for on that day he dug the letters into the clay with uneven pres-

sure. After the pot was glazed and fired, in fact, what he had written was almost illegible. Seen now, his words have the appearance of struggling to free themselves from the surface: "just a mammouth jar . . . for I not . . ." is all that can be read, not enough even to know whether he intended it as a poem or simply a message. Though shaky, it was an impressive return nevertheless: The inclusion of the personal pronoun "I" and the evocative adjective "mammouth" hint at wonderful things to come. Whatever or whoever forced him to stop writing at Horse Creek had no authority at Stony Bluff.

Once he was fully under way again, Dave seems not to have been able to stop writing. His surviving poems increased from one every few years to three in 1857, eight in 1858, and seven in 1859. He sent his rhyming verses into the world one after the other, in one case writing two in the same day. Of his twenty-nine known poems, all but eight were inscribed at Stony Bluff. This flood of verses would have been hard for the surrounding community to ignore. They apparently caused no negative stir, however, perhaps because the fevered excitement that had helped pass the anti-literacy law of 1834 was subsiding. As early as 1848, the influential John Belton O'Neall had written that such laws made it appear as though South Carolinians were afraid of their slaves. "Such a feeling," he wrote, "is unworthy of a Carolina master." By the time Dave reached the peak of his poetic production, the state had let go, at least temporarily, of much of its fear of slave literacy.[6]

The poems that Dave composed at Stony Bluff grew directly out of his daily life. Although some reflected the dark side of his experience ("I wonder where is all my relation . . ."), others were laced with gentle humor. On November 9, 1860, for example, he wrote,

> A noble Jar . for pork or beef —
> then carry it . a round to the indian chief //

This lightness of tone suggests that life in the Miles factory, although focused on production, was in some ways quite relaxed. Two of Dave's

signed pots from this period provide further evidence of this. They are casually embellished with drawings lightly incised into their surface. One of the pots, dated June 1, 1856, bears a primitive image of a horse and rider in strict profile. It reminds me of the work of outsider artist Bill Traylor, who was born a slave in Alabama at just about the time this pot was turned. The horse's legs are made up of narrow, sharply pointed triangles. The rider seems to be wearing a tall military hat, which probably made him immediately identifiable at the time. The other drawing, on a jug dated June 11, 1857, depicts a bird striding purposefully forward, also on pointed legs. It's possible that Dave himself made these drawings it's equally possible that someone else, perhaps a young helper, scratched them onto the freshly turned containers when no one was looking.

More information about life in the turning house comes from an inscription that was written on June 28, 1854. It describes what must have been an impromptu wager between Dave and Lewis Miles:

> Lm says this handle
> will crack

The wager probably came about when Lewis stopped by Dave's pottery wheel, took a look at the jug he had just created, and declared that its short, arc-like handle was unstable. Dave was no doubt taken aback at having his expertise questioned. Perhaps an argument ensued, pleasurable to both men. Calling his owner's bluff, Dave proposed that posterity be the judge of the matter. Writing straight down the side of the jug, he quickly spelled out Lewis Miles's claim. He brought "will crack" up to a second line to emphasize it. Dave won this contest hands down, for more than 150 years later the handle is perfectly intact. At times, the relaxed give and take at the pottery went even further. An undated pot is stamped "lmiles" and inscribed right after with a short, startling characterization: "A Bum." The handwriting, rather condensed, does not resemble Dave's expansive script. My guess is that one of Lewis's

friends, visiting the manufactory one day, carved the words into the clay as a joke guaranteed to disconcert the owner of the place and his star potter.

Dave's pots from this period share certain characteristics. In general, the color of their glaze is olive brown, the result of Lewis Miles's firing style and his individual interpretation of the alkaline glaze formula. The pots are thick walled and sturdy and in some cases give the impression of being almost casually made. The handles of Dave's jugs often bear a deep oval imprint at the point where they join the body of the vessels. This imprint draws attention to the fact that he applied pressure there to strengthen the bond between the two pieces of clay. Collectors speak of it as the imprint of "Dave's thumb," but ceramics historian John Burrison has noted to me that the oval is too small to have been his thumb and is more probably that of his forefinger. Some of Dave's pots are inscribed with a horseshoe shape, usually placed sideways or upside down, which may be Dave's shorthand signature; some jars are inscribed with a series of dots or slashes that are thought to tell (though not always accurately) the number of gallons the container can hold.[7]

Dave's jars could hold a great deal. Whereas other entrepreneurs in Edgefield District produced jars with capacities of up to twenty gallons, already larger than those made elsewhere in the South, Lewis Miles often had Dave make containers that would hold twenty-five, even thirty gallons or more. This was in response to the needs of the cotton planters of the area, who required such jars for storing the great quantities of food that fed their slaves. Historian John Michael Vlach, who has carefully researched this aspect of Edgefield pottery, gives as an example the planter James Henry Hammond, who owned almost three hundred workers. In his manual on the care of slaves, Hammond specified that each of them should receive three pounds of pickled pork per week. Because it took a minimum of four weeks for this type of meat to cure, his need for large jars was considerable.

To produce containers such as these, Dave often used a technique that combined turning and coiling: He turned the lower half of the pot

on the wheel, then coiled ropes of clay around the top of its walls to complete the vessel at the unusual diameter and height that was required. Four handles were necessary for these pots, because it could easily take two men to lift a fully packed jar. Dave spoke with pride of such a vessel in a poem he wrote on April 12, 1858:[8]

A very large Jar = which has 4 handles =
pack it full of fresh meats — then light = candles —

Dave produced the largest of his jars, estimated to have held an astonishing forty gallons, on May 13, 1859. The moving spirit behind it may have been not Lewis Miles but, surprisingly, Dr. Abner Landrum. In about 1837, after the nullification controversy was over, Dr. Landrum had moved with his wife and children to an area outside Columbia known as the sand hills. There, on a site with a lovely vista, he had built a modest house and returned to the manufacture of stoneware, which had not lost its appeal for him. His son, Linneaus, had joined him at the pottery. Dr. Landrum had made an attempt at this time to revive his early dream of manufacturing porcelain, but a request to the state for funds to establish a factory for that purpose had been denied. He died on April 3, 1859, at age seventy-four. Word of his death was sent to Edgefield and on to Stony Bluff, where on April 14 Dave wrote *this couplet* on a fifteen-gallon storage jar[9]:

Over noble Dr. Landrum's head
May guardian angels visit his bed

He may have borrowed the imagery he used here from John 20:12, in which Mary Magdalene looked into Jesus's tomb and saw "two angels in white sitting, the one at the head, and the other at the feet, where the body of Jesus had lain." Writing a few days before Easter, Dave could have found this biblical story of resurrection a suitable context in which to pay homage to his early mentor.

On May 11, the *Advertiser* reprinted a lengthy obituary for Abner Lan-
drum that had appeared in Columbia in the *Carolinian*. It described him
as the father of the pottery business in Edgefield. It was his misfortune, it
said, "if it be a misfortune, to be poor, and engaged in an humble occupa-
tion. But poverty is not a crime. Distinguished for his intelligence, his
industry and his integrity, no one was more respected. He was a man of
rare virtues. His personal morality was unexceptionable, and he has left
to his family a legacy far more valuable than gold or silver." The *Advertiser*
placed the tribute at the top of the front page, to give full honor to this
man against whom so many Edgefield citizens had once railed.

Editor Arthur Simkins added a companion piece inside the issue in
which he said, "No . . . we would not have old Pottersville omitted
when our history comes to be written out, nor Dr. Landrum, nor the
Hive, nor anything good or clever that ever adorned that once promi-
nent locality." Then, in a passage that I mentioned earlier, he spoke of
Dave, telling how boys and girls used to come to the village to watch
him work his "magic." When Dave found his name in the paper, he
must have been moved at having a part in the mourning of Dr. Lan-
drum. Too, after so long away from public notice, now nearing sixty, he
must have been gratified to find himself once more in the limelight. All
of this seems to have fired his ambition: just two days later, he set out
to create his greatest jar.

When Dave put his crutch aside and took his stand at the wheel on
that day, May 13, 1859, a fellow slave named Baddler was there as his
helper. He was probably a replacement for Henry, whose crippled arms
would not have been up to the rigors of such a task. The clay for the ini-
tial turning alone probably weighed about thirty pounds. Baddler would
have carried it to Dave in one piece and placed it heavily on the wheel.
He would have then begun pumping the treadle with his foot, setting
the wheel in motion. Dave would have centered the mound then
opened it up and slowly begun to lift the walls of the vessel out of it, as
he had many times before. This time, however, instead of drawing the
walls together to form a mouth for the jar, he would have continued to

open them outward to an almost unheard of diameter before finally stepping away to let this first stage begin to dry. Drying, though not too much of it, was an important part of the process of making a jar in this fashion: It gave the lower portion of the vessel the stiffness required to support the considerable weight of the upper walls that were still to come. If the May air were warm and breezy enough that day, the drying might have been accomplished within a few hours.[10]

Dave probably took advantage of this interval to roll out the clay coils with which he would continue his work. Baddler would have helped him at the wooden counter: Each coil had to be about one and a half inches in diameter and at least six feet in length, long enough to go one full time around the jar. When the lower part of the jar had set up enough to proceed, Baddler would have carefully scooped up one of the long rolls of clay from the counter, perhaps draping the slick middle of it around the back of his neck, and carried it to the wheel. Taking the end of it, Dave would have begun laying it along the top of the jar's wall as Baddler fed it to him. Dave would have smoothed the new clay into the wall by moving his thumbs and palms along in repetitive, almost machine-like motions. This probably pushed the pot away from him, so it gradually turned on the wheel by itself. When the coil was used up, Baddler would have come back with a second one and then a third.

Toward the end of this building-up process, the top of the vessel probably became too elevated for Dave to reach inside. Baddler would have brought over a sturdy wooden crate and helped him up onto it. Standing high above everything else in the shop, perhaps looking as though this was where he had been meant to be all his life, Dave would have laid coils around the huge mouth to form a rim. He probably then called for handles. Quickly, Baddler would have cut off four short lengths of moist coil and handed them up to him. Dave would have placed each one high on the shoulders of the jar, as if they were at the four points of a compass, and pressed them into the damp clay. He

would have fashioned them into perfect grips so later hands could lift this work of his.

Perhaps this was the moment when Dave took his pointed stick and, not even hesitating, wrote "Great & Noble Jar" across the clay. Entirely up to the importance of the occasion, it was one of his most evocative opening lines. Just below that, he described the uses of the jar—"hold Sheep goat or bear—in his mind pronouncing the final word "bar" to rhyme with "jar." Dave would have rotated the vessel then so that the opposite side was facing him. He wrote "Lm," for Lewis Miles, just above the edge of the left handle, as he often did, and just under that the date. He signed the four letters of his name, but this time he added an ampersand and "Baddler" beneath it. Even after firing, during which a vessel can shrink from 10 to 15 percent, the jar would be an astonishing 81 inches in circumference at its widest point and 25 3/4 inches tall.

On that same workday, Dave would *double his achievement*. With Baddler again at his side, he would create a second jar taller than the first, 28 3/4 inches in height. Perhaps he even turned the base for it while he was waiting for the base of the first one to dry. Each of the two jars would hold approximately forty gallons. Today, historians call these almost twin pots, which are exhibited together at the Charleston Museum, "the largest and most spectacular slave-made vessels known," "a ceramic monument." Potters look at them in wonder."

WITHIN A FEW YEARS OF THIS TRIUMPHANT MOMENT, Dave's supremacy in the world of Edgefield pottery was subtly challenged as new and mysterious clay items began to appear in the area. Though the pieces were usually in the shape of a jug, they in no way resembled those that Dave had traditionally produced. They bore human features—staring eyes, mouths stretched wide, flared nostrils—that turned each vessel into a freestanding head. They were usually less than six inches high,

with coloration that ranged from ochre to almost black. Many of them had carefully delineated teeth made from whiter kaolin clay inside the open mouths. Inserts of the same light clay gave the eyes a piercing look. On a moonlit night their expressions would have been visible all the way across a room.

The containers, which have come to be called "face vessels," looked distinctly African. Col. Thomas J. Davies, a manufacturer who owned a pottery a few miles southwest of Miles Mill, told early pottery historian Edwin Atlee Barber that he recalled seeing his slaves making these curious objects in their spare time in 1862. Barber described them as "homely designs in coarse pottery . . . roughly modeled on the front in the form of a grotesque human face,—evidently intended to portray the African features . . . we can readily believe that the modeling reveals a trace of aboriginal art as formerly practiced by the ancestors of the makers in the Dark Continent."[12]

The origin of these new vessels may lie in an incident that took place in December 1858, when 490 slaves, mostly young men and boys, were brought from Africa to the coast of South Carolina on a slave ship called *Wanderer*. This exploit, conceived by Savannah businessman Charles Lamar, was in every way illegal, for the importation of African slaves had been outlawed a full fifty years earlier. In spite of this, buyers eagerly awaited the new workers. One hundred and seventy of them were secretly ferried up the Savannah River and landed in Edgefield District. The Mileses' neighbor, widow Sophia Tillman, whose husband had earlier purchased slaves at Rev. John Landrum's sale, bought thirty of the Africans. Those and the others sold in the area made an odd fit in the local black community, for some of them had teeth filed to points and jaws so strong they could chew out the rim of a tin pail. Some wore tribal tattoos on their chests or their foreheads. They often chose to speak their native language among themselves, even after they learned English. They said "gooba" for peanuts, "soonga" for tobacco, and "canzo" for pot. Still, it must have been clear

among the country-born blacks of the area that these young men were the most recent to touch the ancestral homeland that everyone shared. Their customs, the language they spoke, even the strange, filed teeth had to be respected.[13]

The pots with "African" faces appeared in the district just four years after the *Wanderer* slaves arrived, which suggests a classic instance of cultural syncretism: The newly imported workers may have combined local pottery techniques with an aesthetic that they brought with them from their homeland. At least one of the Africans, whose name in Edgefield was Romeo, may have worked in the very pottery where face vessels were first reported, for a slave by that name was hired by Colonel Davies for three extended periods in 1863. Within a short time, the secrets of making these new pots spread from Davies' slaves to those at Miles Mill. Archaeologist Mark Newell has discovered sherds in that vicinity that bear facial features from seven different vessels. It's not hard to understand why these cleverly molded faces would intrigue black potters, even those who were generations removed from Africa. No objects had ever summed up the feelings of a slave the way these did—anger, torment, fear, amusement were all contained in the expressions they bore. Here were *black* objects, having nothing to do with the white experience.[14]

There is evidence that Dave tried to master this new and independent expression of blackness. Jill Koverman has identified a face vessel in the collection of the High Museum of Art in Atlanta that is likely his work. It is by far the largest container of this kind ever found, twenty-eight inches high, within three-quarters of an inch of being as tall as the tallest jar Dave ever made. Its sides rise almost straight up from a circular base to flare into a rim at the top. The entire upper third of the front is a face framed by two large ears that could be used as handles. Two pale, rounded eyes stare out from under brows that almost touch above the nose. A wide, downward-turning mouth, lined with teeth, slashes horizontally across the lower part of the visage. Koverman gives three reasons for thinking that this piece may have been done by Dave: The

dark, mottled brown glazing matches that of containers produced at the Lewis Miles pottery while Dave was there; the curved upper parts of the ears match in form and horizontal dimensions the handles on Dave's larger jars; and, most telling, the height and size of the piece could have been achieved only by a potter as skilled as Dave. No one else, black or white, was making pots this large in Edgefield during this period. If Dave made this spectacular vessel, and I am convinced that he did, he would have proved yet again that he was the master of large pots, now with or without faces.[15]

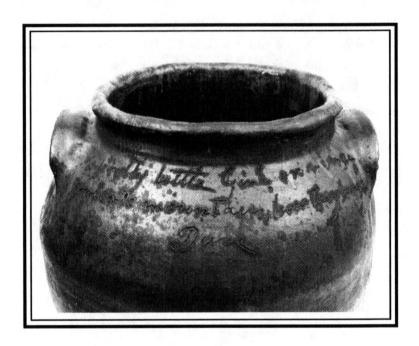

CHAPTER X *Cousins*

*[E]very lady tells you who is the father of all
the mulatto children in everybody's household,
but those in her own she seems to think drop
from the clouds, or pretends so to think.*

— MARY BOYKIN CHESNUT,
DIARIST, 1861[1]

IN 1858, DAVE WAS CLOSE WITNESS TO AN INTIMATE DRAMA
that must have affected the Miles family as profoundly as the death of
Ann had affected the Landrums. The only record of it is in a startling
little note in the archives of the Charleston Museum. It was written in
October 1930 when researchers from the museum visited the site of a
pottery on Shaw's Creek, not far from Stony Bluff, and spoke with Paul
Seigler, a member of the family that had owned the operation. In
describing the last potters who worked at the factory, which closed in
about 1898, Seigler said that they were all black except for a mulatto
named Oliver Miles, whose father was "reputed to be one of the Miles."

Checking the census listings for Oliver Miles, I found that he was
born in 1858, when slavery was still in force. If Seigler's story were true,
then Oliver was the child of a Miles man and a slave woman who proba-
bly lived at Stony Bluff. Because I knew of no Miles relatives who might
be able to tell me about this period in the family's history, I turned to
Louise Landrum Murphey, the great-granddaughter of Franklin Lan-
drum. Without hesitation, she told me that she had known Oliver Miles

when she was a little girl; he was of mixed race, and everyone at the time understood that he was the son of one of the white Mileses.[2]

Louise could not tell me which one of the Mileses was Oliver's father; if members of the family knew, they had never revealed it to her. Certainly, it could have been Lewis Miles. Fifty years old when the boy was born, he could have been making nocturnal visits to the slave quarters for years. But it could just as well have been one of the younger generation at Stony Bluff, for the white sons of slaveholders were in the same proximity to female slaves as were their fathers. Of the Miles boys—Milton, Newton, John, Francis, and Langdon—only Langdon, at five, was too young to be Oliver's father. In fact, more than one Miles, of more than one generation, could have spent nights in the slave cabins during this time. Discovery of this situation upended the picture I had come to have of the Mileses as an almost ideal Southern family. I still believed that they were good people, but, like the Landrums, they seem to have been scarred by the very fact of owning other human beings.

The birth of Oliver was a true scandal for the Mileses. As he grew up, his presence and later that of his children cast a shadow on the Landrums, as well. When Louise Murphey's aunts, Pearl and Rebecca Benjamine Landrum, were little girls, a white woman from the neighborhood taunted them by asking after their "black Miles cousins." Though the girls didn't know it, the woman had been in love with one of Lewis Miles's sons, who had passed her over, and she had remained spiteful toward the family ever since. The girls ran to their aunt, Fannie Landrum Bobo. Fully prepared, as many Southerners of that time had to be, Fannie told them to ask the woman about black members of her own family: "Ask her about her *brother*," she said sharply.

By the time Louise was born, the situation was less charged. The Landrums had apparently grown comfortable with Oliver Miles and he with them. In his sixties now, he would often walk over from his house in the small community of Sunnybrook to sit on the porch with Louise's grandfather, Ben Landrum. "I remember seeing them together," Louise told me. "They would talk about farming and crops and what they were

going to plant the following year." On one visit in 1921, Oliver happened upon a special occasion: The family was having a picture taken of Ben Landrum with a recently born grandson, yet another Benjamin Franklin Landrum. "Come in," the family said to Oliver as Louise remembered it, "let us take one of you with him too." She watched the picture being taken and, for many years, had a copy of it. Even without the photo, she clearly remembered Oliver's appearance: Unlike many mulattos, he was dark skinned; he was more than six feet tall and, when she knew him, he had "white hair, like cotton."

Though it appears to be impossible to accurately identify Oliver's father, there is information in the records that may pertain to his mother. Of the seventeen nameless female slaves listed on the 1860 schedule for Lewis Miles, only two were between sixteen and twenty-six when Oliver was conceived, the probable age range for a girl who would catch a master's eye. Intriguingly, Dave wrote a couplet that may describe this young woman. He composed it on August 24, 1857, at the very moment she was proving so attractive:

> a pretty little Girl, on a virge
> Volcaic mountain, how they burge

With respectful interest, he indicates her innocence and her nascent sexuality. She is, in these wonderfully condensed images, a virgin on the verge of full womanhood. He even manages to suggest the power of her maturing breasts and hips—"how they burge."

It's not difficult, when reading Dave's words, to imagine Lewis Miles or one of his sons being caught in the pull of this unconsciously attractive young girl. Writer Willie Morris, who grew up white in the Mississippi Delta, has described such feelings: "I knew all about the sexual act, but not until I was twelve years old did I know that it was performed with white women for pleasure; I had thought that only Negro women engaged in the act of love with white men just for fun, because they were the only ones with the animal desire to submit that way. So that

Negro girls and women were a source of constant excitement and sexual feeling for me, and filled my day-dreams with delights and wonders." The myth of exceptional passion among black females, which Morris speaks of, had been passed down through generations of white men ever since the early days of the slave trade; it went along with, and in some ways made possible, the myth of the extraordinary purity of the Southern white woman.[3]

The "Girl on a virge" must have had a number of reactions to the attention that her growing attractiveness brought her. Going from a little slave child whom no one noticed to a young woman whom Dave wrote a poem about must have been a heady experience. And when white men turned their eyes, how excited, how frightened she must have been. Attractive young women such as she were sold in some slave markets as "fancy girls," a term of the slave trade that was generally understood to describe prospective sexual partners. Swedish writer Fredricka Bremer, who traveled in the United States in 1850 and 1851, witnessed a group of girls ranging in age from twelve to twenty being offered for sale in the market in Augusta. "Many of these children," she wrote, "were fair mulattoes, and some of them very pretty . . . The slave-keeper told us that the day before, another girl, still fairer and handsomer, had been sold for fifteen hundred dollars." After these girls were purchased, they were installed at the plantations of their new owners; the "Girl on a virge," of course, was already in residence at Stony Bluff. If it were she who caught the eye of a Miles, the moment she was taken could have been coerced, with an ugly edge of violence, or it could have been gently solicited with promises of rewards. W. E. B. DuBois called antebellum miscegenation "stark, ugly, painful, beautiful."[4]

I added Oliver Miles to my family tree in a floating position between generations: If one of the Miles boys were his father, then he would be my first cousin twice removed; if Lewis Miles were his father, then he would be my great-granduncle. The lines that circuitously link us on the chart grew out of slavery and custom and exploitation and attraction and longing and youth. But they are real just the same.[5]

—

OVER THE YEARS, STORIES OF "OUTSIDE CHILDREN" of mixed race have become part of Edgefield's history. Often, they are recalled quite clearly in the black community and only under duress in the white. One of these tells of Arthur Simkins—as editor of the *Advertiser,* he wrote the "buttermilk" article on Dave—and the attraction he felt for his female slave Charlotte. When she resisted his advances, the story goes, he forced her to sit naked on a mound of manure until she finally agreed to submit to him. A male child of this union was born in 1849 and named Paris. He grew up to earn a law degree and become one of the area's foremost leaders during Reconstruction. He looked so much like his white relatives that their children, thinking he was their grandfather, could barely be restrained from running to him across the square in Edgefield.[6]

The most famous of these stories remained only a sketchy rumor for more than three-quarters of a century. Though virtually all Edgefieldians had heard that the town's favorite son, Senator Strom Thurmond, had fathered a child by a black woman, no one knew its identity or the circumstances of its birth. Only after the death of Thurmond in 2003 did a woman in California, named Essie Mae Washington-Williams, come forward to reveal, with great dignity, that she was that child. She was born in 1925 to Carrie Butler, a young and attractive black woman who worked for the Thurmond family in Edgefield as a housemaid. At news of this revelation, the *Advertiser* invited comments from its readers, but there was complete silence; not one person of either race replied.

In spite of this apparent indifference to Mrs. Washington-Williams—some guessed it was hostility—the Tompkins Library invited her to come to town to sign copies of *Dear Senator,* the book she published about her relationship with her father. On the afternoon of the event, I watched as Edgefieldians, both black and white, arrived early at the library and lined up into Courthouse Square. Far from hostile or uninterested, they seemed thrilled to have the opportunity to meet a

living part of town history. Waiting in the sun, they spoke of her simply as "Essie Mae," as if they had known her all their lives. In a way they had: She was the missing piece of the story they had heard for decades. Just after four o'clock, she arrived in a car with her daughter, Wanda. They walked through the welcoming throng, nodding politely, and went directly to a small, private room at the rear of the library. Wanda told me later that they needed this time alone to recover from their amazement. Having been unsure of how the people of Strom Thurmond's hometown would react to them, they found their welcome very moving. "It was a *moment*," she said.

The director of the library, Tonya Browder, had set up tables for punch and sandwiches and decorated the display with red tulle and purple ribbon, the colors of Essie Mae's sorority. On an easel stood a large painting of Essie Mae with her father. His arm was entwined with hers. Because no photos had ever been taken of them together, black Augusta artist Grady Abrams had painted it entirely from his imagination. Large, framed genealogical charts for the Strom and Thurmond families were arranged on either side of it. Mayor McKie welcomed Essie Mae, after which representatives from her sorority presented her with a gift. They said, "We salute your courage, your perseverance, your dignity. We constantly ask God to watch over what you are doing." A smiling young white man came into the library with two bottles of wine for the honorees. Each bottle had a blue South Carolina flag and "Thurmond Place Wines" printed on the label.

As the signing began, Essie Mae took time to speak with each person who arrived at her table and to write out the requested dedications. People waited patiently for their moment with her, but as time passed they began taking turns leaving their places in the hot sun and sitting down on chairs set up inside the library. Tonya Browder found electric fans to bolster the air-conditioning, which was overtaxed by the occasion. Self-consciousness faded, and blacks leaned across chairs to chat with whites, who hooked their feet up on the chair legs and chatted back. Everybody got a little tipsy from the heat and excitement. I sat

down beside a sandy-haired woman who held a large Bible on her lap. It was at least a foot thick, with an ornamented leather cover held closed by a metal clasp. The woman's paternal grandmother and Strom Thurmond's father, as shown in the family listings in her Bible, were brother and sister. "That makes my grandmother Essie Mae's great-aunt," she said. It was almost nine o'clock when, last in line, she reached the table. Essie Mae carefully examined the list of shared ancestors preserved in the heavy book. She posed for picture after picture with her newly found relative. The two women hugged and exchanged e-mail addresses.

Everyone agreed that Essie Mae's coming forward to acknowledge her mixed ancestry was a good thing. On the heels of her visit, however, a rumor circulated through Edgefield that a professor was on the way from Harvard with trouble up his sleeve. He intended to prove that blacks were more accepting of mixed blood in their families than whites. He had contacts in the local black community who claimed to know who was "passing for white." He was going to "out" them to see what happened. There was considerable consternation around the square. When, after several weeks, he had failed to materialize, everyone breathed a bit easier.

SO WHAT DID LEWIS MILES DO with this little black boy who was now a member of the family? We know that neither he nor any of his sons ever acknowledged him; if that had happened, we would know who Oliver's father was. And we can be virtually certain that no attempt was made to set him free, because it was almost impossible to do so in South Carolina at that time. Because free blacks were considered an economic burden and, worse, potential insurrectionists, the laws concerning manumission held that no slave could be emancipated but by act of the state legislature. Indeed, Edgefield was so intent on getting rid of the few free blacks who existed in the district that in 1859, the year after Oliver was born, the local Court of General Sessions made this recommendation:

"We likewise present the free Negroes as a common nuisance & recommend the Legislature to pass a law requiring them either to leave the state or to select a master whose title shall be confirmed by the order of a presiding judge . . . In this way our community would get rid of a corrupting set of vagabonds & either the Abolitionists would be supplied with disgusting idols for their unpatriotic worship or the South would procure additional slave labor to satisfy the pressing demand for more labor in her agricultural pursuits."[7]

If freeing the boy was not an option, selling him was. Former South Carolina slave Savilla Burrell told how this was handled on the plantation where she lived: "Old Marse was de daddy of some mulatto chillun. De 'lations wid de mothers of dese chillun is what give so much grief to Mistress. De neighbors would talk 'bout it and he would sell all dem chillun away from dey mothers to a trader." Sometimes, the wife of a planter would demand that slave mother and mulatto child be sold off. To salve their consciences, slave owners could look to the Bible for precedent. When Sarah, the wife of Abraham, demanded that the slave woman Hagar and the child she had borne to Abraham be cast into the wilderness, it was done, and with God's approval.[8]

Lewis Miles chose not to sell young Oliver. My guess is that he put him to work in the pottery, where, in carrying out small tasks for the older workers, he began to learn the trade that he would practice as an adult. Perhaps, as he passed by on his errands, Oliver stopped to watch Dave incise his name on his pots. Maybe Dave even taught this little Miles boy, for whom schooling was not possible, how to read and write. Though it might have seemed the only workable solution to the family's problem how poignant it must have been for Lewis Miles, coming to oversee production each day, to find a child of his, whether son or grandson, working in the factory as his slave. I wonder what Oliver felt when he was old enough to understand about his parentage. Was he bitter toward the Mileses? Or did he, as a young freedman, find room in his heart to sit on the porch with them, as he did with the Landrums in his old age, and talk about the crops?

The black community seems to have accepted Oliver fully. He became one of the early deacons of Springfield Missionary Baptist, the church that I visited; he is today still referred to in accounts of its history. He married a woman named Kate. She and all the children they had together were listed on the census as black. Oliver was described as mulatto in the early listings, then as black later on, as he perhaps drifted farther from the white side of his family. Their children were Elbert, Charlie, Daisy, Maggie, Callie, Minnie, Frances, Emma, Walter, Alberta, Lucille, Roosevelt, Diratha, and Sara. I have tried to trace the descendants of these children, thus far unsuccessfully. They are a part of my family that I have yet to discover.[9]

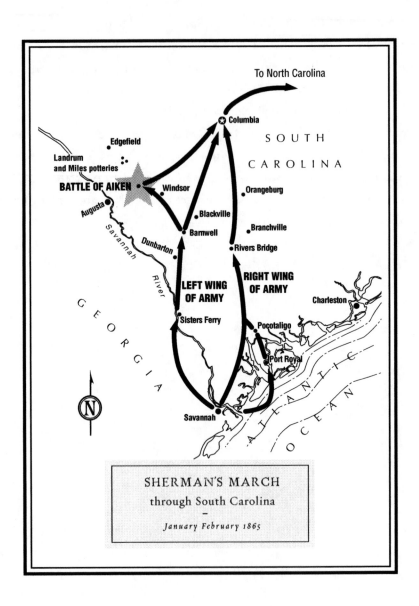

To North Carolina

Columbia

SOUTH

CAROLINA

Edgefield

Landrum
and Miles potteries

BATTLE OF AIKEN

Windsor

Orangeburg

Augusta

Blackville

Branchville

Barnwell

Dunbarton

Rivers Bridge

Savannah

LEFT WING
OF ARMY

RIGHT WING
OF ARMY

Charleston

River

Sisters Ferry

Pocotaligo

GEORGIA

Port Royal

ATLANTIC

N

OCEAN

Savannah

SHERMAN'S MARCH
through South Carolina
–
January February 1865

CHAPTER XI *Battles*

*I would be willing to appeal to the god of bat-
tles—if need be, cover the state with ruin,
conflagration and blood rather than submit.*

— GOV. FRANCIS W. PICKENS,
1860[1]

FEARSOME IMAGES BEGAN TO ENTER DAVE'S INSCRIPTIONS.
In November of 1858, he wrote,

I saw a leppard, & a lions face, \\
then I felt the need of — Grace

The Book of Daniel may once again have been the source of his imagery.
In Chapter 7, Daniel witnessed four extraordinary beasts in a dream,
one of them a lion with eagle's wings and the heart of a man, another a
leopard with four wings and four heads. Daniel watched the beasts till
God appeared on a throne of fire and prepared to pass judgement on
the world. Daniel woke from his dream deeply troubled. In a similar
way, Dave felt the need of God's grace as he emerged from what may
have been his personal vision of Judgement Day. Two years later, he
repeated the couplet word for word.[2]

Lewis Miles also had worrisome thoughts during this period. Like
many Americans of the time, he watched with foreboding as issue after
issue arose to divide the country. The South—and South Carolina, in

particular—was unhappy with the increasing influence of the move-
ment to abolish slavery. In 1856, South Carolina congressman Preston
Brooks, a native of Edgefield, walked onto the floor of the Senate and
brutally beat abolitionist senator Charles Sumner with a gold-headed-
gutta-percha walking stick. It was punishment for insults that Sumner
had leveled against Brooks's kinsman Sen. Andrew Pickens Butler, but it
was also an expression of anger felt by a whole region toward those who
sought to change its way of life. Brooks resigned his seat in Congress;
his constituents immediately reelected him, sending him scores of walk-
ing sticks to replace the one he had broken on Sumner. Brooks's rash
act, which enraged many in the North, pushed the country one step
closer to open conflict.

Knowing that paper money could become worthless if war broke out
between North and South, Lewis Miles turned to pottery to protect his
family. He instructed Dave to make a little stoneware container for him
each month, a miniature version of the great jars he was known for.
According to notes in the archives of the Charleston Museum, Lewis
specified that each of these small pots should have a mouth measuring
less than three inches in diameter, so Miles could fill the container with
gold and silver and bury it. Each container would keep its store of riches
secure until the time came to unearth it. Conveniently, there was a gold
mine in the family. Lewis's brother-in-law, Dr. John Landrum, the
physician son of Rev. John Landrum, owned quite a serviceable one on
the other side of Edgefield, near the Meeting Street settlement. It was
among several mines in this part of the South, including one that
belonged to John C. Calhoun at Dahlonega, Georgia, which for a time
brought handsome profits to their owners. According to family lore,
slaves worked the Landrum mine, and the gold they recovered from it
was in powder form. Perhaps Lewis rode over to Meeting Street each
month to purchase the amount he wanted to bury. On April 8, 1858,
Dave wrote a couplet on a twenty-gallon jar that could refer to these
efforts to preserve something of value.[3]

This noble Jar = will hold, 20
fill it with silver = then you'll have plenty

The following year on October 16, an event occurred that must have heightened Lewis Miles's fears of impending conflict and Dave's need of grace. The militant abolitionist John Brown led a group of twenty-one men in a raid on the federal arsenal at Harpers Ferry, Virginia. Brown's plan was to seize the weapons stored there, welcome the slaves of the area into his band, and lead an ever-growing company of black insurrectionists down the spine of the Allegheny Mountains. Together, they would sweep the heart of the South clean of slavery forever. Brown captured the arsenal, but his rebellion was crushed before it could begin and he was taken prisoner. The *Advertiser* reflected the feeling of the South when it described what had happened as a hare-brained demonstration by "a pack of crazy fanatics and poor deluded slaves." As Brown's trial unfolded, however, he conducted himself with such biblical gravity and conviction that he managed to turn defeat into triumph. Abolitionists adopted him as their saint, predicting that he would, in the words of Ralph Waldo Emerson, "make the gallows as glorious as the cross." Henry David Thoreau called him "a crucified hero."[4]

Though Brown was put to death, the people of the South feared that others would continue his planned assault on their homeland. Their dread of slave uprisings in the past had always been tempered by the conviction that without white leaders, such undertakings had little chance of getting out of control. Now, this leadership had materialized in the followers of John Brown—"white intellect" had joined "black savagery"—and any horror was possible. Maps belonging to Brown were found marked with crosses, which were interpreted as indicating the Southern counties chosen for attack. Edgefield was among them. Newspapers described the Edgefield mark as being near Horn's Creek. Because the early home of the Miles family was on Horn's Creek, and Rev. John Landrum had preached for years at Horn's Creek Baptist

Church, the two families must have felt that the slave army's line of march was aimed directly at them.[5]

Southern anxiety reached a peak during the summer of 1860. Known as the "Great Fear," it has been compared to the *grand peur* that seized French peasants in the revolutionary summer of 1789, when they believed that men from the king were coming to kill them.

The men of Edgefield, along with their counterparts across the state, formed vigilance committees to protect their districts. Franklin Landrum and Lewis Miles were chosen vice presidents of the committee at Horse Creek, and Lewis's son, Newton, was named secretary. The first duty of committee members was to keep an eye on white strangers in the area who might represent the forward contingent of the abolitionists. Their second duty, just as important as the first, was to monitor the comings and goings of the black community. There had been patrols for as long as anyone could remember—the "pattyrollers" who punished slaves caught off the plantation without passes—but these new groups claimed a much wider mandate. In some parts of the district, no black assemblies of any kind, including dances, worship services, prayer meetings, even quiltings, were permitted. Because of such intense monitoring during this time the blacks of Edgefield experienced fear that was at least as powerful as that plaguing the whites.[6]

Just over a year after John Brown's raid, Abraham Lincoln was elected to the presidency of the United States. Southerners were appalled, for in their judgement he and his Republican Party stood firmly against every interest of the South. With him would come abolition and with abolition would come race war. In order to save themselves, South Carolinians felt that they had no choice but to set up their own closed nation. They had almost done it thirty years before during the nullification crisis, and this time they would carry it through. At an immense gathering in Edgefield's town park, prominent lawyer George W. Landrum, Franklin's first cousin, addressed the crowd, boldly proclaiming that he had lost all hope of deliverance except in the immediate secession of South Carolina from the federal union.

I have wondered whether Dr. Abner Landrum, had he lived, would have remained firm in his adherence to the Union in these new circumstances. The evidence is that he probably would not, for the overwhelming majority of citizens in the state, including most of the great Unionists from the nullification period, came over to the side of secession. There were spirited celebrations on December 20, 1860, when South Carolina broke away from the United States of America. Tradition holds that one of Edgefield's own sons, Francis Hugh Wardlaw, drafted the Ordinance of Secession, which made the break official. Other Southern states followed South Carolina out of the Union, and together they formed the Confederate States of America.[7]

Just before the decisive act of secession, turbulent red lights appeared in the night sky above Edgefield. Though it was a natural phenomenon, a magnificent display of the aurora borealis, its impact on the citizens of the district was as great as the vision of leopard and lion had been on Dave. Early historian John A. Chapman remembered that it was enough "to strike any beholder with feelings of awe, and the unlearned with terror." One witness told him, "The whole element appeared to be a solid sheet of blood, and the reflection from the sky caused a pale yellow light to shine upon the earth. Many others saw it, and some say they heard music also. The old men called them 'war lights,' and said such things occurred to their fathers just before the Revolution." Across the Savannah River, near Washington, Georgia, a slave named Marshal Butler also saw the disturbances in the sky. Like many others looking up that night, he took the great billows of red as a sign: "I knew," he said, "war was brewing."[8]

ON APRIL 12, 1861, A CONFEDERATE BATTERY fired on Union troops occupying Fort Sumter in Charleston Harbor, irrevocably setting the Civil War in motion. The Miles boys hurried to join the army of their new country. Three of them, Milton, John, and seventeen-year-old Francis (who was sent back home to wait for his next birthday),

enlisted in the company being organized by their brother-in-law, Lafayette Brenan Wever. A dashing physician from one of the wealthiest local planter families, Wever had married the Miles boys' sister, America, five years earlier. Having served with great distinction in the Mexican War—it was he who was presented the sword for "gallantry" by the citizens of Edgefield—he was already well versed in the ways of the military. His new company, made up of Edgefield men, became Company I of the 24th South Carolina Infantry Regiment. Lewis Miles's remaining son of military age, Newton, along with the sons of Franklin Landrum, joined other companies that were forming in the area. Every eligible male in both families, from cousins to uncles, went to war. Most were privates, though Newton Miles quickly rose to first sergeant and Lafayette Wever to captain and later to brevet major.[9]

These young men donned Confederate gray because they believed with all their hearts and minds that their family fortunes, the traditions of their community, and the very lives of their loved ones were in jeopardy. In the ranks and on the home front, enthusiasm for the war ran high, especially after the easy victory at Manassas in July. A common perception in Edgefield held that if the slaves could be kept in place and the soldiers could be kept in warm socks, the conflict would be over in a trice, and the way of life that the district had preserved all these generations would then reassert itself even more vigorously than before.

The older generation at Stony Bluff and Horse Creek stepped forward to help in the war effort. Mary Miles became a founding director of the Soldiers' Relief Association, through which she and the other women of the district raised money to purchase supplies and clothing for Edgefield's volunteers. Franklin Landrum made "galley pots" to hold medicines for government laboratories in Columbia. He finished them with a beautiful slick glaze fine enough to withstand heat and acid. His daughter once told researchers that the government considered him the only one who knew how to make these pots; he made "thousands and thousands and thousands" of them, she said. Franklin was so busy with

his government commissions that his son, Ben, had to come home from the army to help run the pottery.[10]

Franklin Landrum and Lewis Miles were also expected to contribute to the government a sizable portion of their workforces to help build fortifications around endangered cities. Though they were paid monthly fees for the services of their workers, they were probably not happy about it. In the opinion of slaveholders, this widespread conscription undermined their authority and generally hindered the efficient operation of their plantations. Former Edgefieldian Louis T. Wigfall, then senator from Texas, claimed that planters would willingly put their own flesh and blood into the army, but when they were asked to contribute a slave, it was like "drawing an eyetooth."

Dave's friend Carey Dickson, who was the source of the story about his railroad accident, was one of the workers conscripted from the Stony Bluff and Miles Mill area. As Dickson recounted years later, "I went to Charleston in Sept. 1864 to work on the breastworks and stayed three months and three days. . . . One time the sill under a big gun fell down and caught my foot. Gen'l Beauregard himself took a crowbar and helped lift it off. . . ." Dickson seems to have looked back on his experience as an adventure, but many slaves initially reacted with fear when they were selected for conscription to war. They understood only that they were being taken from their homes and families, which must have seemed like being "sold away." Della Briscoe, a former Georgia slave, recalled that the husbands and fathers who returned to the quarters after months away at the fortifications "fell on their knees" to welcome the children they had left behind.[11]

Because Dave, in his sixties now and missing a leg, was not subject to conscription, he continued to work in the pottery at Stony Bluff. He would have had access to news of the war, however, from at least three different sources. First, because he could read, he could follow it in the newspaper. Probably not even Lewis Miles would have supplied him with papers during wartime, but there were other means of getting them. As Victoria McMullen recalled in a WPA interview: "My

grandma used to steal newspapers out of [the master's] house and take them down to the quarters and leave them there where there were one or two slaves that could read and tell how the War was goin' on. . . . Later she could slip off and they would tell her the news, and then she could slip the papers back." Dave could also learn about the war by overhearing members of the white community, perhaps Lewis Miles and his pottery clients, speak of it in passing. Mary Chesnut and her friends attempted to staunch such leaks by speaking French when their servants were present; they called it "using French against Africa." Dave's third source of war news would have been the slave-to-slave, plantation-to-plantation system of communication that had existed in the South since the beginning of slavery. The system was so efficient that planter James Henry Hammond claimed he could detect a "heavy gloom" on the faces of his slaves in the aftermath of Confederate victories on the battlefield. At such times, they seemed "utterly subdued," he said, "as if by blasted hopes."[12]

Jars that Dave made for Lewis Miles survive from every year of the war except the final one, each inscribed with "Lm," the date, and "Dave." Dave wrote his last known poem on May 3, 1862 on a twenty-inch-high storage jar that is almost perfectly formed:

I made this Jar, all of cross
If you don't repent, you will be, lost =

Dave probably had only a religious message in mind here. Reading it in the context of the war, however, it's hard not to hear it as a Cassandra-like warning. Accounts of death and disaster were everywhere at the time that he wrote it. In the single battle of Shiloh, fought a month earlier, more men died than all the Americans who died in the Revolutionary War, the War of 1812, and the Mexican War combined. This gives terrible weight to the words "you will be, lost."[13]

If Dave's verse carried a tragic prediction, it was not the only one to reach the Miles family at this time. Another came in a letter written by

Albert Miles, the son of Lewis's brother, Aquilla. It was dated October 1, 1861 and sent to Edgefield from Flint Hill, Virginia. With great good humor, Albert began by telling of the efforts of his cousin, Newton Miles, to recover a shoe kicked out of their tent in the middle of the night. Unexpectedly then, he sounded a darker note: "I am not allowed to write what is going on though suffice it to say that Jeff Davis, Beauregard and Johnson are here now. . . . It is said they are picking out the Battle Ground where *we will shortly lie* or I will not say that, where we will shortly fight."

What a tremor must have passed through the family as Albert's letter was read by one and passed on to another—a smile at the wayward shoe, then a catch of breath at the premonition of death. Both cousins came home on furlough soon thereafter, though, and everyone thought they looked better than they had ever seen them. Three months later they were killed near Richmond, one after the other, first Aquilla's son, Albert, at Frayser's Farm on June 28, 1862, then Lewis's son, Newton, the next day at Malvern Hill. Their cousin, Lewis Landrum, saw each of them fall.[14]

Many other Edgefield families began to receive similar news. Before long, as John A. Chapman remembered, "it was impossible to go to church, or to any gathering of people, without seeing wounded soldiers at home on furlough, with arm in a sling or limping on crutches. Every mail brought news of a neighbor or a friend being wounded or killed in battle." The pain cut deeply across South Carolina. Mary Chesnut wrote in her diary, ". . . we fancied we were to have [a rosewater revolution]—and now the reality is hideous and an agony."[15]

EARLY IN MAY 1864, Gen. William Tecumseh Sherman led an army of 98,000 men out of Tennessee and into Georgia. His goal was the capture of Atlanta. The president of the Confederacy, Jefferson Davis, placed the forces of Gen. Joseph E. Johnston in Sherman's path in an effort to keep him from reaching the city. The Confederacy was con-

vinced that if it could hold onto Atlanta through autumn, the increasingly war-weary Union would vote out Abraham Lincoln and the Republicans. With a Democratic administration once more in power, a negotiated peace settlement might be possible. Johnston's men were outnumbered nearly two to one, but they were seasoned, spirited, and aware of the importance of their mission.

Lafayette Wever's Company I was part of Johnston's army. Milton Miles served under his uncle as a private; Francis Miles, now old enough to enlist, became a member of the company in June. Their brother John would join them in October after a medical furlough, reuniting all three of Lewis Miles's remaining soldier sons. The struggle to defend Atlanta lasted throughout the summer. Now commanded by Gen. John Bell Hood, the Southern army lost one-third of its forces in a series of three disastrous battles. It fell back into the city to hold out for an additional month before abandoning the impossible effort. On September 2, Sherman rode triumphantly into Atlanta.

The Miles boys followed General Hood up into Tennessee in an effort to draw Sherman out of Georgia, but he was not to be distracted. He set off with his army on a daring march toward the coast; his mission, quite simply, was to exhaust the heart of the Confederacy. By indicating that he might strike either toward Augusta on his left or Macon on his right, he was able to divide the forces that were arrayed against him and proceed virtually unopposed. His men lived off the land, destroying what supplies they couldn't take with them. The *Advertiser*, in an effort to minimize the gravity of the situation, characterized the march as "Sherman's Retreat Through Georgia," but those in the army's path knew otherwise. As a young Georgia widow remembered, "It seemed to me the whole world was coming. Here came the 'wood-cutters'—clearing the way before the army. Men with axes on their shoulders, men with spades, men with guns. Men driving herds of cattle . . . Men on horseback with bunches of turkeys . . . Then the wagons— Oh! The wagons—in every direction . . . Now came the soldiers, cavalry

and infantry . . . it was all the corps of Sherman's great army, I could easily be excused if I thought it was the world."[16]

Many black Southerners became frantic with joy when they saw General Sherman. "Whenever they heard my name," he wrote in his memoirs, "they clustered about my horse, shouted and prayed in their peculiar style, which had a natural eloquence that would have moved a stone. I have witnessed hundreds, if not thousands, of such scenes; and can now see a poor girl, in the very ecstasy of the Methodist 'shout' hugging the banner of one of the regiments, and jumping up to the 'feet of Jesus';thin"[17]

Word of coming freedom made its way from slave to slave across the state and into South Carolina. Savilla Burrell recalled, "Us looked for the Yankees on dat place like us look now for de Savior and de host of angels at de second comin'." Even in the remote enclave at Miles Mill, the slaves of the Mileses and the Landrums held high expectations of what freedom would bring. An extraordinary article in an October 1864 issue of the *Advertiser*, entitled "A Nuisance that should not be Tolerated," described in detail the state of mind of Dave's companions at that time and possibly of Dave himself: "We are informed that down in the neighborhood of Miles' Mill there sojourns a certain old character, a fortune teller by reputation, who has been tampering somewhat with the colored population by telling the poor simpletons that in a short time they will be free, and putting all kinds of ridiculous ideas into their woolly pates. He tells one that he is to be a great man—a captain, colonel or a general,—a rich man with a gold watch and 'bosom pin,'—and the wenches are to be fine ladies, have carriages, horses, white drivers, etc. This absurd stuff is religiously believed by the poor ignorant dupes, and forthwith they become indolent, impudent and worthless and nothing but the strap will bring them right again. If the reports that we have heard be true, and we have no reason to doubt them, the old rascal alluded to ought to be summarily dealt with, and the quicker the better."

Imagine Dave hearing that he would soon be wearing a "bosom pin."

Did he dismiss such talk as rubbish, or did he become "indolent, impudent, and worthless" along with the others? The workmanship in Dave's last known surviving pot, dated March 31, 1864, seems to indicate that standards were indeed slipping in the Miles shop. Impurities were not thoroughly removed from the pot's clay and glaze, giving it a rough texture that would not have been tolerated earlier. This may have been part of the expectant, barely concealed preparation for freedom that was in the air. Carolina slave Elijah Green quietly sang this song in the last months of the war.[18]

> *Marster gone away,*
> *But darkies stay at home,*
> *The year of jubilee is come,*
> *And Freedom will begun.*

Sherman took Savannah just before Christmas 1864. He then turned his troops toward South Carolina, the most hated state of the Confederacy, to begin the second half of his march. "When I go through South Carolina," he predicted, "it will be one of the most horrible things in the history of the world. The devil himself couldn't restrain my men in that state." He understood that his soldiers felt a moral imperative to crush the state that had started it all. Accordingly, the Yankees swept up from the coast "like a tornado," cutting a swath of destruction forty miles wide. By all accounts, the devastation was far worse than that caused by the march to Savannah.[19]

Sherman again succeeded in dividing his opponent's already outnumbered forces by appearing to threaten two major cities at once, in this case Charleston on his right and Augusta on his left. His men were thus able to proceed in good order, sacking and burning each village they came to. The cavalry unit under the command of Gen. Judson Kilpatrick, which rode on Sherman's far left flank, reached Barnwell on February 5 and set it so thoroughly ablaze that his men dubbed it "Burnwell." Kilpatrick's next target was clearly Aiken and the cotton

mills that lay just beyond it along the Horse Creek Valley. The Graniteville Mill, established in 1849, and a smaller one nearby at Vaucluse were among the most important in the South. One step farther were the Miles and Landrum pottery factories.

As refugees and straggling soldiers brought news of Kilpatrick's fiery progress through the countryside, Edgefieldians grew alarmed. Their village had been a hotbed of secession sentiment, which made it a prime target for Yankee revenge. During four tumultuous days—from February 9 through 12—the citizens of the town were in hourly expectation of being attacked by "howling, ravening, bloodthirsty wolves," as the *Advertiser* described it. "[O]ur people, though for the most part calm and collected, were busy setting their homes in order for the reception of the foe; or rather in turning them topsy turvy. Provisions, furniture, clothing, were sent off and lodged in safe places; silver, jewelry, glass, china, etc., etc., etc., were consigned to the safe and silent . . . earth. Oh, that we possessed half the gold and silver now hid in Edgefield soil!"

At Stony Bluff, Lewis and Mary Miles, like their counterparts in town, would also have been focusing every effort on preparing for the approaching enemy. Perhaps calling together Dave and Henry and any other slaves who had not been conscripted or run away, they might have packed their valuables in whatever jars remained at the factory. They had only one son left at home to help them, the boy Langdon. John was with the remnants of the army in North Carolina; Milton had been captured by the Yankees after the battle of Nashville; and young Francis, though they could not have known it, would die of pneumonia on the very day they began their preparations—February 9, 1865—in the dreaded Northern prison at Camp Chase, Ohio.[20]

Two days later, 2,200 Yankees rode calmly into the outskirts of Aiken. Given the ease with which they had proceeded through the state thus far, General Kilpatrick and his cavalry expected no resistance. However, the men of twenty-eight-year-old Gen. Joseph Wheeler, who had hitherto been nipping at the Yankees' heels to little effect, had hidden themselves behind the shops and houses of the town to form a trap.

It would have worked perfectly had not one over enthusiastic trooper begun to fire when only half the enemy was inside the box. Furious combat ensued on the streets and sidewalks and alleyways of the town; because of the close quarters, much of it was hand to hand. In spite of shells fired into the village from a federal battery, many Aiken women left their homes, and throughout the extended struggle brought water and bandages to the wounded troops. Rev. John Henry Cornish, who was a witness to the battle, reported that at a pivotal point, "[Our] bugles sounded a charge. It is marvelous what a different aspect was thrown over the scene in an instant. The horses started and came tearing down Richland Street, the men rising in their stirrups, with their pistols in their hands, yelling and screaming, each one looking as if he could devour a dozen Yankees. . . ." The Confederates drove Kilpatrick and his cavalry out of Aiken and chased them five miles back to their position of the day before. In the speed of the retreat, Kilpatrick lost his hat, a detail treasured in local retellings of the day's events.[21]

Though a small incident in the great panorama of the war, the battle of Aiken, as it came to be called, had real importance: It preserved the mills at Graniteville; it spared the pottery factories around Horse Creek; and it kept Edgefield Village from being burned, consequently saving many of the documents that have shed light on Dave's story. The battle is celebrated each year with a vigorous reenactment outside Aiken that includes charging horses and booming cannon and, the year I saw it, an actual tornado that unexpectedly touched down to rip apart the tents of the encampment.

The victory at Aiken did nothing to slow the advance of Sherman, however. On February 17, his troops took possession of Columbia, the capital of South Carolina. They were unopposed, but in the first hours of the occupation, cotton stores caught fire—by accident or by plan, through the actions of the North or the South—creating a firestorm that burned much of the city to the ground. Soon thereafter, Sherman led his triumphant men up into North Carolina. Disparate Southern forces, including the Edgefield boys in Company I, gathered there to

counter him. But the game was over. On April 18, as rumors of capitula-
tion reached them, James Tillman, whose family lived near the Mileses
back home, wrote in his diary, "[S]oldiers cried on yesterday . . . I greatly
fear something terrible is before us—Oh! God! Save my country & my
family from disgrace." Ben Landrum summed it up concisely: "Being so
reduced in number," he wrote, "there was not much to do, only to keep
together. Lee soon surrendered."[22]

The war took a heavy toll on the Mileses and the Landrums. Only
two of the four soldier sons of Lewis Miles survived—Milton and John.
All three of Franklin Landrum's sons made it home, but both sons of his
brother, the physician John Landrum, died. Tradition among the
descendants of Dr. Abner Landrum holds that the three sons to whom
he so proudly gave names from the history of ceramics—Palissy, Wedg-
wood, and Manises—all died in the war. Lafayette Wever, the son-in-
law of Lewis Miles, lay gravely ill in an Augusta hospital when peace
came. Though his loved ones thought he would soon die, he managed to
survive and become my great-grandfather.[23]

THE FINAL CHAPTER OF THE WAR included a strange chase that
touched the Miles family. It began on April 2, 1865, when President Jef-
ferson Davis, along with his cabinet, boarded the last train out of Rich-
mond and fled south. Even though he was escorted by three thousand
men and had the gold reserve of the Confederate treasury in tow, the
journey became increasingly threadbare. He traveled in every manner of
conveyance and stayed overnight in the homes of Confederates along
the way, some not at all eager to have him. He met with an ad hoc war
council on the night of May 2 in a house in Abbeville, South Carolina,
northwest of Edgefield. The owner of the house and host for the
evening was Lewis Miles's first cousin, Armistead Burt. Well connected
all around—his wife was a niece of John C. Calhoun—Burt had had a
successful career before the war as an attorney in Abbeville and Edge-
field districts and had served in Congress during the 1840s. There, he

and Davis had become friends. Burt's guests that night, in addition to President Davis, were Secretary of War Col. John C. Breckinridge, Gen. Braxton Bragg, and the five commanders of the brigades that accompanied the presidential party.[24]

Davis began the meeting by proclaiming that he would unite the remnants of his forces and continue the fight in the Trans-Mississippi. "Even if the troops now with me be all that I can for the present rely on," he said, "three thousand brave men are enough for a nucleus around which the whole people will rally when the panic which now afflicts them has passed away." Astonished by their leader's failure to grasp the reality of the situation, the generals respectfully told him that no further resistance was possible. The president renewed his statement, now more a plea, to no avail. As he rose to leave, he appeared to be on the verge of collapse. Breckinridge quickly stepped to his side and helped him from the room. Though Davis would later claim to have no recollection of the occasion, these two hours in Cousin Armistead's parlor effectively marked the end of all hope for the Confederate cause. When the Mileses got word of their intimate connection with the last throes of the Southern nation, they must have felt both puffed up and completely, utterly deflated.

Jefferson Davis was captured in a south Georgia forest within days of leaving the Burt house. When he was brought into Augusta, Gertrude Thomas, a local matron, witnessed a scene worthy of the Haitian Revolution: ". . . I saw a crowd of Negroes (nothing I have ever seen equal to it) running and rushing down Greene St, across the street and coming from every direction, all to see the procession as Jeff Davis was brought from the cars. He was driven down Reynolds Street to the Sand Bar Ferry. I stopped at Dr Eve's and waited until the crowd passed by and felt as if I should have like to have seen a volley of musketry sent among the Negroes who were holding such a jubilee. . . ." The former president was taken to Virginia, where he was imprisoned in Fortress Monroe and made to wear chains. In vain, he protested that "those are orders for a slave. . . ."[25]

As the once mighty masters of Edgefield fell in turn, their slaves must have looked on in triumph and perhaps even pity. This uneasy combination found expression in the recollections of Savilla Burrell: "Young Marse Sam Still got killed in de Civil War. Old Marse live on. I went to see him in his last days and I set by him and kept de flies off while dere. I see the lines of sorrow had plowed on dat old face, and I 'membered he'd been a captain on hoss back in dat war. It come into my 'membrance de song of Moses: 'de Lord had triumphed glorily and de hoss and his rider have been throwed into de sea.";thin"[26]

	Jerry	"	8	M B	at home
	Victoria	"	3	F B	at home
143	Milledge Sturt	35	M B	Farm laborer	
144					
	Ro...				
	Ch...				
	Eliza May		12 F W	nurse	
13 145	David Drake	70 M B	Turner		
	Mark Jones	35 M B	Turner		
	Caroline	"	28 F B	Keeping house	
	Brister	"	10 M B	at home	
	Pierce	"	8 M B	at home	
	Emma	"	6 F B	at home	
	David	"	4 M B	at home	
	Infant	"	1/2 M B	at home	
146	Edward Jones	25 M B	Farm laborer		
	Isabel	"	20 F B	Keeping house	
	Emma	"	9 F B	at home	

No. of dwellings, **6** No. of white females, **5** No. of males, foreign born,
" families, **9** " " colored males, **18** " females, " "
" white males, **6** " " females, **11** " " blind,

CHAPTER XII *Reunions*

*[Every Negro man] seemed to be in search of
his mother; every mother in search of her chil-
dren. In their eyes the work of emancipation
was incomplete until the families which had
been dispersed by slavery were reunited.*

— JOHN W. DEFOREST, FREED-
MEN'S BUREAU AGENT IN
SOUTH CAROLINA, 1868[1]

ON 21 JUNE 1865, UNION TROOPS MARCHED INTO EDGEFIELD
Village to begin the occupation of the district. To the intense humilia-
tion of the white population, the soldiers were black. A "great disinte-
gration of the old order of things" began at that moment, remembered
John A. Chapman. "[It] was as though the foundations of the great deep
were broken up." Uncharacteristically, the *Edgefield Advertiser* urged its
readers to accept reality. It proposed that they sign the oath of alle-
giance to the Union as soon as possible, "the earlier will we begin a civil
government." And the quicker, went the subtext, will the black men in
blue be gone.[2]

The sight of these soldiers gave the slaves of Edgefield tangible
proof that they were free. News of emancipation spread among them
"just like dry grass burning up a hill." That's how Matilda Brooks, then
enslaved on former governor Francis Pickens's plantation, described
it. Rachel Sullivan, another Pickens slave, remembered the inadver-

tent pageantry of what happened next: "Mr. DeLoach [the overseer]
come riding up to de plantachun in one o' dem low-bellied ca'yages.
He call to Jo and James—dem de boys what stay round de house to
bring wood and rake de grass and sich—he sont Jo and Jim down to all
de fields to tell all de hands to come up. Dey unhitch de mules fum de
plows and come wid de chains rattlin', and de cotton hoers put dey
hoes on dey shoulders—wid de blades shinin' in de sun, and all come
hurrying to hear what Mr. DeLoach want wid'em. Den he read de
freedom warrant to 'em. One man so upset he start runnin' and run
clear down to de riber and jump in." Former slave Casper Rumple,
whose father was an Irish overseer in Edgefield, remembered the pro-
found excitement of the day: "Everybody went wild. They was jes'
crazy cause they was free."[3]

At Stony Bluff, Lewis Miles must have walked down the boulder-
strewn hill to give Dave and his companions the news. As they listened
to him, so much must have suddenly seemed possible. A free man could
choose where he wanted to live, what kind of work he wanted to do, and
even what name he wanted the world to call him. No longer would he
be called simply Joe, then Harry if his master changed his mind; like all
free men, he would now have a first name of his own and a name for his
family. In the months after freedom came, several of the former slaves
in the area chose Miles for their family name, less as a symbol of respect
for Lewis Miles than as a means of identifying themselves historically
and geographically. Anyone hearing the name would know that the per-
son bearing it had worked for Lewis Miles and probably lived near
Stony Bluff or Miles Mill. Many ex-slaves across the South took the
name of their former owner for the same reasons.

Dave, however, did not choose to link himself with Lewis Miles. At
first glance, this seems surprising, for "Dave" and "Mr. Miles" had
appeared together on countless pots made at Stony Bluff over the years.
Nor did he take the name "Dave Pottery," by which the *Advertiser* had
identified him in the "buttermilk" article. Instead, as his listings on later
public documents reveal, he chose to call himself David Drake. It was

not only a reference to the Drake family and his early life at Pottersville, it was a graceful combination of words that must have given him to use.[4]

The Drake name also carried with it an unusual cachet that Dave might have found desirable. It recalled the great British explorer Sir Francis Drake. Even though Sir Francis was childless, many people in the nineteenth and early twentieth centuries proudly claimed connection to him through his brother's children. This was certainly the case in my family when I was young. Because of a vaguely remembered story passed down from my grandfather, we were convinced that on the Edgefield side of the family we were linked to Sir Francis. Having discounted the tale after I grew up, I was surprised when my research for this book revealed that we were, in fact, connected by marriage to a line of Drakes: Martha Landrum's marriage to Micajah Drake, which produced Dave's first known owner, Harvey Drake, had brought the families together. I also found genealogical notes that traced the ancestry of the Pottersville Drakes back to the brother of Sir Francis. Informed genealogists assure me that there's no truth in it or any of the other claims, including that of my family. Still, Abbeville Drakes, who consider themselves latter-day cousins of Harvey and Reuben, have told me that the legend persisted in their family just as it did in mine. It could have been spoken of often when Dave was living at Pottersville. His repeated use of the word "noble"—"noble Dr. Landrum," for example—may reflect his admiration for this aristocratic line of descent that promised to dignify everyone it touched.[5]

With legal surnames now to unite them, many former slaves sought to locate relatives from whom they had been separated. Grandparents might be on a plantation in the low country, children on another in the upstate, grandchildren on yet others out west. Many former slaves went on the road in search of loved ones or posted notices for "Lost Friends" in the newspapers. Often, members of extended families chose to live close to one another in kinship colonies. It was not necessary to be related by blood to be accepted into such a network. A child who was orphaned might be taken in, or an elderly man who was left without

family, or a woman whose husband had been sold away under slavery.
Blacks bestowed the titles "brother," "sister," "aunt," and "uncle" to
those brought within the circle of kinship. This emphasis on family ties
is captured in a color lithograph for freedmen entitled "Family Record,"
which has survived from the period and is now in the Library of Con-
gress. Surrounding a genealogical chart ready to be filled out are scenes
of black life before and after freedom—from slaves harassed in the
fields to a family gathered in a prosperous home. Though the ideal exis-
tence that the chart depicted was seldom realized, the affection among
kin that it portrayed was very real.[6]

Soon after freedom came, what appears to be a kinship colony began
to form around Dave. Evidence of it is contained in the federal census
of 1870, the first national tally in which blacks who had been slaves were
enumerated by name. Dave is listed as David Drake, age seventy. He is
shown living in the Shaw's Creek section of Edgefield County just two
houses away from the Miles family. No doubt very different from the
handsome home illustrated in the Family Record, his house was proba-
bly the same cabin he had known for years. Mark Jones, age thirty-five,
is listed just after him in the same household. This is likely the potter
Mark, whose name Dave added beside his own on an 1859 jar. Caroline
Jones, age twenty-eight, is listed next, followed by five Jones children:
Brister, Pierce, Emma, David, and Mark, ranging in age from ten years
to one month.

Though the 1870 census does not specify relationships among mem-
bers of a household, they can be inferred from the order in which the
individuals are listed as well as from their age, gender, and surname.
Dave, listed first, is in the place reserved for head of the household. The
seven Joneses who come after him form a family unit—father, mother,
and children—but their relationship to Dave is less evident. What
seems likely is that either Mark or Caroline was Dave's child. If Mark
were his son, however, he would probably have taken the name Drake;
most sons followed their fathers when choosing names after emancipa-
tion. This suggests, then, that Caroline might have been Dave's daugh-

ter. If true, Dave was surrounded in his old age by children and grand-children; one of them, four-year-old David, was perhaps even named for him.[7]

The census listings suggest an even larger circle of kinship for Dave, with twenty-five-year-old Edward Jones, possibly Mark's brother, and his wife, Isabel, living next door. Like Mark and Caroline, they have a daughter named Emma. Another possible brother, Thomas Jones, who is eighteen years old and working in the "jug factory," meaning the pottery, is shown living six houses away. In the same household with Thomas are three other black men who were probably close friends of Dave: William Gearty, who worked in the Miles tannery; Alfred Landrum, who was a wagon driver, probably for the pottery; and Phillip Miles, who was another turner. A few years later, a young man named Sam Drake, possibly Dave's son, moved into the enclave with his wife, Nancie.[8]

To see whether any of those now living around Dave had appeared with him in earlier documents, I went back to the record of the 1847 estate sale of Rev. John Landrum, in which I had tentatively identified "Woman Louisa" as Dave's wife. This time, as I read down the list of Landrum slaves, two names stood out from the rest, almost as though they had been underlined. At the end of the diagonal indentation under Louisa's name were "Girl Caroline" and "Boy Samuel." I immediately saw that they might be Caroline Jones and Sam Drake, who I suspected were Dave's daughter and son. Using the age given for Caroline on the 1870 census, I calculated that she would have been five years old when the sale was held. Sam Drake was born in 1846, barely in time to make the list. In fact, "Boy Samuel" is not shown on the estimate sheet made out one month before the final sale listing, indicating that he might have been born between the two enumerations. If Caroline and Samuel were Louisa's children, as the diagonal listing under her name seemed to indicate, and if they were Dave's as well, as their presence around him after the war suggested, this would mean that Louisa was indeed Dave's wife.[9]

I felt close to finding the truth about this, yet I was aware that important pieces of the puzzle were missing. I still had no proof that Dave ever had a wife at all. Unexpectedly, then, I was offered that proof in a slim, leather-bound accounts book that had belonged to my great-grandfather, Lafayette Brenan Wever.

Lafayette had apparently carried the book with him during the Civil War. Though worn from use and only about the size of my hand, it was still quite handsome, with a triple-lined border pressed into the leather on the front and back covers. This informal ledger began on April 21, 1862, and for the first eight pages was devoted to the accounts of Company I, the Edgefield boys. It then shifted to November 1864 when, back in Edgefield temporarily, Lafayette bought several large quantities of stoneware from his father-in-law, Lewis Miles. He resold them for approximately twice what he paid, which must have helped support his family when he again rejoined his unit. After the war was over, he returned home and slowly regained his health. He had been trained as a physician, but, according to tradition in my family, he was prevented from resuming his profession when a swollen stream, which he was crossing on horseback, swept away his doctor's bag and all of his medical supplies and instruments.

The ledger indicated that in October 1865 Lafayette went into business with Lewis Miles to form the firm of Miles & Wever. As part of what seem to have been multiple endeavors, the two men started commissary for the workers they hired. Lafayette kept careful accounts of what each freedman, still identified by his slave name, purchased. He devoted several pages to a man called Dave. Because the 1870 census shows no other by that name living near the Mileses, this almost surely was David Drake. On December 6, 1866, according to Lafayette's ledger, Dave made the following purchase at the store: "1 peck meal for his wife." I could scarcely believe my eyes when I read those words. There, on that page written so long ago, my great-grandfather was telling me that, *yes*, Dave was married.[10]

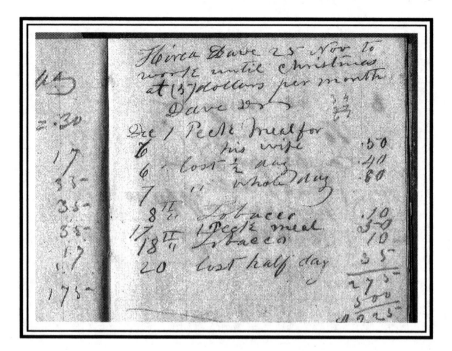

Welcome supporting information came from the 1869 Census for South Carolina in the section for Edgefield County. It showed "Dave Drake" living with one other person, a "colored female." Because no wife for Dave is shown in the federal census, taken the following year, she must have died shortly after the state listing was made. It must have been then that Dave opened his home to Mark and his family."

I laid out all the material I had found on the women in Dave's story, from the earliest mention in 1818 to this most recent reference in 1869. There were four of them, each close to him at a different time in his life. But what if . . . what if they were the *same* woman? I had been considering this possibility for some time, far in the back of my mind. Now, in the excitement of discovery, the idea took on new life. What if, back in 1818, when Dave was not yet twenty, Harvey Drake "had in mind" to sell Eliza, as stated in the mortgage documents that listed them together, but ultimately kept her at Pottersville instead? The name "Eliza" or "Liza" might easily have changed over the years into

"Lidy" or "Lydia," the name of the woman linked to Dave in his thir-
ties. And what if Lydia were never actually taken to Louisiana by the
Drakes when they left Pottersville in 1836? Indeed, I had found no
trace of her there. She might have begged so bitterly to remain with
Dave that Sarah Drake relented and sold her in Edgefield rather than
risk her running away on the trail. Rev. John Landrum could have pur-
chased her at that time and once more altered her name, this time to
"Louisa," or "Louiza," as one document had it. Following a decade at
Horse Creek and her subsequent sale to the Tillmans, she could have
come to Stony Bluff after the war as "Dave's wife," as Lafayette Wever
referred to her. "Eliza," "Lidy," "Lydia," "Louiza," "Louisa"—could all
these names have simply metamorphosed from decade to decade and
owner to owner as this *one woman* lived out her long life? If so, she alone
was Dave's "Dearest miss." And he was perhaps for her, in the words of
another slave woman who married only once, "the first one and the
best one and the last one."[12]

I know that I'm pushing all this farther than I ought to. But the idea
is stirring, really, a great love story.

FOLLOWING THE ELATION among the blacks and the despair among the
whites at the end of the war, the two groups stood back to regard each
other anew. The former slaves noted that their onetime owners were
severely reduced; they had lost sons and they had lost money. On the
other hand, whites sometimes saw blacks as strangely enhanced, with
surprising talents—such as the ability to read—that they had kept hid-
den under slavery. Still, the old ways persisted. Franklin Landrum con-
tinued to whip his workers when they displeased him, just as he had
before the war. James Tillman did the same at Chester Plantation, even
recording it in his diary. A notice ran in the *Advertiser* requesting help in
searching for a "runaway" freedman. Except for the absence of the tra-
ditional little drawing that showed a black man in flight, the ad was
identical to those for escaped slaves that were published everywhere

before the war. Former slave Sarah Jane Patterson remembered Georgia blacks wondering how to address their ex-owners. "You got to say master?" one of them asked. His friend answered, "Naw." But they said it all the same, she recalled; "They said it for a long time."[13]

Confusion about the new order of things was so widespread among and between whites and blacks that Brig. Gen. Ralph Ely, the chief officer in the Freedmen's Bureau in the upstate, was repeatedly stopped and questioned as he rode to the towns in his district. Sometimes it would be a planter making the enquiries, but often it would be a former slave. "Several of the men," wrote a young reporter who accompanied Ely as he approached Edgefield, "after it seemed that all their questions had been answered, would still walk along eagerly asking more, and evidently anxious to ascertain their position and prospects. The enquiries and statements often revealed a total misconception of rights and duties, sometimes on the part of the laborer and sometimes on the part of the employer." A few former slaves tested the limits of the situation for themselves. In Aiken, Phoebe, the serving woman of Reverend Cornish, spoke to him in "intemperate" language one morning. Though he reproved her, she continued to abuse him. When he demanded of her whose servant she was, she replied, "My own servant," and left his house.

Whites tested the limits of their freedom as well. When a long time abolitionist spoke in Edgefield on the injustices that slavery had wrought, James T. Bacon, the new editor of the *Advertiser*, was so affronted by what he deemed to be shameful exaggerations that he seriously considered hurling a stone at the speaker's head. Only the fear of being thrown in jail by federal soldiers deterred him. Unfortunately, he detailed his violent desire in an editorial, which brought him two weeks in a Charleston prison.[14]

Some among the whites in Edgefield so resented the new situation that they hunted down blacks who they thought were out of line and shot them dead. The killers in such cases were generally not members of organized groups. Exceptions to this were the men led by a former

Confederate major named Coleman, who rode the countryside in a band, murdering blacks and driving newly arrived Northerners from their homes. An Edgefield native, Coleman carried with him an envelope containing eight ears that he had cut from blacks as trophies. A federal officer, astounded by what he saw in the district, gave this report: "During the whole of my Military Experience . . . I never traveled so wild and lawless a country."[15]

How ironic this turn of events must have seemed to Dave. When the black people of Edgefield were in bondage, they could at least rely on the knowledge that their owners, loathe to lose their investments, would not allow them to be killed by others. As free men and free women, however, they were worth exactly zero, putting their lives more in danger now than they had been under slavery. Many whites, distressed by the outrages that shook the district, attempted to defend those in jeopardy, but it was only in late 1866, when more federal troops were brought in, that this first outburst of violence subsided. Given what they faced, some freedmen pondered quitting South Carolina for the haven long proposed by abolitionists, Liberia. Some white Edgefieldians, for their part, considered emigrating to Brazil to establish a colony where they could continue slavery and the other traditions they held dear. In the end, leaving posed more problems than staying, and almost everyone, former masters and former slaves alike, decided to remain at home.[16]

One thing that kept many of the freedmen in place was a widespread belief that the government in Washington was going to give each black family a mule and forty acres of the land that they had cultivated as slaves. It had happened on the coast after Sherman's army seized thousands of acres; surely, they thought, it would happen in the upstate. In December 1865, however, General Ely brought bad news to Edgefield. In a speech on the town square, he told the local freedmen that the forty acres they expected would not be coming to them; the government had decided that white property owners should keep the land that had been theirs before the war

Some townspeople had expected trouble when the news was given to the crowd. Instead, at the end of the speech, the disappointed freedmen simply returned to their homes. Looking back after many years, Warren McKinney, a former Edgefield slave, interpreted the situation with surprising equinimity: "[The colored folks] never got nothing cause the white folks didn't have nothing but barren hills left. About all the mules was wore out hauling provisions in the army. Some folks say they ought to done more for de colored folks when dey left, but dey say dey was broke. Freeing all de slaves left em broke."[17]

The only choice for most freedmen now was to continue to work for their former owner. Lafayette wever's accounts book shows that he took on about fifteen workers from 1865 through 1867. One of them was Dave, who on March 26, 1866, agreed to work for five dollars per month until the following Christmas. The type of labor he was hired to do was not specified, though it was surely to turn ware in the pottery factory. His pay was at the upper end of what Lafayette was offering, but after buying items from the store, borrowing forty cents, and missing several days of work, he was twenty cents in the hole at the end of three months. Perhaps unhappy with this, he didn't show up again until November 25, when Lafayette recorded that he once again agreed to work, for one month only. At that time Dave came out better: In spite of missing two days and buying two plugs of tobacco and two pecks of meal (including the peck for his wife), he cleared $2.25. Though some entries in Lafayette's account book are not dated by year, the ledger appears to end in December 1867.[18]

Informal arrangements such as these easily lent themselves to abuse, by workers and by employers. Many freedmen, equating freedom with irresponsibility, saw no need to hold up their end of the agreements they had entered into. Their former masters, equally unfairly, sometimes drove them from their plantations after harvest to avoid giving them their share. In an effort to correct the situation, the Freedmen's Bureau stepped in to oversee all labor contracts. As time passed, a more or less standard sharecropping arrangement emerged: Freedmen fami-

lies agreed to live on and work the land that the owners provided for them in exchange for rations and up to one-third of the crops they harvested. Even when a mutually agreeable contract was signed, however, blacks often felt that they were cheated when the crop was divided. A rhyme, which they sometimes chanted at "settling-up time," summed up this sentiment.[19]

> *Naught's a naught, and five's a figger,*
> *All for the white man and none for the nigger.*

There is an unusual labor contract from this period among my family papers. It is an agreement between Lewis Miles and three freedmen to establish a kind of share-potting system at the Miles kiln. As far as I know, such an agreement was employed at no other pottery in Edgefield. Here it is in its entirety.[20]

A contract between Lewis J. Miles, and the following named Negroes; which said contract is to continue in force till the close of the year one thousand Eight hundred, and Sixty seven, beginning on the 15th day of October 1866.

I, L. J. Miles do agree on my part to let the Freedmen have the use of my Stone-ware Factory, & all its appurtenances, together with the necessary fuel in the forest, clay in the pits, & also three mules, harness, & wagon. I agree further to furnish the said Freedmen with houses to live in, & the usual quantity of firewood without cost or charges.

We the undersigned Freedmen agree on our part, for the use of the Factory & other things above-mentioned to pay, at the end of each month, unto the said L. J. Miles, fifty dollars in the currency of the Country, & also five hundred gallons of saleable ware, to furnish our own provisions, and clothing; to buy food for the three mules, to feed them well, & not to abuse them; to keep

the wagon, harness, & every thing pertaining to the Factory aforesaid in good repair; we will not refuse to obey orders, nor will we fail to act in a becoming, and respectful manner. I, Willis, agree furthermore to make fires in the dwelling House, as usual. I, Jack, do further agree to make fires in the Kitchen as usual. And we do all agree & faithfully promise to take & catch horses as we formerly did. In testimony whereof we have hereunto set our hands & affixed our seals, this 15th day of October in the year of our Lord One thousand Eight hundred, & sixty six.

Lewis Miles signed the contract near the bottom of the page. Each of the three freedmen put his "x" below that: Willis Harrison, Pharoah ("Jack") Jones, and Mark Miles. It's possible that Mark may in reality have been Mark Jones, the young man who seems to have been Dave's son-in-law. New names were still being tried on for size at this time, and Mark may initially have chosen "Miles" before settling on "Jones." The agreement was approved and signed on the reverse by L. William Stone on June 15, 1867, eight months after it was originally drawn up.

The contract is interesting on several levels. For one thing, it indicates that Lewis Miles had faith enough in his former slaves to entrust them with the great kiln at Stony Bluff, which is probably the furnace involved here, a very valuable, technical, and in many ways fragile piece of property. The three freedmen, for their part, must have had confidence enough in their skill to know that they could run a complicated pottery operation without a "master" looking over their shoulder. At the same time, the document suggests the persistence of the ways of slavery, for it requires the men to continue completely unrelated tasks that they were responsible for as slaves. Finally, its anxious requirement at the end suggests that former slaves and former masters were, after months of trying to get it right, still unsure of just where they stood in relation to each other: *We will not refuse to obey orders, nor will we fail to act in a becoming, and respectful manner.*

IN SPITE OF HIS EFFORTS to adjust to the new scheme of things, Lewis Miles, like many of his neighbors, was in serious financial difficulty. A ray of economic hope emerged for him when the new Charleston, Columbia, and Augusta Railroad line was constructed through a portion of his land. It came near Miles Mill, where he had his sawmill. Hoping to take advantage of the possibilities that easy access to the railroad offered for bringing in supplies and carrying out products, he consolidated the remainder of his operations there, including a stoneware factory. One of his Landrum relatives told an interviewer in 1930 that Miles had owned two potteries, "one at his home this side of creek and other across creek." It may be that he built the Miles Mill pottery at this time, leaving him free to lease the one at Stony Bluff to Willis and Pharoah and Mark. In the *Advertiser* of November 6, 1867, he announced:[21]

DOMESTIC TRADE

All of my Manufacturing Interest is now concentrated in one place. My Grain Mill, Saw Mill, as well as the Tannery and Stone Ware Factory are in complete operation.

I have on hand and for sale a quantity of Flour, Lumber, Leather, Jugs, Jars, etc. Any of these articles I will give in exchange for Raw Hides.

My motto is to build up business at home, and establish at least, a Commercial Independence.

Lewis J. Miles

The train ran for the first time on December 17, 1868. To Lewis's consternation, however, the engineers of the railroad chose not to stop at Miles Mill. They claimed that the name wasn't on their official list. Lewis was outraged. This comes from Irene Gingrey, the great-granddaughter of Franklin Landrum, who told it to pottery historian Cinda Baldwin in 1987: "[Lewis Miles] ordered some freight," she said, "and it was supposed to have gotten off at Miles Mills and it wasn't named and the freight went on to Gran[ite]ville and he stopped the

train." He not only stopped it, she said, *he chained it to the tracks.* He pad-locked it in place and, in spite of what must have been a furious engi-neer and dumbfounded passengers, he had his men unload his goods. He probably said something like, *Take your time, boys. This train's not going anywhere.* I can see Irene Gingrey widening her eyes in wonder at this mad relative and his chained-down locomotive: "That was what was told me," she said. After the incident, the owners of the railroad gave in to a force clearly greater than themselves and designated Miles Mill an official stop on the line. The name was inscribed on maps of South Car-olina for decades thereafter.[22]

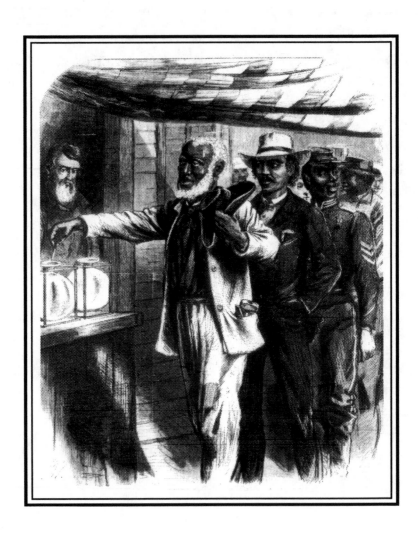

CHAPTER XIII Votes

Think of it, the right to vote, that right which
[the Negroes] have seen their old masters
exercise with so much pride, and their young
masters look forward to with so much pleasure
is within their very grasp—

— ELLA GERTRUDE CLANTON
THOMAS, AUGUSTA MATRON,
1868[1]

IN JUNE OF 1866, CONGRESS PASSED THE FOURTEENTH AMEND-
ment to the Constitution, which gave all Americans, including former
slaves, equal protection under the law. Neither South Carolina nor any
other Southern state ratified the new amendment. Outraged, Congress
decreed in March 1867 that state government no longer existed in the
former Confederacy. They set up five military districts over the terri-
tory, with South Carolina in the second of these. This was the beginning
of the period known as Radical Reconstruction.

In order to be readmitted to the Union, the Southern states were
required, among other things, to open their voting rolls to all those who
were eligible, blacks as well as whites. In Edgefield, the resulting voter
registration was a momentous event for the former slaves of the county,
their first opportunity to present themselves as full citizens. It was
important for the whites of the area as well, as editorials in the *Advertiser*
carefully explained in the weeks leading up to registration day. If they
didn't add their names to the list, the paper said, they wouldn't be able to

vote in future elections, and the control of the state would fall into "nefarious" and "irresponsible" hands, meaning the candidates of the Republican Party. To whip up enthusiasm among their white Democratic readers, who were apparently still suffering the depressive lethargy that had seized them after the end of the war, the paper posted registration results as they came in from other towns across the South. The results read like scores in a great black versus white sporting event: "Registration closed in Savannah on the 3rd. Whites 2,293; Negroes 3,063."[2]

The list of those who registered in Edgefield County is preserved on microfilm at the State Archives in Columbia. There, I found "Drake, David" in Edgefield Court House Election Precinct. From this, I know that on August 28 or perhaps August 29, 1867, the two days set aside for registration in the village, Dave made the trip from Stony Bluff to enter his name on the rolls. He could have registered elsewhere—Lewis Miles and Mark Jones and Sam Drake registered at the Pine House, much nearer to Stony Bluff—but Dave chose to come all the way back to town. It was the reverse of the trip he had made in 1836. Then, he had been leaving Pottersville, the place where he had been almost famous, on the way to a life that held many uncertainties for him. He was coming back now as a free man with a free man's name and a free man's rights. After decades of watching from the sidelines as the great issues of the day seized Edgefield—nullification of the tariff, secession from the Union—he would at last be able to participate directly in governing the world in which he lived.

It is possible that Dave's wife was with him that day, though she would not have been able to accompany him all the way to the registration table. Black women, like their white counterparts, did not have the right to vote. From the first, however, black women involved themselves fully in local political proceedings. They attended party meetings and parades, wore campaign buttons, and sometimes guarded weapon stacks at rallies. When a resolution was put up for approval at a mass meeting, they added their voices to the vote. Dave's wife, like Dave himself, might not have wanted to miss an occasion as important as this one.[3]

There was more than a little anxiety among the freedmen on the first day of registration in Edgefield. For one thing, "artful men" had approached some of them in an effort to charge up to one dollar or more for the privilege of being on the list of eligible voters. For another, many of the freedmen were still wavering in their choice of surname, and they were now under pressure to make a decision. There was even more confusion in Charleston, where some freedmen thought registration was distribution of land under a different name. Amused observers mocked them and took pleasure in describing "ludicrous scenes" at the precinct venues. If such incidents took place, they simply helped make clear the enormous step that the freedmen across the state were making that August. They were moving from a lifetime of enforced servitude into the arena of political choice. Frederick Douglass, granting everything that was being said of the freedman's lack of preparation for this new responsibility, pointed out that "if the Negro knows enough to fight for his country, he knows enough to vote; if he knows enough to pay taxes for the support of the government, he knows enough to vote."[4]

I wonder whether Dave was embarrassed by the uncertainty he saw around him. Did he hold himself a little apart, he who could read, who could even make his writing rhyme? I wonder whether, when his turn came to step into the short, vaulted corridor under the portico of the courthouse, he reached out his hand, almost aggressively, for the pen. Taken aback, the registrar might have given him a searching glance: *You're the potter, aren't you? You belong to Lewis Miles.*

No, sir. I am free.

The registrar, who could have been one of the two whites appointed to the post or the single black one, might have laughed in a show of goodwill and said, *'Course you are, we're all free here.* Nevertheless, the registrar would have done the writing himself, carefully entering "Drake, David" in the "Colored" section of the D's, for the names of the former slaves were kept separate from the names of the former masters. Even so, how different this list was from all the wills, the estate tallies, and the other past documents that transferred human beings from one owner to another.

The blacks listed here were *acting*, not being *acted upon*. When Dave's turn was done, he would have walked out into the square again, perhaps blinking slightly in the bright sunlight. Other freedmen might have called to him nervously and asked him how it went. Like someone safely out of a doctor's office, he might have assured them that there was nothing to be concerned about. Still, as a witness to registration at another location wrote, the eyes of the former slaves "beaming with anxiety were constantly turned in the direction from whence the registrars came: . . . after their names were taken they went on their way rejoicing."[5]

On the first day at the courthouse, the whites of Edgefield showed up to register in far fewer numbers than the blacks. Unnerved, James T. Bacon of the *Advertiser* gave an almost desperate explanation: "[W]e take it for granted they are waiting until the enthusiastic negroes shall have left the coast somewhat clearer—and less fragrant." The final tally offered him no solace, for only 197 whites ultimately registered in the village, whereas blacks added 659 names to the rolls. The totals from across the state were 47,171 for the whites and 80,379 for the blacks. Those who had registered then elected delegates to a convention in Charleston for the purpose of drafting a new state constitution.

The constitution, which ensured black rights, was presented to voters in April 1868. In a landmark moment, Dave and the other newly enfranchised voters of South Carolina not only approved the constitution but elected Republican majorities in both houses of the legislature. Many of these new lawmakers were black: 75 out of 124 in the House and 10 out of 32 in the Senate. It was an astounding swing of the political pendulum: Men who had been slaves only three years earlier now prepared to take positions of power over their former masters. Newspapers across the state voiced the horror of the white community. The *Fairfield Herald* called the results of the election the "maddest, most unscrupulous and infamous revolution in history." In Edgefield, editor Bacon proclaimed to his readers that the state was now, in a word, "Africanized." He wrote, "South Carolina of the great men, great services and great distinction *is no more!*"[6]

The election for president of the United States was scheduled for that fall. The new black voters, who understood that it was the most important task assigned to a citizen, looked forward to it with pride and enthusiasm. Almost to a man, they supported the Republican candidate, Gen. Ulysses S. Grant. Whites, with the exception of a few Radicals, just as firmly supported Governor Horatio Seymour of New York, the Democratic candidate. Many whites in Edgefield tried to influence the black workers under their control. Sometimes they offered to buy their votes; sometimes they threatened to dismiss them from their jobs. Most blacks strongly resisted this. If a man showed signs of breaking ranks, however, he often found himself faced with intimidation of another kind: His own wife, as one of the politically committed black women of the country, might refuse to cook meals for him or wash his clothes, or even, in the manner of the Athenian women led by Lysistrata, sleep with him.[7]

As blacks continued to hold on to their votes, a strange name—Ku Klux Klan—began to be heard in Edgefield. Though the organization had been founded in Tennessee in 1866, its first recorded local mention was in an editorial in the Advertiser on April 1, 1868. Editor Bacon titled his piece "In the Name of Heaven, What Does This Mean?" Baffled or pretending to be so, he quoted a message mysteriously left on a table in his office: "The Great Grand Cyclops † demands attention. Assemble! there is work to be done! 'To them which sat in the region and shadow of death light is sprung up.' Let Justice † now resume her throne—though Blood darkens the plain." It was signed by "Pale Death, Sec'ry." Bacon added this comment: "We have been informed that this Klan will soon have a foot-hold in every town and village in the South, and sooner or later they may burst forth in all their fury, and the horrors of their doings will be too fearful to contemplate."

Indeed, hooded men riding hooded horses soon began to single out blacks for punishment. Every day freedmen would come to the sheriff of Edgefield to report cases of whipping and abuse—in some cases they bore the wounds themselves—and even murder. Though Paris Simkins

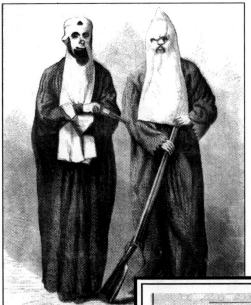

In the Name of Heaven, What Does This Mean?

We found on our office table this morning, the following startling and singular card, accompanied with $1.00 in gold, and instructions to "publish, and fail not at your peril." By what human or spiritual means it found its way into our sanctum, we know not. All we have to do in this matter is to "publish" and pocket the cash. And Messrs. Ku Kluxers—be you men or be you spirits—we are always yours at command. Nothing in this round world would we fail to do if the "Grand Cyclops," or the "Great Giant," or "K. K. K." was attached to the order. But here is their card:

Ku Klux Klan.—HYENA CAVE, Bloody Month, New Moon,† 22X, 9th Hour. *In Hoc Signo.* Hist, ye Brother Skeletons—Division No. 100. The Great Grand Cyclops† demands attention. Assemble! THERE IS WORK TO BE DONE! "To them which sat in the region and shadow of death light is sprung up." Let Justice† now resume her throne—though Blood darkens the plain. By order of the Grand Giant†††
PALE DEATH, Sec'ry.

was descended on his father's side from one of the finest white families in Edgefield, he was not immune to these attacks. His daughter, Grace Jenkins, remembered it this way: "[The Klan] tried to kill Daddy. One night they waited for him as he journeyed toward home on his old horse. He heard them, however, and he jumped from his horse, bid the horse go, and buried himself in the sand. When the horse without a rider passed the white men, they rushed down the road looking for Dad and trampled all over him in the sand but didn't find him." Whites who were friendly to the black cause were also targeted for violence. Some were "carpetbaggers," opportunistic Northerners who had moved to the South after the war; others were "scalawags," native Southerners who sided with the Republicans.[8]

In one instance, which had far-reaching results, threats were made against the Board of Commissioners, a three-man group whose mission was to oversee all aspects of presidential voting in the county. Frightened, the two whites and the single black on the board resigned their positions. The governor appointed a second board, but shortly thereafter one of the new white commissioners, Truman Root, woke up during the night to find his house in Edgefield Village being fired upon. A crowd of men broke down his door and, as a witness later testified, shouted at him, "Come out of that house, you damned Radical son of a bitch; we don't intend for such a Radical son of a bitch as you to stay about here." Thoroughly shaken, Root also resigned from the commission. Another member resigned in turn, leaving the board inoperative, with no time left to appoint yet another one. The result: no election for president of the United States was held in Edgefield County in 1868. Though Grant won a sizable victory in the rest of the state, the chance to vote for the new president was denied to the freedmen of Edgefield. At this point in the county's history, as a legislative investigating committee reported, "the Ku Klux [was] so strong and well organized that it had everything its way."[9]

Only days after the missed election, the collective fears of the county came together in a pair of bizarre racial incidents that threatened Dave's

family as well as my own. The Horse Creek plantation where Rev. John Landrum had once lived was the site of the affair. Known by then as "the old Landrum place," the house and property were owned by a forty-eight-year-old white man named D. A. Fosket, who was originally from New York State. Because he had lived in South Carolina for only four years at that time and in Edgefield County for only two, he probably qualified as a carpetbagger. A Radical Republican, he formed a group of black men into a quasi-military unit, armed them, and began to drill them constantly. Worse, he was said to be inciting his men to kill certain of his neighbors. The Mileses at nearby Stony Bluff and the Franklin Landrums, who lived just across the lake from Fosket, must have reacted with dismay. When homes in the neighborhood were violently assaulted by night, they and the other inhabitants of the area began to live, as a contemporary report put it, "in daily fear of their lives." Adding to the sense of alarm, a white man revealed that Fosket had offered him five hundred dollars to kill a well-known citizen of Edgefield.

The deputy state constable and two special deputies arrested Fosket on November 18 along with six of his men and put them in the village jail. A few nights later, a band of Ku Kluxers swept down on Fosket's place, now almost deserted. They managed to capture a black woman who worked for him and beat her severely. The *Advertiser* said that these twin outrages—Fosket's original shenanigans and the Klan's reprisals—argued that there was "more than one mischievous person in that section.' [10]

The affair at Horse Creek must have left Dave in a shaky position. Because of the involvement of neighborhood blacks in Fosket's militia—Dave's relatives might even have been among them—whites would now have been cautious around him. Because Dave didn't know who might have ridden with the Klan that night, he in turn would have acted with caution around them. His sense of insecurity must have been heightened a few months later when Lewis Miles died. Though varying dates for his death are given in documents from the period, the date supplied by Mary Miles—June 7, 1869—seems the most likely. The cause was "dropsy," a general term that doctors used at that time to indi-

cate edema. Lewis Miles was fifty-nine years old. With his passing, Dave lost the last of the white men who had cared about him. Harvey Drake, Reuben Drake, and Abner Landrum were all gone. Lewis's sons were good men, but they were struggling to make a go of it, and Dave was no longer their responsibility. Like the other former slaves of the area, he could easily fall prey now to the "mischievous persons" whom the Advertiser spoke of.[11]

In this context, Dave perhaps again questioned the blessings of freedom. Yes, he could vote, but only if the election were allowed to take place. Yes, he could enjoy a Fourth of July celebration with other freedmen, but only if he were prepared for the *Advertiser*'s description of it afterward: "The doings here on Saturday last would have been perfectly *comme il faut* in Congo or Ashantee. An idiotic mass of wretched negroes, spending the day in senseless howlings and marchings." In the old order of things, Dave had been able to charm white planters with his verses and amusing malapropisms, but the night riders were different. Embittered by the war, rendered anonymous by their hoods, they didn't care that he had once written poems on great and noble jars.[12]

Dave may have reacted to these difficult times by concealing his intelligence to make himself less of a target. The absence of any known signatures or inscriptions from the period may be one indication of this; another may be a strange and little-noted entry beside his name on the 1870 census. When the federal census taker came to his house that year, an event that should have been a great moment of affirmation, Dave apparently told him that he couldn't read or write. Proof that this was untrue was inscribed on pots in homes and on farms across the South, but the United States Census for 1870 clearly states that Dave was illiterate.[13]

SEISMIC SHIFTS HAVE OCCURRED in Southern politics since Reconstruction: Most blacks in South Carolina are now Democrats and most whites, Republicans. The beginning of the changeover came when Strom Thurmond broke with the Democratic Party to run a separate

campaign for president in 1948, then became a Republican in 1964. As it happened, the 2004 presidential campaign occurred while I was in Edgefield, giving me the chance to see how this reversal continues to play out.

Because there was no question that the state would go Republican in the national contest, the Democratic Committee in the country had chosen to focus entirely on promoting its candidates for local office. It organized an event to raise funds for those seeking to be sheriff, clerk of court, and senator. The tickets, twenty-five dollars each, considered high for the area, bought a serving of chicken barbecued by James Fab Burt, chairman of the local Democratic Party, who was highly respected for his skills as a chef. Though in fact not an event at all—people just drove up to the town gym, picked up their white Styrofoam container of Fab Burt's chicken and fixings, and drove off—it was a success: After all expenses were covered, one thousand dollars was raised for each of the three candidates. This has to be seen in contrast to a private Republican fund-raiser, held almost simultaneously, that took place at the clubhouse of Mount Vintage, a gated community between Edgefield and Augusta that is conceived around a foxhunting theme. The tickets there were five hundred dollars each, and the evening was a smash.

One night during the week before Election Day, I crossed the square to attend a meeting of the local Democrats. Their headquarters was in an empty storefront that had been rented for the last weeks of the campaign in order to have a presence in town. Red-white-and-blue bumper stickers, only recently sent from the state committee after weeks of promises, were pasted on the otherwise blank windows. As people began to show up, someone brought a key for the door, but it didn't work; another key had to be sent for, although in fact the first one turned out to work after all. Once inside, we located the light switch for the big space and everyone sat down in rows around a small oak table. There were sixteen of us there, eleven blacks and five whites. Fab Burt was in charge of the evening's meeting. He was a tall man who, even under the harsh light from the fluorescent tubes overhead, had a look of

unflappability about him. He needed it that night because there were problems: One of the women (a renegade from one of Edgefield's best white families) had experienced difficulty when she voted by absentee ballot in order to test the system. "They told me I could vote straight Democratic ticket and they said that's all I needed to do. But now I find out that didn't include the *president* and the *vice president!*"

"Who told you that?"

"The lady up there!"

Everyone was upset. Questions about the voting machines came up. Somebody said there ought to be one right here to look at. Fab said, "They told me they were going to have it here for us. Swore up and down."

"And where *is* it?" two people said at once.

Somebody else said, "I hear by the grapevine they're putting a sample ballot in the *Advertiser.*"

"Clint says he is. He's 'cross the square right now, getting out next week's issue."

"But he needs to be *here*, listening to what we're *concerned* about."

An older man with short gray hair and a grave face spoke up. "I'm a pastor," he said, "a longtime pastor. I want my congregation's vote to count. But I've got ringing in my head about what happened in Florida last time. I would hate for us to go through all this *commotion* and our vote not *count*."

I could see the steps of the courthouse through the window of the store. I thought about Dave registering there in 1868, perhaps at a table like the one we were gathered around tonight. I thought of what he must have felt in the weeks afterward, as he anticipated the upcoming vote for president—the euphoria, the hot pride, the desire to make the most of the moment. I suspected he had worrisome doubts, as well. Should he vote straight down the line for the party of Abraham Lincoln, or should he "inquire who is the best man for the best place," as some people were telling the freedmen at that time? Voting was a test of Dave's new freedom, his new name, his voice, and it was important to

get it right. How hard, then, at the last minute to have the election canceled. It must have seemed like having a plate of long-promised food swept off the table before a fork could be raised.

Toward the end of the meeting, a man in a blue jacket summed up what everyone was feeling. "On that day next week when it comes time to vote, if you got any doubt about how that machine works, take your time and question those people who're running that thing. You ask them inside and out. I don't care if it takes all *year*." Everybody took that as marking the end of the evening. A woman rose to her feet and said, "I got a baby at home." She walked to the door and pulled on it, but it wouldn't open. "Pull it hard," Fab said. Getting out was no easier than getting in.

IN 1871, PRESIDENT GRANT finally moved to suppress the Ku Klux Klan in South Carolina. Hundreds of arrests were made. Though it was long in coming and a serious matter, the departure of the Klan had its comic aspect. As historian Joel Williamson relates, "One group of Klansmen fleeing across Edgefield county in November, 1871, en route to political asylum in Georgia probably never discovered that the band of mounted men pursuing them were not irate federals but local citizens fervently attempting to congratulate them upon their work." The Klan's disappearance heralded a new day for the blacks of the district. At a July picnic in 1872, Paris Simkins addressed a crowd of jubilant black citizens, saying that President Grant "had stopped the Ku Klux in their murderous work. If Grant had not sent his soldiers down here to stop it, the colored people could not have stood it longer, and before this they and the white people would have been face to face in a bloody conflict, and this fair land been a wild and desolated wilderness."[14]

As if waiting for the return of social peace, Dave once more appeared in the newspaper, in the October 30, 1873, issue of the *Advertiser.* He was mentioned in a short write-up of another pottery worker

who had just died. Here is the reference in its entirety: "Who did not know Alfred Blocker, the jug-factory man, who for the last twenty years has been driving up to our doors and putting out jugs, jars, pots and crocks? An honest and a pleasant fellow was Alfred, black (and so black!) though he was. And now he is dead and gone. And the veteran one-legged Dave Drake is left alone with his glory and his jugs." This brief mention, which came to light only recently, confirms important biographical details about Dave—that he had only one leg, that the surname he took after the war was Drake, and that even late in life—he was seventy-two now—he was still noted for the quality of his work. The image of Dave "alone with his glory and his jugs" is enigmatic and touched with sadness, but it perhaps also suggests that he had arrived at a moment of fulfillment, just as the rest of the black community had.[15]

The respite from violence made many things possible. Black leaders, now able to consolidate their power, succeeded in carving an entirely new county out of Edgefield and other surrounding countries. Created on March 10, 1871, Aiken County included Dave's house just inside its boundaries. Along with his kinfolk and the Mileses and the Landrums, Dave was now an ex-Edgefieldian. In spite of life long ties to his old district, he must have felt a rising excitement at being part of this new black endeavor.

The seat of power in Aiken County was Hamburg, the little town on the Savannah River that had served as the original terminus of the South Carolina Rail Road. Having lost its early prominence—in part because of a railroad bridge that had been built across the river to Augusta—Hamburg had been deserted by most of the white residents. Its vacant buildings offered ready quarters for the new politicians. The leading citizen was an impressive man named Prince Rivers, who had escaped slavery to serve in the Union army. At that time, his commander compared him to the leader of the Haitian Revolution: "He makes Toussaint perfectly intelligible, and if there should ever be a black monarchy in South Carolina, he will be its king." Mayor of Ham-

burg, major general of the state militia, and formerly one of Edgefield's representatives to the state legislature, Rivers was known by all as "The Black Prince."[16]

With their leaders in place, black men across South Carolina once more made their voices heard. In the elections of 1872, they consolidated their earlier gains by electing blacks to 106 of the 156 seats in the legislature as well as to the offices of lieutenant governor, attorney general, Speaker of the House, and president of the Senate. Unfortunately, carpetbaggers and scalawags, who were also part of the state government now, created an atmosphere of graft and corruption to which black officials were not always immune. Bribery of legislators became commonplace. The *Edgefield Advertiser* summed up the resulting sense of discontent: "among the white people—there is a deep feeling of indignation and disgust—of unspeakable humiliation—of intense shame—*that we have come to this, and must put up with it!*"[17]

Sheriff John H. McDevitt, understanding the potency of this resentment, warned a group of unsuspecting blacks to beware what lay ahead. He was addressing a gathering in Edgefield, but he might just as well have been speaking in Aiken or Abbeville or any town in South Carolina. He told the blacks that the Ku Klux Klan, the terrible sword of white retaliation, was "not dead, but only sleeping."[18]

CHAPTER XIV Shirts

Never threaten a man individually if he
deserves to be threatened, the necessities of
the times require that he should die.
A dead Radical is very harmless

—MARTIN W. GARY,
"PLAN OF THE CAMPAIGN
OF 1876"[1]

DAVE HAD REGISTERED TO VOTE AT A MOMENT OF GREAT hope in the black community. He had seen this hopefulness eroded through attempts at repression, including the forced cancellation of presidential voting in Edgefield and a violent Klan raid on his neighborhood, but nothing had prepared him for what he would now encounter. In spite of the warnings of men such as Sheriff McDevitt, neither Dave nor anyone in his community could have foreseen the gravity and extent of the change that lay ahead for them.

The architect of this change was Martin Witherspoon Gary, a former brigadier general in the army of the Confederacy, who had refused to surrender after Appomattox and had returned to South Carolina unbowed. Now, as the 1876 elections approached, he confronted the political situation in his state with the same never-say-die determination. At Oakley Hall, his home in Edgefield, he and others who were like-minded pledged to unseat the Republican governor, Daniel H. Chamberlain, elect war hero Wade Hampton in his place, and return the white Southern elite to power in every corner of the state. Gary's

scheme for accomplishing this, known as the "Edgefield Plan," had a simple blueprint: Harness the anti-black violence that had manifested itself strongly but sporadically in South Carolina since the war and focus it on the single end of keeping freedmen away from the polls on Election Day. Even more simply put: Organize to scare every potential black Republican voter to death.[2]

A slim man with a high, shrill voice, a balding head, and piercing eyes, Martin Gary was known as the "Bald Eagle of South Carolina." Because of his celebrated dedication to the Southern cause, he could count on the new "rifle clubs" of the area for ready support for his plan. Though they claimed to be organized only for the purpose of recreation, their rifles in many cases were outfitted with bayonets. Some clubs, in fact, had evolved directly from the Ku Klux groups of a few years earlier and were fully prepared to carry out whatever acts of intimidation were called for. Club members differed from Klan members in their lack of disguises and their willingness to appear openly at parades, picnics, even balls, but their goals were the same.

There were ten clubs in Aiken County and thirty-five in Edgefield. The commander of one of the groups, the Butler Tigers, was John Cahill, who was married to Lewis Miles's daughter, Sallie. Because Cahill and the other men in his unit lived along the Edgefield-Aiken line, the *Advertiser* admiringly referred to him as a "border ruffian." Cahill, who was originally from Massachusetts, may have come into the community with the railroad, for which he was superintendant. Though he and his sister had married into the Miles family, he perhaps felt it necessary to *prove* that his loyalty to Southern ideals was unassailable. His zeal probably made him someone for Dave to avoid. This would not have been easy to do: They lived only three houses apart.[3]

Just as whites had organized rifle clubs across the area, blacks had formed local militias. The potential for all-out war between these two heavily armed racial groups, each feeling itself threatened, grew alarmingly during this period. It resulted in a clash that took place just twelve miles from Stony Bluff, at Hamburg. The confrontation began on July

4, 1876, the nation's centennial, when a local black politician, Dock (or Doc) Adams, was leading the Hamburg militia in a celebratory drill. The maneuvers of the unit, which consisted of about eighty men outfitted with Winchester rifles, filled the main thoroughfare of the town. When the son and son-in-law of a local white planter, on their way back from Augusta in a buggy, found their way impeded by the drill, they were irate. The road led to their family plantation and they considered it to be theirs. Dock Adams exchanged hostile words with the men before letting them through. After the incident, Adams went to Prince Rivers, who was trial justice at Hamburg, to charge the two men with interfering with a militia drill. The father of the young men retained former Confederate major general Matthew Calbraith Butler, a military hero and prominent Edgefield lawyer, to press charges against Adams for obstructing the highway.[4]

With the two sides drawn up, it immediately became clear to the whites that this incident, as mundane as it was, presented them with a chance to assert their power. We know this and much of what subsequently happened from the extraordinary frank recollections of Ben Tillman, the neighbor of the Mileses and the Landrums at Chester Plantation. It was Ben's father who had bought Louisa from Reverend Landrum's estate, his mother who had purchased thirty Africans from the *Wanderer*, and his older brother, James, who had endured the hardships of the war alongside the Miles boys. Now, in 1876, it was Ben's turn to be at the center of events. Sounding as though he had been fully versed in Martin Gary's plan, he said, "It had been the settled purpose of the leading white men of Edgefield to seize the first opportunity that the negroes might offer them to provoke a riot and teach the negroes a lesson; as it was generally believed that nothing but bloodshed and a good deal of it could answer the purpose of redeeming the state from negro and carpet bag rule."[5]

On Saturday morning, July 8, Matthew Calbraith Butler came to Hamburg for the hearings, as did Prince Rivers, Dock Adams, and about forty of the black militiamen. Butler made two demands: The

militia must give up its arms, and a personal apology must be issued to the young whites who had been stopped on their way through town. Refusing both, Adams and his militiamen barricaded themselves on the second floor of a large brick warehouse alongside the bridge to Augusta. Ben Tillman and the men of his rifle club, the Sweetwater Sabre Club, rode into Hamburg at that time, having been alerted well in advance that they might be needed. Prince Rivers went into the warehouse to talk with Dock Adams and his men. "I tried to avoid a difficulty and prevent bloodshed," Rivers said of the meeting. "I advised the officers of the company to surrender their arms, but they were afraid and refused. They thought they could take care of themselves."[6]

As evening came on, the whites began to fire sporadically on the warehouse, and the blacks fired back. During this desultory exchange, McKie Meriwether, a nineteen-year-old white youth who was standing near the bridge, was killed by a stray minie ball through the head. Prince Rivers later told his young son, Joshua, that with Meriwether's death the battle was truly on: "White men was comin' into Hamburg on every road," Joshua remembered him saying, "and linin' up to fight. They come from Aiken, Edgefield, and Augusta. They was armed wid shotguns, rifles, revolvers, hatchets, axes, grubbin' hoes, or whatever they could pick up." More important, they brought with them an aged cannon, which they fired into the warehouse. Though it did little damage, it drove the defenders of the building to the basement. Several tried to escape through back windows, but they were shot down and one or perhaps two of them were killed. The whites stormed the warehouse and captured those who had not fled. One prisoner was brought to Butler, who demanded, "Are you one of the damned rascals?" Someone shot the man, wounding him in the back, just as he answered, "Yes."[7]

In search of others, whites went door-to-door through the town. They broke into buildings with axes and pulled out men hiding in crawl spaces beneath floors or in cellars. When there was no one left to be found, Butler designated Ben Tillman and several others to take the prisoners—there were approximately thirty-five now—to jail in Aiken.

According to Tillman, there was some grumbling after Butler departed. At issue was "whether it was not a dear piece of work for us to lose one of our best men and have only two negroes dead and another wounded. . . . [W]e could not have a story like that go out as the record of the night's work." Henry Getzen, who was one of the brothers-in-law at the origin of the affair and knew many of the prisoners, was asked to examine the men and point out the meanest and most deserving of death. One by one, five were pulled from the group and shot to death. Ordering the remaining thirty to run, the whites began to fire on them. Three more were wounded. "It was now after midnight," recalled Tillman, "and the moon high in the heavens looked down peacefully on the deserted town and dead negroes. . . ." As they made their way back to Edgefield County, Tillman and several of the others made a stop at Getzen's home to eat watermelon and celebrate the success of the night.[8]

Newspapers across the nation picked up the Hamburg story and strongly denounced the brutality of white South Carolinians. Republican governor Daniel Chamberlain called the affair the "Hamburg Massacre" and asked that federal troops be once again stationed at the courthouses of Edgefield and Aiken. White voters, who had seriously considered supporting Chamberlain in a "fusion" government, saw his action as traitorous and proof that no cooperation between parties was possible. Overnight, they shifted their support to Wade Hampton. In this way, the simple traffic misunderstanding at Hamburg, skillfully and tragically manipulated, served to launch Martin Gary's plan to sweep Radical rule from South Carolina. Ben Tillman said that the Hamburg affair was "more far-reaching in its influences upon the fortunes of the white people of South Carolina than anything of the kind which has ever occurred in the state."[9]

Dave and his kinfolk must have been dismayed when word of the slaughter at Hamburg reached them. Because black militias drew recruits from the surrounding countryside, it's possible that men from Stony Bluff and Miles Mill had been witnesses to the slaughter. Perhaps Dave even knew some of the victims. He and Mark and Caroline and

the others in his kinship colony must have banded even more closely together in the face of this new danger. They lived in small wooden cabins in the country, easy prey to men of the rifle clubs. Perhaps they set up a warning system. One Edgefield black, Mrs. Mamie Rearden, who was 105 years old when I visited her, showed me a large bell that her family had mounted on a stand in the yard of their house generations ago; when danger came, in whatever form, the women would vigorously ring the bell to bring the men running in from the fields.

In early August, an all-black grand jury met in Hamburg and indicted seventy-eight whites, including General Butler and the entire membership of the Sweetwater Sabre Club, for the murders of July 8. The club members, in preparing for their appearance in court, determined to follow the example of whites in Mississippi who had worn uniforms that included red shirts during a recent and successful effort to regain power. Ben Tillman was sent to Aiken to acquire similar garments. The ladies of the town were able to dye homespun cloth with pokeberries and sew up the shirts in time for the men's hearing. On September 5, the defendants, all identically dressed, pistols in their belts, rode together into Aiken. One thousand mounted men accompanied them. The entire Aiken bar stepped forward to defend them. The no-doubt flustered judge postponed the hearing until after the election, allowing the Red Shirts, as they would be known from that day forward, to return triumphant to their homes.[10]

The distinctive red shirts, in spite of their humble pokeberry origin, gave the impression of a great movement on the rise. Rifle clubs across the state understood the effectiveness of the uniform and quickly adopted it. Long columns of mounted Red Shirts accompanied Wade Hampton when he made an historic sixty-day pilgrimage through South Carolina, appearing before enthusiastic crowds in every county seat. Though Hampton gave orders that no efforts to win votes for him should rely on violence, Martin Gary had other instructions for his followers: If a Radical is troublesome, he said, "the necessities of the times require that he should die." As if in response to this directive, a group of

men bashed through the door of the home of Silas Goodwin a black Republican who was active in Edgefield, and shot him to death. "God damn you," one of the killers said, "you was bragging about how you was going to vote, but now vote if you can." Ben Tillman acknowledged that such extreme actions might appear "a ruthless and cruel thing to those unacquainted with the environments [but the] struggle in which we were engaged meant more than life or death. It involved everything we held dear, Anglo-Saxon civilization included."[11]

In a surprising twist, some black men chose to join the Red Shirts. They may have done so to protect themselves, or they may have sincerely believed Wade Hampton's message of "Reconciliation, retrenchment and reform." Although were such blacks welcomed by the whites and held up as proof that Hampton was the friend of the Negro, they were bitterly resented in their own communities. Some were beaten and even turned out of their churches in examples of intimidation almost as severe as that meted out by the rifle clubs. No one knows how many black Red Shirts there were. Even at the time, estimates varied considerably. At a parade of sixteen hundred Red Shirts in Edgefield, a Democratic reporter counted more than two hundred mounted blacks, although a Northern correspondent saw only nine.[12]

I suspect that Dave met the rise of the Red Shirts with a tactic he was already familiar with. Recognizing that this was not the time to exhibit his mastery over words, he could have once again donned the protective illiteracy he claimed in his entry on the 1870 census. There are no known pottery inscriptions from that time, when the Ku Klux held sway, and there are none from the time of the Red Shirts, perhaps a sign that he continued to keep his hand far away from the sharp stick he once used for writing on clay. The severity of the situation he faced is indicated in a letter written on April 7, 1877, by Martha Schofield, a young Northern woman who had started a school for blacks in Aiken: "No time since 1865 have I seen so much bitterness towards the colored people . . . they have been so hunted down since the Hamburg Massacre that they are as timid as wounded Deer."

Because Dave's new county was promoting itself as a winter resort for wealthy Northerners—these efforts would soon attract Astors, Vanderbilts, Whitneys, and an untold number of polo ponies—it was important for white area leaders to tamp down news of racial conflict. Rev. Everett C. Edgerton, pastor of St. Thaddeus Episcopal Church in Aiken, took it upon himself to write the *New York Daily Tribune* and inform its readers that all was well. He told them that he knew of only one rifle club in town, and it was purely for social purposes. He had heard of no organization whose goal was to deter blacks from voting. The paper headlined the letter "South Carolina at Peace. . . . No Intimidation. . . . Good Feeling between Whites and Blacks."[13]

ONE NIGHT DURING MY STAY in Edgefield, I saw a red shirt that had actually been worn by one of Martin Witherspoon Gary's men. It was at an event sponsored by the local chapter of the Sons of the Confederacy in honor of the local chapter of the United Daughters of the Confederacy. I had been invited because of my interest in Edgefield history. The setting for the event was the mansion that had once belonged to Gary. Though it is now a house museum called Oakley Park, it is also known in this area as the Red Shirt Shrine, in part because of Gary's intimate involvement in the movement and in part because hundreds of Red Shirts rallied on its deep, triangular lawn the morning of the 1876 election. The mansion stands at one end of Edgefield's long, straight Main Street, facing the courthouse at the other. The grand porticoes of the two buildings sit like neoclassical bookends holding everything in place.

Having learned that people arrive early in Edgefield, especially when food is involved, I drove up to Oakley Park a good quarter of an hour before the evening's activities were scheduled to begin. It was dark and raining lightly as I climbed the wooden steps to the veranda and pushed open the front door. I stepped into a wide, warmly lit entrance hall to find Sons and Daughters already gathered in force, perhaps forty of them in all. Though they were casually dressed, there was a decidedly

festive air about them: Enameled medals and silver palmetto-tree pen-
dants—the palmetto is the state tree of South Carolina—were much in
evidence. One of the Sons, a fan of Edgefield pottery, came forward to
welcome me. He was delighted, he said, to have a direct descendant of
Lewis Miles at the gathering.

Right on time, four Sons, each bearing a flag, emerged from the far
end of the entrance hall. As they stood at attention, we were ushered
into an intensely pink dining room. A long, polished table that sup-
ported silver candelabra occupied the center of the room; white lace
curtains covered windows that extended from the ceiling to the floor. In
front of the windows stood two banners, the American flag on one side
and the flag of South Carolina on the other. A short, dapper man took
charge. In addition to medals and pins, he wore a necktie printed with
infinite repetitions of the Stars and Bars. At his signal, the flags waiting
in the hall, whose significance I never quite grasped, were marched into
the room and positioned at equal intervals between the two that were
already in place. In unison, we pledged allegiance to the United States
of America, to the State of South Carolina, and finally to the Confeder-
ate States of America. I had to demur on the last pledge, having never
heard it in my life, as far as I could remember. I was able to redeem
myself when we then sang "Dixie," every word of which had been
drummed into me when I was a child. On the tail of the last note,
someone actually gave a rebel yell. It wasn't up to those that struck fear
at Manassas, but it would do. I have to say that this scene—in the very
room where Martin Gary plotted against carpetbaggers, in front of win-
dows that once looked out on cheering Red Shirts, under a blazing crys-
tal chandelier, with six banners and more Stars and Bars than I could
count—was one of the most vivid occasions I have witnessed. To top it
off, the person who had welcomed me earlier stepped forward to
instruct those present on what an honor it was to have me, a direct
descendant of Lewis Miles, among them—and they applauded!

When I could, I slipped into a small room off the main hall to give
myself a moment to think through these impressions. It was there, just

inside the door, that I came face-to-face with the shirt once worn by one of Gary's men. Kept in a glass display case mounted on the wall, it was made of rough material. A little drab, its color would have been much more vivid when the shirt was first pulled on and paraded out in the sun. Still, as I stared at it, I could feel its power. An older cousin had told me that at least one member of our family wore a shirt like this one. The wearer was Melvin Flavius Wharton, known as "Mel," and he was married to Franklin Landrum's daughter, Mattie. As dedicated a supporter of Wade Hampton as one could want, Mel was likely among the Red Shirts who gathered in front of Oakley Park. For an unsettling moment, I reveled in imaginary applause: I was not only related to Lewis Miles but to the outstanding Red Shirt Melvin Flavius Wharton.[14]

How seductive all this was! Yet I knew that the story of the Red Shirts on Election Day 1876 was a complex and violent one. I went out into the entrance hall and made my way through the crowd to the front porch of the mansion. The dark lawn stretched before me. It is estimated that up to eight hundred Red Shirts, many of them on horseback, gathered there at dawn on the day of the vote, completely filling the grounds. Gary, wearing a Confederate greatcoat, cavalry boots, and a brace of pistols in his belt, appeared on a balcony—it was just above where I stood—to rally his troops. He then led them en masse down the driveway to the street. Shouting the campaign slogan "Hurrah for Hampton!" they followed him to the square. Their destination was the courthouse, which, in a last-minute agreement, had been designated the voting place for whites.[15]

Three poll managers were waiting at the courthouse, one white and two blacks. One of the blacks was Abram Landrum, who had been owned before the war by Reuben Landrum, a brother of Abner and John. Abram, a founder of the local Macedonia Baptist Church, was a greatly respected member of the black community. As he later recounted in a sworn affidavit, the voting box was supposed to have been placed in the ground-floor archway of the courthouse, but the sin-

gle white manager, whose action may have been given weight by the double-barreled shotgun he brought with him that morning, took the box on his own initiative into the courtroom on the second floor of the building. It could now be reached only by climbing the steep flight of stone steps that led up from the square. To make sure that recognized Democrats had sole access to the box, armed men crowded round it.

After the Red Shirts arrived and voted, they too chose to guard the premises, so that the entire entrance to the courthouse, steps and all, became tightly packed with men. When acceptable voters approached, they had to be lifted bodily and handed overhead all the way up into the courtroom, there to be deposited beside the ballot box. Despite this, Democrats voted enthusiastically and, in more than a few cases, voted again. Abram Landrum and his colleague vigorously protested these proceedings and attempted to leave. The armed men around them, knowing that the absence of the two managers would invalidate the results at that venue, made them virtual prisoners. Energetic Mel Wharton claimed that he cast his ballot six, maybe seven times by going from polling place to polling place.[16]

A few blocks away in the Macedonia church neighborhood, a small schoolhouse had been designated the location for blacks to vote. There, however, the scene was even more chaotic. An account of what happened comes from a letter written by Mrs. Kellogg, the wife of a United States Army officer stationed in Edgefield. Empassioned, she began, "Is there a God in Israel? . . . I pray that you may never see [what I have seen] and that I may never again." She told how the Red Shirts, "armed to the teeth with shot guns, rifles and pistols," surrounded the school-house and would allow no black man to get inside to vote. "Two or three hundred [Red Shirts] jammed in on horseback close around the door, with pistols drawn and cocked, swearing and cursing. . . . They were threatening the negroes with drawn pistols at their heads, and knocking them over with pistols and clubs. . . . They were trying to provoke some poor negro to strike back. . . ." Soldiers commanded by Mrs. Kellogg's husband were able to clear a path to the voting box only by going in the

side windows of the schoolhouse and coming out the front door to push back the crowd.¹⁷

Voting at Macedonia started so late and was made to proceed so slowly that it soon became clear that the polls would close before most of the blacks got their turn. In a group of perhaps two hundred, they began walking across town toward the courthouse, in hopes of voting there. When they reached the square, they found their way blocked by hundreds of horsemen lined up in tiers before the building; beyond the horsemen, the high front steps and columned entrance porch remained packed with Red Shirts. The commanding officer of the federal troops, Gen. Thomas H. Ruger, ordered Martin Gary to let the blacks inside to vote. Gary's shrill voice rang out across the square: "By God, sir, I'll not do it!" Seeing rifles trained on them from the upper windows of the Masonic Hall, the black delegation turned and retreated. Paris Simkins, who witnessed what happened that day, said Democrats were galloping from box to box, yelling and brandishing their pistols. "I [knew] that if I voted the Republican ticket," he said, "I would be murdered."¹⁸

I wonder whether Dave ventured out of his anonymity on that tumultuous day and attempted to vote. As a resident of Aiken, he wouldn't have come to Edgefield Village. Because he lived so near the county line, however, he might have stopped in to test the waters at the Landrum Store Precinct, an Edgefield polling place that was, I believe, close to his home. One of the two Republican managers of the precinct was a black named Aaron Miles, who had probably been owned by the Miles family before emancipation and might have been an acquaintance of Dave. The Democratic manager, however, was Ben Tillman himself. If Dave and, say, Mark Jones arrived in a wagon at the Landrum Store that morning, they would have found a disturbing scene. According to later testimony, Tillman used veiled threats to cause Aaron Miles to flee; in his place, a "whooping and halloing" group of armed white men gathered. When another freedman made a move to distribute the Republican ballots, the men warned him that if he came any closer to the box, he would "come through blood." Tillman announced that

whites "had been the rulers of Carolina and they intended to rule it."
The events at Landrum Store Precinct—and at almost any other polling
place that Dave might have gone to that day—were simply smaller ver-
sions of those that took place in Edgefield Village.[19]

The Red Shirts were so successful throughout Edgefield County
that the total number of votes cast for the Democratic ticket exceeded
the total number of voters registered by both parties. Though this over-
all tally was officially declared fraudulent, two legislative delegations
from the county, one Democratic and one Republican, managed to
obtain certificates of election from different authorities. They both
showed up in Columbia to join the General Assembly, which, because of
the voting irregularities, was now charged with selecting the governor.
In the struggle that followed, *two* Houses of Representatives were estab-
lished and *two* governors were elected, Chamberlain by the Republicans
and Hampton by the Democrats.

At the same time, the federal government also found itself in crisis,
for Samuel Tilden, the Democratic presidential nominee, was one elec-
toral vote short of victory, with twenty-two votes (including seven from
South Carolina) still in dispute. It was time, it seemed, for a deal. One
interpretation of what transpired is that Southern Democratic con-
gressmen shifted their support to Republican candidate Rutherford B.
Hayes in exchange for withdrawal of federal troops from the South.
When soldiers subsequently marched away from the South Carolina
statehouse, Chamberlain was left without support and Hampton offi-
cially became governor. It was a triumph for Martin Witherspoon Gary,
Matthew Calbraith Butler, and the Red Shirts. Ecstatic whites called
the moment "Redemption."[20]

Blacks were profoundly disheartened. "There is certainly a great
change in the negro population," wrote a white South Carolinian in
1879, ". . . I think their political aspirations are nearly if not entirely at
an end." Many of the blacks who had held political office during Recon-
struction simply disappeared from the scene. Prince Rivers remained a
familiar figure in Aiken, though as a carriage driver, as he had been

when he was a slave. The local newspaper described him this way: "Attired in his livery suit and tall beaver hat, as driver for Mr. Wm. C. Langley, he looked like a piece of statuary, so erect in form was he." Rivers made an effort to explain all this to his young son, Joshua: "He say conditions change, much, since 1876," his son remembered: "When, de nigger 'spect he was as good as anybody." The black people of South Carolina, including Dave and his children and grandchildren, found themselves at the beginning of a new and long period of disenfranchisement.[21]

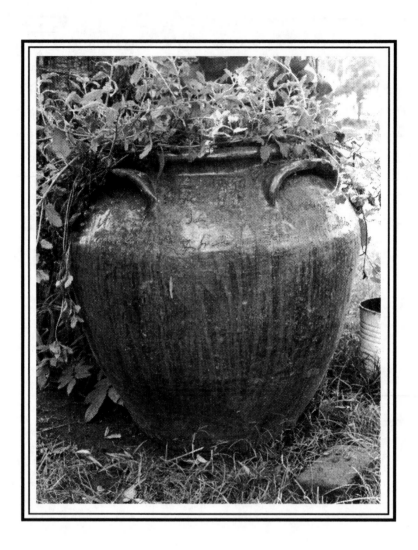

CHAPTER XV *Echoes*

*If I could speak to anyone in American
history, it wouldn't be George Washington.
It would be Dave.*

— SHARON BENNETT,
ARCHIVIST AT THE
CHARLESTON MUSEUM, 2002[1]

By THE 1870S, WHEN HE WAS IN HIS SEVENTIES, DAVE HAD worked as a potter longer than most men of his time had lived. He could have had a number of physical ailments as a result: arthritic hands from constantly working in cold clay, a bad back from lifting heavy materials, shortness of breath from inhaling silica dust. "An old potter back then," Steve Ferrell has told me, "could have been in pretty bad shape." Even so, in a story told in 1930 by the turner George Fletcher, Dave sounded healthy, if a bit in need of a rest. "Old Dave used to sit around the place dozing," Fletcher recalled, "and one day a goat came up and when Dave's head would drop over and jerk back the goat thought Dave was bantering him and that goat just backed off and rammed him, knocking him off his seat. Dave always said that somebody hit him with a plank, and never would believe that a goat did it."[2]

If the entries for Dave in Lafayette Wever's ledger are an accurate reflection of his work habits in his old age, he now turned pots only when he wanted to or needed to in order to pay his bills. At those times, he would probably have been welcomed in the shop of Lewis Miles's

son, John, who had taken over the Miles Mill pottery after his father's death. There were several other potteries in the area, as well, enough so that Dave would have been able to support himself as long as his health remained good. However, something happened between 1873, when the *Advertiser* described him as "alone with his glory and his jugs," and 1880, when his name failed to appear in the federal census listings. Mark and Caroline Jones and their children were shown on the census living in approximately their same location of a decade earlier, but Dave was not with them. The immediacy of his poems and the freshness of his pottery had often given me the impression that he was still very much alive, even today, but the truth is that Dave must have died at some point during those seven years.[3]

Hoping that the collective memory of the Springfield Baptist Church, located near the sites that Dave had known, might hold information about him, I telephoned Rev. Leander Jones. He kindly arranged for me to meet with four of his deacons one Sunday morning in a room behind the sanctuary of the church. There, I asked them if they had ever heard the old people in their families speak about a potter named Dave who worked for the Landrums and then the Mileses. "He lived and died in this area," I said, "the best potter anyone around here had ever known." Reaching as far as they could into what their mothers and fathers and grandparents had told them of the past, they tried to recall some mention of him. Elijah Blocker, the man who had led me into the church when I first came there, was the oldest among them, but even he was born a good fifty years after Dave died. Still, he had heard the name Lewis Miles when he was a boy. He said, "Yeah, Lord, heard my mamma talk about old man Lewis Miles. Don't remember what she said about him. Nooo, children hear talking, but . . . 'Old man Lewis Miles.' That been *long* time ago!" The emphasis in his words made me understand how difficult it was for memory to survive such a stretch of time. Dave had been separated from that room full of good men for so long that no one, not even Elijah Blocker, could remember ever hearing a word about him.[4]

Still hoping to find some echo of Dave, I visited a number of other elderly black Edgefieldians, several more than a hundred years old. They and their children welcomed me into their homes and made every effort to help me. In some cases, their powers of recall were excellent, but most of them knew little about the pottery that was once made in the area, only that their parents had used stoneware churns when they were young. And none of them had ever heard of Dave before his recent renown, Pottery historian Cinda Baldwin had conducted a similar series of interviews in 1987, but even then the information she was able to glean about pottery production in the old days was sketchy. Now, seventeen years later, such information seemed to have vanished almost entirely.

One day, though, while I was attending a celebration on the grounds of Bettis Academy, a fine black school that Rev. Alexander Bettis had founded near Miles Mill after the Civil War, I met Mrs. Thomasina Holmes Bouknight, who had attended the school as a young girl. When I discovered that she was born in 1916 only a few miles from where my family lived, I asked her, almost automatically now, whether she had ever heard of a potter named Dave. She furrowed her brow. "Dave," she said, "now, that name . . ." To my amazement, she began to recall, piece by piece, an incident from her childhood, not thought of for decades, that centered on what must have been one of Dave's last and grandest pots. Here's the story that she told me.[5]

When I was growing up, my mamma had a big pot out in the yard, a big, big old pot. She always told us children not to do anything to it, that it was special, that it was made for her by a man called Dave. "Mr. Dave made that pot for me," she told us, "now don't you lean up against it, don't you break it!" We always paid attention to what Mamma said, 'cause she had a long switch and she'd pop you with it. She popped me many a time. She could just look at you and it would happen!

Our house sat parallel to the road. The walkway to it started out at the road, then split in two; one half went to the front door

on the left of the house and one went to the kitchen on the right. The two walks were marked off with bricks and stones, though not many bricks 'cause we didn't even have a brick chimney back then. There was a verbena bed in the area between the walks, and that's where the pot sat, right in front of the red verbena. We called it "Dave's Pot." I remember that there was writing on it, though I don't remember what it said. I used to go over the letters with my finger. I was too young to write, myself, but I could trace what he'd written.

We used to play Ring-Around-the-Rosie around that pot. We made up a little rhyme with the words "Dave" and "slave" and "cave." We knew about the Indians living in caves. I can't remember how it went. And we'd run in a circle around the pot singing it. Sometimes we'd sing, "Peas porridge hot, Peas porridge cold, Peas potteridge in the pot nine days old!"

One day Mamma went off and left my sister in charge of my twin brothers, Hickman and Hezekiah. Everybody called them "Hick" and "Hez." They were little old bitty things, maybe two years old. I don't know how it happened, but they got inside that pot. Maybe my sister put them in there, so they wouldn't run around, I don't know. But, somehow, one of the older boys hit that pot, maybe with a hoe handle, maybe to scare Hick and Hez—and it broke. To pieces. Mamma came home and—Ohh, Lord!—she whipped us for it. All of us. 'Cause she had told us not to touch that pot. I can't remember if she put it back together. I know she saved the pieces.

Mrs. Bouknight's mother was Mrs. Essie Key Holmes. She was the first child of Mrs. Louisa (Lousa) Tillman Key and Rev. Berry Key, who became pastor of Mt. Sinai Baptist Church. According to the family Bible, Essie was born on May 23, 1879. Dave would have been about seventy-eight then. He could have made the pot to celebrate her birth, which was perhaps the reason she cared for it so deeply. If so, this story

brings him closer to us than any information has before. For that and many other reasons, I'm grateful for it.

It appears, then, that Dave probably died in the late 1870s, at the end of the freedom that came with Emancipation and at the beginning of the new bondage that began with Redemption. Because this was not a prosperous time for blacks in Edgefield and Aiken, his family members probably could not afford to purchase a marker for him. It's likely that they marked his grave instead with pieces of broken crockery, which was a custom in much of the black South at that time. Some historians have made an effort to link this practice to West Africa, where shattered vessels on a grave were said to represent the destruction wrought by death.

Several Edgefield blacks, however, have told me that the custom, as they knew it, had much more practical origins. Mrs. Janie Thurmond Dunbar said, "The families were just trying to mark the grave. And they used what they had. If this was your bowl at home and it broke, you took a piece of it to the grave site and you knew that this was your people." Mrs. Patria Brayboy said, "They didn't have money to buy tombstones, so they would decorate the grave with a broken cup or saucer that the dead person really loved, that he drank his coffee from. Anything pretty like glassware. If it wasn't broken, they broke it, so it would stay there. Because the people will come out and take them." Dave's grave might, in fact, have been covered with sherds of a jar that he himself had made. Perhaps his final marker was a fragment of stoneware with "Dave" written on it in his own hand.[6]

Dave's grave probably soon disappeared. Lewis Miles's grave, as it turned out, lasted only slightly longer. It seems that word got out about the little pots that Dave had made for Lewis to bury gold in. Family members found several of them after he died, which no doubt helped them through the lean period following the war. Ben Landrum found two that held several hundred dollars' worth of gold. News of these discoveries, probably exaggerated with each retelling, must have spread to Lewis's grandchildren in Denver, Colorado, because in about 1907 they

journeyed east to Edgefield to prospect for their share of the riches. Thinking that their forebear might have carried gold with him into the grave, they convinced one of Lewis Miles's former pottery slaves, Jack Thurmond, to take them to the family cemetery and disinter him. The white turner George Fletcher, who later told the story, joined the party. It must have taken place at night, furtively, with torches lighting the way.

What an image: greedy relatives and a onetime slave invading the tomb of the king of potters. They found my great-great-grandfather's bare bones, but not a bit of gold. Jack Thurmond, in an effort at macabre humor, said he could tell it was his old master by his bald head.[7]

IN MARCH 1875, a terrible tornado swept into Edgefield County from Georgia. A man who saw it as it crossed the Savannah River said it filled the air with shingles and limbs of trees, whirling along at a tremendous speed. It destroyed nineteen buildings at Sophia Tillman's plantation and went on to cast debris—"bits, fragments and ruins," the *Advertiser* said—across the countryside for twenty to thirty miles on either side of its narrow track. When it reached the neighborhood of Miles Mill, it savagely laid waste to it. The still visible ruins of Rev. John Landrum's house look as though they were thrown down by such a catastrophe. If the tornado of 1875 didn't do it, the great Charleston earthquake of 1886, which shook houses as far away as the Horse Creek Valley, certainly could have.[8]

Though less apparent at first, equally dramatic changes were simultaneously taking place in the Edgefield pottery industry. Fewer and fewer people were buying the kind of vessels that Lewis Miles and Franklin Landrum and Dave Drake once produced by the hundred. Without vast slave forces to feed, plantation owners no longer needed large stoneware containers; with the advent of glass Mason jars and tin canisters, they no longer needed small ones either. Some stoneware manufacturers in the area abandoned Abner Landrum's alkaline glaze and began to use slip glazes, which were prepared by simply mixing clay with water. Some gave

up hand-turned stoneware altogether in favor of molded flowerpots and bricks. The great Edgefield stoneware tradition, which Dave had been part of from its beginnings, was coming to an end.[9]

Perhaps to hold on to a bit of what was quickly disappearing through social change and natural disaster, the Landrum family retrieved the tombstone of Reverend John from its original site near his home and put it on the porch of the house that his son, Franklin, had built. Franklin died about 1880. As the family remembers it, he had worked out in the fields in the morning, even though he was nearing seventy. He came in for lunch, lay down, and simply never woke up. His son, Ben, continued the family pottery until 1902, when he gave it up because all his old potters had died. When the Landrum house was taken down in the 1950s, descendants moved Reverend John's maker again, this time to Willowbrook Cemetery in Edgefield, where many other prominent historical figures from the district lay.[10]

The Miles family experienced severe financial difficulties in the years after Lewis Miles's death. Because he had been deeply in debt when he died, his executor, Lafayette Wever, was forced to sell off almost all of his landholdings to satisfy creditors. At Mary Miles's request, however, the court ordered that a portion of the land in the "Mill Tract" be retained to compensate her for the dowry she had brought with her when she married and to provide her with a homestead. It included "the Mill and Jug Factory, on the Charlotte Columbia and Augusta Rail Road adjoining Lands of B. F. Landrum . . . & others," which was the area known as Miles Mill. John Miles continued the pottery there at least through 1880, as indicated on the federal census for that year. At some time after that, he left Edgefield to go west, as many in the family had before him.

In 1885, John's brother-in-law, John Cahill, the "border ruffian" from Red Shirt days, formed the South Carolina Pottery Company, which produced a wide range of ceramic ware, including molded pieces decorated with raised images of birds, flowers, and nautical motifs. A series of forest fires and a break in the dam—probably the dam con-

structed in Reverend John's time—made it difficult for the new company to succeed, and Cahill ultimately went west also. I found his grave beside that of John Miles in Minden, Louisiana, just past Mt. Lebanon. They must have done all right without pottery, because the communal granite marker over their plot gives the impression of something approaching a comfortable prosperity. The markers of their Drake cousins, who had gone to Louisiana more than a half century before, were only a few yards away in the same cemetery.[11]

My great-grandparents, America and Lafayette Wever, left Edgefield in about 1871. Instead of going west, however, they traveled southeast to a large tract of land they had acquired in Rocky Ford, Georgia, which was about halfway between Augusta and Savannah. They named their new plantation home Pine Lawn. They still maintained their Edgefield ties, especially with America's sister, Sallie Cahill, and they still relied on Edgefield pottery. In July 1885, when my grandfather Frank Wever, just nineteen years old, was visiting the Cahills, his mother wrote him with a request to renew her pottery supply: "Do ask Johnnie if he can make those jars I wanted to put up fruit in. Let the mouth be about as large as a large mouth pickle bottle, I want two dozen, half gal." As Lewis Miles's daughter, she knew precisely how to specify pots.[12]

America wanted flowerpots, too, an indication that she and Lafayette were trying to establish in Rocky Ford the attractive life they had known before the war. From sad, pleading letters, I know that they did not succeed. Lafayette died in 1890, worn out from unsuccessful farming. After his death, America came to Savannah to live with her son. Frank. She brought with her the letters and account books and agreements with former slaves have helped me fill in the pieces of Dave's life.

Many of the black men and women who had been slaves in the pottery factories continued to work in them during the last quarter of the century, in some cases joined by their now grown children. In 1880, up to ten were employed at Miles Mill by John Miles; up to eleven worked at that time for Ben Landrum; six worked for a black entrepreneur

named Wash Miles, who owned a pottery on Shaw's Creek. Also on Shaw's Creek was the Seigler factory, where Oliver Miles, the mulatto son of one of the Mileses, worked. He was there when it closed in about 1898, as were two other men who had been close to Dave—Mark Jones, who was perhaps Dave's son-in-law, and Mark's son, Brister Jones.

Mark was about fifty-nine years old when the Seigler factory closed by 1910, he was blind and living with his daughter Emma Adams and her family in Gregg Township, south of Stony Bluff. Mark's blindness could have come as a result of his work, for potters sometimes damaged their eyesight by looking directly into the kiln to check on the progress of a firing. Along the way, Mark became a preacher. I wonder whether he took Dave, with his intensely religious verses, as his model. I can picture a blinded Mark holding up a pot in a dramatic gesture, the kind that Southern preachers use so well, and exhorting his listeners: *I made this jar all of cross. If you don't repent, you will be lost!*[13]

Dave's influence is evident in the pots that Mark's son, Brister, made at Seigler's. One of Brister's pieces, a beautifully crafted storage jar about sixteen inches high, turned when he was twenty-one years old, has recently come to light. In addition to a stamped oval containing the words "G. P. Seigler, Trenton SC," this inscription is on the jar:

> *Brister Jones*
> *The maker*
> *Sept the 6 1880*
> *It Will hold*
> *inny thing that*
> *you can get in it*

Brister made no attempt to create a rhyming couplet here, but his witty words are very much in the spirit of Dave's lighter verses. It's easy to understand how Brister could have been influenced by the older potter, because he had lived in Dave's household from the time he was a child. The form of the jar and its inscription are so similar to Dave's, in fact,

that they amount to a kind of homage, Brister's way of honoring the man who may well have been his grandfather.

As the Edgefield pottery tradition came to an end, the formulas, techniques, names of the turners, even locations of the kilns began to be lost. Even Ben Landrum, when he walked with his grandson past the site where his family's pottery had stood, never spoke to him of it. What was over, it seems, was over. By February 1919, when Capt. Samuel G. Stoney gave the Charleston Museum a huge stoneware jar with incised writing on it, the staff was mystified. They had no idea what it had been used for, and they were baffled by its inscriptions. On one side was written the date, May 13, 1859, along with the name of the maker, who appeared to be someone named Dave Baddler; on the other side was a sentence that could be deciphered only in part. Paul Rea, the museum's director, put the jar on display with an accompanying label that asked the public for help on both matters. This simple request was the beginning of the effort to reconstruct the story of Edgefield pottery—and the story of Dave's life, so central to it—that has occupied scholars, archaeologists, and pottery lovers ever since.[14]

Though the mysterious jar caught the interest of visitors, only J. M. Eleazer, a county agricultural agent who came to the museum with the South Carolina Boys' Agricultural Club, was able to offer any useful information. He wrote Paul Rea on April 15, 1919, that he knew of another jar similar to the one in the museum's collection. Owned by Frank T. Carwile of Ridge Spring, a town about twenty miles east of Edgefield, it was dated May 13, 1859, just as the museum's jar was. The owner's elderly mother had told Eleazer that such jars were used keep and store fresh meat. The inscription on the Ridge Spring jar bore this out.[15]

Great & Noble Jar
hold Sheep goat or bear

The cover of the museum's bulletin for April jubilantly announced that the "Puzzle of the Jar" had been solved. Inside the publication, Paul

Rea reprinted Eleazer's entire letter. Not only was the purpose of the jar now clear, the director wrote in an accompanying commentary, but, thanks to a distinct signature on the second jar, its maker was also known. It was not Dave Baddler, as originally thought, but Dave *and* Baddler. Soon after receiving the letter, Paul Rea traveled to Ridge Spring to see the Carwile jar. He measured it carefully and found it to be nearly a duplicate of the one in the museum's collection. In June 1920, the Carwile family loaned the second vessel to the museum, where it can still be seen with its twin. They are, of course, the two wonderful jars that Dave and Baddler, using turning and coiling techniques, made after the death of Dr. Abner Landrum.[16]

Not the least of the secrets revealed by the Carwile jar was the fact that Dave wrote in verse: "bear" rhymed with "jar." With this in mind, the staff of the museum was now able to read all but one word on the original jar:

> made at stoney bluff,
> for making ____ enuff

"We hope it will not be long," wrote Paul Rea, "before the missing word will be deciphered. Not only have the members of the Museum staff been puzzled over this problem for weeks, but people about the city have asked from day to day whether we have had any success."[17]

At some point over the years, it was decided that the missing word was "lard," and the line in which it appears has since been read as "for making lard enuff." Unfortunately, this reading leaves several letters unaccounted for. When I went to Charleston to view the jars, I took an unofficial turn at deciphering the inscription. This was not easy to do, for the powerful overall impact of the jars displayed one above the other in a glass case, makes searching out details difficult.

I studied the wording of the "stoney bluff" inscription close up, far away, glasses on, glasses off, just as those early visitors to the museum must have done. The second line did indeed contain a string of separate letters that seemed to make no sense at all. The first in the series was a

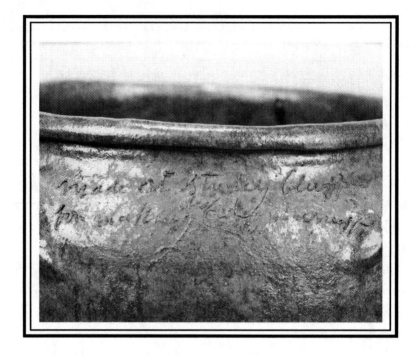

large curved mark combined with a strange curlicue. As I puzzled over
it, I checked the Carwile jar and saw that there was a similar combina-
tion of mark and curlicue in its inscription. There, the combination
appeared to represent an elaborate way of writing "or." Though less easy
to read in the mystery inscription, it might surely signify the same thing.
And if that were true, the remaining letters in the series would be "a-d-
g-i-n," in that order.

Suddenly, I was able to read what Dave had written:

> made at stoney bluff,
> for making or adgin enuff

At least I *think* that's what he was saying! Ageing was part of the curing
process for meats—J. M. Eleazer himself said that the jar was meant for
"curing and keeping meat"—and I think that Dave's slightly misspelled

word refers to that process. That's my entry, at any rate, in the museum's long-running guessing game.[18]

The director who followed Paul Rea at the Charleston Museum was a fascinating woman named Laura Bragg. Gray haired and beautiful, born in Boston, she had been deaf since the age of six. She became passionately interested in the strange pair of jars from Edgefield that were on display at the museum. Starting in 1929, she made repeated expeditions into the upstate to seek information on the potteries that had once existed there and to collect outstanding examples of their ware. On one trip, according to the husband of her traveling companion, Miss Bragg bought "a really fine lot of Carolina pottery. . . . One jar bore an inscription by the 'unknown potter,' a negro named DAVE, who appears to have been one of [the] most expert potters." This inscription may have been the one I originally found so startling, "Dave belongs to Mr. Miles," which is on a jar in the museum's collection. In Edgefield, Franklin Landrum's granddaughter, Rebecca Benjamine Steele, and her sons showed Miss Bragg's party the pottery sites. Mattie Wharton, wife of the family's Red Shirt, Mel Wharton, outlined the various generations of the Landrums and the Mileses for the visitors, or, as the *Charleston Evening Post* reported, "straightened out the history."[19]

It was on collecting trips in 1930 that Miss Bragg and E. B. Chamberlain, a curator at the museum, found Carey Dickson and George Fletcher, who both told them what they knew about Dave. They invited Fletcher, who had worked at a number of the potteries, to come to Charleston to examine the pieces they had collected. In July of that year, Fletcher went over more than fifty examples, explaining their glazes, pointing out slash marks that he said represented capacity in gallons, and identifying the makers of the pots. Careful notes on all he said, taken by a staff member in shorthand and subsequently transcribed, documented this early attempt to understand the complexities of Edgefield pottery.[20]

Though Dave had been identified now, and a few bits of informa-
tion about him had been assembled, it was only in the late 1960s that
his story really began to take shape. Edgefieldian Carlee McClendon
discovered the "buttermilk" article on him in the *Advertiser*, which
linked him to Pottersville and to Dr. Abner Landrum. To bring atten-
tion to Dave and the other potters of Edgefield, McClendon opened a
small exhibition space, the Pottersville Museum, and briefly published
a newspaper, the *Pottersville Hive*. Until then, even Maude Shull, the
great-granddaughter of Abner Landrum, had not known who Dave
was. "I only knew his name," she told me, "and that was because my
sister-in-law had found a pot in her family's barn with 'Dave' and a
date written on it. It was half buried in the dirt, I think, and it still had
some lard in it. She cleaned it up and kept it in her front hall with sea
oats in it. It had a beautiful glaze on it. We knew it was from Edgefield.
But we had no idea in the world what any of the rest of it meant till
Carlee got in touch with us and explained it all. Back then Dave was a
mystery person!"[21]

A series of well-received exhibitions and research projects helped
spread the story of Edgefield pottery. Finally, in 1998, working with the
McKissick Museum, Jill Koverman curated the first exhibition ever
devoted entirely to Dave. This was the show I saw at Winterthur.

When Dave was still a "mystery person," his pots were worth very
little. They served only as umbrella stands or planters or targets for
shooting practice. As interest in him began to grow in the 1960s, "pick-
ers" came looking for them. In those early years, a picker would spot a
poem jar on a country porch, buy it for perhaps $50, then immediately
resell it to a collector for $500; that new owner might hold it for a few
years before selling it at auction for $5,000. By the 1990s it might be
worth $50,000. I attended a 2004 auction in which a poem jar went
for $135,000. With such money at stake, the sites where Dave worked
are often looted. There have even been attempts, usually laughable, to
create copies of his work and sell them as recently discovered originals.[22]

Some Edgefieldians, it should be said, find all this fuss hard to com-

prehend. My fifth cousin once removed on the Landrum side, Noonie Holtzlander, whom I met for the first time when I came to Edgefield, told me, "When I was growing up here back in the 'thirties, no one had ever *heard* of Dave the Potter and all the rest of it. Oh, we had pots all over the place out at the house, churns and all, but nobody thought a thing about it. It was just *utilitarian*. We didn't call it 'Edgefield Pottery.' I went away to school and got married to George and when we came back here about twelve years ago, it was all *art*." She gave me a look that said the world had gone mad.[23]

IN THE CLEAREST READING of Dave that I can make, he was an exceptional man but not the superman that myth would have it. His ability to read and write was unusual though not unheard of in the slave community at that time; his poems, though important documents, were not literary gems; his typesetting ability at the *Hive* was a creation of his latter-day admirers. He wasn't heroic in the mold of other well-known Edgefield blacks: He didn't help carve out a new county, as Prince Rivers did; he didn't become a member of the bar, as Paris Simkins did; he didn't establish a school, as Rev. Alexander Bettis did. He made pots. He made them almost every day of his adult life, no matter whether the world was thriving around him or falling to pieces.

In this way, Dave represents the skill and the daily determination of the enslaved population of his time—the cooks, housekeepers, gardeners, farmworkers, storytellers, musicians, singers, ministers, seamstresses, carpenters, masons, ironworkers, furniture makers, carriage drivers, midwives, nurses. Dave differed from the others in that a combination of circumstances gave him the opportunity to leave an indelible mark on the clay tablets of his time—*I made this jar!*—and he grasped it fully.

Still, genie out of the bottle, Dave's story has taken on a life of its own. I'm now being told that he knew how to speak French, created children's pots that had magic powers, was a great healer, even wrote a

poem about Queen Victoria's coronation. I've seen him described in a national magazine as "Slavery's Poet Laureate" and on eBay as "the most famous and renowned potter of all times." He is becoming a major folkloric hero, in the mold of John Henry the steel-driving man. Perhaps this is all to the good. In the end, the legend that is taking shape around him may be closer to his essence and to that of the other thousands who were enslaved with him that the story of what he "really" did during his lifetime. In exceeding the truth, it may accurately express the miracle, the triumph of his and their survival.

One day during my research, I was at the Augusta Museum of History, virtually alone in the high-ceilinged exhibition hall. I had come upon an intimate, informal showing of Dave's work entitled "Dave— Master Potter and Slave." Displayed in front of a patchwork quilt were two of his jars, a fairly large one dated September 5, 1857, and a smaller cream-colored one dated January 23, 1840. The jars were handsome, and I was delighted to find them. As I lingered in front of the display, I heard a docent coming across the gallery with a group of schoolchildren in tow. She was in the middle of what must have been her standard talk: "It was against the law," she was saying in a jaunty lecture voice, "but some slaves were able to learn to read and write anyway. One of these was a potter named Dave. Everybody say 'Dave.';thin"

"Dave," they said back, with not a great deal of enthusiasm.

I stepped aside so the children could get close to the pots. They were all the same height—I think they were second graders—and they all wore red knit shirts and khaki shorts. Some were girls, some were boys, some were black, some were white. The docent, a cheery blond lady, indicated the display with a sweeping gesture and said, "Dave was wonderfully skilled, and he made pots like these. Since he could write, he put little comments on his pottery. We still have those comments today!"

One of the children raised her hand. "What did he write, Miss Pippin?"

"Oh, dates, and advice and, well, *comments* of all kinds." She shook her

head. "It wasn't so much *what* he wrote but that he *dared* to write it. He was a hero!"

One of the smaller boys, caught up in her story now, called out, "Dave!" His voice echoed through the hall. It was a surprisingly stirring sound. I imagined it carrying across the Savannah River to Stony Bluff and all the way on to Pottersville. Delighted, Miss Pippin said, "*Everybody* say 'Dave!';thin"

"Dave!" they cried.

"Everybody!"

"*Dave!*"

Afterword

PEOPLE IN EDGEFIELD SAY THAT THEIR VILLAGE IS BUILT ON seven hills, much like Rome. Also like Rome, it is dotted with relics from a great and storied past. One needs only to drive along Buncombe Street, which starts at Courthouse Square and leads out toward the site of Pottersville, to find them. One of the town's principal avenues, Buncombe is lined through part of its length with large white antebellum houses. They are fronted with classical colonnades that give them an imperial air. Some Edgefieldians, in fact, call Buncombe the "Appian Way." On this almost ceremonial boulevard, the pride of Edgefield before the war asserts itself.

Directly behind the houses on Buncombe Street is a neighborhood of much smaller homes called New Buncombe, inhabited almost entirely by black families. Housemaids and yardmen lived here in the first half of the last century and walked the short distance to work at the big houses. Though most of the white people who live on Buncombe Street are no longer wealthy, and most of the black people who live behind them in New Buncombe are no longer poor, they still live separate lives. Yet, irrevocably connected, they form Edgefield as it exists today. As C. Vann Woodward has written, "The ironic thing about these two great hyphenate minorities, Southern-Americans and Afro-Americans, confronting each other on their native soil for three and a half centuries, is the degree to which they have shaped each other's destiny, determined each other's isolation, shared and molded a common culture. It is, in fact, impossible to imagine the one without the other and quite futile to try."[1]

My heritage, like that of Edgefield, is closely woven from black

threads and white ones. In deciding to follow Dave wherever he led me, I have discovered a long and complex intertwining in which my family members purchased blacks, whipped them, slept with them, sold them away from one another, wore red shirts to keep them from voting, and sometimes loved them deeply. These same blacks supported my fore-bears with their labor, bore their children, murdered them in anger, killed themselves in protest against them, and sometimes loved them deeply. Members of my family appear to have encouraged Dave to read and to inscribe his feelings on his pots; he used his talents to make them successful manufacturers for more than fifty years. There was an exchange throughout the course of this black-white relationship, not an equal or fair one but an exchange just the same.

I witnessed what may have been a small, contemporary example of this exchange one day during my stay in Edgefield. Along with my wife, who had come from New York for a visit, I had been invited to Marsh-field, a once-lavish plantation house just outside of town. It was the home of Broadus Turner, a generous, eccentric, older man who was one of the best-loved whites in the county. When we joined him and his small party of guests, he introduced us to Moses Simkins, a black man who had a dis-tinguished family tree: He was descended from Arthur Simkins, the white editor of the *Advertiser*, through Paris Simkins, the black Reconstruction leader. Although it was clear that Moses, as a devoted friend of Broadus, was as much a guest as the rest of us, he was soon wearing a white jacket and waiting with great dignity on the table that Broadus had prepared. No one seemed to be uncomfortable with this, least of all Moses. Perhaps he was even doing it as a favor for his friend, who was putting on the dog for his visitors. I began to see that there were many sides to every encounter in Edgefield. A complex history and enduring customs compli-cated and at the same time clarified each situation, whether racial or oth-erwise. I was not surprised when I found out that Christine Costner Sizemore, the woman whose multiple personalities are described in *The Three Faces of Eve*, was born and raised in Edgefield County.

The fascination that this almost mythical place held for my wife and

myself proved to be stronger than we knew: We soon gave up our apartment in Manhattan and moved to Edgefield. We found a house beside a stream, bought a used Ford truck, and adopted a terrier, whom I named Abner, after Dr. Landrum. I wrote this book in a room overlooking the stream.

And so far, so good. In addition to the riveting scandals that have always been its specialty, the village offers much to find exciting. So many local people are writing and publishing books about town history that the genealogical society has taken to holding group book signings. A black genealogical society, recently founded, is also thriving. In its first open meeting, members brought in items from their family history to show to a full house of townspeople—old photographs, pieces of jewelry, precious documents. This was important, for the pain of slavery and Jim Crow had long discouraged looking at the past. Now, the society has plans to record the names carved on every tombstone in the county's black cemeteries. Interest in local black history was given an added boost not long ago when Rev. Al Sharpton, the New York political activist, discovered that his forebears had lived in Edgefield County. He came to town and visited the Sharpton plantation where his ancestor, Coleman, had been enslaved.

Close to my heart is a professional pottery program offered by the new Center for Creative Economies at Piedmont Technical College, just off Main Street in Edgefield. The center gives promise of carrying forward the great local pottery tradition that, except for the work of Steve Ferrell, had been lost here. A traditional groundhog kiln will be built beside the school so that townspeople will once again be able to gather for firings, just as they once did at Pottersville. South Carolina potter Michel Bayne threw two enormous pots to celebrate the opening of the center. On one, a widemouthed jar, he inscribed every poem that Dave is known to have written. The verses ran in a single spiral around and around the piece, seemingly without end. On the day of the center's opening, one of Dave's own pots, a beautifully rounded storage jar, had a place of honor beside the entrance to the potting studios. Just before

the cutting of the ribbon, a collector whispered to me that a new Dave poem had been discovered:

A noble Jar
For lard or tar

He told me that nothing else, not even the date of the pot that bore it, had been revealed. It was a great day!

In my new life in Edgefield, I often encounter descendants of the men and women who peopled Dave's world: the great-grandchildren of Ward Lee, one of the young Africans who was brought here on the slave ship *Wanderer*; Steve Tillman, who shares an ancestor with Pitchfork Ben Tillman; Elijah Blocker, deacon at Springfield Missionary Baptist Church, who looks back to Alfred Blocker, the man who delivered Dave's pots, as his grandfather; and several descendants of Rev. John Landrum, who are my cousins. Yet I have located no descendant of Dave among us. Census information and confidential tips and local rumors have all led to nothing. This has been a great disappointment to me. For one thing, it has emphasized the distance that still separates Dave and myself. It is an inevitable distance, encountered by every writer who tries to re-create the life of someone who lived in the past; still, the encounter is a painful experience. Richard Holmes compares it to coming upon a gap left between the two parts of a broken bridge. Simon Schama gives it another image: "We are doomed to be forever hailing someone who has just gone around the corner and out of earshot."[2]

The closest link I have with Dave, as it turns out, is a memory from my early childhood. It involves my grandfather, Francis Miles Wever, who was born in 1866 before his parents, America and Lafayette, left Edgefield. Just as his life overlapped Dave's, mine overlapped his. I was born on his seventy-fourth birthday, February 10, 1940. Because he was often ill when I was little, I never had a chance to know him well, but I remember with great clarity one particular moment with him. It was Christmas Day 1944 at my aunt's house, where he lived then. I was four

years old. He had come downstairs before the holiday supper to sit in his customary leather chair in the living room. Though he was old and walked slowly, he was slim and straight and was dressed quite elegantly in a gray suit. I sat down beside him on a stool. Feeling rather shy, I studied him from the corner of my eye. He had a carefully trimmed beard, gray, almost white. He might have been smoking; at least I remember yellow-brown stains on his index and middle fingers, where a cigarette would have been. He wore a gold ring set with two small stones, a ruby and an emerald. I think they formed the eyes of snakes that circled the ring from opposite directions. The nail on the thumb of one of his hands was completely split, broken in a firecracker explosion when he was a boy, and half of it slightly overlay the other. His exotic ring and broken thumbnail signaled to me that he had lived a vastly eventful life.

I have wondered whether he once sat beside Dave in the same way that I sat beside him. His mother, America, as Lewis Miles's daughter, would have known Dave well, and I think she might have wanted her young son to know him too. I can see her setting him down on a bench next to Dave. I can imagine my grandfather asking him, in the straightforward way of a child, what happened to his leg. I can see Dave molding a plaything out of clay to amuse him. Perhaps he picked up a scowling face vessel and put it to my grandfather's ear so he could hear echoes of Africa in it. Perhaps my grandfather held that moment in his memory all his life, just as I did my moment with him.

The New York Times article that first introduced me to Dave ended with Jill Koverman issuing an invitation: "Does anything else survive to tell us more about this amazing man?" Having followed her lead and moved further across the broken bridge to the past, I end this book with the same invitation. Perhaps a child of a child of a child of Dave will see it and bring long-stored family memories to light. There are already rumors abroad of newly found pots and never read poems. Fresh secrets are in the air. There is much to come![3]

ART TK

ART TK

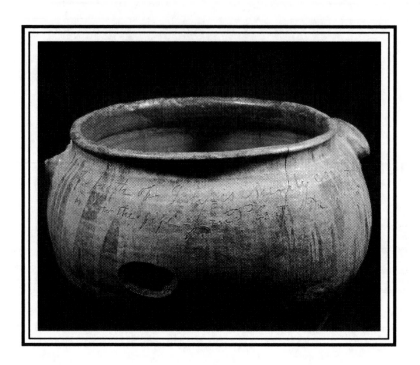

Inscriptions

I
T WAS ALMOST IMPOSSIBLE FOR AMERICAN SLAVES TO WRITE
about their lives while they were in bondage. Fear of punishment,
forced illiteracy, lack of writing materials, exhaustion at the end of the
day all militated against it. Dave, however, found a way to leave a kind of
journal on his jars. In the damp clay that he understood so well, he
wrote about the elements of his daily life—the people he loved, the bib-
lical teachings he believed in, his moments of recreation, and, most
often, the qualities of the very jars he was writing on. He usually pre-
sented his thoughts in short, rhyming couplets that were informal and
were addressed directly to the reader.

In spite of Dave's down-to-earth style, his poems can be puz-
zling. Sometimes the images he evokes within a short two lines seem
incongruent with one another; sometimes his thoughts seem trun-
cated or strangely open-ended. This enigmatic quality has led some
observers to propose that his inscriptions contain covert messages.
My reading of his work and of his life does not lead me to that con-
clusion. I do find indications, however, that he enjoyed using words
that could be understood in more than one sense. For example,
when Dave writes "a pretty little Girl, on a virge," "virge" can indi-
cate the virginity of the girl and the verge of maturity on which she
finds herself (August 24, 1857). One of Dave's most skillful double
meanings occurs in his July 31, 1840, description of the Miles planta-
tion ("wher the oven bakes = & the pot biles"), in which his vivid
imagery applies equally well to the kitchen and the kiln. The fact

that we are rarely able to pin down the exact meaning of what Dave has written gives his poems an elusive quality that is one of their prime attractions.

It's not unusual to find a poem by Dave quoted differently from printed source to printed source. The reason for this is that the inscriptions, when encountered in their original form on the shoulders of his jars, can be difficult to decipher. Written on clay in an idiosyncratic script, covered with a glazing solution (often dark), baked in a furnace, then subjected to potential cracks, scrapes, and chips over many decades, they are, not surprisingly, misreported with some frequency. In one case, the word "Kissing" was read as "wishing" (February 10, 1840); in another, the word "here" was read as "hive" (April 18, 1859). Too, the apparent simplicity of the verses has tempted writers to quote them from memory, ending up with almost what Dave said but not quite. One longtime critic of the carelessness with which Dave's inscriptions have been transcribed is writer and artist Samuel J. Hardman. "Indeed," he comments in frustration, "the corruption of Dave's simple lines is so frequent that I am now convinced that some of the owners [of the pots] and their experts can't read." One could question the need for carefully analyzing each letter in Dave's writings, a process usually reserved for the words of much "greater" men. It matters whether Secretary of War Edwin Stanton said, "Now he belongs to the ages," just after Lincoln died, as we've always heard, or whether he said, "Now he belongs to the angels," as some claim. But does it really matter whether a black man in bondage back in 1840 wrote "Kissing" rather than "wishing?" I believe it does: With so few words surviving from this gifted and unusual person, almost alone in his role of slave witness, it's important for us to get them right.[1]

In the effort to first decipher and then understand what Dave has written, transcribers have often overlooked another aspect of his poems. He carefully added marks between and around his words—commas and colons, certainly, but also plus signs, dots, crosses, paired

hyphens, and long dashes. These occur, in many cases, at the midpoint of his lines. In the parlance of poetry criticism, punctuation marks placed at that location in a poem are known as "medial caesuras" and indicate a pause. Because Dave writes primarily in iambic tetrameter—four beats to the line—these pauses help maintain that rhythm. When he places them just before the last word of a line, which he often does, they are called "terminal caesuras" and help to produce a dramatic effect. I suspect that Dave picked up the use of such devices from poems that were regularly published in the *Edgefield Advertiser* and before that in Abner Landrum's *Hive*. Because the marks he added to his verses help convey his poetic intentions, I've included them in the following transcriptions. The limitations of typesetting give them a uniformity that the original markings, each quite different, firmly resist.

I've used Dave's poems earlier in this book to help tell his story. Here, I've collected them in a chronological listing so that they can be studied for their own sake. In most cases, I have inspected the original verses on the jars or examined detailed photographs of them. In the rare instances in which I have not been able to study a poem even from photographs, I have indicated that in the listing. I've included not only Dave's poetic writings but all his other known inscriptions, save dates and signatures. The list owes a great deal to a compilation by Jill Koverman, who over a period of years located and documented a large number of Dave vessels for the McKissick Museum. The measurements given here were made by her during that survey. As I was finishing this book, Arthur F. Goldberg and James P. Witkowski published in *Ceramics in America* in 2006, a carefully detailed listing of all Dave's known dated pots, which has also been helpful. I've added a short list of rumored inscriptions, as well.

Edgefield novelist Kathy Steele compares Dave's inscriptions to messages in bottles. "He floated his pots out across time," she says, "with greetings for later generations." Here are the messages that have reached us thus far.[2]

DATED INSCRIPTIONS

Concatination

June 12, 1834, for Reuben Drake and Jasper Gibbs at Pottersville
STORAGE JAR WITH TWO SLAB HANDLES;
19.5 INCHES TALL; PRIVATE COLLECTION

This single word is the first known inscription by Dave other than pro-
duction marks and dates. Usually spelled with an "e" rather than an "i"
at its midpoint, it means a linking together, as the pieces of a chain are
linked. It is tempting to think that Dave used it to refer to bondage, but
it may be that its attraction lay in its intriguing five-syllable structure.
Mastery of words of multiple syllables was one of the goals of Webster's
blue-back speller, which helped many slaves learn to read.

.

Put every bit all between
surely this Jar will hold 14

July 12, 1834, for Reuben Drake and Jasper Gibbs at Pottersville
STORAGE JAR WITH TWO SLAB HANDLES; 19.3 INCHES TALL;
SOUTH CAROLINA STATE MUSEUM, COLUMBIA, S.C.

This is Dave's first known verse. It gives instructions for packing meat
into the fourteen-gallon jar on which it is written. The words are
crowded against one handle of the jar, perhaps indicating that Dave had
not yet learned how to center them on the shoulder of a piece. One of
the words, "bit" is raised above the others, apparently because he forgot
it on the first run-through and had to add it later. This poem contains
Dave's first known use of the word "Jar." He would employ it often in
the future, always beginning it with a capital letter.

.

horses mules and hogs ——
all our cows is in the bogs ——
there they shall ever stay
till the buzzards take them away =

March 29, 1836, probably at Pottersville
STORAGE JAR WITH TWO SLAB HANDLES;
16.1 INCHES TALL; PRIVATE COLLECTION

Dave wrote this fully realized quatrain only a few weeks after many of his Pottersville companions were taken by Reuben Drake to Louisiana. Dave was left behind, as powerless to follow as if he were stuck "in the bogs." This may account for the poem's general sense of dejection.

•

catination

April 12, 1836, probably at Pottersville
STORAGE JAR WITH TWO SLAB HANDLES;
14.5 INCHES TALL; PRIVATE COLLECTION

Early in my research, I heard of a Dave pot with a inscription that included the word "coronation." I was later told of another vessel whose inscription read "gatination." Ultimately, I learned that these pots were one and the same and that neither of the readings was correct. The pot in question was auctioned at Charlton Hall Galleries in September 2000, with the inscription recorded in the catalog as "canitation." According to the person who sold the pot, however, the correct word was "catination." Though I have not been able to examine the inscription, the "Concatination" jar of June 12, 1834, which subsequently came to light, supports this last reading.

•

a better thing, I never saw
when I shot off, the lions Jaw

November 9, 1836, possibly for Rev. John Landrum at Horse Creek
JUG WITH TWO LOOP HANDLES; 17.5 INCHES TALL;
HIGH MUSEUM OF ART, ATLANTA, GA.

This cryptic inscription may refer to the sixth chapter of the Book of Daniel, in which Daniel, having been cast into a den of lions, was saved from death by an angel, who firmly closed the lions' mouths. The Bible uses the word "shut" to describe the angel's actions, which in plantation retellings could have changed to Dave's "shot."

.

Ladys & gentlemens Shoes =
sell all you can: & nothing you'll loose . x

January 29, 1840, for Lewis Miles at Horse Creek
JUG WITH TWO LOOP HANDLES;
17.2 INCHES TALL; PRIVATE COLLECTION

This inscription appears to be a rousing endorsement for the shoe business. It is written on the first known poem pot to also carry the name of Lewis Miles. Here, Dave refers to him as "L. Miles"; on the many pots that followed, he would also use "Lm" or "Mr. Miles" or "Mr. L. Miles." Though the final word in the couplet is "loose," Dave probably intended it to be "lose," so it would rhyme with "shoes." I have not examined the inscription; this version of it is based on a careful transcription by the owner.

.

whats better than Kissing —
while we both are at fishing

February 10, 1840, for Lewis Miles at Horse Creek
STORAGE JAR WITH TWO LUG HANDLES;
15 INCHES TALL; PRIVATE COLLECTION

For years this jar sat on a living room television set, its significance and value unrecognized. One night, while watching *Antiques Roadshow* on that same set, the owner saw a Dave jug and realized for the first time what he had. Charlton Hall Galleries sold it for him at auction on December 11, 2004, for $135,000—a record at the time. The final word in the first line of the inscription was quoted in the auction catalog as "wishing," but careful comparison with the poem that ends "spare me a Kiss," which Dave wrote just six months later, shows it to be "Kissing."

.

Give me silver or; either Gold =
though they are dangerous; to our Soul =

June 27, 1840, for Lewis Miles at Horse Creek
STORAGE JAR WITH TWO SLAB HANDLES;
14.5 INCHES TALL; PRIVATE COLLECTION

Enslaved artisans were often allowed to work on their own time and pocket whatever money they made. In this couplet and in one written on August 22, 1857, Dave asks payment for the jar he has made. In both verses, he makes clear that he is aware of the evil that money can bring with it. In a third, less conflicted inscription, written on May 17, 1852, he simply announces, "cash wanted."

.

Dave belongs to Mr. Miles /
wher the oven bakes = & the pot biles ///

July 31, 1840, for Lewis Miles at Horse Creek
STORAGE JAR WITH TWO SLAB HANDLES;
15.1 INCHES TALL; THE CHARLESTON MUSEUM, CHARLESTON, S.C.

This poem describes Dave's situation as a pottery slave of Lewis Miles. The second line presents a picture not only of the kitchen on the Miles

plantation but the pottery, at both of which an oven "baked" and pots "boiled."

·

Edgefield District

August 25, 1840, for Lewis Miles at Horse Creek
STORAGE JAR; 15.7 INCHES TALL; PRIVATE COLLECTION

This inscription, which I have not seen, is one of only two that include the word "Edgefield." The other, a message of farewell that Dave wrote for Milton Miles, is undated.

·

another trick is worst than this +
Dearest miss: spare me a Kiss +

August 26, 1840, for Lewis Miles at Horse Creek
STORAGE JAR WITH TWO SLAB HANDLES;
15.2 INCHES TALL; PRIVATE COLLECTION

This amorous couplet was written six months after Daves's poem about kissing while fishing, from February 10, 1840. He was thirty-nine years old when he made these inscriptions and apparently very much interested in someone at his new home on Horse Creek.

·

not counted

May 16, 1843, for Lewis Miles at Horse Creek
STORAGE JAR WITH TWO SLAB HANDLES;
27.7 INCHES TALL; PRIVATE COLLECTION

Though these two short words probably convey only simple production information, they are nevertheless significant. Within a few months of

writing them, Dave entered a period of silence, during which, as far as anyone has discovered, he made no inscriptions of any kind on his pots. This lasted approximately six years, during which he was purchased by Franklin Landrum. He did not resume writing until he was once more owned by Lewis Miles.

.

just a mammouth Jar [illegible]
for I not [illegible]

October 17, 1850, for Lewis Miles at Stony Bluff
STORAGE JAR WITH TWO HANDLES;
24 INCHES TALL; CURRENT OWNER UNKNOWN

The first inscription that Dave is known to have written after his silent period, other than names and dates, survives only in part. Though I have not seen it, a former owner of the jar on which it appears told me that a very heavy glaze covers the words, which are lightly carved into the clay, leaving most of them unreadable. The sole documentation of the inscription is a listing in the Harmer Rooke Galleries auction catalog of January 26, 1994 (Absentee Auction 56: Important American Stoneware). The catalog rendered it all in capital letters; I have quoted it in upper and lower case, giving an initial capital to the word "Jar," as Dave did in all other known cases.

.

cash wanted

May 17, 1852, for Lewis Miles at Stony Bluff
PRESERVE JAR WITH TWO SLAB HANDLES;
16.1 INCHES TALL; PRIVATE COLLECTION

In this short message, Dave states plainly that he (or perhaps Lewis Miles) wants money for his pottery. Compare his directness with the

more equivocal context in which he offers his work for sale on June 27, 1840, and August 22, 1857.

·

Lm says this handle
will crack

June 28, 1854, for Lewis Miles at Stony Bluff
JUG WITH ONE LOOP HANDLE;
HEIGHT UNKNOWN; PRIVATE COLLECTION

In June 1854, Lewis Miles apparently told Dave that the handle on the jug he had just made was not sturdy enough. To let posterity be the judge, Dave recorded his owner's opinion in this inscription, which he wrote vertically on the side of the jug in question. More than 150 years later, the handle is still intact. In 2001, hundreds of thousands of television viewers became acquainted with Dave's work for the first time when they saw this piece on *Antiques Roadshow,* in a segment taped in Charleston. The young woman who presented it on the show had bought the jug at an estate sale for sixty dollars but afterwards in the parking lot had sold it to a man who offered her a hundred dollars for it. Her mother, hearing what had happened, sent her running after him to undo the deal. Garrison Stradling, who examined the jug for the *Road-show,* called her "one lucky Charlestonian." He appraised the jug at six thousand dollars, which was probably low even then.

·

Drawing of a horse and rider

June 1, 1856, for Lewis Miles at Stony Bluff
JUG WITH ONE LOOP HANDLE;
13.3 INCHES TALL; PRIVATE COLLECTION

Two pots signed by Dave bear images casually drawn on their sides. This one depicts a man in profile, wearing what appears to be a military dress

hat, or shako, and riding a horse. The other, on a one-handled jug that
was made on June 11, 1857, shows a bird in profile, wings folded, striding
purposefully forward. Only a few inches high, the drawings are primitive
yet appear to be the work of an adult. It is not known whether Dave or
someone else in Lewis Miles's shop was the artist. Incised, the drawings
are not to be confused with the decorative figures and motifs that were
applied to pots using slip, a creamy solution of clay and water, at several
other Edgefield potteries. An additional drawing of a waterfowl with a
fish in its beak appears on an unsigned storage jar attributed to the Lewis
Miles factory. Two other drawings, which I have not seen, are on
unsigned, undated vessels in the style of Dave: A jug in Georgia is incised
with the figure of a man; a vase-like pot, also in Georgia, bears the styl-
ized representation of a man, a woman, and what may be a full moon.

.

for Mr. John monday

July 6, 1857, for Lewis Miles at Stony Bluff
STORAGE JAR WITH TWO SLAB HANDLES;
21.7 INCHES TALL; McKISSICK MUSEUM, COLUMBIA, SC

The large and exceedingly fine storage vessel on which this inscription
appears was probably made for John W. Mundy, who owned a large
plantation in Edgefield District. Perhaps playing with words, Dave
wrote the buyer's name as "monday," which was, in fact, the day of the
week on which he turned the jar.[273]

.

I wonder where is all my relation
friendship to all — and, every nation

August 16, 1857, for Lewis Miles at Stony Bluff
STORAGE JAR WITH TWO SLAB HANDLES;
19 INCHES TALL; PRIVATE COLLECTION

In this, Dave's most personal poem, he wonders openly about distant family members. He was apparently separated from his kinfolk three times during his life: in his youth, when he became the property of Harvey Drake; in 1836, when Reuben Drake took his other slaves to Louisiana; and in 1847, when Rev. John Landrum's estate was broken up. Here, years after these events, Dave seems to still be burdened by them.

·

I made this Jar = for cash —
though its called = lucre Trash //

August 22, 1857, for Lewis Miles at Stony Bluff
STORAGE JAR WITH TWO LUG HANDLES;
19 INCHES TALL; MUSEUM OF FINE ARTS, BOSTON, MASS.

Dave was probably familiar with the word "lucre," meaning money or riches, from the expression "filthy lucre." It comes from I Timothy 3:8, in which Paul advises that men aspiring to be deacons of the church must be "grave, not doubletongued, not given to much wine, not greedy of filthy lucre." Compare this inscription with those of June 27, 1840, and May 17, 1852.

·

a pretty little Girl, on a virge
Volcaic mountain, how they burge

August 24, 1857, for Lewis Miles at Stony Bluff
STORAGE JAR WITH TWO SLAB HANDLES;
19 INCHES TALL; MCKISSICK MUSEUM, COLUMBIA, S.C.

Wealthy Southerners often visited the great classical ruins of Europe, including those of Pompeii. They brought back tales of the eruption of Vesuvius, stories that were doubtless overheard and repeated in the slave community. Dave uses the imagery of a volcano here to describe a young girl on the verge of maturity.

Making this Jar = I had all thoughts
Lads & gentlemen = never out walks

January 30, 1858, for Lewis Miles at Stony Bluff
STORAGE JAR WITH TWO SLAB HANDLES;
20.6 INCHES TALL; CURRENT OWNER UNKNOWN

In this verse, Dave reveals what he was thinking when he made the jar on which it was written. Unfortunately, these thoughts are baffling to us today.

I made this for our, sott
it will x never — nver, rott

March 31, 1858, for Lewis Miles at Stony Bluff
STORAGE JAR WITH TWO HANDLES;
22 INCHES TALL; HIGH MUSEUM OF ART, ATLANTA, GA.

Potter Steve Ferrell contends that "sott" refers here to the fermented mash that is part of the beer-making process. My alternative speculation is that it may be a misspelling of the name "Scott," which Dave includes in a poem written only three weeks after this one, on April 21, 1858. The wording for this inscription, which I have not seen, is taken from a transcription made when the High Museum acquired the jar.

This noble Jar = will hold, 20
fill it with silver = then you'll have plenty

April 8, 1858, for Lewis Miles at Stony Bluff
STORAGE JAR WITH TWO SLAB HANDLES;
23 INCHES HIGH; CURRENT OWNER UNKNOWN

In the uneasy years leading up to the Civil War, Lewis Miles told Dave to make a small jar for him each month, so that he could bury a bit of gold or silver in it. This couplet, written during the same period but on a far larger jar, may be a reference to that practice. I have found only one photograph that shows this inscription, in the Harmer Rooke catalog of the sale of Georgeanna Greer's collection of stoneware (November 18, 1992, and January 13, 1993). The latter part of the second line is difficult to make out in the photo, leaving it unclear whether or not Dave added any marks at the end of the poem.

.

A very large Jar = which has 4 handles =
pack it full of fresh meats — then light = candles —

April 12, 1858; for Lewis Miles at Stony Bluff
STORAGE JAR WITH FOUR SLAB HANDLES;
24.5 INCHES HIGH; PRIVATE COLLECTION, ON LOAN
TO ATLANTA HISTORY CENTER, ATLANTA, GA.

Dave's larger jars were extremely heavy, requiring more than the usual two handles for lifting. This one, as he tells us, had four handles. After a jar had been filled with salted meat, it could be sealed with candle wax, a process that Dave may be referring to in the final words of this poem.

.

when you fill this Jar with pork or beef
Scot will be there; to Get a peace, ——

On the opposite side:

this Jar is to Mr Segler who keeps the bar in orangeburg
for Mr Edwards a Gentle man — who formly kept
Mr thos bacons horses

April 21, 1858, for Lewis Miles at Stony Bluff

STORAGE JAR WITH TWO SLAB HANDLES;
23.6 INCHES TALL; PRIVATE COLLECTION

There is a couplet on one side of this jar and a dedication on the other. In both inscriptions, Dave seems to be giving words double meanings. He suggests in the couplet that Scot, who is probably Scott Miles, another pottery worker, will find "peace" in a "piece" of meat. (See the poem of March 31, 1858, which is perhaps about Scott, as well.) In the dedication, he honors Mr. Edwards as a "Gentle man," which may also refer to his job as a groom: Taming or calming a horse, often by stroking, is known as "gentling."[4]

.

<div style="text-align:center">

the sun moon and —— stars ;equals
in the west are a plenty of —— bears ``

July 29, 1858, for Lewis Miles at Stony Bluff
STORAGE JAR WITH TWO SLAB HANDLES;
20.2 INCHES TALL; PRIVATE COLLECTION

</div>

In these two lines, Dave expresses his wonder at the contents of the sky above him. The bears to which he is referring may be those that are represented in the constellations. Ursa Major and Ursa Minor. He makes his rhyme work by pronouncing "bears" as "bars." Dave scholar Samuel J. Hardman has recently pointed out the existence of the "a" in the second line of the verse, which had managed to escape the notice of transcribers ever since the jar first came to light.

.

<div style="text-align:center">

I saw a leppard, & a lions face, ``
then I felt the need of —— Grace.

November 3, 1858, for Lewis Miles at Stony Bluff

</div>

STORAGE JAR WITH TWO SLAB HANDLES;
23.4 INCHES TALL; MUSEUM OF EARLY SOUTHERN DECORATIVE ART,
WINSTON-SALEM, N.C.

There are several possible sources for the imagery in this poem. Traveling circuses with menageries of wild animals often came through the Edgefield area in Dave's time; a fantastic beast, called the Gyascutus, once visited the county to thrash behind a curtain in a hoax that terrified and delighted the population. Because Dave wrote this verse during the buildup to the Civil War, however, it may be that he is referring instead to beasts such as those that heralded the Day of Judgement in the Book of Daniel, Chapter 7. Dave repeats this verse on August 7, 1860, when the Great Fear that came after John Brown's raid on Harpers Ferry had seized the South.[5]

.

nineteen days before Chrismas Eve
lots of people after it's over, how they will greive

December 6, 1858, for Lewis Miles at Stony Bluff
STORAGE JAR WITH TWO SLAB HANDLES;
APPROXIMATELY 20.5 INCHES TALL; PRIVATE COLLECTION

When Steve Ferrell posted all known Dave poems on his Old Edgefield Pottery Web site, the owners of this previously undocumented pot sent him a photograph of it to show that there was at least one inscription that hadn't yet been counted. They sent it on December 6, the same day and month on which it was written. The extreme beginning and end of each line are not visible in the photo, so there may be additional marks that form part of the poem. Dave wrote another holiday poem on July 4, 1859.

.

Mark and Dave

March 10, 1859, for Lewis Miles at Stony Bluff
STORAGE JAR WITH TWO LUG HANDLES;
15 INCHES TALL; SMITHSONIAN INSTITUTION, WASHINGTON, D.C.

Though this is technically a signature, I am including it here because of its significance. Mark, who was apparently Dave's helper on the day the jar was made, was probably Mark Jones, whom the 1870 federal census shows living in Dave's household, along with his family. It's possible that Mark's wife, Caroline, was Dave's daughter, making Mark his son-in-law.

.

I made this out of number, & cross ``
if you do not lisen at the bible you'll be lost ——

March 25, 1859, for Lewis Miles at Stony Bluff
STORAGE JAR WITH TWO SLAB HANDLES;
21 INCHES TALL; MADISON-MORGAN CULTURAL CENTER, MADISON, GA.

For years, the opening line of this couplet was inadvertently omitted in lists of Dave's inscriptions. With it in place, the verse can be clearly seen as an early version of his last known poem, written three years later on May 3, 1862. Dave ends this rendering with a flourish by drawing a serpentine mark down the shoulder of the jar and fitting "you'll be" into it on a lower line, probably because he had run out of room for what he had left to write.

.

Over noble Dr. Landrum's head
May guardian angels visit his bed

April 14, 1859, for Lewis Miles at Stony Bluff
STORAGE JAR WITH TWO SLAB HANDLES;
ABOUT 15-GALLON CAPACITY; CURRENT OWNER UNKNOWN

In about 1997, Dr. John Burrison, author of *Brothers in Clay: The Story of Georgia Folk Pottery*, was invited to see this jar in the home of its owner, who lived in eastern Georgia. Although the light was poor in the storage room in which it was housed, Burrison was able to carefully note down its inscription and approximate capacity. He planned to return within a few weeks with a camera, but the owner unexpectedly died in the meantime—and the pot disappeared. Relatives knew nothing of its whereabouts. Other collectors also may have seen the pot before the owner's death, for a different version of the inscription was reported to Jill Koverman, who listed it in the catalog for the 1998 McKissick Museum show of Dave's work: *When Noble Dr. Landrum is dead / May Guardian angels visit his bed.* Both versions clearly refer to the death of Dr. Abner Landrum, Dave's early mentor, who died in Columbia on April 3, 1859, just eleven days before this jar was made. The imagery of guardian angels probably comes from John 20:11 and 12, in which Mary looks into the empty tomb of Christ and "seeth two angels in white sitting, the one at the head, and the other at the feet, where the body of Jesus had lain."

·

here is eighteen hundred & fifty nine
unto you all I fell in , cline ``

April 18, 1859, for Lewis Miles at Stony Bluff
STORAGE JAR WITH TWO SLAB HANDLES;
19.5 INCHES TALL; PRIVATE COLLECTION

Because this jar was long unavailable to researchers, extravagant rumors arose about what its inscription said. I was told it spoke of Dave falling in something, perhaps in love. Some claimed it began with the word "Hive," a reference to Abner Landrum's newspaper. When I was given the opportunity to examine the inscription, I read it instead as Dave marking the year of Dr. Landrum's death and sending his condolences to all those in mourning for him. Perhaps to show the extent of his

emotion, he inserted an inordinately long space after "in"—room enough for a slow sigh—before ending with "cline."

•

Good for lard — or holding — fresh meats ;equals
blest we were — when peter saw the folded sheets

May 3, 1859, for Lewis Miles at Stony Bluff
STORAGE JAR WITH TWO SLAB HANDLES;
26.4 INCHES TALL; PHILADELPHIA MUSEUM OF ART, PHILADELPHIA, PA.

Some scholars have read this poem as a reference to Acts 10:10–16, in which God gives Peter permission to eat any kind of meat, even that considered "unclean." My alternative suggestion is that Dave may again have been referring to the recent death of Dr. Abner Landrum. If so, his imagery would come from John 20:6–7, in which Peter discovers that the tomb of Jesus is empty but for the linen his body had been wrapped in and "the napkin, that was about his head, not lying with the linen clothes, but wrapped together in a place by itself." Jesus, as his disciple later comes to understand, had risen from the dead. Dave is writing nine days after Easter, when thoughts of resurrection for Dr. Landrum might still be vivid in his mind.[6]

•

Great & Noble Jar
hold Sheep goat or bear

May 13, 1859, for Lewis Miles at Stony Bluff
STORAGE JAR WITH FOUR SLAB HANDLES;
25.7 INCHES TALL; THE CHARLESTON MUSEUM, CHARLESTON, S.C.

Dave made two enormous jars on May 13, 1859, of which this is one. He shared credit with another pottery slave, Baddler, by signing them with both their names. As he had done in his poem of July 29, 1858, Dave pronounced "bear" as "bar" to create a rhyme. The ending of the

inscription was originally transcribed incorrectly as "and bear," and it has consistently been quoted that way until now. Cinda Baldwin used the powerful opening line of this couplet for the title of her book on the traditional stoneware of South Carolina.

·

made at stoney bluff,
for making or adgin enuff

May 13, 1859, for Lewis Miles at Stony Bluff
STORAGE JAR WITH FOUR SLAB HANDLES;
28.7 INCHES TALL; THE CHARLESTON MUSEUM, CHARLESTON, S.C.

The poem on this, Dave's tallest jar, opens with a reference to Stony Bluff, Lewis Miles's pottery manufactory. The jumbled lettering of the second line, however, has always made the meaning of this inscription a mystery. When the jar was first exhibited at the Charleston Museum in 1919, the baffled staff actually invited visitors to aid them in reading the line. For years it was thought to say "for making lard enuff," even though that left several letters unaccounted for. I think the mark mistaken for the first letter in "lard" may actually be an insertion device for "or," which is then followed by the word "ageing," spelled "adgin." If my reading is correct, Dave would be referring here to the process for curing meat.

·

the fouth of July — is Surely come —
to blow the fife = and beat the drum / /

July 4, 1859, for Lewis Miles at Stony Bluff
STORAGE JAR WITH TWO SLAB HANDLES;
24 INCHES TALL; ATLANTA HISTORY CENTER, ATLANTA, GA.

Because drums could be employed as a means of communication during insurrections, slaves were not allowed to use them. Dave's mention of

them here has led some observers to wonder whether his poem might have a subversive message. Because nothing else in his story suggests that he was an agitator for revolt, it seems likely that his words were meant only to mark an enjoyable holiday.[7]

•

Rev. W. A. Lawton

July 19, 1859, for Lewis Miles at Stony Bluff
JUG WITH TWO LOOP HANDLES;
16.2 INCHES TALL; PRIVATE COLLECTION

This jug was probably made as a gift for Rev. Winborn Asa Lawton (1793–1878), whose name is inscribed on it. He was married to Lucinda Landrum, daughter of Rev. John Landrum and sister of Lewis Miles's wife, Mary. The current owner of the piece tells me that a second, almost identical jug, inscribed with the same name and date, is in another private collection.

•

I Saw a leopard, & a lions face =
then I felt, the need of Grace =

August 7, 1860, for Lewis Miles at Stony Bluff
STORAGE JAR WITH TWO SLAB HANDLES;
16.7 INCHES TALL; PRIVATE COLLECTION

Here, Dave appears to be reporting a frightening vision filled with beasts similar to those described in the Book of Daniel, Chapter 7. Because a mood of foreboding was strong in the black and the white communities of Edgefield at the time he was writing, Dave may have considered such images predictive of disasters to come. He inscribed this same poem earlier, on November 3, 1858, with a few differences in spelling and punctuation.

·

A noble Jar . for pork or beef —
then carry it . a round to the indian chief / /

November 9, 1860, for Lewis Miles at Stony Bluff
STORAGE JAR WITH TWO SLAB HANDLES;
21.5 INCHES TALL; PRIVATE COLLECTION

At the time Dave wrote this, Native Americans still hunted wild ani-
mals in the Carolina mountains. Lewis Miles could have traded jars for
his hides for his tannery, providing Dave with the subject for his poem.

·

I made this Jar, all of cross
If you dont repent, you will be, lost =

May 3, 1862, for Lewis Miles at Stony Bluff
STORAGE JAR WITH TWO SLAB HANDLES; 20 INCHES TALL;
SMITHSONIAN INSTITUTION, WASHINGTON, D.C.

This is Dave's last known poem, written in the midst of the Civil War.
It is based on an earlier, more irregular verse of March 25, 1859. Both
are warnings, but this one, with its terrible word "repent," rings more
strongly. It is inscribed on what Jill Koverman calls Dave's "most per-
fectly formed vessel."

UNDATED INSCRIPTIONS

New
X

Undated, possibly for Rev. John Landrum at Horse Creek
JUG WITH ONE LOOP HANDLE; 8.8 INCHES TALL; PRIVATE COLLECTION

Dave is thought to have made this unsigned jug during the period he
worked for Rev. John Landrum. The word "New" on its shoulder would

have been accurate for only a short time, because he made thousands of pots during his lifetime. The "X" below it is probably a production mark.[8]

·

Think of me when
far away Rosa D G Never
Mr Milton Miles
Edgefield

Undated, probably for Lewis Miles at Stony Bluff
STORAGE JAR WITH TWO SLAB HANDLES;
15.3 INCHES TALL; PRIVATE COLLECTION

Milton Miles, the eldest son of Lewis Miles, must have asked Dave to write this romantic message. Rosa, to whom it is addressed, may be Rosa D. Wever, who was related to Milton through his sister's marriage into the Wever family. Rosa's home, the Pine House, one of the grandest houses of the area, was only a short ride on horseback from Stony Bluff, where the Mileses lived. My Wever grandmother, annoyed whenever the family name was pronounced "Weaver," as it often was, always firmly corrected the speaker: *"Wever,"* she would say, "as in *never."* It may be that this was a standard rejoinder even in Rosa's time, and that the surname "Never," which Milton had Dave write here, was a gentle joke.

·

H. Panzerbietar
Groceries
King & Columbia
Charleston
S.C.

Undated, probably for Lewis Miles at Stony Bluff
STORAGE JAR WITH TWO SLAB HANDLES;
12.6 INCHES TALL; THE CHARLESTON MUSEUM, CHARLESTON, S.C.

This inscription, containing the name and address of a grocer in Charleston, is evidence of the wide-ranging clientele for Edgefield pottery. A second undated vessel, a jug in a private collection, bears almost the same inscription.

.

. . . y my chic . . .

Undated, for Rev. John Landrum
SHERDS; THE CHARLESTON MUSEUM, CHARLESTON, S.C.

A photo in the Laura Bragg Papers at the Charleston Museum Archives shows a group of pottery sherds. One sherd, positioned so its outer surface can be seen, bears this inscription, which appears to be by Dave. Sherds in a matching photo, kept in the same envelope, are noted to be "from scrap heap of pottery of the Rev. John Landrum," indicating that they were probably gathered during one of Miss Bragg's research trips to the upstate.

.

April

Undated, probably for Harvey or Reuben Drake at Pottersville
MOLDED BRICK; PRIVATE COLLECTION

Terry and Steve Ferrell found this brick on land that they own at the site of Pottersville. It is inscribed with the word "April" in what appears to be Dave's hand. While molding the brick, he may have used its smooth surface as a "slate" for practicing his writing. If so, it is the only known inscription by Dave that is not on a piece of pottery.

RUMORED INSCRIPTIONS

A noble Jar
For lard or tar

Though several people have told me about this inscription, none of them has actually seen it. It is said to be dated February 20, 1858.

·

Ponderosity

An archival reference to this single-word inscription was reported in 1976 to John Michael Vlach, who included it in a section on Dave in *The Afro-American Tradition in Decorative Arts*. However, I have not been able to locate the original reference or anyone who has seen the inscription.[9]

A WORD ON SOURCES

Primary Sources on Dave

The richest information on Dave comes from Dave himself. He offers it in two forms. The first, his inscriptions, provides a slim thread of data that runs through most of his adult life. Though he does not write directly of historical events, such as South Carolina's secession from the Union or the Civil War that followed, a careful reading of his words (almost always dated) helps create a background for his experience during such periods. The second form of information, his pots, reveals his extraordinary abilities and helps explain why he was such a well-known artisan during his lifetime. His inscribed vessels can be viewed in many major museums, including the High Museum in Atlanta, the Philadelphia Museum of Art, and the Smithsonian Institution.

Other valuable primary sources are available for study:

• Documents on Dave preserved in the Edgefield County Archives; among these are an 1818 mortgage agreement, which establishes his birth date, and 1833 and 1847 estate sale records, which document his transfer between owners; all can be studied on microfilm at the archives.
• *Edgefield Advertiser*, which mentioned Dave three times during his lifetime; copies of the paper from 1836 through 2005 are available for study on microfilm at the Tompkins Library in Edgefield.
• 1868 Voter Registration Rolls for South Carolina, the 1869 South Carolina Census, and the 1870 U.S. Census, each of which lists Dave under David (or Dave) Drake, the name he took after he was free. These documents can be viewed on microfilm at the South Carolina Department of Archives and History in Columbia.
• Laura Bragg Papers at the Charleston Museum Archives, which contain the story of Dave's railway accident as well as much information on Edge-

field pottery. Photocopies of the documents in the collection can be studied at the archives.

• Archaeological data gathered from the sites where Dave worked. The findings of the South Carolina Institute of Archaeology and Anthropology, the McKissick Museum, the Georgia Archaeological Institute, and others are contained in publications listed in the bibliography.

The WPA Slave Narratives

To help establish the background for Dave's story, I have often quoted other men and women who were enslaved in the South. These quotations come in many cases from interviews that were conducted in the late 1930s by the Federal Writers Project, a part of the Works Progress Administration (WPA). Initiated to provide work for unemployed writers during the Great Depression, the program sent representatives into the homes of aged blacks throughout the Southern states. It amassed an enormous trove of interviews in the few years it was in existence. The interviews were eventually edited by George P. Rawick and published as *The American Slave: A Composite Autobiography* (Westport, Conn.: Greenwood Press, 1972 and 1977).

The WPA Slave Narratives, as they are referred to, are not without problems. The former slaves were very old when they were speaking of events that happened when they were very young. In addition, the interviewers, usually white, were perhaps not always trusted by the blacks. Distortions, either to please or to shock, no doubt occurred in some instances. Perhaps most disturbing for us today is the heavy dialect that the writers often used to represent the speaking voice of the former slaves. "De broom wus de law!" might have been what an interviewer heard, or thought he heard, but it is difficult to read such a sentence without seeing it as an attempt to patronize or lampoon the speaker. In spite of the problems inherent in the narratives, however, I decided to make full use of them as they were written. The insights that they often provide are stirring.

Rawick's multi-volume publication is in many large libraries. In recent years, however, the Library of Congress has made most of the interviews available on its Web site, where they can be searched by the name of the person interviewed or by the state in which he or she lived. Because of this ease of access, I have chosen to cite the Web site rather than the published volumes in my source notes. The address of the home page for the narratives is

http://memory.loc.gov/ammem/snhtml/snhome.html

Another way to access the interviews is to perform a search for "Born In Slavery," which is the name of the page. From the home page, there is also a link to an excellent introduction to the interviews by Norman R. Yetman, who discusses at greater length some of the problems I have mentioned.

Exhibitions and Research Projects

Beginning in the 1970s, a number of projects contributed to the slowly growing body of knowledge about Dave and the history of alkaline-glazed pottery in Edgefield District. The first project was in 1970, when Edgefieldian Carlee McClendon, who discovered the "buttermilk" article on Dave, opened a small museum on the site of Pottersville to exhibit the pottery that had once been produced in the area. Six years later, Steve and Terry Ferrell helped organize an exhibition entitled "Early Decorated Stoneware of the Edgefield District South Carolina" at the Greenville County Museum of Art. In 1978, John Michael Vlach's catalog for "The Afro-American Tradition in Decorative Arts," an exhibition at the Cleveland Museum of Art, called Dave "the most accomplished Afro-American potter of the period." From April to December 1981, Carlee McClendon published a monthly newspaper on Edgefield pottery, the *Pottersville Hive*. The McKissick Museum carried out the first comprehensive survey of alkaline-glazed stoneware in 1982, and later organized a landmark exhibition, "Crossroads of Clay." Joe and Fred Holcomb published their archival and archaeological findings on alkaline-glazed pottery in *South Carolina Antiquities* in 1986 and 1989. The South Carolina Institute of Archaeology and Anthropology (SCIAA), with George J. Castille as principal archaeological investigator, examined nine pottery sites in Old Edgefield District in the fall of 1987. Carl Steen continued this work in 1993 under a grant from the South Carolina Department of Archives and History. In that same year, Cinda Baldwin, who had been principal historical investigator on the SCIAA project, chronicled the story of traditional stoneware in South Carolina in *Great and Noble Jar*. Her book, which borrowed its title from Dave's writings and pictured one of his jars alone on the cover, listed twenty of his poems. Georgeanna Greer and other noted researchers also contributed information during this period. In 1998, Jill Koverman, working with the McKissick Museum, curated the first exhibition ever devoted entirely to Dave, "I made this jar . . .: The Life and Works of the Enslaved African-American Potter, Dave." It opened at the McKissick and later traveled to three other museums around the country. Arthur F. Goldberg and James P. Witkowski compiled an annotated list of Dave's known pots for *Ceramics in America* in 2006. Dr. Mark Newell, of the

Georgia Archaeological Institute, is currently carrying out extensive research on the final decades of pottery making in Edgefield and Aiken counties.[1]

Each of the publications that documents these endeavors has been a source of information for this book. All are included in the bibliography.

NOTES

FOREWORD

1. EXHIBITION: An excellent catalog documents this exhibition: Jill Beute Koverman, ed., *I made this jar . . .: The Life and Works of the Enslaved African-American Potter, Dave* (Columbia: McKissick Museum, University of South Carolina, 1998).

2. "ONE OF THE MOST HISTORICALLY SIGNIFICANT COMMUNITIES": Orville Vernon Burton, *In My Father's House Are Many Mansions: Family and Community in Edgefield, South Carolina* (Chapel Hill and London: University of North Carolina Press, 1985), xviii. "THE MOST OUTSTANDING AFRICAN-AMERICAN POTTER": Cinda K. Baldwin, *Great and Noble Jar: Traditional Stoneware of South Carolina* (Athens and London: University of Georgia Press, 1993), 77.

3. EDGEFIELD COUNTY COURTHOUSE: Research by architectural historian John M. Bryan indicates that the courthouse was designed by Charles Beck. Gene Waddell and Rhodri Windsor Liscombe, *Robert Mills's Courthouse & Jails* (Easley: Southern Historical Press, 1981), 14. Peter Matthiessen, whose novel *Bone by Bone* begins in Edgefield, describes the courthouse in his book as "a white-windowed brick edifice upon a hill approached by highroads from the four directions, as if drawing the landscape all around to a point of harmony and concord. The building is faced with magisterial broad steps on which those in pursuit of justice may ascend from Court House Square to the brick terrace. White columns serve as portals to the second-story courtroom, and an arched sunrise window over the door fills that room with austere light, permitting the magistrate to freshen his perspective by gazing away over the village roofs to the open countryside and the far hills, blue upon blue." Peter Matthiessen, *Bone by Bone* (New York: Random House, 1999), 3.

4. QUOTE ON WALL: William Watts Ball, *The State That Forgot: South Carolina's Surrender to Democracy* (Indianapolis: Bobbs-Merrill, 1932), 22.

5. THURMOND STATUE: The statue of Strom Thurmond was sculpted by Maria Kirby-Smith and put in place on the square in 1984. "AN UNGUARDED PART OF THE PAST": W. S. Merwin, interview on "Morning Edition," August 7, 2003, National Public Radio.

CHAPTER ONE: *Purchases*

1. "ONE OF THE NECESSARY ATTRIBUTES OF CIVILIZED LIFE": Philip Rawson, *Ceramics* (London: Oxford University Press, 1971), 3.

2. GEOLOGIC CHANGES: Baldwin, *Great and Noble Jar*, 2, 3. LOCAL CLAY BEDS: Baldwin, *Great and Noble Jar*, 105.

3. EQUIPMENT USED BY EDGEFIELD POTTERS: Baldwin, *Great and Noble Jar*, 21. A FULL-SCALE FACTORY: Cinda K. Baldwin, "The Scene at the Crossroads," in Catherine Wilson Horne, ed., *Crossroads of Clay: The Southern Alkaline-Glazed Stoneware Tradition* (Columbia: McKissick Museum, University of South Carolina, 1990), 48.

4. POTTERSVILLE PARTNERS: Deed Book 35, p. 237, Edgefield County Archives. AMOS LANDRUM'S DRINKING: Stephen T. Ferrell and T. M. Ferrell, *Early Decorated Stoneware of the Edgefield District, South Carolina* (Greenville: Greenville County Museum of Art, 1976), n.p. AMOS LANDRUM'S OTHER QUALITIES: Louise Landrum Murphey, personal communication, May 27, 2004.

5. HARVEY DRAKE'S GENEALOGY: Jane Drake Brody, *Richard Drake of Southhampton, Va.*, http://www.xroyvision.com.au/drake/history/hist42. HARVEY DRAKE'S HEALTH: "Died," *Columbia Hive*, November 10, 1832.

6. FIRST MENTION OF DAVE: Deed Book 35, pp. 237-38, Edgefield County Archives. Earlier printed sources have incorrectly cited Deed Book 47. DEFINITION OF "COUNTRY BORN": Edward Ball, *Slaves in the Family* (New York: Ballantine Books, 1999), 178.

7. ADS FOR SLAVES: *Augusta Chronicle*, December 10, 1819. INCREASE IN SLAVES: Burton, *In My Father's House*, 19.

8. EUGENE SMITH AND LAURA STEWARD: WPA Slave Narratives, Georgia, Vol. IV, Pt. 4, pp. 342, 343. Also see Burton, *In My Father's House*, 179, 390, n. 99.

9. REV. JAMES W. C. PENNINGTON: Quoted in Mia Bay, *The White Image in the Black Mind: African-American Ideas about White People, 1830-1925* (New York and Oxford: Oxford University Press, 2000), 142.

10. ESTIMATE OF YOUNG DAVE'S MARKET VALUE: Dr. Edward J. Cashin, personal communication, January 25, 2005. I converted this figure (and subsequent figures given in this book) to today's money using the Columbia Journalism Review Inflation Calculator (www.cjr.org). DAVID HOLMES: Quoted in John W. Blassingame, The Slave Community: Plantation Life in the Antebellum South *(New York: Oxford University Press, 1972), 182.*

11. TURNERS WITH BRITISH ROOTS: John Michael Vlach, "International Encounters at the Crossroads of Clay," in Catherine Wilson Horne, ed., *Crossroads of Clay: The Southern Alkaline-Glazed Stoneware Tradition* (Columbia: McKissick Museum, University of South Carolina, 1990), 21; Baldwin, *Great and Noble Jar,* 47,57, 59.

12. "ENLARGING THIS ESTABLISHMENT": 1820 U.S. Census: South Carolina, Industry/Manufactures Schedules, Digest (Edgefield). DAVE AS COLLATERAL: Two mortgage agreements, one between Harvey Drake and Eldrid Simkins (signed on June 13, 1818) and the other between Amos Landrum and Eldrid Simkins (signed on October 26, 1818), document Dave as partial collateral for the loan taken out by Drake and Landrum; Deed Book 35, pp. 237–38, Edgefield County Archives.

13. HARVEY DRAKE AS TEACHER: Jill Beute Koverman. "Searching for Messages in Clay," in Koverman, ed., *I made this jar . . .*, 26–28.

14. 1821 JUG: Koverman, in Koverman, ed., I made this jar . . ., 26.

15. DANIEL: Baldwin, Great and Noble Jar, 220. HARRY: Baldwin, Great and Noble Jar, 221. BLACK POTTERY WORKERS IN EDGEFIELD: John Michael Vlach, The *Afro-American Tradition in Decorative Arts* (Athens and London: University of Georgia Press, 1990), xii.

16. ELIZA AS COLLATERAL: Deed Book 35, pp. 237–38, Edgefield County Archives.

17. HAMMOND'S WEDDING GIFTS: Burton, *In My Father's House,* 161. BROOMSTICK WEDDINGS: Eugene D. Genovese, *Roll, Jordan, Roll: The World the Slaves Made* (New York: Pantheon, 1974), 475–81.

18. CHANDLER WEDDING COOLER: Baldwin, *Great and Noble Jar,* 149.

19. "DEATH OR DISTANCE": Genovese, *Roll, Jordan, Roll,* 481. MATTHEW JARRETT: Quoted in Genovese, *Roll, Jordan, Roll,* 481.

20. REBECCA JANE GRANT: WPA Slave Narratives, South Carolina, Vol. XIV, Pt. 2, 180–81.

21. LYDIA: Lydia is first named, as Lidy, in an agreement between Reuben and Harvey Drake, signed July 1, 1830; Deed Book 46, p. 78, Edgefield County Archives. George and the other male slaves belonging to the Drakes are named in the same document. Lydia's children are named in a January 12,

1833, list of goods and chattels in the estate of Harvey Drake; Probate Records, Box 9, Pkg. 304, Edgefield County Archives.

22. STORY OF DAVE'S DRUNKENNESS: "Notes made on trip to Seigler's Pottery, near Eureka, S.C.," Laura Bragg Papers, Charleston Museum Archives.

CHAPTER II: *Discoveries*

1. FIERY FURNACE: *Edgefield Advertiser*, May 11, 1859.

2. 1688 ARRIVAL FROM SCOTLAND: Joel P. Shedd, *The Landrum Family of Fayette County, Georgia* (Washington, D.C.: Moore and Moore, 1972), 6. LINK WITH NORTH CAROLINA POTTERS: Charles G. Zug III, *Turners and Burners: The Folk Potters of North Carolina* (Chapel Hill and London: University of North Carolina Press, 1986), 78–80. A POTTERY IN LAURENS: "Mr. Frank Landrum, Aiken," Laura Bragg Papers, Charleston Museum Archives. Though it conflates generations, this interview, which was probably with Hastings Landrum, appears to indicate that Samuel Landrum operated a small pottery in Laurens when he first came to South Carolina, then opened another at Eureka when he came to Edgefield District. 1773 ARRIVAL IN SOUTH CAROLINA: Obituary of Rev. John Landrum, *Advertiser*, December 23, 1846.

3. STUDIED WITH DR. WADDEL: "The Late Dr. Abner Landrum," *Advertiser*, May 11, 1859. INTERNED WITH DR. HARRIS: Mark M. Newell, Ph.D., and Nick Nichols, *The River Front Potters of North Augusta* (Augusta: Georgia Archaeological Institute, 1999), 51. "DR. LANDRUM HAS LATELY DISCOVERED A CHALK": Quoted in Carl Steen, *An Archaeological Survey of Pottery Production Sites in the Old Edgefield District of South Carolina* (Columbia: Diachronic Research Foundation, 1994), 16.

4. JEFFERSON'S EMBARGO: Steen, *Pottery Production Sites*, 16–17. THOMAS ANDERSON'S MAP: South Carolina Department of Archives and History, S.C. Map Collection, MC 4–6. Copies of an 1825 version of this map are for sale at the Tompkins Library in Edgefield.

5. CHARACTERISTICS OF EARTHERNWARE AND STONEWARE: Baldwin, *Great and Noble Jar*, 11.

6. HOUSE IN POTTERSVILLE: Robert Mills, *Statistics of South Carolina, Including a View of Its Natural, Civil, and Military History, General and Particular* (Charleston: Hurlbut and Lloyd, 1826), 522–24; *Advertiser*, May 11, 1859. MAHETHALAN PRESLEY LANDRUM: Baldwin, in Home; ed., *Crossroads of Clay*, 49. NUMBER OF WHEELS AND WORKERS: 1820 U.S. Census, South Carolina, Indus-

try/Manufacturies Schedules, Digest (Edgefield). Though the schedule does not name the pottery it refers to, it is probably Dr. Landrum's. ROBERT MILLS: Mills, *Statistics of South Carolina*, 523–24. JUGGERY: *Advertiser*, May 11, 1859.

7. STONEWARE VERSUS PROCELAIN: Baldwin, *Great and Noble Jar*, 11. POTTERSVILLES SITE STUDY: Steen, *Pottery Production Sites*, 31–32. The survey found similar results at the site of the pottery belonging to Abner Landrum's oldest brother, John, which was located across the district on Horse Creek: "[E]vidence was recovered that indicates experimentation with clays and glazes that suggests the Landrums were trying to make refined wares, like porcelain and Ironstone." (Ibid., 33). The quest for porcelain may have been a joint undertaking by the two brothers. "A SPECIMEN OF UPCOUNTRY PORCELAIN": *Edgefield Hive*, April 9, 1830.

8. LEAD AND SALT GLAZES: Baldwin, *Great and Noble Jar*, 13–14; Catherine Wilson Horne, "Introduction," in Horne, ed., *Crossroads of Clay*, 2. ALKALINE GLAZE: Excellent discussions of the alkaline glaze and the conditions that led to its development can be found in Baldwin, *Great and Noble Jar*, 13–16; Zug, *Turners and Burners*, 70–74, and John A. Burrison. *Brothers in Clay: The Story of Georgia Folk Pottery* (Athens and London: University of Georgia Press, 1983), 58–62. Though Abner Landrum is generally credited with developing the alkaline glaze, it is possible that his brother, Rev. John Landrum, made contributions at his Horse Creek Pottery.

9. A CERAMIC MYSTERY: Howard A. Smith, *Index of Southern Potters* (Mayodan: Old America Company, 1982; reprinted by Mayo Publishing, 1996), 107. PÈRE D'ENTRECOLLES: The letters of Père d'Entrecolles are available on the Internet at www.ceramicstoday.com/articles/entrecolles; Baldwin, *Great and Noble Jar*, 17–20, provides a full explication of the d'Entrecolles connection theory; Zug, *Turners and Burners*, 72–74, offers several alternative theories.

10. SPREAD OF THE ALKALINE GLAZE: Smith, Index of Southern Potters, 155. SHANGHAI GLAZE: John Burrison, personal communication, February 19, 2007. VARIATIONS IN APPEARANCE OF ALKALINE GLAZE: Baldwin, *Great and Noble Jar*, 33, 144–47.

11. "ANYTHING A HAND HAS TOUCHED": Richard Holmes, *Footsteps: Adventures of a Romantic Biographer* (New York: Vintage Books, 1996), 67.

12. GROUNDHOG KILNS: Baldwin, *Great and Noble Jar*, 20–21; Burrison, *Brothers in Clay*, 91–97; Zug, *Turners and Burners*, 202–15. TEMPERATURE OF THE KILN: Ferrell and Ferrell, *Early Decorated Stoneware*, n.p.

13. TIMBER AGREEMENT: Deed Book 43, pp. 359–60, Edgefield County Archives; Baldwin, *Great and Noble Jar*, 36–36.

14. GRAFTING EXPERIMENTS: *American Farmer*, 1822, Vol. IV, pp. 6–8, 39, 268–69, for two letters by Dr. Landrum describing the grafts; L. J. Grauke, U.S. Department of Agriculture, Agricultural Research Service, http://extension-horticulture.tamu.edu/CARYA/PECANS/Centennial.html, for information on Dr. Landrum's pecan experiments; *Advertiser*, May 11, 1859, for an assessment of his contribution to scientific agriculture. MEDICINAL USE OF HERBS: Joe L. Holcombe and Dr. Fred E. Holcombe, "South Carolina Potters and Their Wares: The Landrums of Pottersville," *South Carolina Antiquities*, Vol. 18, 1986, p. 55.

15. NAMES OF LANDRUM CHILDREN: Holcombe and Holcombe, "The Landrums of Pottersville," 48–49; Burrison, *Brothers in Clay*, 286, n. 19; "Genealogical Chart of the Landrum Family of Edgefield," Dave File, McKissick Museum Archives. Horne, ed., *Crossroads of Clay*, 51, also lists Eliza, Leslie, Abner, and Manning; these children may have died in childhood.

16. "A LITTLE CRAZY": Maude Stork Shull, personal communication, May 24, 2003. "OUR PECULIAR WAYS": Catherine Holland Scavens, personal communication, March 21, 2003.

CHAPTER III: *Words*

1. JAMES W. C. PENNINGTON: Quoted in Mia Bay, *The White Image in the Black Mind: African-American Ideas about White People, 1830–1925* (New York and Oxford: Oxford University Press, 2000), 7.

2. JAMES GRONNIOSAW: Quoted in Janet Duitsman Cornelius, *"When I Can Read My Title Clear": Literacy, Slavery, and Religion in the Antebellum South* (Columbia: University of South Carolina Press, 1991), 16. FREDICKA BREMER: Quoted in Genovese, *Roll, Jordan, Roll*, 565. FREDERICK DOUGLASS: Quoted in Cornelius, *"When I Can Read My Title Clear,"* 1.

3. THE SECOND GREAT AWAKENING: Walter Edgar, *South Carolina: A History* (Columbia: University of South Carolina Press, 1998), 292–93. ABBEVILLE SLAVEHOLDERS: Records of the General Assembly, Petitions, Abbeville: ND 2822, South Carolina Division of Archives and History. DRAKE DESCENDANTS: Tim Drake, personal communication, July 8, 2004. Though Tim has not yet been able to document the connection between his line of Abbeville Drakes and the Edgefield Drakes, a strong oral tradition in his family holds that they are descended from a cousin of

Harvey Drake. Tim's grandfather, Harris Campbell Drake, told him that Harvey taught his slaves to read so that they would have access to the Bible. HARVEY DRAKE'S RELIGIOUS BELIEFS: "Died," *Columbia Hive,* November 10, 1832. SARAH DRAKE'S CHURCH MEMBERSHIP: Edgefield Village Baptist Church Minutes, February 8, 1823, February 5, 1825, and April 3, 1825, Tompkins Library.

4. THE BLUE-BACK SPELLER: Cornelius, *"When I Can Read My Title Clear,"* 69–71.

5. 1813 EDITION: Noah Webster, *The American Spelling Book, Containing the Rudiments of the English Language, for the Use of Schools in the United States* (Brattleboro, Vt., printed by William Fessenden, 1813). TWELFTH-GRADE LEVEL: Cornelius, *"When I Can Read My Title Clear,"* 70. PERCENTAGE THAT COULD READ: Cornelius, *"When I Can Read My Title Clear,"* 7–9.

6. REASONS NOT TO TEACH WRITING: Cornelius, *"When I Can Read My Title Clear,* 71–73, 109. JAMES J. BRADLEY: Quoted in John W. Blassingame, *Slave Testimony: Two Centuries of Letters, Speeches, Interviews, and Autobiographies* (Baton Rouge: Louisiana State University Press, 1977), 689.

7. STONO REBELLION AND 1740 SLAVE CODES: Edgar, *South Carolina,* 74–75; Ball, *Slaves in the Family,* 140–41. The slave codes of 1740 and 1820 are in Thomas Cooper and David J. McCord, *The Statutes at Large of South Carolina (1682–1838),* 10 vols. (Columbia, S.C.: A. S. Johnston, 1838–1841).

8. VESEY REBELLION: A complete account of the planned rebellion is given in David Robertson, *Denmark Vesey* (New York: Alfred A. Knopf, 1999); Ball, *Slaves in the Family,* 267; Cornelius, *"When I Can Read My Title Clear,"* 30. END OF ATTEMPTS TO TEACH SLAVES TO READ: William W. Freehling, *Prelude to Civil War: The Nullification Controversy in South Carolina, 1816–1836* (New York and Evanston: Harper & Row, 1966), 73.

9. ONLY REMAINING POTTERSVILLE HOUSE: Steve Ferrell, personal communication, March 19, 2003. FINDING DAVE'S BRICK: Steve Ferrell, personal communication, March 19, 2003.

10. FREDERICK DOUGLASS'S COPYBOOK: David W. Blight, ed., *Narrative of the Life of Frederick Douglass, an American Slave, Written by Himself* (Boston and New York: Bedford/St. Martin's, 2003), 70.

11. HANDWRITING ANALYSIS: Robert Backman, personal communication, June 11, 2005. THOMAS JONES: Quoted in Blassingame, *Slave Community,* 312.

12. DR. LANDRUM'S NEWSPAPERS: I have based the general chronology of Dr. Landrum's newspapers on John Hammond Moore: *South Carolina Newspapers* (Columbia: University of South Carolina Press, 1988), 98. Sometimes

conflicting information can be found in Eleanor Mims Hansen, *The Edge-field Advertiser and Its Editors* (Edgefield: The Edgefield Advertiser, 1980), 4–7. ORIGIN OF THE *HIVE*'S NAME: *Edgefield Hive*, January 1, 1830.

13. OFFERINGS IN THE *HIVE*: The prospectus for the *Hive* appeared in the *Edge-field Carolinian*, November 7, 1829. SALE OF FACTORY SITE: Deed Book 42, p. 430, Edgefield County Archives. SALE OF TIMBER RIGHTS: Deed Book 43, pp. 359–60, Edgefield County Archives. SALE OF REMAINING POT-TERSVILLE PROPERTY: Deed Book 45, pp. 373–74, Edgefield County Archives.

14. DURISOE'S BIRTH DATE: 1865 Federal Amnesty Oath Book, Edgefield County Archives. DURISOE'S BACKGROUND: Hansen, Editors, 31. DURISOE AS TYPESETTER FOR THE *HIVE*: Hansen, Editors, 31.

15. TYPE-STAMPED SHERDS: Baldwin, *Great and Noble Jar*, 34–35.

16. ESSAY ON HEAT AND LIGHT: First installment in *the Edgefield Hive*, January 12, 1830. DR. BRAZIER: "Obituary," *Advertiser,* November 22, 1843; John A. Chapman, *History of Edgefield County From the Earliest Settlements to 1897* (New-berry, S.C.: Elbert H. Aull, 1897), 344–345. HERCULES VERSUS MINERVA: *Edgefield Hive*, February 2, 1830.

17. WHAT DICK HEARD: C. Vann Woodward, ed., *Mary Chesnut's Civil War* (New Haven and London: Yale University Press, 1981), 464.

18. "HOW DOES YOUR CORPOROSITY SEEM TO SAGATIATE?" *Advertiser,* April 1, 1863. brer rabbit: Joel Chandler Harris, *The Complete Tales of Uncle Remus* (Boston: Houghton Mifflin Co., 1955), 6–8. SHIRLEY TEMPLE: *The Little Colonel,* 20th Century Fox, 1935. I am grateful to Wendy Schmalz for this reference. JAMES JOYCE: James Joyce, *Ulysses* (New York: Modern Library, 1946), 418.

19. HER FATHER USED TO SIT: Mrs. Stella Dorn, personal communication, March 21, 2003. "COMPRESSIBILITY": Webster, *The American Spelling Book,* 1824 ed. 110, reprinted by Applewood Books, Applewood, Mass.

CHAPTER IV: *Fire-Eaters*

1. JOHN C. CALHOUN: Quoted in William W. Freehling, *The Nullification Era: A Documentary Record* (New York: Harper & Row, 1967), 182.

2. "COLLISION OF OPINIONS AND FEELINGS": "To Our Patrons," January 18, 1831, bound into the 1830 volume of the *Hive*. NULLIFICATION CONTRO-VERSY: Edgar, *South Carolina,* 331–34; William W. Freehling, *Prelude to Civil War: The Nullification Controversy in South Carolina, 1816–1836* (New York and Evanston: Harper & Row, 1966); Freehling, *Nullification Era,* ix–xvii.

3. DESCRIPTION OF GEORGE MCDUFFIE: David Franklin Houston, *A Critical Study of Nullification in South Carolina* (Gloucester, Mass.: Peter Smith, 1968), 36–37, 70.

4. FOUR-FIFTHS ESTIMATE: *Edgefield Hive*, February 2, 1830. "BLUNDERING EDITOR": *Edgefield Carolinian*, August 15, 1829. "SUBMISSIONIST": Edgar, *South Carolina*, 334. EDGEFIELD CROWDS: Chapman, *Edgefield County*, 84. RECOMMENDATION OF POETRY: *Edgefield Hive*, March 12, 1830.

5. "HAZARDOUS EXPERIMENT": *Columbia Free Press and Hive*, January 28, 1832. "WHERE THE VOICE OF [MY] COUNTRY CALLS": "To Our Patrons," January 18, 1831, bound into the 1830 volume of the *Hive*. DR. LANDRUM WASN'T "AGAINST THE SOUTH": Maude Stork Shull, personal communication, May 17, 2003. ARMED WITH TRUTH ONLY: *Columbia Free Press and Hive*, January 28, 1832.

6. LOCATION OF DR. LANDRUM'S OFFICE: *Columbia Free Press and Hive*, April 2, 1831. FIRST PUBLICATION OF DR. LANDRUM'S NEW PAPER: Moore, *South Carolina Newspapers*, 198. The *Columbia Free Press and Hive* became the *Columbia Hive* on February 4, 1832. EDGEFIELD AGENTS: "H. & R. Drake & Co." is listed in numerous issues of Dr. Landrum's paper as its Edgefield agent. AD FOR A HELPER: *Columbia Free Press and Hive*, April 2, 1831.

7. "THIS POLITICAL MONSTER": *Columbia Free Press and Hive*, November 5, 1831. GREENVILLE VIOLENCE: Edgar, *South Carolina*, 334. CHARLESTON VIOLENCE: Mark Perry, *Lift Up Thy Voice: The Grimké Family's Journey from Slaveholders to Civil Rights Leaders* (New York: Viking, 2001), 110. ATTACK ON DR. LANDRUM: *Columbia Free Press and Hive*, April 2, 1831.

8. SOUTH CAROLINA'S THREAT AND JACKSON'S RESPONSE: Edgar, *South Carolina*, 336.

9. YELLOW JACKETS: Chapman, *Edgefield County*, 82–84. A TENNESSEEAN'S OFFER: Edgar, *South Carolina*, 336. COMPROMISE TARIFF: Freehling, *Prelude to Civil War*, 293.

10. HARVEY DRAKE'S DEATH: "Died," *Columbia Hive*, November 10, 1832.

11. HARVEY DRAKE ESTATE SALE: Probate Records, Box 9, Pkg. 304, Edgefield County Archives. DRAKE-GIBBS PARTNERSHIP: Baldwin, *Great and Noble Jar*, 45; Koverman, in Koverman, ed., *I made this jar . . .*, 23.

12. SERIES OF EVENTS: Cornelius, *"When I Can Read My Title Clear,"* 31–32. PRICE ON WALKER: Dorothy Schneider and Carl J. Schneider, *An Eyewitness History of Slavery in America, From Colonial Times to the Civil War* (New York: Checkmark Books, 2001), 409.

13. 1834 ANTI-LITERACY LAW: Cooper and McCord, *Statutes of South Carolina*, 468–470. There was a ban against teaching slaves to write from 1740 until

1820, when a new slave code was written that didn't include it. Only in 1834 was the ban reinstated, along with an additional one against teaching a slave to read. POSITION OF UNIONISTS: Cornelius, *"When I Can Read My Title Clear,"* 37, 39, 41. GREAT REACTION: Freehling, *Prelude to Civil War,* 333.

14. FORMER SLAVES IN WPA NARRATIVES: Sylvia Cannon, South Carolina, Vol. 14, P. 1, 192; Elijah Green, South Carolina, Vol. 14. P. 2, 197; Abram Harris, Arkansas, Vol. 2. P. 3, 172. THUMB MASHING: Paul D. Escott, *Slavery Remembered: A Record of Twentieth-Century Slave Narratives* (Chapel Hill: University of North Carolina Press, 1979), 40.

15. 1859 MENTION OF DAVE: *Advertiser,* May 11, 1859. LETTER DESCRIBING POTTERSVILLE VISIT: William M. Miller to John B. Miller, March 7, 1832, Miller-Furman-Dabbs Family Papers, South Caroliniana Library, University of South Carolina. I am grateful to Steve Ferrell for this reference.

16. "NEUTRAL CLOAK OF ANONYMITY": William Styron, *The Confessions of Nat Turner* (New York: Vintage Books, 1993), 65.

CHAPTER V: *Trips*

1. THREE CAUSES FOR EMIGRATION: Mills, Statistics of South Carolina, 527. "A RAGE FOR EMIGRATION": *Advertiser,* February 11, 1836. CANFIELD FINDS SITE: Lavinia Egan, "Material Collected or Written for a History of Northwest Louisiana," Lavinia Egan Papers, Louisiana Tech University Library, Ruston, La. Eagan, who grew up in Mount Lebanon, Louisiana, knew Martin Canfield and other original settlers of the town. Her manuscript note include much information on the South Carolina Colony. Also, see Billie Gene Poland, *History of Bienville Parish* (Bienville, La.: Bienville Parish Historical Society, 1984), 93, 168–69.

2. DIFFUCULTIES OF DISPLACED BONDSMEN: Burton, *In My Father's House,* 180. SARAH DRAKE JOINED THE PARTY: Virginia Morrow Newman Yardley, "History of Mt. Lebanon Baptist Church, July 8, 1837–July 8, 1987," Mt. Lebanon file, Tompkins Library, Edgefield.

3. CAREY DICKSON: "Notes made on trip to Seigler's Pottery, near Eureka, S.C., October 4, 1930," Laura Bragg Papers, Charleston Museum Archives. GEORGE FLETCHER: "Notes collected on trip to various potteries. Miss L. M. B. & E. B. C. June 24–26, 1930," Laura Bragg Papers, Charleston Museum Archives; Mark M. Newell and Nick Nichols, *The River Front Potters of North Augusta* (Augusta: Georgia Archaeological Institute, 1999), 17–20. 1834 JARS: I am grateful to Jim Witkowski for this suggestion.

4. LABORDE'S RIDE: *Advertiser,* original date unknown, reprinted October 30,

1985. DISTRIBUTION OF WARE ON THE RAILROAD: Baldwin, *Great and Noble Jar*, 46–47.

5. HARVEY DRAKE AS TEMPERANCE ADVOCATE: Tim Drake, personal communication, June 14, 2004. WILLIAM BRAZIER AS TEMPERANCE ADVOCATE: Holcombe and Holcombe, *South Carolina Antiquities*, Vol. 18, 1986, 50. DR. LANDRUM ON ALCOHOL ABUSE: *Columbia Hive*, March 31, 1832. POEM IN THE *HIVE*: *Edgefield Hive*, April 2, 1830.

6. USE OF WHISKEY IN WHITE HOMES: Genovese, *Roll, Jordan, Roll*, 645–46. AMOS LANDRUM'S DRINKING: Ferrell and Ferrell, *Early Decorated Stoneware*.

7. DRINKING AMONG EDGEFIELD BLACKS: "Whiskey," *Edgefield Carolinian*, February 20, 1830.

8. KEG OF RUM: Louise Landrum Murphey, personal communication, May 27, 2004. MEDICINAL PURPOSES: Steve Ferrell, personal communication, March 19, 2003.

9. A YANKEE AMONG THE NULLIFIERS: "The South Carolina Railroad," *Georgia Constitutionalist*, January 3, 1834. The original letter is dated November 10, 1833.

10. DETAILS OF TRAIN: A full-size replica of the first train to run between Charleston and Hamburg, The Best Friend of Charleston, is displayed at the South Carolina State Museum in Columbia. It is painted forest green, with yellow and red details. AMPUTATION: Alfred Jay Bollet, M.D., *Civil War Medicine: Challenges and Triumphs* (Tucson: Galen Press, 2002), 81. REMOVAL OF WEDGWOOD'S LEG: Jenny Uglow, *The Lunar Men: Five Friends whose Curiosity Changed the World* (New York: Farrar, Straus and Giroux, 2002), 176–77.

11. DEPARTURE OF DRAKES: Lavinia Egan, "Material Collected," 126. According to Egan, an earlier party that left Edgefield for Mt. Lebanon took approximately two months to get there. Because, as she says as the Drake party arrived at their new home in March 1836, they would therefore probably have left Edgefield sometime in January of that year. "SECOND MIDDLE PASSAGE": Ira Berlin, *Generations of Captivity: A History of African-American Slaves* (Cambridge and London: Belknap Press of Harvard University Press, 2003), 161–73.

12. MT. LEBANON POTTERY: Descendant of the original settlers, personal communication, October 19, 2004. The pot has very thin walls; it is brown with a drippy black overglaze. SALT WORKS: Jacqueline Fesq Haislip, "Reuben Drake: Rise and Fall and Survival," Chapter 7 of a privately published Drake family history.

CHAPTER VI: *Sermons*

1. IVERSON L. BROOKS: Quoted in Burton, *In My Father's House,* 27.

2. DRAKE'S ARRIVAL IN MT. LEBANON: Lavinia Egan, "Material Collected," 126. DAVE'S SECOND KNOWN POEM: The words "hog" and "bog" are presented together on page 17 of the 1824 edition of Noah Webster's *American Spelling Book,* the blue--back speller. It's possible that the lists of rhyming words in the speller were an inspiration for Dave's verses. I am grateful to James P. Witkowski and Arthur F. Goldberg for sending me a reprint of this edition.

3. "FED LIKE PIGS": Bay, *The White Image in the Black Mind,* 119.

4. MENTION OF DAVE IN 1847: Estate of Rev. John Landrum, Box 56, Pkg. 2312, Probate Records, Edgefield County Archives. DAVE'S OWNER AFTER REUBEN DRAKE: It is possible that Lewis Miles, the son-in-law of Rev. John Landrum, purchased Dave from Reuben Drake and Jasper Gibbs when the Drakes left for Louisiana. This is suggested by the census of 1840, which shows that Miles owned the only male slave at the Horse Creek compound in the age category "36 and under 55." Because Dave was approximately thirty-nine at that time, this could have referred to him. His own inscriptions show that he was working for Miles during the early 1840s. If Miles initially owned Dave, however, he would then have had to sell him to his father-in-law, because Dave is listed in the estate of Reverend Landrum in 1847. I find it more likely that Reverend Landrum purchased Dave from Drake and Gibbs, then lent him to his new son-in-law. Dave may, in fact, have been listed under Reverend Landrum on the 1840 census, which shows Landrum owning two male slaves in the age category "24 and under 36." It could be that Dave, taken for thirty-five rather than thirty-nine, was one of these. REVEREND LANDRUM'S ENTERPRISES: The "Saw Mill formerly owned by the Rev. John Landrum, dec'd." is referred to in an ad placed by Lewis Miles in the *Advertiser,* November 3, 1847. Landrum also apparently owned a gristmill, for one of his descendants, Louise Landrum Murphey, told me that she had been told long ago that "one of the Landrums" (probably Reverend John of his father, Samuel) asked relatives in Scotland to send him a "fulling cloth, something like a great, large sieve," so that he could start the first mill in the area. The minister also owned a tannery (Baldwin, *Great and Noble Jar,* 44).

5. POTTERY FACTORIES ON SHAW'S CREEK: Baldwin, *Great and Noble Jar,* 45--48. SHERDS FROM THE WASTER PILE: Joe L. Holcombe and Dr. Fred E. Holcombe, "Archaeological Findings Related to Dave at Edgefield Pot-

tery Sites," in Koverman, ed., *I made this jar . . .* , 76–77. CAREY DICKSON: "Notes made on trip to Seigler's Pottery, near Eureka, S.C., October 4, 1930," Laura Bragg Papers, Charleston Museum Archives. DAVE WAS "INSTRUMENTAL" IN THE POTTERY: Kathryn Landrum Diveley, personal communication, May 28, 2004. "BEST POTTER IN THERE": Louise Landrum Murphey, personal communication, May 27, 2004.

6. JOHN LANDRUM'S EARLY LIFE AND EDUCATION: "Obituary," *Advertiser*, December 23, 1846. ENCOUNTER WITH TORY: Chapman, *Edgefield County*, 306.

7. "CORRECT THE MORALS" AND "WARM APPEALS": "Obituary," *Advertiser*, December 23, 1846. FRANKLIN WAS RUNNING THE SAWMILL: "Lumber for Sale," *Advertiser*, December 15, 1836.

8. RELIGIOUS SHIFT: Edgar, South Carolina, 294; Blassingame, *Slave Community*, 80–85; Genovese, *Roll, Jordan, Roll*, 202–3.

9. DAM: The dam is indicated on the survey of Rev. John Landrum's property made in January 1847 by A. R. Able; Equity Records, Roll 737, Edgefield County Archives. Remains of the dam are still visible at the site. HISTORY OF REVEREND LANDRUM'S HOUSE: "Mr. Frank Landrum, Aiken," Laura Bragg Papers, Charleston Museum Archives. This interview, which was probably with Hastings Landrum, great-grandson of Rev. John Landrum, conflates several generations of the Landrum family. It begins, "His gr-grandfather, John Landrum, was from Scotland. Went to Va. & from there came . . . down here . . . about 1770 . . . ," which is impossible, because the original John Landrum from Scotland died in 1707 (Shedd, *The Landrum Family*, 6). With some interpolation, however, it makes sense: "[Hasting's great-great-great-great]-grandfather, John Landrum, was from Scotland. Went to Va. & from there [John's grandson, Samuel] came to Laurens Co. S.C. He moved down here about 3 mi. from Eureka about 1770 and started a pottery. He began building his house about 1776. Cut timber here, had it rafted down Shaw's Creek to Port Royal, shipped from there to England to be dressed. It took from 1780–1805 to build the house." Landrum descendants Kathryn Diveley and Louise Murphey told me they remembered hearing about the house, though they knew it by its later name, the "Fosket place"; they heard that it had "marble steps" and its lumber had been sent to England to be dressed; personal communications, May 27 and 28, 2004.

10. EIGHTEENTH SLAVES: "Executor's Sale," *Advertiser*, February 3, 1847.

11. THE LANDRUMS BUILT A CHURCH: Landrum Family Papers, as quoted in Holcombe and Holcombe, "South Carolina Potters," *South Carolina Antiqui-*

ties, Vol. 21, 1989, 11; Mary Ellen Corley Cato, great-great-great-grand-daughter of Rev. John Landrum, personal communication, April 5, 2004.

12. "GOD LOCK DE LION'S JAW": James H. Cone, *Risks of Faith: The Emergence of a Black Theology of Liberation, 1968--1998* (Boston: Beacon Press, 1999), 20.

13. JAMES RAINSFORD: Quoted in Burton, *In My Father's House,* 22

CHAPTER VII: *Families*

1. "DESE ALL MY FADDER'S CHILDREN": Quoted in Webber, *Deep Like the Rivers,* 3.

2. DESCRIPTION OF LEWIS MILES: "Louis Miles," Laura Bragg Papers, Charleston Museum Archives. LEWIS MILES'S MARRIAGE: It is often claimed that Lewis Miles married Abner Landrum's daughter, Sallie, then after her death married Mary Landrum. This is not true. Letters written to this same Sallie Landrum many years after her supposed death are preserved at the McKissick Museum (Landrum-Stork family letters, South Carolina Folk Arts Resource Center, McKissick Museum, University of South Carolina). I have traced the original error to shaky genealogical information given to Howard Smith in his early years of research on Edgefield pottery and subsequently published in his Index of *Southern Potters.* I am grateful to Anne Smith for sending me copies of her late husband's notes regarding Lewis Miles. LEWIS MILES'S LAND: Survey of Rev. John Landrum's property made in January 1847 by A. R. Able Equity Records, Roll 737, Edgefield County Archives. REBECCA STEELE: "At Landrum's Pottery near Eureka," Laura Bragg Papers, Charleston Museum Archives.JANUARY 23, 1840, JAR: Arthur F. Goldberg and James P. Witkowski: "Beneath His Magic Touch: The Dated Vessels of the African-American Slave Potter Dave," in Robert Hunter, ed., *Ceramics in America* (Milwaukee: Chipstone Foundation, 2006), 67.

3. SLAVES OF AQUILLA MILES: Will of Aquilla Miles, Probate Records, Record Book A, p. 509, Edgefield County Archives. FAMILY SUIT: Francis Burt and Others vs. Henrietta Miles and Others, Equity Records, Roll 415, Edgefield County Archives.

4. REPUTATION FOR GENEROSITY: "Louis Miles," Laura Bragg Papers, Charleston Museum Archives. JANUARY 27, 1840, JAR: Goldberg and Witkowski, in Hunter, ed., *Ceramics in America,* 67.

5. IRENE GINGREY: Baldwin, interview with Mrs. Irene Gingrey, July 24, 1987, *Archaeological Survey,* A-28.

6. "CASES OF GENUINELY WARM FEELING": Paul D. Escott, *Slavery Remem-*

bered: A Record of Twentieth-Century Slave Narratives (Chapel Hill: University of North Carolina Press, 1979), 20–21.

7. DAVE'S SILENT PERIOD: Koverman, in Koverman, ed., *I made this jar...*, 33; Goldberg and Witkowski, in Hunter, ed., *Ceramics in America*, 67. INSURRECTION IN AUGUSTA: Koverman, in Koverman, ed., *I made this jar...*, 33, 37.

8. PHOTOGRAPH OF SHERDS: Photographic Images MK-3168, File no. VII-12-25, Charleston Museum Archives.

9. DEATH OF REVEREND LANDRUM: "Obituary," *Advertiser*, December 23, 1846. "18 LIKELY NEGROES": "Executor's Sale," *Advertiser*, February 3, 1847. JOHN BROWN: Quoted in Webber, *Deep Like the Rivers*, 114.

10. INVENTORY OF SLAVES: Estate of Rev. John Landrum, Probate Records, Box 56, Pkg. 2312, Edgefield County Archives.

11. RESULTS OF SALE: Estate of Rev. John Landrum, Probate Records, Box 56, Pkg. 2312, Edgefield County Archives

12. SIDNEY GEORGE FISHER: Quoted in Schneider and Schneider, Slavery in America, 77, WILLIAM MASSIE: Quoted in Genovese, *Roll, Jordan, Roll*, 453.

13. COLLIN RHODES MOVES TO LOUISIANA: Baldwin, *Great and Noble Jar*, 91.

CHAPTER VIII: *Murders*

1. DISAGREEMENT BETWEEN FRANKLIN AND LEWIS: "At Landrum's Pottery near Eureka," Laura Bragg Papers, Charleston Museum Archives.

2. DATES AND DESCRIPTION OF HOUSE: Louise Landrum Murphey, Kathryn Landrum Diveley, and Mary Ellen Corley Cato, personal communications, 2004; "Years Gone By," *Advertiser*, January 11, 1949.

3. "THE FRENCH WOMAN": Kathryn Landrum Diveley and Louise Landrum Murphey, personal communications, 2004. REBECCA'S CONCERN FOR HER CHILDREN: M. L. Miles to A. E. H. Bleckley, March 24, 1862, Sylvester Bleckley Papers, South Caroliniana Library, University of South Carolina. VIAL OF LAUDANUM: B. F. Landrum's entry for 1854, Old Store Ledger, p. 25, Edgefield County Archives. FORMULA FOR THE GLAZE: Kathryn Landrum Diveley, personal communication, May 28, 2004. FLUERS-DE-LIS: "Years Gone By," *Advertiser*, January 11, 1949.

4. BURT-MILES CONNECTION: Burt and Miles Families, Leonardo Andrea Files, South Caroliniana Library, University of South Carolina. DESCRIPTION OF DR. BURT: Chapman, *History of Edgefield*, 348–49. AGE OF DR. BURT: "Obituary," *Advertiser*, March 31, 1847. FIGHT BETWEEN TWO SLAVES: Chapman, *History of Edgefield*, 348–49.

5. EVENTS LEADING TO THE MURDER: "State vs. The dead body of A. W. Burt," Coroner's Reports, March 25, 1847, Edgefield County Archives. DESCRIPTION OF THE MURDER: "State vs. The dead body of A. W. Burt." A "HORRID MURDER": *Advertiser*, March 31, 1847. SLAVE RETALIATION: Ira Berlin, *Many Thousands Gone: The First Two Centuries of Slavery in North America* (Cambridge and London: Belknap Press of Harvard University Press, 1998), 2. TOLL WAS CONVICTED AND HANGED: State Records, Petitions to the Legislature, 0010-003-1847-16-05, South Carolina Department of Archives and History; I am grateful to Tricia Glenn for this reference.

6. DESCRIPTION OF PRUE: Harriet Beecher Stowe, *Uncle Tom's Cabin or Life Among the Lowly* (New York: Penguin, 1986), 319--25. LANDRUM CAME TO CHESTER: James Tillman Diary, entry for September 26, 1865, Robert Muldrow Cooper Library, Clemson University.

7. DILEMMAS OF SLAVEHOLDING: Kenneth M. Stampp, *The Peculiar Institution: Slavery in the Ante-Bellum South* (New York: Vintage Books, 1956), 89--90. BETHEL BAPTIST ASSOCIATION MINUTES: Quoted in Burton, *In My Father's House*, 25. WHIPPING AS A REFORM MEASURE: Genovese, *Roll, Jordan, Roll*, 67.

8. BEECH ISLAND FARMER'S CLUB: Minutes, August 7, 1847, and September 4, 1847, Beech Island Farmer's Club Records, 1846--93, South Caroliniana Library, University of South Carolina.

9. CORONER'S REPORT: "State vs. The dead body of Ann," Coroner's Records 1844--68, pp. 97--100, Edgefield County Archives. LANDRUM OWNED FOUR ADULT MALES: 1850 U.S. Census Slave Schedule, South Carolina, Edgefield District, p. 81a.

10. WHIP WRAPPED IN TISSUE PAPER: I am grateful to Nicole Green, curator of the Old Slave Mart Museum in Charleston, for showing me the stored collection of the museum, February 27, 2003.

11. CORONER'S INQUEST: "State vs. The dead body of Ann."

12. EDGEFIELD COUNTY CORONER: Thurmond Burnett, personal communication, November 27, 2006.

13. "TO 'SCAPE HE MIS'RY": Adeline Marshall in WPA Slave Narratives, Texas, Vol. 16, P. 3, 46. "THE HORRID CRUELTIES": Stowe, *Uncle Tom's Cabin*, 363.

14. DEATH OF MATILDA POSEY: "State vs. The dead body of Matilta Posey," Coroners Reports, Records of Inquisitions, 1851--59, p. 188, Edgefield County Archives; "Trial of Martin Posey," Advertiser, October 10, 1849; "Report on the Trial of Martin Posey," 1850 pamphlet, copy in Posey Family File, Tompkins Library, Edgefield.

CHAPTER IX: *Jars*

1. MARY'S PETITION: Lewis J. Miles and Mary S. Miles, Petition for Trustee, Equity Records, Box 49, Pkg. 19, Edgefield County Archives. The exact circumstances of Dave's transfer to the Mileses are not clear. Two Dave jars inscribe with Lewis Miles's name slightly predate Mary Miles's petition to have Franklin Landrum replaced as her trustee. See Goldberg and Witkowski's list of dated pots in Hunter, ed., *Ceramics in America*, 67.

2. REVEREND LANDRUM'S SAWMILL: "Lumber for Sale," *Advertiser,* November 3, 1847. MILES MILL: The name has been spelled different ways over the years, sometimes with an apostrophe after the first word, sometimes with an "s" after the second; "Miles Mill" is its generally accepted form. LETTERS FROM STONY BLUFF: M. L. Miles to A. E. H. Bleckley, April 6, 1856, and March 24, 1862, Sylvester Bleckley Papers, South Caroliniana Library, University of South Carolina.

3. "I GOT ON TO IT": Steve Ferrell, personal communication, June 11, 2002.

4. LAYOUT OF STONY BLUFF: This reconstruction of Stony Bluff is based on speculation by Steve Ferrell; personal communication, February 20, 2005.

5. "BEST WARE IN [THE] COUNTRY": "Louis Miles," Laura Bragg Papers, Charleston Museum Archives.

6. HIS SURVIVING POEMS: See the list of dated vessels compiled by Goldberg and Witkoswki in Hunter, ed., *Ceramics in America*, 67--70. ANTI-LITERACY SUBSIDES: John Belton O'Neall, *The Negro Law of South Carolina* (Columbia: John G. Bowman, 1848), 23; also see a petition against the anti-literacy law in Records of the General Assembly, Petitions, Abbeville: ND 2822, South Carolina Division of Archives and History.

7. olive-brown glaze: Baldwin, *Great and Noble Jar*, 97. "DAVE'S THUMB": Dr. John Burrison, personal communication, February 19, 2007. DOTS AND SLASHES: Baldwin, *Great and Noble Jar*, 78, 97.

8. SIZE OF POTS: Koverman, in Koverman, ed., *I made this* jar . . ., 29; Castille *et al., Archaeological Survey,* 23--24. HAMMOND'S STORAGE NEEDS: John Michael Vlach, in Horne, ed., *Crossroads of Clay, 27, 38, n. 51.* ALTERNATIVE METHOD: Another approach probably used by Dave in making large jars is known as "piecing" or "capping." It involves turning the lower and upper sections of a jar separately and joining them together; see Koverman in Koverman, ed., *I made this jar* . . ., 29. The consensus among large-jar potters whom I have talked to, however, is that the coiling method that I describe is more likely to have permitted the tremendous diameters that Dave achieved in his largest jars.

9. INFORMATION ON DR. LANDRUM: "The Late Dr. Abner Landrum," *Adver-tiser*, May 11, 1859. LINNEAUS WORKED WITH HIM: Baldwin, *Great and Noble Jar*, 117. REQUEST TO THE STATE: Baldwin, *Great and Noble Jar*, 68.

10. TYPE OF WHEEL DAVE USED: We don't know precisely what kinds of pot-ting wheels were used in Edgefield District in Dave's time. They could have been foot powered or hand powered. Dr. John Burrison has told me: "More recent folk potters such as those I've known in the South (and American stoneware potters in general) have used the treadle and crank-shaft type, developed in England in the late 1700s. Southern potters stand at these (leaning against a padded rail) to better pull up larger pieces, while northern and English potters who used this type sat at it. The story about one-legged Dave's turning being helped by a slave with a missing or crippled arm suggests this type. But there were other types used in Eng-land that might have been used in Edgefield District, including types pow-ered by the hands of a helper." Personal communication, October 19, 2007. DRYING THE LOWER PORTION OF THE JAR: There are several theo-ries among pottery experts about how this drying might have been accom-plished. One is that the May air that day was warm enough to do it within a few hours; another is that Dave turned the base of the pot the day before and let it "set up" overnight.

11. "LARGEST AND MOST SPECTACULAR": Baldwin, *Great and Noble Jar*, 77. "A CERAMIC MONUMENT": John Michael Vlach, *The Afro-American Tradition in Decorative Arts* (Athens and London: University of Georgia Press, 1990), 79.

12. "HOMELY DESIGNS IN COARSE POTTERY": Edwin Atlee Barber, *The Pottery and Porcelain of the United States: An Historical Review of American Ceramic Art from the Earliest Times to the Present Day*, 3d ed., rev. and enl. (New York: G. P. Put-nam's Sons, 1909), 465–66, as quoted in Michael D. Hall, *Stereoscopic Per-spective: Reflections on American Fine and Folk Art* (Ann Arbor and London: UMI Research Press, 1988), 198.

13. THE SLAVE SHIP *WANDERER*: The story of the *Wanderer* is told in detail in Tom Henderson Wells, *The Slave Ship Wanderer* (Athens: University of Geor-gia Press, 1967). See also Manisha Sinha, *The Counterrevolution of Slavery: Poli-tics and Ideology in Antebellum South Carolina* (Chapel Hill and London: University of North Carolina Press, 2000), 163–73. THEIR NATIVE LAN-GUAGE: Charles J. Montgomery, "Survivors From the Cargo of the Negro Slave Yacht *Wanderer*," *American Anthropologist*, October 1908, 617.

14. CULTURAL SYNCRETISM: For a full discussion of the origin of Edgefield face vessels, see Vlach, in Horne, ed., *Crossroads of Clay*, 27–36; Baldwin, *Great and Noble Jar*, 79–87; Jill Beute Koverman, *Making Faces: Southern Face*

Vessels from 1840–1990 (Columbia: McKissick Museum, 2001), 5–9; Mark M. Newell with Peter Lenzo, "Making Faces: Archaeological Evidence of African-American Face Jug Production," *Ceramics in America,* 122–38. A SLAVE CALLED ROMEO: Baldwin, *Great and Noble Jar*, 83. SITE AT MILES MILL: Newell and Lenzo, *Ceramics in America* 125–26.

15. ATTRIBUTION TO DAVE: Jill Beute Koverman, personal communications, February 26, 2003, and May 30, 2007. "From the late 1850s to the 1870s," Koverman says, "there was no other potter working in the Edgefield factories who is known to have made pots this large." A drainage hole in the bottom of the vessel may indicate that the jar originally served as an umbrella stand.

CHAPTER X: *Cousins*

1. "EVERY LADY TELLS YOU": C. Vann Woodward, ed., *Mary Chesnut's Civil War*, 29.

2. NOTE IN THE ARCHIVES: E. B. Chamberlain, "Notes made on trip to Sei-gler's Pottery," October 4, 1930, Laura Bragg Papers, Charleston Museum Archives; Baldwin, *Great and Noble Jar*, 99. CLOSING OF THE SEIGLER FACTORY: Smith, *Index of Southern Potters*, 174. OLIVER MILES'S BIRTH DATE: Oliver Miles was listed on the federal census several times during his life, each time with a different birth date. I have taken 1858 from the 1880 census, his first listing. SHE HAD KNOWN OLIVER MILES: Louise Landrum Murphey, personal communication, May 27, 2004.

3. "I KNEW ALL": Willie Morris, *North Toward Home* (Boston: Houghton Mifflin Co., 1967), 79.

4. "FANCY GIRLS": Joel Williamson, *New People: Miscegenation and Mulattoes in the United States* (Baton Rouge: Louisiana State University Press, 1980), 68–69. FREDRICKA BREMER: Quoted in Williamson, *New People*, 69. W. E. B. DUBOIS: Quoted in Genovese, *Roll, Jordan, Roll*, 413.

5. MY RELATIONSHIP TO OLIVER MILES: I am grateful to Raymond Timmerman, of the Tompkins Library, for help in determining these connections.

6. ARTHUR SIMKINS AND HIS SLAVE CHARLOTTE: Burton, *In My Father's House*, 185–86, 392, n. 117. "GRANDFATHER!": Francis Butler Simkins, untitled manuscript, N-125, Francis Butler Simkins Papers, Longwood University; Paris Simkins is referred to in the manuscript as "Rome Simkins."

7. "FREE NEGROES AS A COMMON NUISANCE". Journal of the Court of General Sessions, Fall Term 1859, Edgefield County Archives.

8. SAVILLA BURRELL: WPA Slave Narratives, South Carolina, Vol. 14, P. 1, 150; HAGAR'S STORY: Genesis, Chapters 16 and 21.

9. CENSUS LISTINGS FOR OLIVER MILES: 1880 U.S. Census: South Carolina, Aiken County, Wards Township, p. 283D; 1900 U.S. Census: South Carolina, Aiken County, Shaw Township, p. 110B; 1920 U.S. Census: South Carolina, Aiken County, Shaw Township, 7B.

CHAPTER XI: *Battles*

1. GOV. FRANCIS W. PICKENS: Quoted in Edgar, *South Carolina*, 376.

2. FOUR EXTRAORDINARY BEASTS: Daniel 7:10 and 28.

3. LEWIS MILES INSTRUCTED DAVE: "Louis Miles," Laura Bragg Papers, Charleston Museum Archives. LANDRUM GOLD MINE: Elizabeth ("Noonie") Holland Holtzlander, personal communication, June 20, 2002. Noonie, great-granddaughter of Dr. John Landrum, made the complete file of family documents on the mine available to me.

4. "PACK OF CRAZY FANATICS": "The Insurrection at Harper's Ferry," *Advertiser*, October 26, 1859. EMERSON AND THOREAU: Quoted in James M. McPherson, Battle Cry of Freedom (New York and Oxford: Oxford University Press, 1988), 209--10.

5. "INTELLECT" AND "SAVAGER": Clarence L. Mohr, *On the Threshold of Freedom: Masters and Slaves in Civil War Georgia* (Athens and London: University of Georgia Press, 1986), 28. MAPS BELONGING TO BROWN: "The Virginia Insurrection," *Advertiser*, November 2, 1859.

6. THE GREAT FEAR: McPherson, *Battle Cry of Freedom*, 212. McPherson lists other historians who have compared the mood of the South in 1860 to that of the French countryside in 1789. OFFICERS AT HORSE CREEK: *Advertiser*, December 5, 1860. NO BLACK ASSEMBLIES. "Public Meeting," *Advertiser*, October 17, 1860.

7. GEORGE W. LANDRUM: "The Meeting of the Citizens," *Advertiser*, November 21, 1860. ORDINANCE OF SECESSION: For an examination of the controversy surrounding the authorship of this document, see Charles H. Lesser, *Relic of the Lost Cause: The Story of South Carolina's Ordinance of Secession* (Columbia: South Carolina Department of Archives and History, 1996), 6--7.

8. TURBULENT RED LIGHTS: Chapman, *Edgefield County*, 86--87. MARSHAL BUTLER: WPA Slave Narratives, Georgia, Vol. IV, P. 1, 167.

9. EVERY ELIGIBLE MALE: Information on what happened to the men in the Miles, Landrum, and Wever families during the war is taken from their

Confederate Service Records, available from the National Archives in Washington, D.C., and from Broadfoot Publishing Company in Wilmington, N.C.

10. MARY MILES'S EFFORTS: Chapman, *History of Edgefield*, 233; "Correction," *Advertiser*, November 27, 1861. FRANKLIN LANDRUM MADE POTS FOR MEDICINES: "At Landrum's Pottery near Eureka," Laura Bragg Papers, Charleston Museum Archives.

11. CONSCRIPTION OF EDGEFIELD SLAVES: "Slave Labor for the Coast," *Advertiser*, October 12, 1864. "DRAWING AN EYETOOTH": Ward, et al., *The Civil War*, 196. CAREY DICKSON: "Notes made on trip to Seigler's Pottery," Laura Bragg Papers, Charleston Museum Archives. DELLA BRISCOE: WPA Slave Narratives, Georgia, Vol. 4, P. 1, 130.

12. VICTORIA MCMULLEN: WPA Slave Narratives, Arkansas, Vol. 2, P. 5, 35–36. "USING FRENCH AGAINST AFRICA": Woodward, ed., *Mary Chesnut's Civil War*, 36. JAMES HENRY HAMMOND: Quoted in J. William Harris, *Plain Folk and Gentry in a Slave Society: White Liberty and Black Slavery in Augusta's Hinterlands* (Hanover: Wesleyan University Press, 1987), 174.

13. JARS FROM EVERY YEAR OF THE WAR: Goldberg and Witkowski, "Dated Vessels," *Ceramics in America*, 70. ALMOST PERFECTLY FORMED VESSEL: Koverman, in Koverman, ed., *I made this jar . . .*, 30. DEATHS AT SHILOH: Ward, *et al.*, *The Civil War*, 121.

14. "I AM NOT ALLOWED": A. Miles to Dr. L. B. Wever, October 1, 1861, Wever Family Papers, collection of the author. HOME ON FURLOUGH: M. L. Miles to A. E. H. Bleckley, March 24, 1862, Sylvester Bleckley Papers, South Caroliniana Library, University of South Carolina. SAW BOTH OF THEM FALL: Louise Landrum Murphey, personal communication, May 27, 2004.

15. "IT WAS IMPOSSIBLE": Chapman, *Edgefield County*, 89. "THE REALITY IS HIDEOUS": Woodward, ed., *Mary Chesnut's Civil War*, 339.

16. "SHERMAN'S RETREAT THROUGH GEORGIA": *Advertiser*, November 23, 1864, and December 7, 1864. "IT SEEMED TO ME": Mrs. "L. F. J.," quoted in Katharine M. Jones, *When Sherman Came: Southern Women and the "Great March"* (Indianapolis, Kansas City, and New York: Bobbs-Merrill Company, 1964), 41.

17. GENERAL SHERMAN: Quoted in McPherson, *The Negro's Civil War*, 66.

18. SAVILLA BURRELL: WPA Slave Narratives, South Carolina, Vol. 14, P.1, 151. "A NUISANCE": *Advertiser*, October 5, 1864. IMPURITIES WERE NOT REMOVED: Koverman, in Koverman, ed., *I made this jar . . .*, 24, 30. ELIJAH GREEN: WPA Slave Narratives, South Carolina, Vol. 14, P. 2., p. 197.

19. "WHEN I GO THROUGH SOUTH CAROLINA": Quoted in Ward, et al., *The Civil War,* 356. "LIKE A TORNADO": General Sherman, quoted in Jones, *When Sherman Came,* viii.

20. "BLOODTHIRSTY WOLVES": "Troublous Times in Edgefield," *Advertiser,* February 14, 1865.

21. THE BATTLE OF AIKEN: My account of the conflict is drawn from John C. Rigdon, *The Battle of Aiken* (Augusta: Eastern Digital Resources, 2001). REV. JOHN HENRY CORNISH: Quoted in Rigdon, *The Battle of Aiken,* 78.

22. "SOLDIERS CRIED ON YESTERDAY": James A. Tillman Diary, April 18, 1865, Benjamin Ryan Tillman Papers, Special Collections, Robert Muldrow Cooper Library, Clemson University. "BEING SO REDUCED": Quoted in *Recollections and Reminiscences: 1861--1865 through World War I* (South Carolina Division United Daughters of the Confederacy, 2001), Vol. 1, 238.

23. LEWIS MILES'S SONS: Confederate Service Records. FRANKLIN AND JOHN LANDRUM'S SONS: Confederate Service Records. ABNER LANDRUM'S SONS: Baldwin, *Great and Noble Jar,* 117. LAFAYETTE WEVER: Mary Miles to "My Dear Niece," April 25, 1865, Sylvester Bleckley Papers, South Caroliniana Library, University of South Carolina.

24. HOST FOR THE EVENING: My retelling of Jefferson Davis's stay in the Burt home is based primarily on William C. Davis, *An Honorable Defeat: The Last Days of the Confederate Government* (New York, San Diego, London: Harcourt, Inc., 2001), 213--41.

25. "I SAW A CROWD": Virginia Ingraham Burr, *The Secret Eye: The Journal of Ella Gertrude Clanton Thomas, 1848--1889* (Chapel Hill and London: University of North Carolina Press, 1990), 268--69. MADE TO WEAR CHAINS: Ward, *et al., The Civil War,* 393.

26. SAVILLA BURRELL: WPA Slave Narratives, South Carolina, Vol. 14, P. 1, 151.

CHAPTER XII: *Reunions*

1. JOHN W. DEFOREST: John W. DeForest, *A Union Officer in the Reconstruction,* James H. Croushore and David M. Potter, ed. (New Haven: Yale University Press, 1948), 36. The selection quoted was originally published in *Harper's New Monthly Magazine,* XXXVII, November 1868, 766--75.

2. "FOUNDATIONS OF THE GREAT DEEP": Chapman, *Edgefield County,* 258. "BEGIN A CIVIL GOVERNMENT": "Occupation of Edgefield by U.S. Troops," *Advertiser,* June 28, 1865.

3. MATILDA BROOKS: WPA Slave Narratives, Florida, Vol. 3, 49; RACHEL SULLIVAN: WPA Slave Narratives, Georgia, Vol. IV, P. 4, 229. CASPER RUMPLE: WPA Slave Narratives, Arkansas, Vol. 2, P. 6, 105.

4. DAVE CHOOSES A SURNAME: Jill Beute Koverman was the first to propose that Dave took the surname Drake after the war. She based this on the listing for David Drake in the 1870 census. The information given for him—first name, age, gender, race, location, profession—exactly matched what was known about Dave.

5. DRAKE FAMILY GENEALOGICAL NOTES: W. Warren, "Memorandum Concerning the Ancestry of the Drake Family," in "Landrum: Genealogy," compiled by Mrs. D. B. Hollingsworth, Dave File, McKissick Museum Archives. THE LEGEND PERSISTED: Charlotte Drake Stone, personal communication, July 13,2004.

6. KINSHIP COLONIES: Burton, *In My Father's House,* 278, 315. "BROTHER," "SISTER," "AUNT," AND "UNCLE": Ira Berlin and Leslie S. Rowland, ed., *Families and* Freedom: A Documentary History of African-American Kinship in the Civil War Era (New York: New Press, 1997), 225.

7. LISTED AS DAVID DRAKE: 1870 U.S. Census: South Carolina, Edgefield County, Shaw's Creek Township, p. 433.

8. SAM DRAKE: 1880 U.S. Census: South Carolina, Aiken County, Shaw Township, p. 253.

9. "GIRL CAROLINE" AND "BOY SAMUEL": Estate of Rev. John Landrum, Probate Records, Box 56, Pkg. 2312, Edgefield County Archives.

10. LEATHER-BOUND BOOK: Cashbook of L. B. Wever, Wever Family Papers, collection of the author. FIRM OF MILES & WEVER: Lafayette's ledger does not make it clear which member of the Miles family was Lafayette's partner. There is some suggestion that it might be M. L. Miles (Lewis's son, Milton), who furnished certain assets for the firm. However, "Firm of Wever & L J Miles" is written across the back of another document in my family papers, an 1869 bill paid by Lewis Miles, leading me to conclude that Lafayette Wever and his father-in-law were partners in the various endeavors outlined in the ledger. (Bill from Kennedy and Youngblood, February 9, 1869, Wever Family Papers, collection of the author.)

11. "COLORED FEMALE" LIVING WITH DAVE DRAKE: 1869 South Carolina State Census: Edgefield County, Shaw's Creek Township, p. 226.

12. WHAT IF LYDIA BEGGED TO REMAIN? A description of emigrants going west from Augusta, written in 1836, the year the Drakes left Edgefield, could explain what happened: "Many of the Negroes [owned by the emigrants] are exceedingly averse to a removal from the sites on which they

have been bred, and where their connections are formed. In these cases, planters who are uncertain of the personal attachment of their slaves, generally dispose of them amongst their neighbors." Tyrone Power, in Oscar Handlin, ed., *Readings in American History, Volume One: From Settlement to Reconstruction* (New York: Alfred A. Knopf, 1970), 278–79. "THE FIRST ONE": Quoted in Escott, *Slavery Remembered,* 48. For a short while, I thought I had found a direct record of Dave and his wife reuniting after the war. James Tillman mentioned in his diary on September 5, 1865, that a woman named Eliza, probably one of his former slaves, left Chester Plantation along with five children to go to Lewis Miles's place. Lafayette Wever recorded that he hired an Eliza on January 1, 1866. I wondered whether this might be Eliza/Lydia/Louisa coming back to Dave with their grandchildren. However, I also found an Eliza Pughe on the 1869 South Carolina State Census living nine houses away from Dave. Head of a household that contained six others, she could have been the Eliza who left Tillman's plantation.

13. LANDRUM CONTINUED TO WHIP: James A. Tillman Diary, September 26, 1865, Clemson University. TILLMAN DID THE SAME: James A. Tillman Diary, September 27, 1865, and December 13, 1865. RUNAWAY NOTICE: *Advertiser*, May 8, 1867. SARAH JANE PATTERSON: WPA Slave Narratives, Arkansas, Vol. 2, P. 5, 286.

14. QUESTIONS FOR GENERAL ELY: John Richard Dennett, *The South As It Is: 1865–1866* (New York: Viking Press, 1965), 247. PHOEBE LEAVES REVEREND CORNISH: Joel Williamson, *After Slavery: The Negro in South Carolina during Reconstruction, 1861–1877* (Chapel Hill: University of North Carolina Press, 1965), 53. BACON CONSIDERS HURLING A STONE: *Advertiser*, July 12, 1865, and Hansen, *Edgefield Advertiser*, 71.

15. COLEMAN'S BAND: Baldwin, *Great and Noble Jar*, 91, 94. "SO WILD AND LAWLESS A COUNTRY": Quoted in Burton, *In My Father's House*, 298.

16. VIOLENCE TEMPORARILY SUBSIDES: Burton, *In My Father's House*, 298. LEAVING FOR LIBERIA: "The Fat of the Land for Four Hours' Work per Diem!" *Advertiser*, November 25, 1868. COLONY IN BRAZIL: Eugene C. Harter, *The Lost Colony of the Confederacy* (Jackson: University Press of Mississippi, 1985), 32–33.

17. GENERAL ELY BROUGHT BAD NEWS: Dennett, *The South As It Is*, 250. WARREN MCKINNEY: WPA Slave Narratives, Arkansas, Vol. 2, P. 5, 28.

18. WORKERS HIRED BY L. B. WEVER: Cash book of L. B. Wever, Wever Family Papers, collection of the author. A woman named Martha is referred to in Dave's section of Lafayette Wever's cashbook. The first mention is "food

for Martha" ($3.75) on April 7, 1866; the second is "house rent for Martha" ($2) on June 7. This second entry suggests that she had a house of her own and was therefore probably not Dave's wife. She could have been a close member of his circle of kin whom he was helping to support. She must have been relatively young, because she is mentioned several times in Lafayette's ledger as one of the people who picked cotton for him. The only "Martha" I have been able to locate in the area where Dave lived is listed on the 1869 South Carolina State Census. She was Martha Johnson, a black woman who lived twelve houses away from Dave. She shared her home with a male and a female, both under the age of twenty-one. UNDATED ENTRIES: The year of the November 25 entry for Dave is not specified, though it seems likely that it is 1866.

19. SHARECROPPING ARRANGEMENT: Abbott, *Freedmen's Bureau*, 69. "NAUGHT'S A NAUGHT": Quoted in Williamson, *After Slavery*, 175.

20. SHARE-POTTING CONTRACT: "Contract. L. J. Miles & the Freedmen. Stone Ware Factory," October 15, 1866, Wever Family Papers, collection of the author.

21. LEWIS MILES OWNED TWO POTTERIES: "Mr. Frank Landrum, Aiken," Laura Bragg Papers, Charleston Museum Archives.

22. FIRST RUN OF THE TRAIN: "The New Railroad in Successful Operation," *Advertiser*, December 23, 1868. IRENE GINGREY: Interviewed by Cinda Baldwin, July 24, 1987, in Castille, *et al.*, *Archaeological Survey*, A-25.

CHAPTER XIII: *Votes*

1. ELLA GERTRUDE CLANTON THOMAS: Burr, *Secret Eye*, 297.

2. FIVE MILITARY DISTRICTS: Edgar, *South Carolina*, 384--85. "NEFARIOUS" AND "IRRESPONSIBLE" HANDS: *Advertiser*, June 19, 1867, and July 10, 1867. RESULTS FROM SAVANNAH: *Advertiser*, August 7, 1867.

3. DAVE'S NAME ON THE ROLLS: Voter Registration Rolls for 1868: South Carolina, Edgefield County, Edgefield Court House Precinct, p. 31; microfilm CW 1508 (AD 846) at the South Carolina Department of Archives and History, Columbia. BLACK WOMEN IN POLITICS: Eric Foner, *Forever Free: The Story of Emancipation and Reconstruction* (New York: Alfred A. Knopf, 2005), 131.

4. "ARTFUL MEN": *Advertiser*, July 17, 1867. "LUDICROUS SCENES": Quoted in Francis Butler Simkins and Robert Hilliard Woody, *South Carolina during Reconstruction* (Chapel Hill: University of North Carolina Press, 1932), 88. FREDERICK DOUGLASS: Quoted in Milton Meltzer, ed., *The Black Americans:*

A History in Their Own Words, 1619--1983 (New York: Thomas Y. Crowell, 1984), 99.

5. "BEAMING WITH ANXIETY": Quoted in Simkins and Woody, *South Carolina During Reconstruction*, 88.

6. "WE TAKE IT FOR GRANTED": *Advertisers*, September 4, 1867. TALLY AT EDGEFIELD COURTHOUSE: *Advertiser*, October 2, 1867. STATE TOTALS: Richard Zuczek, *State of Rebellion: Reconstruction in South Carolina* (Columbia: University of South Carolina Press, 1996), 41. DELEGATES ELECTED TO DRAFT A NEW CONSTITUTION: Decades after it happened, this stirring event in the state's history caught the attention of novelist Howard Fast. Intrigued by the ability of the former slaves to move from bondage to positions of leadership, he wrote *Freedom Road*, the story of a fictional black delegate to the convention from a district much like Edgefield. The book was first published in 1944. MANY OF THESE LAWMAKERS WERE BLACK: Edgar, *South Carolina*, 387. "MADDEST REVOLUTION IN HISTORY": Quoted in Simkins and Woody, *South Carolina During Reconstruction*, 110. "SOUTH CAROLINA OF THE GREAT MEN": *Advertiser*, May 30, 1868.

7. WHITES TRIED TO INFLUENCE BLACK WORKERS: Williamson, *After Slavery*, 98--99. HIS WIFE MIGHT REFUSE TO COOK MEALS: Thomas Holt, *Black Over White: Negro Political Leadership in South Carolina during Reconstruction* (Urbana, Chicago, London: University of Illinois Press, 1977), 34--35; Simkins and Woody, *South Carolina During Reconstruction*, 512.

8. REPORTS TO THE SHERIFF: John H. McDevitt, in *State of South Carolina. Evidence Taken by the Committee of Investigation of the Third Congressional District, Under Authority of the General Assembly of the State of South Carolina, Regular Session, 1868--69* (Columbia: John W. Denny, 1870), 681. A copy is on file at the South Caroliniana Library, University of South Carolina. I am grateful to Doug Kiesler for directing me to this information. "[THE KLAN] TRIED TO KILL DADDY": Grace Jenkins, "A Tiny Piece of My Life," as told to Julia P. White, February 10, 1980, privately published. I am grateful to Donna Marie Landrum-Hill for providing me with a copy of this material.

9. TRUMAN ROOT'S HOUSE FIRED UPON: *Evidence Taken by the Committee of Investigation*, 684. NO ELECTION WAS HELD: *Evidence Taken by the Committee of Investigation*, 683, 704. "THE KU KLUX [WAS] SO STRONG": Quoted in Simkins and Woody, *South Carolina During Reconstruction*, 445--46.

10. A PAIR OF RACIAL INCIDENTS: *Advertiser*, November 25, 1868, and December 2, 1868. BIOGRAPHICAL INFORMATION ON FOSKET: *Evidence Taken by the Committee of Investigation*, 713; 1870 U.S. Census: South Carolina, Edgefield County, Shaw's Creek Township, p. 433. "IN DAILY FEAR OF THEIR

LIVES": *Advertiser*, November 25, 1868. "MORE THAN ONE MISCHIEVOUS PERSON": *Advertiser*, December 2, 1868.

11. DATE OF LEWIS MILES'S DEATH: "Mary S. Miles: Petition for Homestead and Dower," December 26, 1870, New Loose Documents, Edgefield County Archives. THE CAUSE WAS "DROPSY": 1870 U.S. Census: Mortality Schedule, South Carolina, Edgefield County.

12. "THE DOINGS HERE ON SATURDAY": *Advertiser*, July 7, 1869.

13. COULDN'T READ OR WRITE: 1870 U.S. Census: South Carolina, Edgefield County, Shaw's Creek Township, p. 433.

14. "ONE GROUP OF KLANSMEN": Williamson, *After Slavery*, 264. PARIS SIMKINS ADDRESSED A CROWD: *Advertiser*, July 4, 1872.

15. 1873 MENTION OF DAVE: Doug Keisler, one of the many private researchers who are diligently illuminating Edgefield's history, discovered this previously unknown reference. Tonya Browder, director of the Tompkins Library in Edgefield, searched all available records for information on Alfred Blocker, "the jug-factory man" mentioned along with Dave. Finding no record of anyone by that name, she concluded that he might be another Alfred, this one with the surname Landrum, who is shown on the 1870 U.S. Census (South Carolina, Edgefield County, Shaw's Creek Township, p. 434) living only six houses from Dave. Sharing quarters with William Gearty ("Tanner"), Thomas Jones ("in Jug factory"), and Phillip Miles ("Turner"), he is listed as a "Wagoner," which would fit with the description of him in the article as "driving up to our doors" with stoneware. At a time when black surnames were new and changing, it seems likely that the two Alfreds could be one and the same.

16. "HE WILL BE ITS KING": Williamson, *After Slavery*, 27. "THE BLACK PRINCE". A detailed account of what is known about Rivers is included in Isabel Vandervelde, *Aiken County: The Only South Carolina County Founded During Reconstruction* (Spartanburg: The Reprint Company, 1999), 133–62, 442–43.

17. 1872 ELECTION RESULTS: Williamson, *After Slavery*, 360; Butterfield, *All God's Children*, 40. "AMONG THE WHITE PEOPLE": *Advertiser*, July 8, 1875.

18. "NOT DEAD, BUT ONLY SLEEPING": *Advertiser*, July 4, 1872.

CHAPTER XIV: *Shirts*

1. "NEVER THREATEN": Quoted in Simkins and Woody, *South Carolina During Reconstruction*, 567.

2. MARTIN W. GARY NEVER SURRENDERED: Zuczek, *State of Rebellion*, 167.

"THE EDGEFIELD PLAN": "Plan of the Campaign of 1876," Gary Papers, South Caroliniana Library, University of South Carolina.

3. "RIFLE CLUBS": Zuczek, *State of Rebellion*, 138–39, 170. NUMBER OF CLUBS IN AIKEN AND EDGEFIELD: Simkins and Woody, *South Carolina During Reconstruction*, 501. "BORDER RUFFIAN": *Advertiser*, September 7, 1876. INFORMATION ON CAHILL: 1870 U.S. Census: South Carolina, Edgefield County, Shaw's Creek Township, p. 433.

4. CONFRONTATION AT HAMBURG: I have based my retelling of the Hamburg Massacre and the events surrounding it on several sources, including Williamson, *After Slavery*, 267–71; Zuczek, *State of Rebellion*, 163–65; Foner, *Reconstruction*, 570–72; Holt, *Black Over White*, 199–200; Martin, *Southern Hero*, 207–11; Kantrowitz, *Ben Tillman*, 64–71; and Vandevelde, *Aiken County*, 421–41, which includes contemporary coverage by the *Augusta Chronicle and Sentinel*.

5. BEN TILLMAN'S RECOLLECTIONS: Senator B. R. Tillman, *The Struggles of 1876—How South Carolina Was Delivered from Carpet-Bag and Negro Rule: Speech at the Red-Shirt Re-Union at Anderson [S.C.], Personal Reminiscences and Incidents*, August 25, 1909, typed copy at Tompkins Library, Edgefield, S.C. "IT HAD BEEN THE SETTLED PURPOSE": Tillman, *The Struggles of 1876*, 12.

6. "I TRIED TO AVOID A DIFFICULT": Quoted in Vandevelde, *Aiken County*, 433.

7. JOSHUA RIVERS: WPA Slave Narratives, South Carolina, South Caroliniana Library, University of South Carolina (Stiles M. Scruggs, compiler, "Joshua Rivers, Son of the Negro Leader, Tells the Story of the Hamburg Riot of 1876"). "ARE YOU ONE OF THE RASCALS?": Quoted in Samuel J. Martin, *Southern Hero: Matthew Calbraith Butler* (Mechanicsburg, Pa.: Stackpole Books, 2004), 210.

8. DOOR-TO-DOOR SEARCH: Tillman, *The Struggles of 1876*, 15. GRUMBLING AFTER BUTLER DEPARTED: Tillman, *The Struggles of 1876*, 17. "IT WAS NOW AFTER MIDNIGHT": Tillman, *The Struggles of 1876*, 18.

9. "MORE FAR-REACHING IN ITS INFLUENCES": Tillman, *The Struggles of 1876*, 11.

10. ALL-BLACK GRAND JURY: Martin, *Southern Hero*, 213. ORIGIN OF THE RED SHIRT: F. W. P. Butler, in the *Edgefield Chronicle*, November 2, 1916. ENTIRE AIKEN BAR: *Augusta Chronicle*, August 2, 1876.

11. HAMPTON GAVE ORDERS AGAINST VIOLENCE: Simkins and Woody, *South Carolina During Reconstruction*, 503. "NECESSITIES OF THE TIMES": Quoted in Vandevelde, *Aiken County*, 187. MURDER OF SILAS GOODWIN: Stephen

Kantrowitz, *Ben Tillman and the Reconstruction of White Supremacy* (Chapel Hill and London: University of North Carolina Press, 2000), 74. "A RUTHLESS AND CRUEL THING": Tillman, *The Struggles of 1876*, 46.

12. RESENTED IN THEIR OWN COMMUNITIES: Simkins and Woody, *South Carolina During Reconstruction*, 512. BLACK RED SHIRTS IN EDGEFIELD PARADE: Williamson, *After Slavery*, 410–11.

13. "AS TIMID AS WOUNDED DEER": Quoted in Catherine Smedley, *Martha Schofield and the Re-education of the South, 1839–1916* (Lewiston, N.Y.: E. Mellen Press, 1987), 154. REVEREND EDGERTON'S LETTER: Smedley, *Martha Schofield*, 145.

14. MEL WHARTON AS RED SHIRT: Kathryn Landrum Diveley, personal communication, May 28, 2004.

15. EIGHT HUNDRED RED SHIRTS: William Arthur Sheppard, *Red Shirts Remembered: Southern Brigadiers of the Reconstruction Period* (Atlanta: Ruralist Press, 1940), 150. Other details in this paragraph are also from Sheppard, who seems to have had access in some cases to eyewitnesses of the day's events.

16. INFORMATION ON ABRAM LANDRUM: Donna Marie Landrum-Hill, *Amazing Grace: Slaves in the Landrum Family of Edgefield, South Carolina*, privately published, 2003. TESTIMONY OF ABRAM LANDRUM: Affidavit of W. J. Williams, Abraham Landrum & D. B. Cotton, November 9, 1876, Martin W. Gary Papers, Duke University Library. DOUBLE-BARRELED SHOTGUN: Testimony of A. A. Glover in "George D. Tillman contestant Against Robert Smalls contestee, contest for a Seat in Congress," April 9, 1877, p. 44, Estate of George D. Tillman, Box 128, Pkg. 5278. VOTERS HANDED OVERHEAD: Sheppard, *Red Shirts Remembered*, 152. MEL WHARTON VOTES MULTIPLE TIMES: Kathryn Landrum Diveley, personal communication, May 28, 2004.

17. MRS. KELLOG'S LETTER: *Advertiser*, November 30, 1876.

18. DELIBERATELY SLOW PACE: Sheppard, *Red Shirts Remembered*, 153–54. TWO HUNDRED BLACKS: *Advertiser*, November 30, 1876. "BY GOD, SIR!": Sheppard, *Red Shirts Remembered*, 155. UPPER WINDOWS OF THE MASONIC HALL: Manly Wade Wellman, *Giant in Gray: A Biography of Wade Hampton of South Carolina* (New York: Charles Scribner's Sons, 1949), 269–70. "I WOULD BE MURDERED": Quoted in Martin, *Southern Hero*, 216.

19. EVENTS AT LANDRUM STORE PRECINCT: Simkins, *Pitchfork Ben Tillman*, 67; Kantrowitz, *Ben Tillman*, 75–76.

20. RED SHIRTS WERE SO SUCCESSFUL: Edgar, *South Carolina*, 404. EVENTS

FOLLOWING THE ELECTION: Edgar, *South Carolina*, 404–6; Kantrowitz, *Ben Tillman*, 76–77.

21. "GREAT CHANGE IN THE NEGRO POPULATION": Quoted in Williamson, *After Slavery*, 362. "ATTIRED IN HIS LIVERY SUIT": Quoted in Vandevelde, *Aiken County*, 155. JOSHUA RIVERS: WPA Slave Narratives, South Carolina, South Caroliniana Library, University of South Carolina.

CHAPTER XV: *Echoes*

1. "IF I COULD SPEAK TO ANYONE": Sharon Bennett, personal communication, April 9, 2002.

2. "AN OLD POTTER BACK THEN": Steve Ferrell, personal communication, March 19, 2003. "OLD DAVE USED TO SIT AROUND": "Notes collected on trip to various potteries," June 24–26, 1930, Laura Bragg Papers, Charleston Museum Archives.

3. "ALONE WITH HIS GLORY": *Advertiser*, October 30, 1873. DAVE'S NAME NOT IN THE CENSUS: 1880 U.S. Census: South Carolina, Aiken County, Shaw Township, p. 256.

4. SPRINGFIELD CHURCH: Meeting with deacons, March 16, 2003.

5. STORY OF "DAVE'S POT": Mrs. Thomasina Holmes Bouknight, personal communications, April 24, 2004, and June 13, 2004.

6. LINK WITH WEST AFRICAN FUNERAL PRACTICES: Genovese, *Roll, Jordan, Roll*, 200–201. "THE FAMILIES WERE JUST TRYING": Mrs. Janie Thurmond, personal communication, May 17, 2004. "THEY DIDN'T HAVE MONEY": Mrs. Patria Brayboy, personal communication. May 6, 2004.

7. DIGGING UP LEWIS MILES: "Louis Miles," Laura Bragg Papers, Charleston Museum Archives. Jack Thurmond's words upon seeing the bones of Lewis Miles are incorrectly quoted in Baldwin, *Great and Noble Jar*, 98; the correct reading is that he could tell it was "his old master," not "his old man."

8. TORNADO OF 1875: *Advertiser*, March 25, 1875. EARTHQUAKE OF 1886: Vandevelde, *Aiken County*, 201.

9. CHANGES IN EDGEFIELD POTTERY PRODUCTS: Baldwin, *Great and Noble Jar*, 95. The story of the final decades of pottery production in Edgefield and Aiken counties is told in Mark M. Newell and Nick Nichols, *The River Front Potters of North Augusta* (Augusta: Georgia Archaeological Institute, 1999).

10. TOMBSTONE OF REVEREND JOHN: "Years Gone By," *Advertiser*, January 11, 1949. DEATH OF FRANKLIN LANDRUM: Louise Landrum Murphey, per-

sonal communication, May 27, 2004. BEN CONTINUED UNTIL 1902: "Mr. Frank Landrum, Aiken," Laura Bragg Papers, Charleston Museum Archives.

11. HOMESTEAD FOR MARY MILES: "L. B. Wever, Admr. of Lewis J. Miles, vs M. L. Miles & others: Petition to Sell Land," July 10, 1871, New Loose Documents, Edgefield County Archives. I am grateful to Betsy Bloomer for directing me to this information. JOHN MILES CONTINUED THROUGH 1880: 1880 U.S. census: Manufacturing schedule, South Carolina, Aiken County, Shaw Township, p. 47. I am grateful to Doug Keisler for directing me to this information. SOUTH CAROLINA POTTERY COMPANY: Baldwin, *Great and Noble Jar*, 105--7. A letter from Sallie Miles Cahill to her sister, America Miles Wever (February 1, 1885, Wever Family Papers, collection of the author), may have to do with the formation of this company: "Johnnie [Cahill] has been in Charleston for two weeks prospecting or rather testing a Phosphate place for a party down there. He may while there take a contract of something to make money to work with. Steve Hughes has sold out his half interest in the jug business to Mr. James Jervy for $5000. I think the business will go better now as Jervy is a more able man than Steve and will push it. You must come out anyhow this Summer if not before then. You will see an improvement on the way of making jugs. Johnnie never did send you jars you wrote. before you need them again I hope you can get them. he was not burning ware at all then just making and not burning. They have to build a furnace for burning ware on a different place and very expensive." DIFFICULTIES FOR THE NEW COMPANY: Baldwin, *Great and Noble Jar*, 107. GRAVES OF MILES AND CAHILL: Minden Cemetery, Miles Plot: John Miles (June 23, 1842--September 18, 1903); John Cahill (February 10, 1849--December 27, 1925).

12. "DO ASK JOHNNIE": America Miles Wever to Francis Miles Wever, n.d., Wever Family Papers, collection of the author.

13. BLACKS CONTINUED AT THE POTTERIES: 1880 U.S. Census: Manufacturing Schedule: South Carolina, Aiken County, Shaw Township, p. 47. Also see Baldwin, *Great and Noble Jar*, 89, 96, 99; Wash Miles is misidentified in Baldwin as Josh Miles. LAST DAYS OF SEIGLER'S POTTERY: Smith, *Index of Southern Potters*, 174; "Notes made on trip to Seigler's Pottery," October 4, 1930, Laura Bragg Papers, Charleston Museum Archives. MARK JONES WAS LIVING WITH HIS DAUGHTER: 1910 U.S. Census: South Carolina, Aiken County, Gregg Township, p. 136A. MARK JONES'S BLINDNESS: Mark Jones is listed as blind on the 1910 census; he is described as a blind

preacher in "Notes made on trip to Seigler's Pottery," Laura Bragg Papers, Charleston Museum Archives.

14. BEN LANDRUM NEVER SPOKE OF THE POTTERY: Cinda Baldwin, interview with Harold Steele, August 5, 1987, in Castille, *et al.*, *Archaeological Survey*, A-2. DONATION BY CAPTAIN STONEY: Koverman, in Koverman, ed., *I made this jar . . .* 19. PAUL REA ASKED THE PUBLIC FOR HELP: *Bulletin of the Charleston Museum*, Vol. XV, No. 4, April 1919, 44–45.

15. LETTER TO PAUL REA: J. M. Eleazer to "Curator," April 15, 1919, Laura Bragg Papers, Charleston Museum Archives.

16. SOLUTION TO THE PUZZLE OF THE JAR: *Bulletin of The Charleston Museum*, Vol. XV, No. 4, April 1919, 44–46. PAUL REA TRAVELED TO RIDGE SPRING: "Field Notes on Collecting Trip of P. M. Rea to Edgefield County," April 24, 1919, Laura Bragg Papers, Charleston Museum Archives.

17. "WE HOPE IT WILL NOT BE LONG": *Bulletin of the Charleston Museum*, Vol. XV, No. 4, April 1919, 46.

18. "CURING AND KEEPING MEAT": J. M. Eleazer to "Curator," November 19, 1919, Laura Bragg Papers, Charleston Museum Archives.

19. BIOGRAPHICAL INFORMATION ON LAURA BRAGG: Louise Anderson Allen, *A Bluestocking in Charleston: The Life and Career of Laura Bragg* (Columbia: University of South Carolina Press, 2001). "A REALLY FINE LOT OF CAROLINA POTTERY": Quoted in Allen, *A Bluestocking in Charleston*, 139. VISIT TO EDGEFIELD: *Charleston Evening Post*, July 22, 1930.

20. GEORGE FLETCHER'S COMMENTS: "Notes on Pottery," July 7, 1930, Laura Bragg Papers, Charleston Museum Archives.

21. CARLEE MCCLENDON'S EFFORTS: Carlee McClendon, personal communication, March 24, 2003, and June 10, 2004. "I ONLY KNEW HIS NAME": Maude Stork Shull, personal communication, May 24, 2003.

22. 2004 AUCTION: Fine Southern Americana, December 11 and 12, 2004, Charlton Hall Galleries, Columbia, S.C., lot 128.

23. "WHEN I WAS GROWING UP": Elizabeth Holland Holtzlander, personal communication, February 11, 2003.

Afterword

1. C. VANN WOODWARD: Quoted in Genovese, *Roll, Jordan, Roll*, xv.

2. BROKEN BRIDGE: Holmes, *Footsteps,* 27. "OUT OF EARSHOT": Simon Schama, *Dead Certainties (Unwarranted Speculations)* (New York: Alfred A. Knopf, 1991), 320.

"DOES ANYTHING ELSE SURVIVE?": Reif, *New York Times,* January 30, 2000.

Inscriptions

1. CORRUPTION OF DAVE'S SIMPLE LINES": Samuel J. Hardman, "Dave (David) Drake of Edgefield, South Carolina, c. 1800–c. 1870, Aframerindian Poet-Potter," privately published, 2006. Hardman values Dave's inscriptions enough to have created a detailed analysis of them (*Dave's Poems: The Poetry of Enslaved African-American Poet David Drake,* 2001) and a series of witty and iconic paintings based on them. "ANGELS" VS. "AGES": Adam Gopnik, *New Yorker,* May 28, 2007, 30–37.
2. KATHY STEELE: personal communication, November 13, 2005.
3. J. W. MUNDY: 1860 U.S. Census: South Carolina, Edgefield County, Duntonville P. O., p. 65.
4. SCOTT MILES: Baldwin, *Great and Noble Jar,* 224.
5. GYASCUTUS: Chapman, *History of Edgefield,* 241–43.
6. SOME SCHOLARS: Aaron De Groft, in *Pottery, Poetry and Politics Surrounding the Enslaved African-American Potter, Dave,* proceedings of a symposium held at the McKissick Museum, University of South Carolina, April 25, 1998 (Columbia: McKissick Museum, 1998), 56–57.
7. POSSIBLE SUBVERSIVE MESSAGE: John A. Burrison, in *Pottery, Poetry and Politics,* 27.
8. "NEW" FOR REV. JOHN LANDRUM: Holcombe and Holcombe, in Koverman, ed., *I made this jar . . . ,* 76–77.
9. "PONDEROSITY": Vlach, *The Afro-American Tradition in Decorative Arts,* 77–79.

A Word on Sources

1. VLACH'S COMMENT: Vlach, *Afro-American Tradition,* 77, 79. PUBLICATIONS AND EXHIBITIONS: Baldwin, *Great and Noble Jar,* ix–x, 187–90; Koverman, ed., *"I made this jar . . . ,"* 14–15, 20–21.

SELECTED BIBLIOGRAPHY

Publications Relating to Dave, Edgefield Pottery, and the History of Edgefield

Abbott, Martin. *The Freedmen's Bureau in South Carolina, 1865–1872*. Chapel Hill: University of North Carolina Press, 1967.

Allen, Louise Anderson. *A Bluestocking in Charleston: The Life and Career of Laura Bragg*. Columbia: University of South Carolina Press, 2001.

Baldwin, Cinda. *Great and Noble Jar: Traditional Stoneware of South Carolina*. Athens and London: University of Georgia Press, 1993.

Barber, Edwin Atlee. *The Pottery and Porcelain of the United States: An Historical Review of American Ceramic Art from the Earliest Times to the Present Day*, 3d ed., rev. and enl. New York: G. P. Putnam's Sons, 1909.

Bleser, Carol. *The Hammonds of Redcliffe*. New York and Oxford: Oxford University Press, 1981.

Bleser, Carol, ed. *Secret and Sacred: The Diaries of James Henry Hammond, a Southern Slaveholder*. Columbia: University of South Carolina Press, 1997.

Brown, Richard Maxwell. *Strain of Violence: Historical Studies of American Violence and Vigilantism*. New York: Oxford University Press, 1977.

Burrison, John A. *Brothers in Clay: The Story of Georgia Folk Pottery*. Athens and London: University of Georgia Press, 1983.

———. "Fluid Vessel: Journey of the Jug," in Robert Hunter, ed., *Ceramics in America*. Milwaukee: Chipstone Foundation, 2006.

Burton, Orville Vernon. *In My Father's House Are Many Mansions: Family and Community in Edgefield, South Carolina*. Chapel Hill and London: University of North Carolina Press, 1985.

Butterfield, Fox. *All God's Children: The Bosket Family and the American Tradition of Violence*. New York: HarperCollins, 1996

Cashin, Dr. Edward J. *The Story of Augusta*. Augusta: Richmond County Board of Education, 1980.

Castille, George J., Cinda K. Baldwin, and Carl R. Steen. *Archaeological Survey of Alkaline-Glazed Pottery Kiln Sites in Old Edgefield District, South Carolina.* Columbia: McKissick Museum, South Carolina Institute of Archaeology and Anthropology, 1988.

Channing, Steven A. *Crisis of Fear: Secession in South Carolina.* New York and London: W. W. Norton, 1974.

Chapman, John A. *History of Edgefield County From the Earliest Settlements to 1897.* Newberry, S.C.: Elbert H. Aull, 1897.

Dennett, John Richard. *The South As It Is: 1865--1866.* New York: Viking Press, 1965.

Edgar, Walter. *South Carolina: A History.* Columbia: University of South Carolina Press, 1998.

Edgefield County, S.C., African-American Cemeteries. Compiled by the Old Edgefield District Genealogical Society, Box 546, Edgefield, S.C. 29824.

Edgefield County, S.C., Cemeteries, Volumes I--IV. Compiled by the Old Edgefield District Genealogical Society, Box 546, Edgefield, S.C. 29824.

——— . *An Educator's Guide: I made this jar . . .: The Life and Works of the Enslaved African-American Potter, Dave.* Columbia: McKissick Museum, University of South Carolina, n.d.?

Ferell, Stephen T., and T. M. Ferrell. *Early Decorated Stoneware of the Edgefield District, South Carolina.* Greenville, S.C.: Greenville County Museum of Art, 1976.

Foner, Eric. *Reconstruction: America's Unfinished Revolution, 1863--1877.* New York: Harper & Row, 1988.

Freehling, William W. *Prelude to Civil War: The Nullification Controversy in South Carolina, 1816--1836.* New York and Evanston: Harper & Row, 1966.

Goldberg, Arthur F., and James P. Witkowski. "Beneath His Magic Touch: The Dated Vessels of the African-American Slave Potter Dave," in Robert Hunter, ed., *Ceramics in America.* Milwaukee: Chipstone Foundation, 2006.

Greer, Georgeanna H. *American Stonewares: The Art & Craft of Utilitarian Potters,* Exton, Pa.: Schiffer Publishing Co., 1981.

Hall, Michael D. *Stereoscopic Perspective: Reflections on American Fine and Folk Art.* Ann Arbor and London: UMI Research Press, 1988.

Hansen, Eleanor Mims. *The Edgefield Advertiser and Its Editors.* Edgefield: Edgefield Advertiser, 1980.

Harris, J. William. *Plain Folk and Gentry in a Slave Society: White Liberty and Black Slavery in Augusta's Hinterlands.* Hanover: University Press of New England, 1987.

Holcombe, Joe L., and Dr. Fred E. Holcombe. "South Carolina Potters and Their Wares: The History of Pottery Manufacture in Edgefield District's

Big Horse Creek Section." *South Carolina Antiquities*, Vol. 21, 1989.

——— . "South Carolina Potters and Their Wares: The Landrums of Pottersville." *South Carolina Antiquities*, Vol. 18, 1986.

Holt, Thomas. *Black Over White: Negro Political Leadership in South Carolina during Reconstruction.* Urbana, Chicago, London: University of Illinois Press, 1977.

Horne, Catherine Wilson, ed. *Crossroads of Clay: The Southern Alkaline-Glazed Stoneware Tradition.* Columbia: McKissick Museum, University of South Carolina, 1990.

Jones, Eugene W. Jr. *Enlisted for the War: The Struggles of the Gallant 24th Regiment, South Carolina Volunteers, Infantry, 1861–1865.* Hightstown, N.J.: Longstreet House, 1997.

Kantrowitz, Stephen. *Ben Tillman and the Reconstruction of White Supremacy.* Chapel Hill and London: University of North Carolina Press, 2000.

Koverman, Jill Beute. *Making Faces: Southern Face Vessels from 1840–1990.* Columbia: McKissick Museum, 2000.

Koverman, Jill Beute, ed. *I made this jar . . .: The Life and Works of the Enslaved African-American Potter, Dave.* Columbia: McKissick Museum, University of South Carolina, 1998.

Lesser, Charles H. *Relic of the Lost Cause: The Story of South Carolina's Ordinance of Secession.* Columbia: South Carolina Department of Archives and History, 1996.

McArthur, Judith N., and Orville Vernon Burtom. *"A Gentleman and an Officer": A Military and Social History of James B. Griffin's Civil War.* New York and Oxford: Oxford University Press, 1996.

McClendon, Carlee T. *Edgefield Death Notices and Cemetery Records.* Columbia: Hive Press, 1977.

——— . *Edgefield Marriage Records, Edgefield, South Carolina: From the Late Eighteenth Century up through 1870.* Columbia: R. L. Bryan, 1970.

Mills, Robert. *Statistics of South Carolina, Including a View of Its Natural, Civil, and Military History, General and Particular.* Charleston: Hurlbut and Lloyd, 1826.

Mohr, Clarence L. *On the Threshold of Freedom: Masters and Slaves in Civil War Georgia.* Athens and London: University of Georgia Press, 1986.

Montgomery, Charles J. "Survivors from the Cargo of the Negro Slave Yacht Wanderer." *American Anthropologist*, October 1908.

Newell, Mark M., with Peter Lenzo. "Making Faces: Archaeological Evidence of African-American Face Jug Production," in Robert Hunter, ed., *Ceramics in America.* Milwaukee: Chipstone Foundation, 2006.

Newell, Mark M., and Nick Nichols. *The River Front Potters of North Augusta.* Augusta: Georgia Archaeological Institute, 1999.

Nicholson, Alfred W. *Brief Sketch of the Life and Labors of Rev. Alexander Bettis: Also an Account of the Founding and Development of the Bettis Academy*. Trenton, S.C.: published by the author, 1913.

Pottery, Poetry and Politics Surrounding the Enslaved African-American Potter, Dave. Proceedings of a symposium held at the McKissick Museum, April 25, 1998. Columbia: McKissick Museum, University of South Carolina, 1998.

Revis, Tim. "Dave the Potter: Slavery's Poet Laureate Craftsman." *Veranda*, May/June 2006.

Rigdon, John C. *The Battle of Aiken*. Augusta: Eastern Digital Resources, 2001.

Shedd, Joel P. *The Landrum Family of Fayette County, Georgia*. Washington, D.C.: Moore and Moore, 1972.

Sheppard, William Arthur. *Red Shirts Remembered: Southern Brigadiers of the Reconstruction Period*. Atlanta: Ruralist Press, 1940.

Simkins, Francis Butler. *Pitchfork Ben Tillman: South Carolinian*. Columbia: University of South Carolina Press, 2002.

Simkins, Francis Butler, and Robert Hilliard Woody. *South Carolina During Reconstruction*. Chapel Hill: University of North Carolina Press, 1932.

Smith, Howard A. *Index of Southern Potters*. Mayodan: Old America Company, 1982; reprinted by Mayo Publishing, 1996.

Steen, Carl. *An Archaeological Survey of Pottery Production Sites in the Old Edgefield District of South Carolina*. Columbia: Diachronic Research Foundation, 1994.

Vandervelde, Isabel. *Aiken County: The Only South Carolina County Founded During Reconstruction*. Spartanburg: Reprint Company, 1999.

Vlach, John Michael. *The Afro-American Tradition in Decorative Arts*. Athens and London: University of Georgia Press, 1990.

Washington-Williams, Essie Mae, and William Stadiem. *Dear Senator: A Memoir by the Daughter of Strom Thurmond*. New York: HarperCollins, 2005.

Wigginton, Eliot, and Margie Bennett ed. *Foxfire 8*. New York: Doubleday, 1983.

Williamson, Joel. *After Slavery: The Negro in South Carolina during Reconstruction, 1861-1877*. Chapel Hill: University of North Carolina Press, 1965.

Zuczek, Richard. *State of Rebellion: Reconstruction in South Carolina*. Columbia: University of South Carolina Press, 1996.

Zug, Charles G. III. *Turners and Burners: The Folk Potters of North Carolina*. Chapel Hill and London: University of North Carolina Press, 1986.

Acknowledgments

Among the many people who have helped make this book possible, there are three who deserve special mention. The first is Jill Beute Koverman, who curated the McKissick Museum show on Dave, "I made this jar. . . ." She shared her extensive knowledge of Dave with me at every turn, generously allowing her research to serve as a foundation for this book. The second is Bettis Rainsford, Edgefield's preminent historian, who broke out a bottle of champagne to inaugurate the first day of my research and remained my reliable guide throughout this project. The third is potter Steve Ferrell, who took me to the sites where Dave worked and tirelessly revealed to me the intricacies of traditional stoneware production. I am more grateful than I can say to these three friends.

I am also deeply grateful to Tricia Glenn, archivist for Edgefield County, who spent many hours helping me find obscure documents; Tonya Browder, director of Edgefield's Tompkins Library, who aided me in unraveling numerous genealogical puzzles; Broadus Turner, who told me fables of Dave and old Edgefield; Dr. Arthur Goldberg, pottery scholar and collector, who tried to keep my speculations about Dave within reasonable bounds; Dr. John Burrison, who freely shared his knowledge of Southern pottery history with me; Betsy Bloomer, who guided me through the landholdings of the early local potters; Dr. Mark Newell, who provided me with information on the final years of pottery production in the Edgefield area; Doug Keisler, who discovered a previously unknown mention of Dave in the *Edgefield Advertiser*, Dr. James

Farmer, Carolyn Mitchell, Maureen Murdock, Patricia Ryan, and Jim Witkowski, each of whom made valuable comments on an early version of my manuscript; and potter Gary Klontz, who gave me patient instruction in turning pots of my own.

Descendants of the original Edgefield potters generously shared their family stories with me. Among them were Mary Ellen Corley Cato, Kathryn Landrum Dively, Bo Drake, Tim Drake, Jr., Jacqueline Fesq Haislip, Elizabeth ("Noonie") Holland Holtzlander, Mary Katherine Jones, B. F. Landrum III, B. F. Landrum IV, Deanne Drake Miller, Louise Landrum Murphey, Catherine Holland Scavens, Maude Stork Shull, Charlotte Drake Stone, and Jackie Zets.

Senior members of Edgefield's black community kindly supported my project by searching their memories for stories of Dave and other enslaved pottery workers. Among them were Mr. Pernell Ashley, Mrs. Patri Bettis Brayboy, Mrs. Thomasina Holmes Bouknight, Mrs. Billie Lloyd Carter, Mrs. Josie Daniels, Mrs. Stella Dorn, Mrs. Janie Thurmond Dunbar, Mrs. Vivian Greene Floyd, Mrs. A'La Pearl Ashley Hickman, Mrs. Mary Mathis, Rev. L. K. Miles, Mrs. Daisy Newsome, Mrs. Josie Brown Pack, Mrs. Mamie Rearden, Mrs. Leatta Weaver Price Stevens, and Mr. Jesse Thurmond. I am also grateful for assistance from the following families: Lorenzo Williams and other members of the Weaver family; Mrs. Ocea Lee Barnes, Patricia Bishop, Joe Norman, and other descendants of Ward and Rosa Lee; and James Jones and Marilyn Bloodworth, of the Jones family. Members of the Springfield Missionary Baptist Church, especially Rev. Leander Jones, Rev. Pearl Stallworth, Deacon Robert Stallworth, Deacon Elijah Blocker, Deacon Walter Blocker, and Deacon Willy Blocker, welcomed me into their fellowship and helped me with my research wherever possible.

A number of individuals aided in establishing the text of Dave's inscriptions. They include Louise Alexander, Steve Cumbee, Donnie F. Garrett, Samuel J. Hardman, Paul and Sally Hawkins, Dr. John E. Hoar, Mildred Hosang, John and Virginia Kemp, Sam Phillips, Jane and George Rainsford, Levon Register, Jenn and Jim Robertson, Tony

Shanks, Jim and Mary Smith, Garrison and Diana Stradling, and Jim Yates. Others who helped me in various ways were JoAnn Amos, Bill Babb, Robert E. Backman, Martha Bates, Michel Bayne, Jon and Eve Blossom, Tom Bracco, Carol Hardy Bryan, Thurmond Burnett, James Fab Burt, Orville Vernon Burton, Ethel Butler, Beth Cali; Carrie Clark, John Owen Clark, Greatha Clement, Beverly and LeGrande Cooper, Chalmers Culbreath, Councilman Norman Dorn, Linda Ely, Terry Ferrell, Patricia Fleming, Starkey Flythe, Glasglow Griffin, Theresa Harvey, Chris Judge, Willa Lanham, Carlee McClendon, Dr. Connie McNeill, Dot Mims, Marie Mims, Pamela Urban Moore, Sam Morgan, Angela Newsome, Anne and Evarist O'Neil, Janie Ruth Osborne, Howery Pack, Kojak and Lisa Padgett, Sharon Parler, Hans Pawley, Judy Pendarvis, Martha Rearden, Dori Sanders, Joe Scavens, Ralph Scurry, Moses Simkins, Anne Smith, Kathy Steele, Carl Steen, Carolyn Taylor, Rosalind and Ted Tedards, Wanda Terry, Kelvin Thomas, Robert and Rebecca Tidwell, Mott Vann, John Michael Vlach, Jackie Wash, Essie Mae Washington-Williams, Rev. William Weaver, and Glenn Zimmerman.

I am grateful for the assistance of the volunteer staff of the Tompkins Library in Edgefield (Malissa Browder, Thomasina Adams Dais, Vernon Miller, Barbara Pulliam, Raymond Timmerman); the staff of the Edgefield County Library (Anu Acharekar, Janet Burgess, Tom Dobbins, Natalie Pulley, Renee Reel); Suzanne Derrick and the staff of the *Edgefield Advertiser*; Kate Plowden and the staff of Piedmont Technical College; the staff of the Caroliniana Library, the staff of the McKissick Museum, and the staff of the Thomas Cooper Library, all at the University of South Carolina in Columbia; Fritz Hammer and the staff of the South Carolina State Museum in Columbia; the staff of the South Carolina Department of Archives and History in Columbia; Ron Long at Charlton Hall Galleries in Columbia; Sharon Bennett and the staff of the Charleston Museum Archives; Grahame Long and Jan Hiester at the Charleston Museum; Nicole Green at the Old Slave Mart Museum in Charleston; Sherman Pyatt at the Avery Center for African Ameri-

can History and Culture in Charleston; the staff at the South Carolina Historical Society in Charleston; the staff of the South Carolina Room at the Charleston County Public Library; Mary Lehr and Tommy Burkhalter at the Charleston Chapter, National Railway Historical Society; Gordon Blaker and Guy Robbins at the Augusta Museum of History; Christine Miller-Betts at the Lucy Craft Laney Museum of Black History in Augusta; Susan Jackson at Meadow Gardens in Augusta; Sara Hindmarch, Sarah Meyers, and Beth Hancock at the High Museum of Art in Atlanta; Susan Neill and Betsy Rix at the Atlanta History Center; Angela Nichols at the Madison-Morgan Cultural Center in Madison, Ga.; Jennifer Beanbower at the Museum of Early Southern Decorative Arts (MESDA) in Winston-Salem; Marcia Erickson at the North Carolina Museum of Art; Holly Frisbee at the Philadelphia Museum of Art; Ross Day at the Goldwater Library and Ken Soehner at the Watson Library, both at the Metropolitan Museum of Art in New York; Mary Beth Shine at OAN Books in New York; Irene Bromberg at the Collectors Club in New York; Thomas Lisanti at the New York Public Library; Bonnie Lilienfeld and Michael Barnes at the National Museum of American History in Washington, D.C.; David Landon at *Northeast Historical Archaeology*; and Robert Hunter at *Ceramics in America*.

In Louisiana, Lestar Martin was a great help to me in uncovering the story of Mt. Lebanon's Edgefield Colony, as were Dr. Phillip Cook, P. F. Eaton, Ruby Grubs, Olen Jackson, Tom Martin, Jennifer and Herbert Newman, Elizabeth Towns, Jeannie Basinger, the staff of the Bienville Parish Library, the staff of the Bienville Parish Clerk of Court's office, the staff of the Claiborne Parish Clerk of Court's office, and the staff of the Louisiana Tech University Library.

I am profoundly indebted to Wendy Schmalz, my literary agent of many years, who believed in this book from my earliest notion of it. I am equally grateful to Starling Lawrence, my editor at W. W. Norton, who, with constant grace, helped me bring it into being. Molly May, editorial assistant, promptly and with good humor answered all my queries.

Production manager Julia Druskin kept the project on schedule. Project editor Nancy Palmquist and copy editor Barbara Feller-Roth edited the text with thoroughness and sensitivity. Art director Francine Kass and designer Barbara Bachman gave the final volume a handsome look.

I am especially grateful to my wife, Laurel, who listened to my ideas and read my manuscript and discussed Dave's life with me with unflagging interest. As a poet, she was able to shed light on the idiosyncratic style in which Dave wrote. I also owe a debt of gratitude to my great-grandparents, my grandparents, and my parents for the care with which they preserved the letters and other family papers that eventually helped me tell Dave's story.

Finally, I would like to express my appreciation for the encouragement that Donna Marie Landrum-Hill has given me from the beginning of this project. She is descended from Abram Landrum, the former Landrum slave who tried to keep the balloting lawful at Edgefield Courthouse on the violent election day of 1876. Our conversations have helped me understand the complex inheritance that we share.